BETWEEN
MONEY AND LOVE

BETWEEN MONEY AND LOVE

The Dialectics of Women's Home and Market Work

Natalie J. Sokoloff

foreword by
Elise Boulding

PRAEGER

PRAEGER SPECIAL STUDIES • PRAEGER SCIENTIFIC

Library of Congress Cataloging in Publication Data

Sokoloff, Natalie J
 Between money and love.

 Bibliography: p.
 Includes index.
 1. Women—Employment—United States. 2. Marxian
economics. I. Title.
HD6095.S64 331.4'0973 80-17101
ISBN 0-03-055296-6 (hb)
 0-03-060286-6 (pb)

Published in 1980 (hb) and 1981 (pb) by Praeger Publishers
CBS Educational and Professional Publishing
A Division of CBS, Inc.
521 Fifth Avenue, New York, New York 10017 U.S.A.

0123456789 145 987654321

Printed in the United States of America

FOREWORD by
Elise Boulding

This is an important book. In its pages the old themes of capitalism and patriarchy take on new life as Natalie Sokoloff develops her theory of the dialectics of women's work. Going beyond contemporary theories of work, both mainstream and Marxist, she enables the reader to get to the core of the dynamic process that recreates patriarchal relations for women both in the home and the workplace and to see that partriarchy and capitalism are social forces that operate independently of one another. The woman worker is punished at home for not giving adequate nurturant service because of her workplace responsibilities; she is punished at the workplace both for being an "unreliable" person who may be called to her home responsibilities at any time and for being a person who at most has only "housekeeping" skills to offer at the workplace. Thus, each of her activities downgrades the other and cements her position at the bottom of the status and power hierarchies of both the public and the private sphere. The more the woman tries to compensate for the rigid dichotomy between public and private spheres by humanizing public spaces as a worker and a volunteer, the more her efforts are trivialized. Until the nature of this dynamic is understood, policies aimed at upgrading the status of women are bound to fail.

While the book is written in reference to the experience of working women in industrialized societies, particularly the United States, the theoretical implications go far beyond any particular cultural region or specific degree of industrialization. The cross-cultural implications of this work are far-reaching and should certainly be developed in the future. Another area that deserves further exploration is that of women who are unpartnered: the never-married, the separated, the divorced, and the widowed. As a substantial part of the women's work force, these women live in the shadow of patriarchy both in their husbandless homes and in their workplaces, where they work for other women's husbands, subject to the same dialectic as the partnered women with the added twist that they are also punished for not having the husbands they are "supposed" to have. Custom and legal institutions combine to see that patriarchy exercises its force over these women. The saddest victims of all, the displaced homemakers, pushed into a labor force they never dreamed of having to enter, also strengthen the system by their very compliance with their fate. The myth of the family wage, the wage assigned to the male breadwinner because only men support families, goes unchallenged because women must accept their pin-money wages to stay alive.

Patriarchy becomes both metaphor and paradigm for all hierarchical relations, including class relations, thus clarifying the all-important point that men suffer because of this dialectic of work as well. The men of the oppressed classes become, in effect, women. Only in part, of course, because they still have females over whom they can exercise power. As men exploit weaker men, so may women exploit weaker women. The irony of this circle of exploitation is that the exploiters themselves, by assigning service and nurturance-type work to women and to the weak, remain in infantile dependence and helplessness throughout their adult lives, knowing only how to be served and not how to take care of themselves. If we add Dorothy Dinnerstein's work on the pathology of mother-reared human beings to Sokoloff's work on the pathology of male domination of home and workplace, we realize how much of human history has been a theater of the absurd.

Today patriarchy is under attack from many other quarters besides Marxism. Peace and ecology groups, radical feminists, and a variety of radical political and nonpolitical new-order groups reject every type of hierarchical relationship. Within the mainstream middle class, the women's movement, in its emphasis on dual parenting, shared housework, and flexitime work for both spouses, is whittling away at an important source of patriarchy within the family. Yet Sokoloff's point that patriarchal power relations can so easily be re-created in each new setting is one that egalitarian movements tend to overlook. We had better understand the dynamics of that process as we move into the twenty-first century. The social, economic, and political discontinuities that lie ahead through the combined effects of resource depletion, environmental pollution, and the war-making proclivities of nation-states may well involve shifting to a more labor-intensive, localist postindustrial society. If patriarchy survived the transition from agrarian to industrial society, it could also survive the transition to a postindustrial society. It could well be that the more things change, the more they will stay the same—for women.

Sokoloff's book lays solid groundwork for the new analyses that need to be made to avoid old dangers, particularly through its skillful summary of the limits of existing theories of the participation of women in the labor force. Sokoloff gives an excellent review of structural-functional analysis and the relative uselessness of status attainment theory as a point of departure for policy makers. The opening up of new opportunities for women can hardly take place within structures that embody the very limitations that the status-enhancement policies purport to overcome. Her analysis of the dual labor market theory points to the same structural dilemmas. As long as a social system requires labor that can easily be disposed of at the convenience of its managers, equal pay for equal work and

equal access to job opportunities remain political slogans, untranslatable into economic reality. I am not myself sufficiently versed in Marxist Feminist theory to be able to say more than that her critique of these theories appears penetrating to this non-Marxist reader. The distinctions between varieties of Marxist Feminist theories are sometimes a bit complex to follow, but in the end she makes good use of those distinctions. She backs out of some theoretical culs-de-sac with notable skill in her conceptual work of disentangling patriarchy and capitalism.

While the groundwork has been laid for new thinking by Sokoloff's work, serious tasks lie ahead if the dynamics of inequality are to be successfully addressed. One of the areas in which new work needs to be done is the area of labor itself. New conceptual categories to deal with the phenomenon of work may help the understanding of the exploitative processes associated with patriarchy. Referring to domestic work as "consumption work," for example, mystifies some rather straightforward production work of a craft nature that goes on in most households even in urban areas—crop cultivation and the preserving of food and the making of clothes, furniture, and convenience household items—some significant parts of which are sold or bartered by the housewife. Because the housewife's activities are stereotypically categorized, and because most of the housewives that the sociologist studies are suburban chauffeurs of children, the production work of the rural and small-town housewife and of the rural immigrant to urban areas is undocumented. In my research on farm women, I have found that a farm wife typically has one or two of her own economically productive cash-generating enterprises in addition to the farm work she does jointly with her husband. Current research on women in small towns suggests that in addition to substantial amounts of home craft work, women labeled "housewives" are continually moving in and out of the labor force, doing a great variety of part-time jobs, most of which are not thought of as "working" because they are of short duration.

Until we know what women labeled as economically inactive homemakers actually do, we are missing out on understanding the empirical reality of work, of economic production in its broadest sense, not in the specific technical sense in which Marx uses the term productive labor. Marx was right in identifying the home as a significant locus of exploitation of women but wrong in his assumption about the nature of the work women were doing there. The reconstruction of the social order requires a better knowledge of the range and types of work actually performed by human beings of all ages in each social setting. We need to understand the types of labor that society actually utilizes as distinct from what it is said to utilize.

This means more attention should be given to the work that children do, as well as women. Children, like women, perform much

labor that is hidden from social view. In part, like women, they are in and out of the labor force at part-time jobs that are never counted (most of them are, in fact, "illegal"). Such work begins at roughly the time when they enter school in industrial societies, at age five or six. For children in agrarian societies, helping on the farm or in family craft enterprises begins at age three or four. Again, the hiddenness of this work has to do with its role in helping to reproduce patriarchal relations.

One dynamic that has always worked to contravene exploitation in any society is revolutionary consciousness. Interestingly enough, the revolutionary consciousness is nurtured in the very setting that is known as the seedbed of patriarchy—the family. The passing on of revolutionary consciousness from parents to children is recognized but little studied. In the century preceding the French Revolution, there was a very conscious process of working out new ideas in intergenerational dialogues within certain families, and the same was true in Russia. Of course, the home was not the only place where revolutionary dialogue took place, but it offered a very special, protected place for mental experiment and social praxis. In our time we see women, and men as well, engaged in intergenerational dialogues with their offspring, working out new social contracts in the family, new types of social aspirations, and new values. Jessie Bernard writes of the social phenomenon of the tipping point, when a sufficient number of people have adopted a new mode of behavior so that the old equilibrium is suddenly gone. When enough women opt out of abusive patriarchal structures in the home, in the marketplace, and in the civic arena, and enough men refuse to play the old roles, then the work of restructuring becomes possible. Without good theoretical understanding, however, old mistakes can be built into new structures. Sokoloff's book is an important contribution in two ways. She helps to shape the revolutionary consciousness, and at the same time, she offers new tools for increasing our theoretical understanding of patriarchy and capitalism as process.

PREFACE

In the past decade, the increase in the number of women working in the paid labor force has changed from being front-page news to being a commonplace and an accepted phenomenon. In the United States, almost 60 percent of all husband-and-wife families have multiple wage earners, and 59 percent of all adult women aged 18 to 64 years old were employed in 1978. The most spectacular increase in labor force participation has been among women in their childbearing years. Thus, by 1978, almost 66 percent of women between 25 and 34 years old were engaged in waged labor, despite the fact that over 70 percent of these women had children under age 18 at home. Further, 75 percent of all employed women were working in full-time, though not necessarily year-round, jobs. This high percentage of employed women is reflected in the increased number of popular and professional books, magazines, and journals as well as television programs and movies that focus on the "liberated woman"—although she may be one who still experiences the double burden of both home and market work. In all this the women's movement has been crucial in expanding women's consciousness, demanding equal pay for equal work and, more recently, equal pay for work of comparable worth, decent working conditions, and dignity for all women.

Despite the increased participation of women in the labor force, the inequality experienced by women in the market is as persistent and pervasive as ever. While some women have fought their way into traditional male preserves, usually with the help of the women's movement, the vast majority of women are still employed in "female" or sex-typed jobs—lower status, less powerful, dead-end, and, most especially, lower-paid jobs. A fully employed woman still makes only $0.57 for every $1.00 a man makes, according to the most recent data available in 1979. On the average a woman who completed four years of college still earns less than a man who has completed only an eighth-grade education. This disparity holds equally true for women who work both full time and year-round as for women who are unable to find stable employment. And, finally, while it is clear that some progress in employment has been made by women since the 1950s, it is likewise true that women are just beginning to reattain the level of educational and occupational achievement that they established clear back in the 1930s. The progress of the working woman is a "mixed bag" indeed.

What can be done to ensure that the rising numbers of women in waged labor will be more equitably treated? To change the nature of

women's work and its associated burdens, we must first be able to explain women's disadvantaged position in the market. A wide variety of explanations have been offered by social scientists, politicians, and the general public alike. One such suggestion is that women are not as well educated as men nor as interested in the education and training needed for success in male-dominated occupations. Another is that women's length of service on the job is not as long nor as continuous as men's because of their child-care and domestic responsibilities. And still another is that women are more likely to work in sex-segregated jobs, which are economically disadvantaged because of the overcrowding of women in these areas. Fully 80 percent of employed women work in only 25 job categories, all widely considered "women's jobs."

The debate is clearly continuous between those who see the socialization process and women's socially structured home responsibilities as causing women's employment problems versus those who see the structure of the labor market itself as causal. In this book I argue that behind all these so-called causes are the even more recalcitrant social relations of patriarchy and capitalism, which reinforce women's subordination in both the home and the market and also provide the sources for change. It is these sets of social relations that I call "the dialectical relations of women's work."

Only by viewing women's work in its totality can we begin to understand the complexity of women's labor market experience. Work within this perspective means both paid labor in the market and unpaid labor in the home. Thus, it is not enough to simply provide job opportunities for women in the market; nor is it enough for men to share home responsibilities with their women partners. There must be a reorganizing of work itself and of the forces that underlie it—patriarchy, capitalism, and racism*—in both the home and the market.

In developing its analysis of women's work, this book will describe the theoretical frameworks in sociology that attempt to explain women's position in the labor market. The reader will find a systematic analysis of the underlying assumptions of each of these theories, as well as an evaluation of their strengths and weaknesses.

The issue of work in U.S. society has probably been studied by sociologists most clearly in the literature on social stratification. This book explores the two major intellectual currents that underlie

*This book is inadequate in understanding and analyzing the importance of racism in the lives of women and all home and market workers alike. It reflects the state of the field as it exists today and must be changed.

most of the theory and research in this sociological specialty through-out its history. Although they are referred to in a variety of ways in the sociological literature, here these two schools of thought are called mainstream and radical sociology.

The first school, or mainstream, is that most commonly accepted by U.S. sociologists. It can be broken down further into two subspecialties: structural functional theory and conflict theory (not to be confused with class conflict theory in radical sociology). Structural functional theory holds that "amorphous classes" emerge as a consequence of individual mobility in those situations in which the most fit or the best prepared are the most highly rewarded. Social mobility through one's own achievement, rather than social assignment through one's ascribed status, is viewed as both desirable and widespread. Conflict theory, on the other hand, suggests that conflict, not the stress toward order, is what organizes people's relationships with one another and with the larger society. This conflict exists in numerous areas of life. Descriptions of institutional inequalities dominate. Attempts to reduce these inequalities focus on reforms within the existing society. (Another commonly used way of distinguishing these two groups in mainstream sociology is the "normative" versus the "structural" or "situational" approach.)

Radical theory, the second major tendency in stratification theory and research, is identified most of all with the work of Karl Marx. Here, the motive force in society is not simply abstract conflict in general but class conflict between the owners of the means of production and the workers—at least potentially—the two major classes in a society such as our own. Concentration is on class conflict among key social forces and on internal contradictions that inevitably produce change. Mobility within the current social system is rarely discussed: since real mobility or equality is not held possible within existing social institutions in U.S. society, it is argued that new social arrangements must emerge.

Within each of these intellectual currents, several currently influential theories deal with women in the labor force. In the mainstream literature two such theoretical perspectives stand out. The first is status attainment theory (Chapter 1), which concludes that a degree of equality between men's and women's occupational achievements, at least in terms of status, exists in U.S. society. The second is occupational sex stratification or segmentation theory, which emphasizes the inequality that women are subjected to in the labor market. This second theory, more commonly known as the dual labor market theory (Chapter 2), comes from the field of economics but is currently being explored in sociology, too.

In the radical literature, three important theories relate to women in the labor force. In different ways these three theories un-

derstand women to be severely disadvantaged in comparison with men when they enter the labor market. First is the work of Marx and contemporary Marxist theorists of monopoly capital (Chapter 3). Their work provides the necessary tools with which to understand the nature of class conflict in a certain type of social and economic system: monopoly capitalism. Most important, I show how their analysis demonstrates that the nature of work and the types of jobs created by twentieth century monopoly capitalism forcefully affect the ways in which women have been incorporated into the labor market in severely disadvantaged occupational positions.

Two tendencies among Marxists who are also feminists focus not only on women's disadvantaged position in the market but also on their disadvantaged position in the home and the ways in which the two are intimately interrelated. For all Marxist Feminists, both sex conflict and class conflict become overriding concerns. Introducing a key distinction between these two groups, I elaborate on the Marxist Feminist theorists of the home (or Early Marxist Feminists, Chapter 4) as against the Marxist Feminist theorists of patriarchal capitalism (or Later Marxist Feminists, Chapter 5). They differ significantly in their view of sex conflict versus class conflict as causes of women's severely disadvantaged position in the labor market. The former group focuses on capitalism and its influence on women's domestic labor, the latter on the interrelation between patriarchy, systematic male power, and capitalism in all spheres of women's lives. Chapter 6 sums up the contributions to the analysis presented here of each theoretical perspective and tendency outlined in the previous five chapters. This summary singles out certain building blocks that each theoretical approach provides to help explain what happens to women in the contemporary U.S. labor market.

I conclude that it is not possible to understand what happens to women in the labor market only by analyzing what happens to them in that sphere of existence. Any attempt to understand a woman's position in the market must relate that to her position in the home. Such an analysis, moreover, requires an understanding of the social forces of class conflict and sex conflict as they relate to one another in both the home and the market. Hence, I stress the totality of women's experiences—in the home, in the market, and in society in general— as created by the interacting forces of class conflict and sex conflict (or of capitalism and patriarchy). This stress on totality, I hold throughout, is absolutely necessary if we are to understand women's position in the labor market today.

Finally, in Chapter 7 I build the concept of the dialectical relations of women's work out of these various theoretical building blocks. I then use this analytic tool to explain the totality of women's disadvantaged position in the labor market, taking into account women's steadily increasing participation in the 1970s.

From this analysis, new questions emerge—questions that call for changes in theory and practice. These emergent issues suggest the kind of investigation necessary to transcend currently available frameworks to gain a fuller, more comprehensive view of women's work. One such currently held idea, for instance, is that patriarchy is diminishing in the contemporary home. Within a perspective such as the dialectical relations of women's work, however, we can now also investigate how patriarchal relations have been transformed and intensified within the labor market, instead of focusing solely on patriarchal relations at home. Another such idea is that with women's increasing participation in the labor market, capital is losing an important part of its reserve of labor: the married homemaker. But the dialectical relations of women's work forces us not only to look at the way capital operates in this process but also to evaluate the historically specific struggles and alliances between two groups of men—working-class and ruling-class men—over women's labor as well.

In the end I show how we must understand the conflicts as well as the mutual accommodations between patriarchy and capitalism. Only by examining these conflicts will we be able to understand the sources of resistance and the strategies needed to bring about those changes in women's lives that we want, both individually and collectively.

ACKNOWLEDGEMENTS

This book is a product of individual life experience growing out of, and contributing to, a certain historical moment. It is based on my Ph.D. dissertation, which I completed in November of 1978. After finishing my master's degree in 1967, I did not return to graduate school for another seven years. The difference in feminist consciousness on university campuses between the mid-1960s and early 1970s was incredible. In the 1970s not only was I able to pursue some course work on women in U.S. society, but I was even able to take courses from a few women professors. This had never happened to me in my earlier graduate or undergraduate education. Moreover, a whole body of feminist theory was beginning to develop that challenged many of the assumptions that I, like my teachers and colleagues earlier, had taken for granted. Most important for me, this was true within all varieties of sociological thought.

Without the women's movement, neither my dissertation nor this book would have been written. I have been fortunate enough to grow intellectually and politically during this rich period of theoretical development and social change.

I am indebted to the women's movement in general and to several groups of women in particular—for their support, their critical ideas, their continual encouragement, and their friendship—even when they disagreed with me. My thanks to Karen London, Eleanor Batchelder, and Fabi Romero-Oaks, the founders of Womanbooks; to the women in my New York City dissertation support group; and to the Marxist Feminist community, many of whose individual members were generous enough to share their "rough drafts" and unpublished materials with me over the past five years.

During the past year, I have learned of the need to continue to clarify the ideas and goals presented in this book, as I have participated with and learned from my sisters and colleagues in my Baltimore and Washington, D.C., study groups. From them I have gained both criticism and support as well as the reinforced knowledge that we are all struggling around similar problems, even if our analyses or interpretations are not exactly alike. In fact, their diversity has made me stronger. Further, in the summer of 1979, I met a group of British Marxist Feminists who reinforced for me the idea that the struggle for understanding and changing the lives of women is so clearly an international one. While this book does not adequately reflect much of the current work of women in other countries (in large part, because materials are so new and therefore are either unpub-

lished, difficult to reproduce, or not yet translated), the need for such an international perspective is abundantly clear. To all these groups of women I want to express my thanks.

There are many individual people I would also like to thank for their encouragement, support, challenge, sharing of ideas, and critical reading of the manuscript. To the people who read chapters of the book during its early stages—sometimes in very rough form—I would like to thank Betty Yorburg and Steve Steinberg, important members of my dissertation committee, as well as Chris Bose, Renate Bridenthal, Rayna Rapp, Carol Brown, and Marty deKadt. Their comments and criticisms were most helpful in making it possible for me to move along, very often when I was just at the point where I might stop struggling on a particular set of ideas and clarifications.

Between the dissertation and book stage, others critically evaluated different parts of my work and offered helpful suggestions. These included most especially Heidi Hartmann, as well as Joan Kelly, Nona Glazer, Natalie Hannon, Jean Turner, Pam Cain, Roberta Spalter-Roth, and Joan Huber. Their insights and exchanges have strengthened this book. I am most grateful to them all.

My thanks also goes to Anne Goldberg Lipnick for being proud of me in my accomplishments; to Mike Brown who was always there when I needed him; and to Bill O'Donnell for teaching me to celebrate my accomplishments, especially my abilities as an intelligent and sensitive scholar.

I also am indebted to Margaret Blanchard for her editorial comments; to Sue Hahn for her impeccable typing and endless patience; to Sarah Begus who, despite her own hectic schedule, offered to proofread the first version of this manuscript; and to Jean Turner who graciously responded to my request to edit the last chapter of the present version of the book.

Finally, these acknowledgments would not be complete without thanking two people in particular without whose support this book could never have been completed. It is to George Fischer that I owe a deep sense of gratitude. As the chair of my dissertation committee, he helped me to move from doing a conventional piece of research to doing a new and challenging theoretical and critical analysis. During this process we became friends and colleagues. His dedication to the people he works with, his warmth and openness, his determination to meet people on their own terms, and his willingness to help others grow and to grow and change himself will always be remembered.

And to Fred Pincus, who helped with the endless tasks one needs help with in writing a manuscript, who encouraged me to be independent in thought—especially when it meant disagreeing with him, who always believed in me and that I would finish, who taught me to take "one step at a time," and whose warmth and friendship supported me through the many years of graduate school and the writing of this book, I am forever grateful.

CONTENTS

LIST OF TABLES AND FIGURES

1
THE THEORY OF
STATUS ATTAINMENT

INTRODUCTION

An upsurge of concern in the 1970s about women's employment
in the labor market is as prevalent in sociology as elsewhere in the
society. Until recently, however, sociology tended to segregate
women off into the institution of the family, as did the rest of society.
Women were all but forgotten in mainstream sociology—especially as
active participants in occupational and organizational life.[1]

As a rule sociology is still broken down into specialty areas
that represent the different institutions of society. An overriding goal
of sociology is to then put these institutions all together again—to un-
derstand how they each influence one another. In practice the sociol-
ogy of the family is a specialty that is analyzed as an institution unto
itself. So are the sociology of organizations, political sociology, race
and ethnic relations, sociology of education, social stratification, and
the sociology of work.

Unlike all the other institutions studied by sociologists, however,
"no matter how central the family is considered to be—and family so-
ciologists usually see it as the basic unit in society—it is nonetheless
marginal to society" (Glazer [Malbin] 1975, p. 43). That is, it lies
outside the social, political, and economic networks that are consid-
ered to be the mainstream of life. It is outside the arenas of prestige,
power, and decision-making control for the society. All the same, as
noted, it is in this sphere that women are most likely to be studied.

The separation of family from work in our society is reflected,
too, in the separate specialties of family sociology and occupational
sociology. (The world of "work" has typically been studied by sociol-
ogy in the specialties of occupations and professions, organizations,
and social stratification.) The occupational literature until recently

1

generally excluded women, assuming that their major adult responsibility lay with their families—which it clearly did and does. Today, however, despite all earlier emphases in the mass media as well as professional sociology, major responsibilities for many women challenge them both at home and at "work."

Under the influence of the women's movement in the 1960s, a range of feminist sociologists criticized mainstream sociology for its exclusion of women as subjects worthy of investigation, especially in the area of occupational status attainment. Status attainment research has been concerned particularly with studies of occupational choice and social mobility. In both cases, researchers attempt to look for the factors that influence people's occupational achievment. Researchers have moved away from the more static approach of studying occupational choice to a more process approach in terms of how these occupational statuses were attained. Likewise, they have moved away from societal-level processes toward exploring more individual-level processes. Two of the most widely recognized models in status attainment research are those offered by Duncan (1966) and Blau and Duncan (1967) and by Sewell and Haller (1965, 1969)—the latter known as the Wisconsin Model. Thus, as one set of researchers conclude, "Status attainment research represents the search for intervening influence between the success of parents and their offspring" (Falk and Cosby 1975, p. 308).

In short, the status attainment approach does not ask questions about the structure of occupations and the nature of work itself. Rather, it addresses itself to the questions of how people find their ways into the different occupations available at any one point in time (or over time in comparison with their fathers in particular) and what factors were most influential in this process. Moreover, this research was originated for, and applied to, male populations.

Recognition of more and more women in the labor force prompted investigations of women's participation in the labor market. At least two particular ways can be identified in which these studies have been carried out. On the one hand, studies that deal with the occupational status attainment process as experienced by women in the social mobility literature either ignore or refer in passing to women's position in the home as a "problem" for such an analysis but one that cannot be handled by the data. These studies investigate the intergenerational mobility of daughters with their parents (mainly fathers) and look primarily at women active in the labor market itself. In the discussion of the literature below, the focus will be particularly on this area of research.

On the other hand, feminist concern with the impact of women's "traditional home responsibilities" on their employment experiences has prompted a whole series of new investigations. The overriding

goal here is to include or to take into account variables that help explain women's labor market position through marital and fertility plans (Martin 1971), career contingency plans (Almquist and Angrist 1975), childbirth experiences and demographic trends (Presser 1975), work histories in the labor market (Rosenfeld 1976; Wolf 1976), husbands' attitudes toward wives' employment (Weill 1971), and role conflict engendered by women's dual commitments to home and market (Holmstrom 1973; Rapoport and Rapoport 1971). A national study of proximate and distal variables (current and earlier home influence variables) has also been done in England (Fogarty, Rapoport, and Rapoport 1971). These studies, and others like them, have provided a rich source of data and are numerous in the literature today.

Rosenfeld (1976) states the overriding position of many researchers in this second perspective:

> Women and men differ in their patterns of work. Primarily because of their role as worker within the home, women are employed intermittently over their work lives, while men are generally continuously employed. Until the effect of this difference on rewards received in the occupational structure is taken into account, it will be very difficult to understand the occupational achievements of women as compared with men. [Pp. 5-6]

Most important from this feminist perspective within mainstream sociology, such models would allow for special contingencies related to women's occupational choices and status attainment, thereby making possible a more accurate picture of women's occupational achievements. As Falk and Cosby (1975) suggest:

> When we consider current attainment modeling, . . . it is apparent that few special considerations for women have been adequately dealt with. Although parsimony is theoretically desirable, researchers interested in the status attainment process for women seem doomed to be frustrated by the failure to consider sex-related limitations. . . . This comment is not meant as just sage prophecy. Our whole thesis is that there are certain contingencies in choosing and attaining an occupation which are unique to females. In the status attainment literature, the validity of this position is just now being subjected to empirical testing. [P. 311]

If women are hampered in their occupational careers by home responsibilities, so the argument goes, one must account for this by includ-

ing relevant variables in the status attainment model. All too often, however, the method by which women's family-related sex role responsibilities are incorporated in this model is to factor out, control for, or otherwise take into account these relevant or confounding influences, which, no doubt, play a role in determining women's occupational statuses and rewards.[2]

Investigating women's unique career histories is of no limited importance. Describing the reality of women's daily work commitments both inside and outside the home—a major contribution of recent researchers on status attainment—has already clarified many myths about women's aspirations and behaviors in our society. Future research will hopefully do even more to explain women's double burden as they increasingly work in both the home and the market.

However, most of the feminists within the status attainment school do not get at the underlying problems: the construction, in the first place, of women's responsibility for the devalued sphere of the home and of men's for the more highly valued social world outside the home. Moreover, they do not (and cannot, in such a perspective) adequately take into account the continuing responsibility women have for their work in the home—even as more and more of them become active participants in the labor market. Typically, this is how one author tries to show that women must now be included in the status attainment research in their own right—not simply as an appendage of their husbands:

> Previous research concentrated on the role of women as a housewife and mother. Therefore a woman's mobility was primarily determined by the man she would marry. Since it was assumed that a woman played the reactive role when it came to marriage (proposals, etc.) it appeared that women had little control over their future statuses.
>
> These assumptions can no longer be accepted as applicable to the present generation of younger women; particularly to contemporary female adolescents.
>
> The exclusion of females from studies of mobility which results from these past assumptions should no longer be tolerated in studies which offer to generalize about the social mobility of the population as a whole. [Goodman n.d., p. 6]

In the context of both standard and feminist approaches within status attainment theory, the remainder of this chapter is organized as follows. First, relevant findings in the literature on status attainment—findings that describe women's position in the contemporary

labor market—will be discussed. The influence of fathers' and then mothers' occupations on those of their daughters will both be examined. Second, one of the important contributions of this school of thought will be looked at: its focus on sex roles and the socialization process as it relates to women's experiences in the labor market. Finally, a critique of status attainment theory will be presented.

RELEVANT FINDINGS IN THE
LITERATURE ON STATUS ATTAINMENT

One of the main ways that status attainment theory looks at achievement in U.S. society is to study intergenerational social mobility between parent and child. Social mobility is supposed to measure the extent to which the social system is open or rigid. Occupational mobility is most frequently studied, although education, income, general prestige, and socioeconomic status are also sometimes explored.

In whatever way one chooses to study social mobility, the history of males—of the father's influence on the son's status in the labor force—has been the most frequently and seriously investigated. Early studies (Glass 1954; Lipset and Bendix 1959; Rogoff [Ramsøy] 1953; Sorokin 1927), pioneering methodological studies (Blau and Duncan 1967), and the most recent studies (Duncan, Featherman, and Duncan 1972; Hauser and Featherman 1974; Ornstein 1976; Sewell and Hauser 1972, 1975) continue this trend. One finds the most current journals of the 1970s filled with references to social mobility of males only and with measures of parental origins (usually the father's "social class" or "socioeconomic status"), which totally eliminate the mother's influence.

The main exception to such a pattern in mainstream sociology lies in small-scale studies using unsophisticated methods and limited samples where the influences of both mother and father on the son's mobility aspirations and behavior are investigated (Z. S. Blau 1972; Cohen n.d.; Guttmacher 1971, n.d.; Komarovsky 1967; Krauss 1964; McClelland 1961).

The early landmark study in status attainment research, which assesses influences on the son's status achievement, is by Blau and Duncan (1967; see also Duncan 1966). More recent attempts at establishing a model to understand the status attainment process are provided by Sewell and Haller in what has come to be known as the Wisconsin Model (Haller and Portes 1973; Sewell, Haller, and Ohlendorf 1970; Sewell, Haller, and Portes 1969; Sewell and Hauser 1972). Blau and Duncan were particularly interested in a model that could predict the relationship between the son's occupational status and that

of his father's. Thus, for Blau and Duncan, the father's occupational status is an ascribed status that became an "origin status" for his offspring. Using this reconceptualization, a model was created to move the researcher away from the traditional social mobility table and toward regression and eventually path analysis.

For Sewell and Haller, status attainment is treated in a three-phase causal model. Relatively fixed contextual variables, like parental socioeconomic status and intelligence, are said to exert influences on the offspring's attainment. These influences are mediated by social psychological variables such as academic performance, educational and occupational aspirations, and significant others. In short,

> according to the status attainment approach it is not simply that parents' statuses are transmitted to their children but rather the transmission occurs because they influence their offspring to achieve higher levels of academic performance in school and experience more influence from significant others, which in turn operate to develop higher levels of educational and occupational attitudes which then directly affect attainment. [Falk and Cosby 1975, p. 308]

Recently, the approach of looking at the influence of male socioeconomic variables on occupational achievement has been extended from sons to daughters. Even though the mother's employment status, occupation, and related features have not yet been systematically included in these large-scale studies, they are beginning to be seen as important.[3]

These studies begin by looking only at the father's social status influence on daughters and then, sometimes, add some features of the mother's influence. Moreover, they do not always look at the women's (that is, daughter's) own labor force and income attainment with regard to mobility. Thus, in the large-scale studies that use sophisticated research techniques (in the tradition of the studies either copying men's mobility as above or comparing men and women in some form of national data) the first area of a woman's mobility to be studied was in terms of her marriage. That is, researchers looked at a woman's intergenerational mobility from her father's occupational status to that of her husband's (Chase 1975; Elder 1969; Glenn, Ross, and Tully 1974; Z. Rubin 1968).

Two of these studies (Chase 1975; Glenn, Ross, and Tully 1974) compare women's mobility through marriage with men's mobility through occupational attainment. They find that contrary to what has been believed, there is no pronounced tendency for women to "marry up" in our society. And women are no more likely to move into a

higher social stratum through marriage than men are able to do through their occupational attainment. In fact, much downward mobility occurs for women: they are more likely to move downward (from a white-collar father to a blue-collar husband) across the white-collar/blue-collar line than are men (when the father's and the son's occupations are compared).

Only in the 1970s did it become generally acceptable to study women's own occupational mobility (DeJong, Brawer, and Robin 1971; Featherman and Hauser 1976; Havens and Tully 1972; McClendon 1976; Rogoff [Ramsøy] 1973; Treiman and Terrell 1975; Tyree and Treas 1974).[4] These studies are a real breakthrough for investigating the attainments of women—in addition to those of men.

These studies generally find, first, that while social class origins (mostly as measured by the father's socioeconomic variables) do influence the daughter's occupational attainment, a woman's socioeconomic origins are found to be less important than her own educational achievement.[5] This is a similar process to the one that is said to occur for men. Second, they support the idea of equal rewards for equal input into the labor market through one's education. Thus, they conclude that men and women with the same educational requirements achieve the same occupational status in the labor market.[6]

The earliest of these studies on women's occupational status attainment and the one generating the most methodological and theoretical work after it was done is by DeJong, Brawer, and Robin in 1971. It compares the occupational mobility of both men and women who are, or were ever, in the labor market.[7] The origin status of both males and females was said to be the occupational status of the respondent's father; the destination status of both males and females was said to be their own current or latest occupational status. This study found similar intergenerational mobility patterns existing for both males and females. Both sexes experienced considerable amounts of occupational inheritance, upward mobility, and short-distance mobility. "No major differences" were said to exist in "the patterns for males and females, and generalizations about occupational mobility which have been made for males" were said to "apply to females" (DeJong, Brawer, and Robin 1971, p. 1040).[8]

In their study of men's and women's occupational status attainment, Treiman and Terrell (1975) concluded that "when it comes to occupational status, taken as an attribute sui generis, women fare about as well as men" (p. 182).[9] Nor do women have to present higher qualifications for a job. In short, women secure jobs as prestigious as men and on the same basis—superior educational qualifications. They do add, however, that women do not get the same wages for their occupational achievements.

McClendon (1976) improved on the DeJong, Brawer, and Robin study by using more comparable data on men and women in the labor force. Not only was McClendon able to look at more recent data (General Social Survey studies of 1972, 1973, and 1974), but he was also able to include both single and married respondents of both sexes. Again, his findings support those of DeJong's group and Treiman and Terrell: Not only is the occupational status attainment of white males and females similar, but education is the most important factor for allocating men and women into their occupational status hierarchies. What McClendon adds, however, is that "the similar status hierarchies for men and women are built on quite dissimilar occupational structures." McClendon views this "awkward status parity" as an "integral part of a pervasive inequality of sex roles, albeit a highly paternalistic aspect" (p. 63). Thus, he says, women are found in the occupational structures of their status hierarchies because of society's protection of the "weaker sex" from "dirty" and strenuous male blue-collar jobs. This paternalism, as McClendon calls it, increases the occupational status of women relative to men to allow them equal status in their occupational hierarchies. In short, it is in large part the fact that men and women are socialized differently—men for "dirty" hard labor in blue-collar jobs and women for "clean," less strenuous white-collar jobs—that is said to lead to such results.

Again, in a study of the occupational experiences of college graduates in 1968, Spaeth (1975) finds that there are no differences in occupational levels attained by sex. (Spaeth's analysis utilized the National Opinion Research Center [NORC] national sample of 1961 college graduates, reinterviewed several times between 1961 and 1968.) However, he does find differences in dispersions around the mean for occupational levels by sex. He interprets this to mean that the reason for the differences in dispersion is that women arrived at college with more restricted occupational aspirations. Therefore, sex role socialization and channeling earlier, not sex discrimination while in college, determined the women's different specific occupational choices and experiences.

Finally, in 1976, Featherman and Hauser reported on the changes in educational and occupational opportunities for men and women "pre-" and "post-" women's movement. They studied a sample of married men and married women who were in the labor force through two separate Occupational Changes in a Generation studies: one in 1962 and one in 1973. Again, despite certain differences and changes over time, they concluded that, in general, equality of educational and occupational opportunities existed in 1973 for men and women, as it did in 1962. Moreover, the process remains much the same: education is the most important criteria for occupational status attainment. They do, however, report that the dissimilarity

in earnings between men and women is quite substantial. While 85 percent of this discrepancy is said to be owing to discrimination, Featherman and Hauser end their analysis by concluding that the "nation is moving toward a meritocratic, 'post industrial' era (e.g., Bell 1973) in which technical skills and formal education are prerequisite to advancement in the economic system" (p. 480).

Most important, they say, the increased socioeconomic returns to schooling for both men and women have accompanied decreases in the importance of socioeconomic origins "on occupational status and earnings, a pattern consistent with the notion that change is in the direction of the 'meritocracy.'" Moreover, they provisionally conclude—for men only, not for women—that "the relative bearing of education versus family factors has shifted more toward 'universalism,' while the allocative processes themselves are, in the main, no more deterministic than in the last decade" (p. 481).

Moving from the influence of fathers on daughters to the influence of mothers on daughters' occupations in national surveys of the literature is even more limited. In the past, if the mother were brought into the picture at all, it was usually as part of the overall socioeconomic index and, in particular, in terms of her education. This fits well with two beliefs: that the mother's place is in the home where critical early socialization experiences occur and that education is related to values—and the mother's values are important in the socialization for the achievement of her sons and daughters. The influence of the mother's own occupational achievement has been a typically neglected area of research for both women and men in the past. Currently, though, this is an area of considerable investigation among feminists in the literature on status attainment. The influence of the mother's occupation on the daughter's is just now being investigated in large-scale studies. It is still not the pattern to deal with this in sophisticated methodological studies on men's occupations.

The author is aware of only two large-scale, national studies that evaluate the influence of the mother's own occupational status on the daughter's status attainment: one is an unpublished paper by Pearson (1976);* the other, by Rosenfeld,† was published in 1978. Their

*Pearson's data of black and white men and women come from a questionnaire administered by the U.S. Commission on Civil Rights by the NORC in 1966 under Robert Crain. Data are on occupational status of respondents in 1966.

†Rosenfeld uses the Parnes data (see Shea et al. 1970) on black and white women 30 to 44 years old. Her sample comes from women from families with two parents (or stepparents) working outside the home when respondent was 15 years old. Respondents were

analyses of black and white women demonstrate that traditional measures of female social mobility (where the father's occupation is used as the base comparison with the daughter's occupation or that of her husband) "[understate] the degree of occupational inheritance and constraint experienced by the female population in the United States" (Pearson 1976, p. 30).

Pearson continues that when the occupational status of a woman is compared with that of her mother instead of her father,

> the female mobility picture changes strikingly. For both races, mother's occupational status was clearly influential in the determination of her daughter's occupational destination. The influence of mothers on daughters is shown to generally exceed the influence of fathers on daughters and fathers on daughters' spouses; and in the case of blacks it is shown to exceed the influence of fathers on sons. [P. 30]

In Rosenfeld's (1978) study, when mothers were full-time housewives, fathers' occupations contributed the most to explaining the distribution of daughters across occupational categories. But, when mothers held jobs outside the home, she found that the "distribution of these mothers over occupational categories contributes more to predicting the occupational distribution of the daughters than does the fathers' distributions" (p. 44). Further calculations suggested a somewhat greater inheritance of the daughter's occupation from the mother than from the father. This was especially true of clerical/sales and farm occupations. Moreover, there was a greater association between professional and clerical/sales occupations for mothers and daughters than for fathers and daughters.

The findings of stronger mother-daughter than father-daughter occupational inheritance patterns are explained by several possibilities by these two authors: labor force patterns, role model effects (including occupational knowledge), and additional financial resources offered by the employed mother. In the first case, because most daughters tend to enter typically "female" occupations, Pearson suggests that daughters who work tend to perpetuate the status attainments of their mothers rather than their fathers. These kinds of inheritance patterns would not necessarily be reflected in daughters' husbands' occupations or in the occupational mobility measures involving fathers' occupational statuses.

themselves in a civilian occupation at some time before being interviewed in 1967.

With regard to role-modeling effects, employed mothers have been found to transmit as positive an attitude toward working to their daughters as do fathers to sons. If this is the case, suggests Pearson, then the connections between the daughter's occupational destination position and her origin position measured from her mother's occupation "should not be too surprising."

In contrast to the meager attention paid to mothers' own employment characteristics as they influence daughters' occupational attainments in national studies of intergenerational mobility, a large number of small studies (numbers tend to range between 50 and 200 respondents) on unique samples of college-educated women see this as an important issue. This research emphasizes role modeling or reference group and socialization theory. How mothers' own careers and occupational experiences influence daughters' career-versus-homemaker orientation and male-versus-female occupational interests is very often part of the research. In fact, the issue of the mother being employed became a popular topic in the 1960s. (Early bibliographies and reviews are those of Nye and Hoffman [1963] and Siegal and Curtis [1963]. An updated review of the literature can be found in Hoffman [1976] and Hoffman and Nye [1974].)

One author, Saffilios-Rothschild (1970), suggests that this popularity was due most especially to two factors in sociology. First is the fact that employment of married women generally and mothers of young children specifically became a controversial subject for traditional family sociology as well as a matter of personal relevance for female family sociologists. The former were concerned with the disorganizing influences of the wife's and mother's work on the family. The latter seemed motivated to disprove the existence of such disorganizing effects or to establish the neutral or beneficial effects of married women's labor force participation. Of course, this was the period of increasing female and maternal labor force demand. (See Chapter 2.)

The second reason suggested by Saffilios-Rothschild is that Blood and Wolfe's (1960) influential "resources theory" of power structure made the employment of women a "sine qua non variable since it constitutes an important resource of the wife" (Saffilios-Rothschild 1970, p. 681). Moreover, this research has led to an examination of women's employment status mostly in terms of the effect of wives' employment on relative decision-making power between husbands and wives, role conflict engendered by women's dual roles of homemaker and market worker, the division of labor in the home, and the degree of marital satisfaction. Saffilios-Rothschild concludes that "few studies have dealt with other influences of the wife's working status upon the husband-wife or the parent-child relationship" (p. 681).

What is so interesting is that despite the limited research on female employment in mainstream sociology, much of what was done in the past 15 to 20 years or so has focused on one question: What effect will the employed woman have on her children and her husband? The controversy over the employed mother and the role conflict she experiences certainly has generated a considerable amount of research interest in contemporary sociology.

Since the 1960s most studies have found that the mother's employment status (that is, whether she was primarily a homemaker or employed) is related to the career orientation of college-educated daughters. The employed mother is more likely than the homemaker mother to have a daughter who plans to incorporate employment in her own adult life. The homemaker mother is more likely to have a daughter whose primary identification is likewise to be a homemaker. (See Almquist and Angrist 1971, 1975; Altman and Kaplan-Grossman 1977; Astin 1971; Cook 1967; Angela Lane 1974; Lovett 1969; Rapoport and Rapoport 1971; Siegal and Curtis 1963; Veres 1974. Bernard [1964] and Fogarty, Rapoport, and Rapoport [1971] conducted national studies—the first was done in the United States; the second, in Great Britain.) Baruch (1972), however, finds no such impact; likewise, neither do Lipman-Blumen and Thompson (1976).

The effect of having an employed or homemaker mother on the daughter's choice of a traditional or nontraditional occupation that is male or female dominated is less clear. A number of researchers find that maternal employment predisposes daughters toward higher-status occupational choice (Almquist and Angrist 1971; Astin 1971; Marsden 1976; Tangri 1972). On the other hand, the mother's employment status is not found to be related to the daughter's choice of "male" or female" occupations in an equally large number of studies (Klecka and Hiller 1975; Klemmack and Edwards 1973; Levine 1968; Tannis 1972; Trigg and Perlman 1976; Veres 1974).

Furthermore, the homogeneity of the samples usually precludes any conclusions about the influence of socioeconomic origins and other background factors influencing the relationship between the mother's employment status and the daughter's career and occupational choice. When socioeconomic origins are studied, results are conflicting (Lipman-Blumen and Thompson 1976; Sokoloff in progress; Tangri 1972; Thompson, Lipman-Blumen, and Abrams 1976).

Finally, the consideration of whether the mother's employment status is more or less important than her own educational and occupational achievements has produced a wide variety of results. For example, Almquist and Angrist (1971, 1975) as well as Bernard (1964) find that the mother's employment (or lack of) is the only important background characteristic among many that differentiates "career salient" from homemaker-oriented daughters. On the other hand,

Levine (1968) finds that the mother's education is more important than whether she works and more important than socioeconomic origin as measured by the father's occupation. However, Levine also finds that the mother's occupation is more important than whether she was employed in her daughter's decision to do graduate study in a male- or female-dominated profession. Trigg and Perlman (1976), on the other hand, suggest that the mother's attitude toward work is more important than her work status, and Marsden (1976) reports that the mother's work status is more important than her occupation.

In short, the controversy continues unabated as to the relative impact of both the mother's own achievements and her employment status and occupation on her daughter's career and occupation in these numerous small-scale studies. Moreover, in these studies, the question of the influence of mothers' employment and homemaking experiences on daughters' careers never asks such questions as how this is related to the demands of the society for female employment. This issue will be dealt with in later chapters.

In concluding this section on the review of the mainstream literature, the findings should be summarized. First, a survey of all the main large-scale studies of occupational status attainment comparing men and women leads to virtually the same findings. The socioeconomic status of the father does influence the occupational attainment of his daughters, but less so than their own educational achievements. This process is virtually identical for men and women in the labor force. Second, when the mother's influence is measured in relation to the father's, in national intergenerational mobility studies, the results are dramatically altered. Not only is the mother's occupational status clearly influential for the daughter's occupational status; but the influence of mothers on daughters is shown to exceed the influence of fathers on daughters and even fathers on daughters' spouses. However, these results are based on only two studies. When one looks at the myriad of small-scale studies of the influence of mothers' employment or homemaking and occupational status on daughters' careers and occupations, results are mixed at best and, more frequently, simply inconsistent.

All the studies mentioned above focus on the factors that influence the process of intergenerational status attainment, not on the structure of the market, the occupations themselves, or how both change over time. Nor do any of the national studies focus on features other than occupational status—the major dependent variable. While a few studies report differences between men and women on their incomes for the same occupational statuses that they are said to achieve, this is not the major emphasis of these studies.

SEX ROLES AND SOCIALIZATION

An important feature of the status attainment school of thought, both in terms of its underlying assumptions and its major contributions, is the idea of sex role socialization. Thus, as almost all the status attainment research reviewed above points out, while men and women achieve similar occupational statuses, they do not work in the exact same jobs.

For example, McClendon (1976) suggested that since men and women are socialized differently, they will end up working in different occupations, although not necessarily occupations of different hierarchical prestige. The norms of what is acceptable work for women in the labor market are different from the norms of what is acceptable for men. Such assumptions are also being made by most of the other researchers in this tradition. Thus, values, attitudes, and experiences related to sex roles—especially educational aspirations and achievements but also occupational aspirations, work attitudes and behaviors, values, and behaviors toward childbearing and rearing, years and continuity of labor market experience, women's so-called commitment to the labor force, and so on—are understood as causing women's lack of success in employment, when and where it occurs. In fact, to the degree that occupational inequality does exist between men and women, Featherman and Hauser (1976) claim that two-thirds of this discrepancy is due to women being socialized into being housewives and mothers.

Now, the author will briefly review the history of sex role research in mainstream sociology as it relates to the topic of this book.

The two most common explanations for sex roles may be classified as biological determinism and cultural determinism. Biological determinism assumes that women must mother—that is, that there is a biological predisposition for women to take care of children since they bear children and have breasts with which to feed them. The presumed "naturalness" of women's mothering is based on equating the biological capacity to mother with social, emotional, and physical tasks of child care. (For an excellent critique of this perspective, see Plotnick 1973/74.)

A modification of this approach (intermediate between biological and cultural determinism) is the biosocial perspective. It "does not argue that there is a genetic determination of what men can do compared to women; rather it suggests that the biological contributions shape what is learned, and that there are differences in the ease with which the sexes can learn certain things," based on their historically evolved biologies (Rossi 1977, p. 4). An added feature to this argument, with more apparent credulity, is the developmental needs of children (which Parsons et al. clarified in 1955). According to

Glazer (Malbin) (1975), this feature in the biosocial approach sees children

> as needing a one-to-one relationship and a small group
> within which to develop. Women lactate and are therefore
> the first person to whom children are attached, and the
> logical ones to stay in the home. This latter modification
> of the original assumptions about female characteristics is
> a necessity in the face of the irrelevance of musculature to
> task performance in an industrialized society, of sophisti-
> cated reproductive control and of bottle-feeding for infants.
> [P. 8]

The biosocial approach is more common among the early mainstream theorists on the family—for example, Parsons (1949a) and Blood and Wolfe (1960).

The approach most commonly accepted among mainstream feminists in general has been cultural determinism. Its overriding assumption is the plasticity of human beings and their responsiveness to normative pressures of their cultures. The reason that men and women act in sex role-related ways is based on their different socialization, supported by the organizational structures of the society. This argument is supported particularly by cross-cultural research that shows that men may be considered "maternal" in their personality and behavior in one society and just the opposite in another (Mead 1935). Or, it shows that women may be the primary providers of food and subsistence—the family breadwinner, so to speak—in some societies and just the opposite in other societies. (Evidence for this position abounds. For descriptions of such studies, see Beneria 1978; Blumberg 1978; Yorburg 1973.) Research among those who see sex roles as learned through socialization and not as innate has been extremely significant in demythologizing the potential and capacities of men and women. (It is the case, however, that changes in sex role socialization are not sufficient by themselves to render men and women truly equal in society. This, however, is not typically understood by this school of thought. The author will return to this point in Chapter 7.) Several such studies will be referred to below. First, however, will follow an explanation of why the earlier biosocial school of theory has been so important. The most famous proponent of this school has been Talcott Parsons.

The notion of sex roles implies a culturally prescribed set of sex-linked traits that differentiate men and women in both personality and behavior. Frequently based on a biosocial idea of sex roles, male and female characteristics and capabilities are assumed to be different but equal. Men and women are said to have specialized roles

that are complementary to each other (see Barry, Bacon, and Child 1957; Parsons 1949a; Winch 1963), especially as this complementarity is directed toward their primary spheres of existence: men's in the world of "work" and women's in the home. A good deal of this kind of thinking is exemplified in the work of Parsons.

Much of Parsons's (1949a; Parsons et al. 1955) ideas about the sexual division of labor between husbands and wives comes directly from Emile Durkheim, whose discussion of the origins of the division of labor (that between the sexes simply being one example) is considered by some to be more an ideology than a description of reality. (For a sociology of knowledge on Durkheim and Parsons on the family, see Glazer [Malbin] 1975.)

Durkheim's (1964) analysis of social structure was elaborated by Parsons into a theory of social differentiation. He then applied this theory to family structure through the concept of role differentiation. Task specialization is seen as based on potent biosocial factors. The specialization of tasks between men and women in the family is articulated in the following way: the man is the instrumental-adaptive leader; the woman, the expressive-integrative leader. Task specialization is necessary because the same person is said to be unable to fill these roles. It is assumed that instrumental-adaptive behavior generates hostility among group members, and hostility is incompatible with expressive-integrative functions. Thus, according to Parsons, women must not work in the labor force, or their working will threaten their husband's position in the family—conflict would be generated.[10] The most recent translation of this approach is that if they are employed, women must work at jobs that will not threaten their husbands' stability and security.

To the degree that Parsons's observations capture the reality of what we expect from men and women—to that degree it is important to recognize the value of his analysis. Unfortunately, however, it has been used as the basis for further research—or a mechanism for interpreting family behavior—without clarifying in any way that a sex role, as defined by Parsons, is no more than an ideal of what is desirable in a particular type of society at a certain phase of development.

In contradistinction to Parsons, recent feminist scholarship of the 1970s has focused on trying to elucidate the importance of sex role socialization for the development of women's and men's capabilities in carrying out the tasks of our society. They document a set of sex role stereotypes that people believe reflect male and female capabilities. Moreover, they identify the greater value attributed to male-identified characteristics in our society and the inferior value attributed to female-identified characteristics (Broverman et al. 1972 [see below]; Hartnett 1977; Rosaldo and Lamphere 1974).

As one such writer argues, a sex role system is a belief system whose main components comprise assignment of personality traits on the basis of sex; division of labor on the basis of sex, when sex per se has nothing to do with work requirements; and the investing of the male with a higher value than the female (Hartnett 1977).

Clearly, in our society, men and women are expected to think and act in ways that are substantially different from each other. Moreover, they show that pervasive and persistent sex role stereotypes are found to exist among people from a wide variety of backgrounds. This study has been replicated numerous times. Both men and women expect men to be more competent, instrumental, assertive, competitive, objective, and dominant. Women, on the other hand, are supposed to be more tender, expressive, emotional, and gentle, as well as manipulative and noncompetent outside domestic and nurturant situations. This type of stereotypical belief system of sex roles is documented in a classic study by Broverman et al. (1972).

Whether because of culture or biology, women are expected to be better able to handle small children. Even among college men who want their future wives to be educated, competent, and equal, they still expect their wives to do (or supervise) the early child care (Yorburg and Arafat n.d.). Even when women are employed outside the home, the number of hours of work men are expected to do in the home—and what they actually contribute—does not increase very much. Pleck (1977) and Vanek (1974) are only two of the numerous recent studies to document these phenomena.

More to the point with regard to work in the labor force per se, however, several studies on women in business enterprises show that women are perceived as inferior, less competent, less dependable than men (Feldman-Summers and Kiesler 1974; P. Goldberg 1974; Oleary 1974), and incapable of maintaining their authority in supervisory positions (Bass, Krusell, and Alexander 1971; Hunt 1975). Thus, for example, P. Goldberg's classic study on perceptual bias indicates how the same intellectual material is perceived as less valued and less competent if done by a woman in comparison with when done by a man. Deaux and Emswiller (1974) demonstrate that successful males are perceived as skillful but successful females as "lucky." And Spence and Helmreich's (1972) controlled video-tape study of "Who likes competent women?" demonstrates that men have great difficulty in acknowledging competence in women even when they see it.

All these stereotypes exist, despite the evidence to the contrary. For example, all the controlled studies just mentioned used men and women of equal competence, ability, and/or performance. This is confirmed by the work of Kanter (1975a), Hartnett (1977), and Poll (1978) (see Brannon [n.d.] for a summary of studies).

Thus, careful comparisons and reviews of long-standing beliefs about sex differences have not been taken as given by feminist scholars in mainstream sociology but have been challenged on the basis of careful empirical investigation of actual sex differences. The empirical research invalidates much of what has been believed to be "the facts." This holds true especially when one looks at the vast expanse of social psychological testing and research on ability, motivation, and personality. In terms of the presumed basis for the capabilities of people acting in certain sex roles,[11] one finds much more overlap than differences between men and women.

In one of the most complete reviews of the social and psychological literature on intellectual performance and social behaviors thought to be differentiated by sex—such as dominance and passivity—Maccoby and Jacklin (1974) summarize the findings of over 2,000 articles and books. The bulk of the studies evaluated by them covered white middle-class U.S. children and young adults. However, when comparisons with cross-cultural materials are made (see Blumberg 1978; Oakley 1972), the variability in sex role behavior is heightened even further.

The findings from Maccoby and Jacklin are as follows: no reliable established differences were found between males and females in sociability or social orientation, suggestibility, self-esteem,* role-learning ability, cognitive and analytic ability, visual and auditory ability, or achievement motivation. This is counter to a widespread stereotype about women's greater susceptibility to social influence (or need for affiliation), greater irrationality, and lower motivation for achievement in comparison with men. In addition, sex differences in anxiety, level of activity, timidity, competitiveness, dominance, compliance, and nurturance are unsubstantiated. The evidence is either too limited or, at best, ambiguous.

Only four differences between males and females are fairly well established according to Maccoby and Jacklin: on the average, girls are more likely to excel in verbal ability, and boys are more likely

*Maccoby and Jacklin claim that girls do not have lower self-esteem than boys. However, the author's reading of their evidence does not support such a conclusion. The findings are more ambiguous. It is true that the overall self-esteem is the same for boys and girls —with girls rating themselves higher in social competence and boys on measures of strength, power, dominance, and potency. But, in college, the few studies mentioned find that men have a greater sense of control over their own fate than do women and a greater confidence in probable performance on school-related activities. These differences show up in college, but the data are very limited.

to excel in visual-spatial and math ability as well as to be more aggressive. (The findings on aggression by Maccoby and Jacklin are also open to a different interpretation than they suggest.) However, even these findings are conditional. Boys and girls are similar in verbal, visual-spatial, and math ability up until at least 11 years of age. Moreover, differences on these four measures were small in general.

In sum, an important contribution of mainstream sociology—and in particular, recent feminist research in this area—has dealt with sex role stereotyping and the potency of socializing children to accept certain sex role requirements, despite the evidence that such requirements are not biologically or inherently necessary. Where equality has not already occurred, the status attainment literature sees this as the main realm in which change in the home and market is possible.

The mainstream notion of males and females playing different roles carries with it, however, several problematic assumptions. First, even where differences do exist, mainstream sociologists tend to underemphasize the greater similarities than differences between men and women. Average differences, on which most measures of men and women are based, typically distort the wide range that exists for both men and women and, thus, the incredible overlap in capabilities and performance between the two sexes on most traits.

Second, a whole range of human aspirations and behaviors that are statistically differentiated on tests by men and women are defined as phenomena related to sex roles. Moreover, social or cultural gender is frequently confused with biological sex. Finally, even where it might be appropriate to acknowledge gender-linked traits, little or no distinction is made with regard to the importance of different types of phenomena: the work women do and the ideology surrounding it are not differentiated from a series of other less central so-called sex-linked traits (clothing style, speech patterns, and the like). In short, sex role terminology is frequently used unreflectively. (See Lopata and Thorne [1978] for a review of these and other criticisms.)

Third, much of the sex role literature is not only a description of existing roles for men and women but frequently ends up being a prescription of how people should behave—even though sometimes quite unintentionally.

CRITIQUE OF STATUS ATTAINMENT THEORY

In this closing section of Chapter 1 the underlying assumptions made by these researchers with regard to women's behavior in the

labor market will be perused by asking, How does status attainment theory explain women's participation in the labor force today?

Status attainment theory depends on the Weberian concept of social status. This concept ranks all occupations in relation to one another on the basis of culturally valued criteria. It assumes that a single labor market exists in which men and women from the same and different backgrounds compete with one another for the available jobs. This competition grows out of the productivity characteristics people bring with them to the existing job structure, primarily their education, training, and sex role socialization. In economics the comparable approach is known as the "human capital" school, but the dependent variable is usually income rather than prestige.

The resulting sociological research in this area leads its proponents to conclude that society allocates men and women to the available occupational statuses in the same way, which is primarily through their own educational achievements. Education is more important than social class origins for both men and women. In this way education is said to equalize opportunity for the masses of Americans. One consequence of this approach is that those who do not achieve highly within the confines of the readily available status hierarchies are said to be responsible for their own poor performance—a process called blaming the victim.

Max Weber's (1947, 1968) discussion of class, status, and power has been a major source of reference for mainstream stratification theory. [12] Although Weber was very clear in his distinction between economic class and social status, and in their interrelationship (to him, social status depended more on economic class than vice versa), interpretations of his ideas by U.S. sociologists do not share his clear distinction.

In fact, the modification of Weber's ideas by mainstream stratification theorists has led to two overriding problems. First, on the basis of Weber's theory, they have claimed to separate out occupational hierarchies as the single most important measure of social class in contemporary U.S. society. Weber himself did not do this. Second, mainstream stratification theorists have severed most of the connections Weber made between occupational strata and property classes. This has had a dual effect. It has led to a shift in the focus of analysis from an understanding of property classes to a description of hierarchical strata. And it has altered the focus from an analysis of the system of production to a description of consumption patterns and life-styles in the U.S. stratification literature.

According to Weber (1947, 1968), the stratification of society was based on three factors: class, status, and power. However, he divided class into three types. Only one, property class, was said to be the core on which society was built. The three types of classes

are property classes, made up of the privileged (propertied) and the unprivileged (propertyless)—or "class" in the Marxian sense; acquisition (or occupational) classes, made up again of the positively and negatively privileged, where mobility to other classes through one's occupation was possible; and social classes, composed of personal associations based on the material conditions of property classes.

Thus, the most important element for Weber in measuring class is property relations, followed by occupation (acquisition class) and only then by prestige (social status). Moreover, property, the economic component, underlies political power as well.

Social status, on the other hand, is of course a measure of prestige only, derived from one's occupation and "style of life." A social stratum is a group of people with the same level of prestige. Often, a property class provides the basis for a social stratum. According to Weber (1968), then,

> with some over-simplification, one might say that classes are stratified according to their relations to the production and acquisition of goods; whereas status groups are stratified according to the principles of their consumption of goods as represented by special styles of life. [P. 937]

Claiming to use Weber as their intellectual mentor (although as has been seen, sometimes distorting him), a number of mainstream U.S. sociologists have chosen to give Weber's three factors of class, status, and party equal weight. In addition, they have given Weber's three types of classes equal weight. However, a distinction between theoretical and empirical analyses in the Weberian tradition must be made here. On the one hand, when class, status, and party are discussed and interrelated on a theoretical level, both property ownership and power relations are said to be important in understanding stratification theory—although not necessarily more important than education, occupational prestige, and the like. On the other hand, operational definitions of social classes virtually totally exclude both property ownership and power relations. Instead, hierarchical rankings of income (typically wages or salaries), education, occupation, or some measure of socioeconomic status (based on income, education, and occupation) are typically used. It is within the context of this tradition that occupational prestige measures have emerged during the twentieth century to be seen as definitive measures of both social class and social status (see Barber 1957; Centers 1949; Kahl and Davis 1955; Parsons 1949b; Warner 1949).

The status attainment theory assumes that a single hierarchy of occupational statuses exists, to be ranked according to their pres-

tige in the community and larger society. Not only are occupations ranked on the basis of how people feel about them, as in the "reputational" method of the NORC scale of occupational ratings. They can also be ranked on the basis of certain attributes such as in the more "objective" method of Duncan's socioeconomic index, which incorporates education and income.

From his analysis, Duncan, a pioneer in the development of the status attainment model, concluded that a high correlation exists between the amount of education and the size of income of workers in an occupation with the NORC prestige rating of them and that income and education and occupation are functionally related. This means that education is a cause of occupation while income is an effect of occupation (see Duncan in Reiss et al. 1961, pp. 116-17). While most studies have dealt with male occupations[13] and continue to do so, recently the same approach has been applied to women (Bose 1973; Featherman and Hauser 1976).

In all these studies, socioeconomic origins are found to be less important than education in one's status attainment. This is analagous to the position of orthodox economists' ideas about human capital theory.[14] These findings exist for studies of men only (Blau and Duncan 1967; Duncan, Featherman, and Duncan 1972; Ornstein 1967; Sewell and Hauser 1975; Spaeth 1968, 1970;* Spaeth and Greeley 1970), as well as for those where analysis is extended to include women (Featherman and Hauser 1976; McClendon 1976, Treiman and Terrell 1975). Thus, not only is status attainment for men and women similar, but the actual process by which this occurs is said to be virtually the same for men and women. (This is true when only college graduates are used [Spaeth 1975] or when the larger labor force is used irrespective of educational level [Treiman and Terrell 1975].) This research is summarized by McClendon (1976) who suggests "first, that the white male and female occupational statuses are very much alike and second, that education is the most important factor for allocating both males and females to positions in the status hierarchies" (p. 63).

Turning to general criticisms of status attainment theory, the author finds six major areas that fail to meet the theoretical needs of a study such as this. In this context each of the six areas calls for criticism.

First, a set of questions will be raised related to the problem that status attainment theory elevates occupational status to a special

*Further, in 1975, Spaeth, who uses NORC college graduate data, does not explore class differences per se. However, he finds no differences in occupational levels (means) by sex for college graduates.

category of importance. After discussing the failure of mainstream stratification theory to distinguish between the concepts of social class and social status, certain problems will be specified that are inherent in segregating out and focusing on occupational prestige to the exclusion of other occupational features such as labor markets and occupational rewards.

In mainstream stratification theory, classes and strata are frequently indistinguishable. They are indiscriminately said to be based on ranked characteristics: occupation, income, education, and socioeconomic status being the most familiar. Social class, however, in the way the author uses it, is a term that expresses a historical process of expanding capital and is developed from Marx's definition (1967a, 1967b, 1967c) (for a more in-depth analysis of Marx's work, see Chapter 3).

According to Marx, one's position in the class system is determined by one's relationship to the means of production. On a theoretical level, there are essentially two main overriding classes: those who own and control the means of production (the capitalist class or bourgeoisie) and those who are both available and forced to work for wages because they do not own any property—other than their own labor power (the working class or proletariat). On this basis, the interests of the capitalists are fundamentally opposed to the interests of the proletariat. Within each class, distinct strata stand out. This holds true for the occupational strata that status attainment theorists overemphasize, as well as for income, education, and socioeconomic strata that other mainstream stratification theorists tend to use. The point to be made here is that the understanding of social class in the analytical Marxist sense—in terms of the relationship to the means of production, the related class interests, and decision-making and power relationships—forces one to go beyond stratification as such. It leads one to look at how the stratification system itself fits into a larger, all-embracing class system.

Thus, in whatever way strata are defined, these categories must be viewed in light of, and grounded in, the historical process of capitalist accumulation in the United States. The system between public production of goods and services and private profits intensifies over time. Class formation and class composition are not static concepts. According to Marx, they are always in flux. Capitalism continues to transform labor more and more into wage labor. (Today, 90 percent of U.S. people are waged laborers. Fewer and fewer are independent artisans and professionals.) Marginal groups are less important in theoretical class analysis than the dominant forces.

What is important to remember is that social class is a process determined by one's relationship to the means of production as organized in the process of capital accumulation for private profits. It is

true that formal education may determine in large part certain differences in occupational comparisons (for example, between blue-collar and white-collar; between professional and nonprofessional) and income. However, neither the level of educational training, the occupational categories themselves, nor the specific incomes by themselves are decisive class variables. Educational, occupational, and income stratification must be placed, at least on an explanatory level, within the larger perspective of property classes, or the relations to production per se.

What all this means is that mainstream stratification with its status attainment theory fails to ground its system of stratification in the historical development of modern capitalism and its class system.* This shapes the entire underlying set of assumptions that will be delineated below in the criticisms of status attainment theory's treatment of women employed in the contemporary U.S. labor force.

Within the constraints specified above, the elevation of occupational prestige to a special position, as differentiated from all other socioeconomic bases of stratification, leads one to ask a series of questions. The most obvious question to ask within this context is, Are occupations comparable just because they have the same prestige ratings? For example, secretaries and construction operatives can be equal on the NORC prestige hierarchy. But the former have "cleaner," "safer," more "mind-oriented" work, while the latter have "dirtier," "manual" jobs but with higher pay. So what does it mean to say that they are equal in status?

Next, even among data analyzed by status attainment theorists, women do not fare well on the upper end of the prestige distribution in comparison with men. The most coveted positions are clearly "for men only." Thus, Treiman and Terrell (1975) note, but only in a footnote, that whereas 5.2 percent of all employed men have a prestige score of 70 or more, this applies to only 0.5 percent of employed women (pp. 181-82) (scores range from 0 to 96).

In addition, far too much emphasis is put on the prestige of an occupation at the expense of other criteria by which occupations are measured—for example, their economic remuneration. Thus, it is very clear to everyone concerned, including status attainment theorists themselves, that despite their conclusion that occupational status equality exists, women are seriously discriminated against in

*As an example, one status attainment theorist, in his discussion of "Inequality and the Process of Attainment," says: "No attempt will be made here to explain how the distribution of attainments comes into being. For the purposes of this paper, it is taken as given" (Sørenson 1977, p. 967, n. 2).

terms of the income paid for these similar statuses (Featherman and Hauser 1976; Suter and Miller 1973; Treiman and Terrell 1975). Moreover, in what way is it meaningful to say that women get the same status jobs as men when they do not work in the exact same jobs and do not get paid the same as men when they do work in the same jobs?

Finally, status attainment theorists do not direct themselves to the power and control that come from different jobs as well as their organization (for example, unionization or lack thereof). Instead, focus is on life-style (as revealed in values and consumption patterns) or individual orientations toward job satisfaction (see, for example, Andrisani 1978).

The second major area of criticism generated by status attainment theory is that the following assumption must be seriously questioned: that what people bring with them to the labor market, most especially their education (which implies the best fit are the most educated and the best rewarded in terms of the jobs and their tangible and intangible remunerations), is what determines how they will fare in the labor market.

In this model family socioeconomic origins are used to predict the educational attainment of sons and daughters; educational attainment, in turn, is used to predict occupational prestige; and socioeconomic origins are found to be less important than education. (For a summary of this position, see Almquist 1977b, pp. 848-49.)

For example, while college graduates are more likely than all others to enter into "higher-level white-collar jobs" irrespective of their social class origins (Eckland 1965), a college-educated woman, on the average, is paid less than a high school-educated man (Ehrlich n.d.; Ehrlich et al. 1975; U.S., Department of Labor, Employment Standards Administration 1976). Moreover, the fact that women are less likely than men to continue on in school at every step of the post high school educational process (Sewell 1971), despite their superior demonstrated academic performance (Roby 1973), means that they would be less likely to even compete in the job market based simply on institutionalized discrimination at each level of the educational system. This is true at all socioeconomic levels but is even more severe for women in comparison with men the lower down the socioeconomic hierarchy one goes (Sewell 1971). Thus, to say that men and women with the same education work at jobs with the same status (but not the same jobs exactly and for much different pay) denies the entire process by which this "achievement" occurs, which in itself is highly discriminatory against women.

Using the traditional occupational categories within the white-collar and blue-collar job distinctions, it is known that while more women have traditionally been considered to be professional than men, even with the same education women are more likely to be work-

ing in lower-level professions and men in higher-level professions (Gross 1971; Theodore 1971). Likewise, with blue-collar work, education for women was found to be less important than for men. While increased education (that is, graduating from high school as opposed to having only one to three years of high school) did not give women an increase in job position from operatives to crafts workers, it clearly did so for men (Bibb n.d.).

In fact, when all of the characteristics of the worker are included in an analysis of occupational status attainment—including education, training, aspirations, number of hours worked, and so on—Almquist (1977a) finds that the status attainment "model explains only about one-third of the variance in either men's or women's occupational prestige." She concludes that with such results "we cannot even assume it [the model] has identified the most important elements" (p. 9).

And, when one looks at the connection between education and income, which is supposed to be the outcome of the kind of job one works at, the evidence is quite conclusive: no one compares favorably with white males. This is true for white women, nonwhite males, and nonwhite females. At every educational level, women are paid less than men (and white women, black men, and black women are paid less than white men). To be sure, higher-educated women are typically better off than lower-educated women. The relationship holds true for education and wages among men also. On the other hand, if one looks across all groups of workers, education does not appear to be the main criterion that explains income inequality. Sex and race are clearly at least as, if not more, important (Ehrlich n.d.; Ehrlich et al. 1975; U.S., Department of Labor, Employment Standards Administration 1976).

A careful analysis of worker characteristics—in terms of education, training, number of hours worked, and number of years worked—shows that as little as zero and only up to 44 percent[15] of the income gap between men and women can be explained by the workers' own characteristics. Thus, not even one-half of the variance is thereby explained. This model hardly does what it says it can do.

According to Jencks et al. (1972), in addition, three-fourths of all variations in income is unexplained by traditional measures of education, occupational training experiences, and so forth. Instead, they speculate that variances in "luck" and "personality" may explain their findings. Even using these possible explanations, women are seriously disadvantaged. Thus, men are said to be more likely than women to have the proper personality type[16] for successful competition and achievement in employment and to go to the "right" schools, concentrate in the "right" majors, and meet the "right" people for advancement. In short, it would seem that these two factors of luck

and personality might help to further explain men's over women's greater economic rewards—but they are unrelated to "universalistic" criteria as assumed by human capital and status attainment theorists.

Moreover, a very small relationship between education and earnings was found in a national longitudinal study (replication of the Wisconsin Model) of high school students followed over time (Alexander, Eckland, and Griffin 1975). As one critic concludes, this indicates that contrary to human capital theory, a person's capital (for example, education and ability) is not as important a factor in determining his or her earnings as socioeconomic origins (for example, family income) (Montagna 1977). In addition, the claim that IQ scores determine one's career rewards is simply not validated by much rigorous research (Bowles and Gintis 1973, 1976; Jencks et al. 1972). Thus, for example, Bowles and Gintis show that among white males class origins are more important than either education or IQ in determining one's earning power.

When human capital theory is tested with care—as done, for example, by Stevenson (1975)—it becomes very clear that men and women who work in jobs requiring the same amount of education and training (conditions of human capital theory) do not work in the same occupational group (but, rather, in another one that requires the same education and training of cognitive skills), do not usually work in the same industry, and do not get paid equally—women get paid less than men. The reason for this, according to Stevenson, is that industries employing women tend to be less profitable and have less market power than those employing men—regardless of the individual's educational attainment.*

Finally, it is necessary to question status attainment theory's uncritical acceptance of the existing occupational structures. By focusing on those mechanisms (like education) that try to get more women into higher-status positions of the occupational status quo, as it exists in any particular time and place under investigation, this theory takes for granted, rather than challenges, existing social arrangements that lead to ever greater occupational stratification in the first place.

The third major problem with status attainment theory, as demonstrated by Stevenson's study, is the assumption of a single labor market where men and women not only compete for the same jobs but

*Lesser average physical strength of women might explain their lower wages. In checking for this, Stevenson found that jobs requiring physical strength in our society are the lowest paying jobs and are generally relegated to black men. So the differences in physical strength, just as in intelligence for high-status jobs, cannot explain why men earn more than women (p. 249).

are believed to end up in jobs with the same prestige. In Chapter 2 this point will be challenged. Suffice it to say here that an analysis of the data shows that men and women are segregated by industry as well as by occupation. Thus, Stevenson concludes, it is this sex segmentation that lowers women's wages by "crowding" them into a limited number of occupations.

Related to this problem is the fact that statistical aggregations of prestige scores in the status attainment literature obscure the real differences between men's and women's employment. This is recognized by one status attainment theorist (McClendon 1976) when he says that (1) women are concentrated in white-collar jobs, and (2) most especially in lower-status white-collar and nonwhite-collar jobs; and that (3) women are more likely to be found in the lower-status white-collar clerical and service jobs that have lower pay and less power but higher prestige than the higher-level blue-collar jobs of men (crafts workers and foremen). Women's greater prestige in clerical work over blue-collar work is based on jobs that are said to be more comfortable, safer, cleaner, and "thinking-oriented." (Being a file clerk or typist in a secretarial pool of a large corporation is hardly prestigious "mental" work in the sense implied by prestige accorded to white-collar work.) Thus, McClendon concludes: "The lower female status within categories counterbalances the tendency for women to have higher status due to their concentration in the white-collar category, and thus produces the status 'equality' of males and females" (p. 63). A further problem here is that within the very same occupational category—for example, sales—women have lower-status jobs.

A fourth key problem stems from the assumptions of the status attainment theorists generally that a single labor market exists in which education is the main allocating mechanism to occupations. This leads to an explanation of income and other types of socioeconomic inequalities between the sexes in terms of the characteristics of women themselves (for example, low aspirations, inadequate education, or inappropriate training) that disadvantage them rather than exploring the causes of the sex inequality itself. Certain attempts are made to partial out the amount of sex discrimination in the income differentials. (See Featherman and Hauser 1976; Fuchs 1971; Suter and Miller 1973; Treiman and Terrell 1975. For a review of government-sponsored research using this approach, see Sexton 1977.)

Thus, for example, women's marital status, number and ages of children, length of lifetime labor force experience, number of hours employed per year, age-earning profiles, and so on are added to the equations of the status attainment model. After all these characteristics are considered, the residual or remaining unexplained variance in income is said to be a function of sex discrimination. Even here,

however, it is not uncommon for further attempts to be made to look at norms about, or the attitudes of, women themselves. That is, the remaining residuals are often said to be a result not only of overt sex discrimination but also of differences in "preferences . . . [as much as] constraints arising out of sex role relationships in the family setting" (Treiman and Terrell 1975, p. 197). In short, while women's family-related sex role responsibilities are incorporated in this model, the process by which this is done continually tries to reduce the amount of sex discrimination possible by controlling for attitudes and behaviors related to the women themselves. This type of approach all too often ends up "blaming the victims" rather than looking to the larger social, political, economic, and sexual system of the society.

In sum, women's lower wages are said to be caused by their own personal behavior—for example, the "choice" to have a child, the "decision" to leave the labor market either to maintain the husband's prestige or bear and rear children, the alleged lack of labor force "commitment" generally, the "choice" of working part-time or more geographically convenient to be closer to home "for the children," the possession of certain female personality traits that self-select women out of the higher-status jobs,[17] the alleged higher turnover and absenteeism rates of women, and so forth.

However, these so-called causes are either wrong or more appropriately understood as ex post facto descriptions of mechanisms that perpetuate and intensify sex inequalities in our society, not cause them.

The fact that a woman is socialized according to norms that stress her primary interest to be in her own husband, children, and home is not determined sui generis by the woman's personal desires or simply by the fact that she was "brought up that way." Rather, it relates to the larger structures of the society. Sociologists from virtually every school of thought agree that the type of family and women's role in it are strongly dependent on the kind of economic organization of a society (Engels 1972; Goode 1963; Parsons 1949a). The main difference between the schools is that some (mainstream) find contemporary Western industrialized or "postindustrialized" society to be "liberating" for women, while others (radicals or Marxists) are much more critical of the impact of the contradictions in advanced capitalist economies on women's several roles.

Role conflict theory probably comes closest to not blaming women for their lesser position in the labor market when it is documented to occur. Women are said to experience role conflict between their homemaking and labor force responsibilities. However, the conceptualization of the problem as role conflict implies an acceptance of the underlying structures of society that make child care women's

responsibility and breadwinning men's responsibility—even when this is empirically not the case (see, for example, Barron and Norris 1976; Rapoport 1977).

This then leads to the fifth key problem with status attainment theory: the tendency to analyze women's labor market activity as if it is separated from her nonmarket (or family) activity. Thus, as two sympathetic status attainment theorists conclude:

> Our conventions lead us to ignore these roles [child rearing and homemaking] in our studies of socioeconomic stratification. Nevertheless, the institutionalization of child-rearing and homemaking as the dominant domains of women is one of the major bases of sexual inequality of socioeconomic opportunity. [Featherman and Hauser 1976, pp. 462-63]

In fact, they conclude, as much as two-thirds of the difference in occupational inequality between men and women is due to "this element of sex-role allocation" (p. 463). It is no longer acceptable to ignore these roles in stratification theory.

This author has previously argued that one cannot understand women's position in the economy of U.S. society without looking at both her labor force and family roles (Sokoloff 1977). Women's role in the isolated nuclear family intimately connects to her role in the labor force in a capitalist society. On a theoretical level, one cannot discuss one without the other. On an empirical level, the theory of status attainment cannot incorporate this relationship into its model.

The sixth and final problem in status attainment theory is that this theory not only discusses women's occupational stratification as if it is segregated from the rest of women's lives, but it goes even one step further: it discusses both women's occupational and home experiences as if they are unrelated to the analytic concept of class. Thus, they ignore the fact that women's dual roles in employment and the family are played out in the context of an advanced capitalist economy, which colors any interpretation one might make about women's labor force activity. Status attainment theory does not make these crucial connections. Most important, the practice of separating out the institution of the family from the institution of the labor force, and both of these from the capitalist and patriarchal modes and relations of production and reproduction, has contributed to an underestimation of the importance of the many forms of women's labor (for example, both home and market, both domestic and wage labor) as well as to an inability to solve women's problems in the labor market, when and where they are said to exist.

In short, to use the theory of status attainment without focusing on the larger structures within which it is said to operate makes the theory only a very partial one. Such a limited approach—one that characterizes most of mainstream sociology today—leads to major misunderstandings about women's roles in the labor force and the tendency to "blame the victim" whenever convenient to do so. Rather than looking more critically at the larger structures involved, status attainment theory assumes some of the most important features that need to be explained.

To conclude, mainstream sociology and its theory of status attainment provide a large and varied base of empirical data on the labor market. Under the influence of feminists in sociology, an analysis of women in the labor market has become, more recently, an important area of investigation. Moreover, it provides us with the important concepts of sex roles and the socialization process. As used by this theory, these concepts help to explain some of the processes that women go through in learning how to behave in this society —both at home and in the market.

However, what status attainment theory mainly does is to focus on social status and prestige rather than to look at the lack of wealth, power, and decision making necessarily experienced by women (both in the home and in the market) in a society organized along the lines of monopoly capital and male domination. It takes for granted and hence fails to challenge the existing social arrangements that lead in the first place either to occupational stratification or to women's responsibility for child care in the home.

By moving to other theoretical perspectives in this book, the author is able to clarify problems in understanding women's labor market activity, so that one can make use of status attainment theory and research where appropriate as well as develop an alternative.

NOTES

1. Acker (1973) and Hoffman (1972) document this for stratification and achievement research, respectively, while Bart (1971) and D. E. Smith (1975) do so for sociology in general. A recent collection of essays on feminist perspectives in the social sciences addresses the failure of sociology to adequately deal with the female half of the population in such specialties as social change, deviance, culture, medical and urban sociology, and so on (Millman and Kanter 1975).

2. While the focus of status attainment research has been on occupational status, and while debates on causes of wage discrimina-

tion are more common in economics, sociologists have recently begun to add earnings as a further dependent variable in the status attainment model (see Featherman and Hauser 1976; Suter and Miller 1973; Treiman and Terrell 1975). The emphasis on supply-side characteristics is as prevalent in these more recent studies explaining male-female income differentials as has been true with attempts to explain male-female occupational status similarities and differences.

3. Acker (1973) discusses problems of concept and method that arise in analyzing social stratification when women are assumed to be significant participants in society.

4. It is true that the issue of female employment was recognized earlier, so that in the 1950s two reports on this topic came out: National Manpower Council's Womanpower (1957) and Smuts's Women and Work in America (1959). However, as Astin (1971) documents in her excellent annotated bibliography on women and work, of the 350 abstracts included, all but 16 were published after 1960, and 124 out of 350 were published in 1970/71. (See Wartenberg [n.d.] for an updated analysis of married women in the labor force.) The greatest increase noted by Astin is in the category "Determinants of Women's Career Choice." Here, three times more studies were generated in 1967-71 than had appeared in the preceding years.

5. Of the studies mentioned above, neither DeJong, Brawer, and Robin (1971) nor Tyree and Treas (1974) specifically look at the influence of education. See the following paragraph, however, where DeJong, Brawer, and Robin conclude that there is much similarity in the patterns of occupational mobility between men and women.

6. Most recently, the occupational status attainment process suggested here has been qualified by Marini (1979). Her 15-year follow-up study of students from ten Illinois schools in 1973/74 finds that, like the studies presented in this section, the mean level of occupational status at initial entry into the labor force is virtually the same for men and women. However, an analysis of intragenerational status attainment for these men and women shows that women experience little subsequent mobility over the work cycle (during the 15-year period studied), whereas men's occupational prestige scores increase over the course of their careers.

7. National data comparing men and women were not available at the time of this study. Therefore, DeJong, Brawer, and Robin used the 1962 Occupational Changes in a Generation (OCG) data for males—from the study by Blau and Duncan (1967) on men; and six National Opinion Research Center (NORC) nationwide surveys conducted between 1955 and 1965 for the data on females. The studies of this sort, though utilizing a variety of different data, all attempt to use national data. Moreover, they all try to compare men and women in the same study.

8. The only study since DeJong, Brawer, and Robin to disagree with these findings is that of Tyree and Treas (1974). They reanalyzed the data used by DeJong and his colleagues. They concluded that the occupational mobility of women is found to be less similar to mobility patterns of men than is women's marital mobility. Thus, similar patterns were found to govern movement of both men and women from their paternal occupational origins to the occupational status of the male head of their families of procreation (the men themselves or the husbands of the female respondents).

9. Treiman and Terrell compared single and married women aged 30 to 44 who were employed in 1967. They utilized the Parnes data for the women. For the men they, too, used the Duncan and Blau 1962 OCG data but only the men aged 30 to 44. For reference to the Parnes data, see Shea et al (1970); for Duncan and Blau data, see Blau and Duncan (1967).

10. This is even carried through in recent feminist scholarship, which describes the degree to which the wife's employment threatens or does not threaten the husband in the family. An example here is the piece by V. K. Oppenheimer (1977). Despite her pioneering work on the sex-segregated nature of the labor market, which shows the labor market to be disadvantageous to women (see Chapter 2), Oppenheimer studies the degree to which women threaten husbands when they are employed and how status inconsistency matters in this situation. Although all the while testing hypotheses about the disruption of wives' employment for husbands, using Parsons's assumptions as the basis from which she tests her arguments, whether wives' occupational behavior is disruptive (and whether Parsons was right or not) is important regarding demystification. This, however, is not the issue. The issue, instead, is to question the underlying reason why it should be tolerated that we consider wives' behavior as disruptive to husbands. Why is the question hardly ever asked in the opposite manner: How is husbands' employment or failure to be responsible for child care disruptive to women? Here, see Hesselbart (1978).

11. In addition to the previous references, a good example of similar capabilities that end up in different behaviors is seen in a recent study by Newson et al. (1977). Mothers report boys and girls equally as likely to be "good with their hands." Behaviorally, though, girls do not get into doing carpentry or metalwork, and boys do not get into sewing or needlework. See also Deckard's reference to women who are good with their hands to sew and sort but not good with their hands to be surgeons.

12. For a discussion of Weber, his U.S. "followers," and distortions of his theory, see Anderson (1974); Montagna (1977), chap. 1; and Pease, Form, and Huber (Rytina) (1970).

13. For a history and summary of the NORC study and related studies, see Reiss et al. (1961); also see Inkeles and Rossi (1956); Siegal, Hodge, and Rossi in progress, as reported in Bose (1973).

14. See Gordon (1972) for a summary of this and other economic perspectives.

15. The percent-of-dollar gap left unexplained between men and women includes the following estimates: 100 percent (Blinder 1973); 84 to 85 percent (Featherman and Hauser 1976); 74 percent (Oaxaca 1973); 62 percent (Suter and Miller 1973); 56 percent (Treiman and Terrell 1975). For a discussion of these findings, see Almquist (1977a, 1977b). Oaxaca also estimated the impact of not only personal worker characteristics but also occupation, industry, and union membership. Using this "full equation," Oaxaca found that only 47 percent of the income gap between men and women was explained. Thus, "occupational barriers" faced by women can be said to account for approximately 21 percent of the disparity between women's and men's earnings, while 26 percent is accounted for by personal characteristics. The remaining 53 percent, however, is still "unexplained."

16. See studies presented earlier in section called Sex Roles and Socialization. See particularly references by Broverman et al. (1972), Hartnett (1977), Brannon (n.d.), and Kanter (1975a).

17. This is compatible with a whole line of research that says that women, as other lower-status people, "drift" into their jobs rather than "plan rationally" for them. See readings in Pavalko (1972).

2
THE THEORY OF
DUAL LABOR MARKETS

INTRODUCTION

Two major tendencies in mainstream sociology that explain women's activity in the labor market are status attainment and sex stratification theories. In this chapter the second approach will be discussed, which is best understood as a challenge to status attainment theory. Unlike status attainment theory, occupational sex segregation and stratification theory asserts that women are treated unequally in comparison with men in the labor market—both in terms of their statuses and wages. Although there is a recent attempt by sociologists to develop this perspective in the mainstream stratification literature,[1] this theory has primarily been developed by economists. Therefore, the major analysis in this chapter comes from a review and evaluation of the dual labor market theory, presented by economists as challenges to the neoclassical economists' assumptions of a unitary labor market and a direct link between human capital qualifications (in particular, education) and occupational positions.* The major contribution of this theory to the author's analysis is in terms of its understanding that men and women are recruited into different occupations and labor markets that are structurally organized to be disadvantageous to women. In a word, women are employed in sex-segregated occupations.

*Dual labor market theory has a variety of forms. As specified in this chapter, it should not be confused with the more radical theory of labor market segmentation, more appropriately belonging in Chapter 3. For a clarification of these differences, see Gordon (1972), who discusses orthodox, dual labor market, and radical economic theories.

This chapter consists of four sections. First, this theory will be discussed, especially as it has developed around the idea of the duality of the labor market. Second, with the help of dual labor market theory, the fact that men and women do usually work in different jobs, in different industries, and in different labor markets will be documented in order to understand women's disadvantaged position in both job experiences and rewards. Then the dual labor market approach is applied to women's employment in general. Third, it is suggested that with some important exceptions it may be possible to extend dual labor market analysis even to some of the features of semiprofessional jobs held by college-educated women. Finally, certain basic contextual problems that dual labor market theory shares with that of status attainment, as well as certain problems of its own, will be addressed and criticized.

SPECIFICATION OF DUAL LABOR MARKET THEORY

Despite certain contextual problems and criticisms (see "Criticisms of Dual Labor Market Theory" later in this chapter), dual labor market theory makes a definite contribution to the understanding of women's occupational experiences. The underlying assumptions of this theory allow one to understand that women and men do not work in the same jobs. Instead, our system employs people in sex-segregated occupations, industries, and labor markets.

This interpretation of the data invalidates the prevalent claim that men and women earn equal "status attainments" in an allegedly single labor market with uniform and universal criteria. Education does not "equalize" opportunity in this theory. In fact, it is said to operate differently for those in "better" and "worse" labor markets.

Education is not seen as the means by which one moves from "worse" to "better" job markets but only as a partial explanation for job entry and mobility within parts of the more stable sectors of the economy. Other than for high-status professionals and managers, one author argues that it is a myth that education and schooling develop the necessary skill traits in people that are required to allocate them in particular job categories (Piore 1975). And, in the case of the high-status jobs requiring much education, formal education is seen as a screening or rationing device for existing mobility patterns. This type of analysis, however, neither explains the origins nor questions the legitimacy of the existing social arrangements.

Mobility between the major sectors of the labor market is for all purposes nonexistent (Gordon 1972). Instead of changing characteristics of disadvantaged individual workers (that is, such as their education, their personality attributes, or their attitudes toward work),

dual labor market theory stresses the need to change institutional and labor market structures themselves. Most important, since women are more likely to be found in the "worse" labor markets, education may hold even less promise for women than men. As one author concludes:

> Thus, from a policy point of view, it is not sufficient simply to advocate the integration of presently segregated occupational categories through altering the supply characteristics [like years of schooling or occupational aspirations] of female workers. The factors on the demand side which tend to segment the male and female labor forces among the dimensions of establishment of employment must be investigated and combatted. [F. Blau 1975, p. 274]

In short, despite increasing education of the total population and its clear implications for women, even well-educated women do not reap the same rewards as men in terms of types of jobs and economic, social, and political remunerations. In fact, as women's education has increased, their wage levels have decreased relative to men's. Thus, while increased education may help individual women to move up in the occupational world, it has not helped to change the position of women as a group vis-à-vis men as a group in the labor market.

Dual labor market theory has developed over the past decade as a way of organizing how experience operates in low-income labor markets. (For summaries, see Gordon 1972, chap. 4; Montagna 1977, chap. 4.) It was in the context of trying to understand poverty, unemployment, and underemployment in urban "ghettos" in the later 1960s that economists developed this paradigm depicting two separate work forces—the primary and secondary labor markets.

Initially, dual labor market theory was used to explain racial discrimination in jobs and income. (For a history, see Piore 1975. Also see Otero and Boggs 1974; U.S., Department of Labor, Bureau of Labor Statistics 1972.) It was extended to include discrimination by sex and age (Doeringer and Piore 1970, 1971; Piore 1975). However, applications of dual labor market theory to the position of women specifically have been quite limited. As Gordon (1972) says, "Dual Labor Market analysts refer to the employment problems of women only implicitly" (p. 48). The response by feminist economists in the 1970s is just beginning to be felt in this theoretical framework too.[2]

The general hypothesis of dual labor market theory is that the labor market has been divided into two distinct types of segments over time, forging two separate labor markets—termed the primary and secondary sectors. The workers and employers in one sector operate by fundamentally different rules than the workers and employ-

ers in the other sector. The more disadvantaged members of any group being looked at—usually in terms of class, age, race, or sex— are more likely to end up in the secondary markets. The area of concern in this study is women and their placement in the labor market.

At one extreme, the primary job market offers jobs with stability as well as clear and available career ladders. These two features have been specified by Piore (1975) as being the most important characteristics of primary market jobs.* They lead to jobs with relatively high wages, good working conditions, job security, opportunities for advancement, and administration of work rules on the basis of equity and due process. Job stability and career ladders (or mobility chains as defined by Piore) are mainly a function of the fact that the primary sector is a highly structured internal labor market. Internal labor markets are defined on the basis of two types of jobs: entry-level and administered or internal jobs.

Entry-level jobs are restricted to a relatively few lower-level jobs on the mobility chain. In place of the direct operation of market forces (be they in equilibrium or monopolized) as with entry jobs, an internal market develops on the job. That is, an administrative apparatus develops that allocates labor and determines wage rates within the firm. No claim whatsoever to a "free market" is said to exist within the business enterprise itself. On-the-job training and enterprise-specific skills are not only available but are required for advancement up the career ladders. Therefore, advancement opportunities open to workers within an enterprise are generally determined by organizational entry-level jobs of the workers and are restricted to those who are most stable in the firm. This is also called "balkanization" of the labor force.

Secondary sector jobs, by contrast, are characterized by their instability and short or nonexistent mobility chains. There may be numerous ports of entry into this relatively unstructured market, but more important is the fact that job stability is discouraged by low wages, little advancement opportunity, the dead-end nature of jobs,

*Piore tries to deal with the fact that professionals and managers are more privileged than other primary workers, by separating out two levels of primary workers. Thus, there is an upper tier (professional/technical/manager/administrator) and a lower tier (sales/ clerical/skilled [craftspeople]) in addition to the secondary jobs (semiskilled [operatives, transport equipment operators], nonfarm laborers [unskilled], service). These three groups are said to correspond to middle-class, working-class, and lower-class subcultures, respectively. What unites the upper and lower primary tiers is job stability and mobility chains.

poor working conditions, and little job security. In addition, second-
ary jobs have a more highly personalized relationship between workers
and supervisors. This leaves wide latitude for favoritism and is con-
ducive to harsh and capricious work discipline as well as arbitrary
work rules in practice.

Instability of the work force is not only accepted but is encour-
aged by employers in the secondary sector. Since secondary jobs
are isolated—not connected to significant job ladders—workers may
quit in hopes of finding better jobs. This leads to their job instability
and high turnover rates. (However, they tend to end up in similar
secondary jobs, unemployed, underemployed, or lost from employ-
ment statistics. Piore [1975] notes a similar rate of high turnover
among high-status primary workers—but for advancement rather than
unemployment.)

Thus, the secondary labor market fails to provide jobs with se-
curity, wages, and working conditions required to stabilize the work
relationship. The employees' instability is a historical end product
developed over time between employer demands and employee-supply
characteristics. The historical forces interact to sharpen the separa-
tion between the two markets—in the interest of employers in both
markets.

Primary market employers' desire to retain certain stable em-
ployees is therefore conducive to this continuing division between the
two types of markets. These employers want to balkanize the labor
market (that is, create internal or administered markets), defining
different clusters of jobs for which they establish different entry cri-
teria (Gordon 1972). Moreover, they stabilize their work force by
shifting costs to secondary sector jobs. Two examples of institutional
arrangements through which this transfer is accomplished are sub-
contracting and temporary help services. Another way is to maintain
a secondary sector within the primary establishment itself. For ex-
ample, there may be certain departments composed of low-seniority
workers in which employment fluctuations are concentrated (Piore
1974). These procedures relate directly to women's employment.
They include such examples as temporary office help and sorting and
checking departments at the end of assembly lines in electronics and
pharmaceutical industries (Winkler n.d.).

The shift of costs from primary to secondary sector employees
is done in conjunction with secondary employers who purposely place
new types of jobs or clusters (for example, key punch operator) into
the secondary market. This is particularly relevant for employed
women, since it seems to be the case for numerous service-type jobs
that have emerged since World War II as women's labor force partici-
pation has numerically increased (Gordon 1972).

The basic problem for secondary workers, according to this
theory, is more due to the way work is structured in the secondary

market rather than to particular characteristics of the worker (such as their marginal productivity or occupational preferences). * In fact, dual labor market theory stresses that many job candidates excluded on such grounds in primary sector employment do possess the requisite behavioral characteristics, training and attitudes. Thus, secondary workers are generally barred from primary jobs, not because they lack certain work skills, according to Piore but because of their employment instability—they work unreliably or intermittently.

This problem is particularly applicable in the case of women and takes the form of what Piore has called "statistical discrimination," where decisions regarding individuals are based on group-derived probabilities. Thus, if employers believe women are less stable, and there is much evidence saying they are (this is equivalent to the self-fulfilling prophecy), then individual women may be excluded from primary-type employment on a probabilistic basis. As Blau and Jusenius (1976) point out, this is discriminatory to individual women, even if average differences do exist. †

In addition, as Gordon (1972) says in an explanation of poverty and unemployment generally, "No matter how long an employee worked at these [secondary jobs] or how clearly he [sic] demonstrated his diligence or skill, there seemed to be no fixed channels through which he could rise above his original job" (p. 45). Thus, he concludes that "abstract, generalized individual abilities (like reasoning and reading abilities) become less and less important in determining or explaining variations in labor market status or income" (p. 79).

It is the notion of duality‡ or multiplicity[3] of labor markets that is useful in trying to explain women's labor force activity. Its most

*Differences among dual labor market theorists certainly do exist. Their particular solutions for women's inequality in a sex-segmented labor market differ according to their different interpretations of the problem. Most dual labor market theorists would agree with the above analysis. See Blau and Jusenius (1976), however, for one way to interpret differences among dual labor market theorists.

† Absenteeism and turnover rates are very similar for both sexes. This principle applies especially when one controls job status and income. Then, no sex differences occur in absenteeism and turnover for people in jobs with the same status and remuneration (U.S., Department of Labor, Wage and Labor Standards Administration 1969).

‡ Duality of the labor market is expressed by different theorists in terms of primary versus secondary, internal versus external, and structured versus unstructured markets. In Chapter 3, this duality is referred to as core versus periphery and competitive versus monopoly capital labor markets.

powerful observation is that men and women do not compete with one another in general in the labor market. Instead, they are paid to work in separate jobs, separate industries, and separate labor markets. In each case, women are paid less than men. This approach is best summarized by V. K. Oppenheimer (1970):

> In sum, instead of conceiving of the labor market and the demand for labor, a more realistic view is that of a multiplicity of labor markets—some may be only partially competitive with each other, and some wholly noncompetitive.
> The relevance of this approach to the analysis of the demand for female labor is this: to the degree that men and women concentrate in different occupations and industries, they tend to be relatively noncompetitive with each other —that is, they are operating in different labor markets. In that case, it is meaningful to talk about a demand for female labor per se—if for no other reason than that there exists a demand for workers in labor markets where females predominate. [P. 65]

DUAL LABOR MARKETS: THE CASE OF WOMEN'S EMPLOYMENT

In this section the contention that women generally are segregated by occupation, industry, and labor market will be documented. Then an attempt is made to show (in the next section) that despite certain problems dual labor market theory is potentially relevant for explaining certain market experiences of highly educated women in the professions.

Occupational segmentation by sex has been recognized in sociology for some time now. * Documentation of continuous sex segregation in the paid labor force throughout the twentieth century is quite substantial. [4] It is true that the increase in the numbers of women in the paid labor force has been dramatic over the twentieth century. (Remember, however, that what is remarkable about twentieth cen-

*It is also commonly called sex-typing, where one sex dominates an occupation in numbers in addition to there being an expectation that this numerical dominance is the way it "should be" (see Epstein 1971). In this way, sex-typing is understood as a structural or institutionalized mechanism that helps perpetuate discrimination against women. As such, it does not challenge the existing status quo. Rather, it is said to describe it.

tury industrial capitalism is the relegation of women to the home as
a separate and private entity generally and the total responsibility for
children's care.)

Between 1900 and early 1975 women increased from 18 percent
to just under 40 percent of the total labor force (Montagna 1977; V. K.
Oppenheimer 1970; U.S., Department of Labor, Bureau of Labor Sta-
tistics 1975). And by 1970 more than 50 percent of all women between
18 and 64 years old were employed (in comparison with only 20 per-
cent in 1900) (V. K. Oppenheimer 1973a). This increase began to ac-
celerate in 1940 when 30 percent of women aged 18 to 64 were em-
ployed. Most of the increase in women's labor force participation
has been among older and married women; and in the 1960s and 1970s,
particularly, among those married women who are mothers with pre-
school children (V. K. Oppenheimer 1973a; see also Kolko 1978).

As Oppenheimer explains, the industrial and occupational shifts
over the course of the United States's economic development led to a
rise in the demand for female labor specifically, a demand particu-
larly marked since 1940. Demand has been the dominant factor in the
situation, and supply has adjusted itself to that demand. Oppenheimer
continues by explaining that it is easier to change norms about married
women working when the number of young and single women declines.
Until this happened, married women's employment was considered
"unacceptable."

A combination of forces led to the decline in the supply of young
single women: a decreased birthrate in the 1920s, which affected the
1940s labor force; an increased likelihood for girls to stay on longer
in school; and a decline in the age of marriage. Moreover, it is
cheaper to employ women of all ages and marital statuses generally
than to either employ men* or introduce machines.

However, a quantitative increase should not be confused with a
qualitative change. As the number of paid women workers has in-
creased since 1900, women have continued to be recruited into a rela-
tively small number of low-status, low-paying "female" jobs that lack
access to resources, security, and decision-making power. Thus, as
one author has shown: "Historically, women have been concentrated
in occupations not only where they are overrepresented but where they
are actually in the majority."† Thus, by 1960, 81 percent of all em-

*Oppenheimer points out that the supply of young single men who
might be ready and willing to enter the labor force in poor jobs de-
creased along with the lowered birthrates in general.

† Occupations where women are overrepresented are those where
the percentage of women in those occupations are greater than the per-
centage of women employed in the total labor force. Occupations

ployed women were in occupations where women were overrepresented, and a full three out of every five employed women were in occupations where women constituted 70 percent or more of the workers. Preliminary 1970 census occupational data showed that "if anything, the concentration may even be greater" (Oppenheimer 1973a, p. 949).* Further evidence for this trend is supplied by Howe (1977) and Dubnoff (1979), among others.

The U.S. Bureau of the Census listed 250 different occupations in 1969, but half of all employed women were concentrated in only 21 of these (U.S., Department of Labor, Women's Bureau 1969). By 1973 more than 66 percent of all women workers were employed in ten specific occupational categories,† in comparison with only 20 percent of all men employed in the ten largest occupations for men (U.S., Department of Labor, Women's Bureau 1975).

The concentration of women in a limited number of occupations can be expressed in terms of the Index of Dissimilarity. This index represents the amount of occupational sex segregation. It may be interpreted as the percentage of women (or men) who would have to change jobs in order that the ratio of males to females in each occupation would match the ratio of male to female workers in the labor force as a whole. According to Gross (1971), the Index of Dissimilarity unequivocally demonstrates that the degree of occupational sex segregation has been high and constant (between 66 percent and 69 percent) since 1900. In 1960 it was 68 percent. In fact, it is higher than the degree of occupational segregation by race (47 percent in 1960 in comparison with 68 percent for women). (For more recent data than Gross's, see Szymanski 1974b; Williams 1975.)

where women are in the majority are those where women represent more than 50 percent of the workers in those categories.

*For example, Oppenheimer reports that the proportion of employed women who were clerical workers rose from 30 percent in 1959 to 35 percent in 1970; and women as a proportion of all clerical workers went up from 68 percent to 74 percent.

† The ten occupations are registered nurse, elementary schoolteacher, secretary, typist, retail trade salesworker, bookkeeper, sewer and stitcher, cashier, waitress, and private household worker. Each occupation employed more than 800,000 women. Also, by 1973, about 75 percent of all employed women worked in 57 occupations in which at least 100,000 women worked. In 17 of these 57 occupations, women accounted for 90 percent or more of all employees. In more than 50 percent (31/57), women made up 75 percent or more of all employees (U.S., Department of Labor, Women's Bureau 1975).

TABLE 1

Percentage of U.S. Population Employed in Different Occupational
Categories, by Sex, 1974

Occupational Category	Men Employed	Women Employed
White-collar	40	62
High-status (professional/ technical/manager/offi- cial/proprietor/admin- istrator)	28	20
Low-status (clerical/sales)	12	42
Blue-collar		
High-status (crafts worker/ foreman)	21	2
Low-status (operative/nonfarm laborer)	26	14
Service	8	22
Farm	5	1
Total	100	101*

*The total is 101 percent owing to rounding errors.

Source: Adapted from U.S., Department of Labor, Bureau of
Labor Statistics 1975, p. 7.

The degree of sex segregation is true despite the fact that oc-
cupations have changed from being "male" to "female" and vice versa
over time. Gross finds only one previously sex-segregated occupa-
tion that has become integrated: elevator operator. The more usual
course is for women to enter a previously male occupation in such
large numbers that it becomes resegregated as a "female" occupation,
"much in the same way and for similar reasons that an all-white resi-
dential neighborhood changes to all black after the first few black
families move in" (Stevenson 1975, p. 247, n. 19).

Even when using gross occupational categories, such as defined
by the U.S. Bureau of the Census, it is possible to see the intense

occupational segmentation by sex. Women are more likely than men
to be employed in white-collar and service work,* while a higher pro-
portion of men than women are found in blue-collar and farm work
(see Table 1).

However, within both blue-collar and white-collar jobs overall,
men are much more likely than women to be found in the higher-status
occupational categories. For example, men are two to three times
more likely to be found in high-status (professional/technical/manager/
official/proprietor/administrator) than low-status (clerical/sales)
white-collar jobs; while just the reverse is true for women: they are
twice as likely to be in low-status than high-status white-collar jobs.
A similar case exists when comparing high-status (crafts worker/
foreman) and low-status (operative/nonfarm laborer) blue-collar cate-
gories. Service work, which is low in status and rewards generally
is overwhelmingly "women's work."

Thus, women dominate in service, domestic household, and
clerical jobs, while men dominate in the following job categories:
manager and proprietor, foreman and craftsman; farmer and farm
worker, and laborer (see Table 2). The remaining occupations of
factory operative, salesperson, and professional/technical worker
are "mixed-sex" occupations: they contain a representative percent-
age of both men and women. In what follows, it will be shown how
each of these mixed-sex occupational categories are sex-segregated
by specialty, rank, and/or industry. It will be helpful for the reader
to refer to Table 2 for this discussion.

Among professionals, the first of these mixed-sex occupations,
women are elementary-school teachers, while men are college pro-
fessors; nurses while men are physicians; and dental hygienists while
men are dentists. In fact, almost three-fourths of all women profes-
sionals are either teachers or nurses and allied health workers (U.S.,
Department of Labor, Women's Bureau 1975). However, even within
these professional categories, when women enter more prestigious
male professions, it is at the lower levels. For example, in medi-
cine women are more frequently found in pediatrics, psychiatry, and
anesthesiology; in law, in family law (Theodore 1971; White 1971).

On the other hand, men's entrance into primarily the higher-
level and decision-making positions in typically female professions

*Service usually refers to unskilled, nonunionized "gray-collar"
and "pink-collar" jobs, frequently paid below minimum wages (such
as waitresses, beauticians, nurses' aides, and protective services).
About half of these jobs are found in the food trades (Winkler n.d.).
It does not include the higher-status service-oriented work of profes-
sionals: doctors, lawyers, nurses, social workers, and so on.

TABLE 2

Concentration of Male- and Female-Type Jobs in the United States, 1970

Occupational Category	Women as Percentage of Total in Occupation
Mainly male occupations	
Foreman and craftsman	3
Laborer (nonfarm)	3
Farmer and farm worker	15
Manager and proprietor	16
Mixed-sex occupations*	
Factory (male—durable goods; female—nondurable goods)	31
Professional/technical (male—physician/lawyer/and so on; female—nurse/teacher/and so on)	39
Salesperson (male—wholesale; female—retail)	42
Mainly female occupations	
Service (nondomestic)	61
Clerical	75
Domestic	98
Total occupations	40

*Mixed-sex occupations refer to those occupations that include approximately a representative percentage of men and women in the labor force.

Source: Adapted from Deckard (1975, p. 317).

continues unabated. Thus, in education men are more likely to be principals and supervisors (Bernard 1971; Grimm and Stern 1974; Howard 1975). This phenomenon is also reproduced in nonprofessional categories. Recently, a study of banking practices in eight urban areas revealed that many more women were recruited into the banking industry than men—but mostly as lower-status tellers and clerks

(80 percent to 90 percent female). Men, on the other hand, recruited in smaller numbers into banking, were much more likely to be found in higher-level and more highly rewarded decision-making jobs. In this case, male take-over of high-level typically female jobs was found to be as true for blacks as for whites (see Shanahan 1976b).

In short, men rank higher than women in both "men's" and "women's" jobs. Women's low professional status is recognized in sociology by the fact that their work is typically defined as semiprofessional (see Etzioni 1969). When professional jobs are classified as between professional (for example, physician, lawyer, architect, accountant, judge) and semiprofessional (for example, teacher, social worker, nurse, librarian), three-fourths of all semiprofessionals are women, whereas this applies to only one out of every ten professionals (Theodore 1971).

Among salespersons, another mixed-sex occupational category, men are employed more in wholesale and women in retail sales (Deckard 1975). In 1970 women were 42 percent of all salespersons but 58 percent of all retail salespersons (Winkler n.d.). However, even in retail sales, women are "countergirls" or "salesgirls" at salaried jobs, often at minimum wages. High-commission sales work, such as in appliances and automobiles (heavy items) or jewelry (valuable items), are reserved for men. Such sex segregation in sales work always works against women. It is among salespersons that women are the most financially disadvantaged in comparison with men: on the average, in the United States in 1975, a woman was only paid $0.59 for every $1.00 earned by a man. In sales work this dropped to $0.42. And this figure reflects full-time, year-round workers only (U.S., Department of Labor, Bureau of Labor Statistics 1975).

Even when male and female salesclerks are doing the exact same work—for example, selling clothes—it has been argued by some companies that men "deserved more pay on the grounds that it's harder to sell to men than women." Another argument proposed is that it is allegedly "harder to fit garments on men than women."* This is supposed to justify differential wages.

Caplow (1954) describes the way in which sales work is said to be divided by sex:

*These arguments were used by Loveman's Department store in Montgomery, Alabama, as reported in the Guardian on November 21, 1973 ("Charged Sex Bias" 1973). The court ruled against both of these arguments. However, the Third Circuit Court of Maryland, Delaware, and Pennsylvania also ruled that the part-time (female) workers at Robert Hall did a substantially different kind of work from full-time (male) employees and that the differences in pay rates was justifiable on this basis.

The prevailing pattern is that salesmen serve male cus-
tomers, and saleswomen serve female customers. Where
the customers are mixed in gender, the sales force follows
the majority. An exception is made for very heavy or very
valuable commodities, which are commonly sold by men.
A whole set of organized folkways is developed on the basis
of these principles. Thus, in a normally organized depart-
ment store, there will be men in the sportsgoods depart-
ment, women to sell curtains and dishware, men to sell
books, but men to sell wedding silver and furniture. [P.
232, emphasis added]

In challenging the assumption that this description of occupa-
tional sex segmentation is either acceptable or inherently logical,
Stevenson (1975) goes on to point out the element of pure arbitrariness
in sex divisions in the labor market:

A job that is clearly and exclusively women's work in one
factory, town, or region may be just as clearly and ex-
clusively men's work in another factory, town, or region.
According to the National Manpower Council, cornhusking
is women's work and trimming is men's work in the Mid-
west, while just the opposite is true in the Far West.
Caroline Bird says that "cornhusking was woman's job in
Eureka, Illinois, but a man's job in Jackson, Wisconsin,
while textile spinning was done by women in Chatanooga
mills and by men in North Carolina." [P. 245-46; see
nn. 13 and 14 for references to the National Manpower
Council and Caroline Bird]

This brings us to industrial work done by female operatives and
how it differs from that done by men. This is the third and final set
of mixed-sex occupations to be discussed. The three areas of female
factory work to be discussed include the garment, electronic, and
pharmaceutical industries. By understanding how women are used in
these industries one learns, in addition to the industrial segregation
by sex, that women function in the secondary type of labor market.
 Women are employed in factories typically making products that
were formerly produced at home before the Industrial Revolution:
textiles, food products, and household supplies. These are nondurable
goods industries. Men, on the other hand, dominate in more profit-
able durable goods industries such as automobiles and steel.
 Women comprise 80 percent of the workers in the garment in-
dustry (see Kihss 1977; Quick 1972). The fixed-capital level in this
industry is low, leaving only small margins of profits for owners and,

thus, low and inadequate wages for workers. There is very little au-
tomation principally because styles change too frequently. [5] There is
little formal training, and the prospects for promotion are practically
nonexistent. In addition, the industry is highly susceptible to foreign
competition from countries with even lower wage rates. As Quick
(1972) concludes, "It is not coincidental that women do this kind of
work" (p. 17).

Unlike the garment industry, electronics and pharmaceutics are
located in the more stable durable goods sector of the economy. The
major recent growth spurt for women factory workers has been par-
ticularly in the electrical industries, with an 82 percent increase in
the number of women employed between 1950 and 1967 (Winkler n.d.).
However, it has the lowest average wage of any durable goods indus-
try, which one author attributes to the large number of women who
have been hired to displace more highly paid male workers, as well
as to the fact that three separate unions represent electrical workers.

However, despite women's significant numbers in the electronics
work force, they work only in low-level, unstable, low-paying jobs
with little or no mobility or seniority. While only 1 percent of all
employed women in the United States are assemblers, two-thirds (67
percent) of all electronic assemblers are women. (Four-fifths of all
female assemblers are in industries where 60 percent or more of the
assemblers are women [V. Oppenheimer 1973a].) Compare this with
automobile assemblers who are predominantly men (84 percent) in
monopoly capital markets with more job stability, union protection,
higher pay, advancement opportunities, and so on. In the electronics
industry, women are not found in production per se but on the assem-
bly line where technology is especially spotty. Here they check and
recheck finished products: automation is limited and human hand-eye
coordination is preferred. Women are said to be especially suited
for this intricate and delicate work. To quote Quick again, "It is not
coincidental that women do this kind of work."

In contrast with garment and textile industries, the pharmaceu-
tical industry uses modern technology in abundance, and its profits
were the highest in the United States for ten years in a row (Ehren-
reich and Ehrenreich 1971). However, advanced technology stops at
the doors of "women's departments": women's work involves packing,
stamping, labeling, checking, and rechecking. In short, even if
women work in profitable, typically male-concentrated industries,
they do so on the basis that they are recruited from "female" labor
pools to work in "female" jobs at "female" wages.

To quote Stevenson (1975) in her study that concludes that wom-
en's inferior economic position results from a highly segregated oc-
cupational structure:

TABLE 3

Representation of Women in Ten Highest-Paid and Ten Lowest-Paid
Occupations
(in percent)

Occupation	1970
Ten highest-paid	
Stock and bond sales agent	8.6
Manager and administrator, not elsewhere classified	11.6
Bank official and financial manager	17.4
Sales representative, manufacturing	8.5
Real estate appraiser	4.1
Designer	23.5
Personnel and labor relations worker	31.2
Sales representative, wholesale	6.4
Computer programmer	22.7
Mechanical engineering technician	2.9
Ten lowest-paid	
Practical nurse	96.3
Hairdresser and cosmetologist	90.4
Cook, except private household	62.8
Health aide, except nursing	83.9
Nurse's aide	84.6
Sewer and stitcher	93.8
Farm laborer	13.2
Dressmaker and seamstress	95.7
School monitor	91.2
Child care worker, except private household	93.2
All study occupations	35.9
All occupations	37.7

Source: U.S., Department of Labor, as reproduced in Eisen (1977b, p. 9).

A third hypothesis was that men and women within an oc-
cupation group were segregated, not only by occupation,
but also by industry. For this hypothesis, I used multiple
regression analysis on a number of industry variables,
such as profitability and market power. In fact, not only
are women segregated into different industries than men,
but women's industries tend to be less profitable and have
less market power than men's. For a semiskilled occu-
pational requirement group, about one-third of the differ-
ence in wages was attributable to the fact that men are in
the more profitable and powerful industries. The labor
market assigns women to those industries which are not
capable of paying higher wages because of the economic
environment in which they operate. [P. 250, emphasis
added]

In short, dual labor market theory explains women's disadvan-
taged market position and remunerations in terms of the following:
women are recruited into a relatively small number of jobs and these
jobs are located in industries and markets with low capitalization,
small profits, low wages, poor organization among workers, limited
or nonexistent job mobility or advancement, job instability, and high
turnover rates.

In dual labor market theory, occupational sex segregation in
disadvantaged sectors of the economy is typically seen as the cause
of women's inferior position—socially, economically, politically—in
the labor market. It is most commonly expressed in the "crowding
hypothesis": women are crowded into only a limited number of jobs,
thus increasing their supply and decreasing what employers have to
pay them.

This phenomenon can be seen in Tables 3 and 4. In Table 3
one sees that women are the overwhelming majority in the lowest-
paid occupations in the labor market. Crowding of women into cer-
tain jobs is said to cause low wages. On the other hand, they are
simultaneously a minority in the highest-paid jobs. Moreover, Table
4 shows that the highest-paid worker in the typical women's occupa-
tion earns much less than her counterpart in the typical men's occu-
pation—even though she has more education.

In fact, it has generally been the case that as women have gained
more education over the past quarter century, the earnings gap be-
tween the wages of men and women has increased. In 1955 a full-
time, year-round employed woman made $0.64 for every $1.00
earned by a full-time, year-round employed man. By 1974 this
dropped to $0.57—despite women's increased educational attainment,
13 years since passage of a federal equal pay act, and 12 years after

TABLE 4

Educational Attainment and Earnings, Predominantly Male and
Predominantly Female Occupations

Occupation	Median Years of Schooling Completed in 1970	Median Earnings of Full-Year Workers[a]
Occupation Employing Largest Number of Males		
Auto mechanic	10.5	9,070
Carpenter	9.7	9,720
Deliveryman	11.7	9,080
Farm owner and tenant	10.5	7,780
Foreman	12.7	12,320
Heavy equipment mechanic	11.1	10,300
Manager and administrator, not elsewhere classified	13.8	16,770
Salesclerk, retail trade[b]	12.7	6,470
Sales representative, wholesale	13.8	13,690
Truck driver	9.0	9,640
Occupation Employing Largest Number of Females		
Bookkeeper	13.7	6,530
Cook	9.1	5,470
Hairdresser and cosmetologist	13.0	5,770
Nurse's aide	11.8	4,890
Practical nurse	13.2	5,870
Salesclerk, retail trade[b]	12.7	6,470
Secretary	13.9	6,860
Sewer and stitcher	8.5	4,880
Registered nurse	14.2	8,090
Typist	13.7	6,070
All U.S. occupations	12.4	9,945

[a]In 1973 dollars.

[b]This occupation is listed in both groups since it provides employment to large numbers of both men and women.

Source: U.S., Department of Labor, as reproduced in Eisen (1977b, p. 9).

the Equal Employment Opportunity Commission was established
(U.S., Department of Labor, Employment Standards Administration
1976). As one analyst concluded, "When the effects of inflation were
taken into account, the gap between the purchasing power of men's
earnings and women's earnings increased by 79 percent over the pe-
riod from 1955 to 1976" (Shanahan 1976a, p. 18). This gap in wages
correlates with the increased demand for women in the labor market
and their recruitment into a limited number of occupational categories
in certain types of markets.

Now that the dual labor market theory has been used to estab-
lish that women do not operate in the same markets as men or com-
pete against men on the job, let us ask still more specifically: What
are the overall figures for women's secondary labor market partici-
pation?

According to one dual labor market theorist in sociology (Mon-
tagna 1977), seven out of ten employed women in the 1970 U.S. labor
force work in the secondary labor market. For blacks and Latinas
this figure increases to eight out of ten women. Thus, on the one
hand, it is true that our economy has become a service-oriented econ-
omy. On the other hand, contrary to claims made by many sociolo-
gists, it is not true that increases in higher-status white-collar, as
opposed to lower-status blue-collar, jobs have been in stable, lucra-
tive jobs offering job security and upward mobility.

As Montagna shows (in his table 3.5, not reproduced here), an
increasing number of secondary jobs are in the service-producing
sector of the economy (that is, "nonindustrial industries" as he calls
them). Thus, he documents that four out of every five clerical work-
ers and one out of every two unskilled workers are found in the sec-
ondary labor force. As he says:

> This puts an entirely different light on what is happening in
> the postindustrial or service society. According to dual
> labor market analysis, if we are to be a service-producing
> society, we are also to be a society of mostly secondary
> jobs. [P. 71]

And as numerous writers have shown (for example, Howe 1977; Mills
1956; V. K. Oppenheimer 1970), the increase in female employment
since World War II has been primarily in the service industries.

In a comparison of the percentage of men and women in white-
collar versus primary labor market categories for 1970, Montagna
(1977) makes this point quite clearly. From Table 5 it is clear that
the percentage of white women in white-collar jobs is large (65 per-
cent), but is much smaller for black (36 percent) and Latin (48 per-
cent) women. However, when we look at primary versus secondary

TABLE 5

Percentage of Labor Force in White-Collar and Primary Labor
Market Categories, by Race and Sex, 1970

	Men			Women		
	White	Black	Latino	White	Black	Latina
White-collar (professional, managerial, sales, clerical)	42	19	28	65	36	48
Primary labor market (professional, managerial, sales, craftsworker, transport equipment operatives)	62	36	50	30	17	20

Note: Primary labor markets are characterized by relatively
high wages, job stability, good working conditions, job security,
favorable mobility conditions, heavy capitalization, and so on.

Source: Montagna 1977, p. 139, table 6.6.

(instead of white-collar versus blue-collar) categories, far fewer
women are found in primary than white-collar jobs. The percentage
of women in primary jobs is less than one-half of the percentage of
women in white-collar jobs. For whites, blacks, and Latinas, the
figures are 30 percent, 17 percent, and 20 percent, respectively.

And even more dramatically, according to Montagna,

> comparing men to women, one sees an almost complete
> reversal in proportions. The men's white-collar category is smaller than the women's. But the percentage
> of men found in primary occupations is larger than their
> percentage in white-collar occupations and twice the size
> of women in primary occupations. [P. 136, emphasis
> added]

In short, while women are more often found in white-collar and service jobs than men, they are twice as likely as men to be found in the

more disadvantaged secondary labor markets. This appears to be a more accurate explanation of women's labor force participation than status attainment theory. Moreover, it helps account for the alleged discrepancy between status and income with which that theory left the reader.

THE SPECIAL CASE OF
COLLEGE-EDUCATED WOMEN

While dual labor market theory advances one's understanding of women's disadvantaged market position generally, the question of how useful it is for analyzing employment experiences of college-educated women, who presumably are employed in professional jobs in the primary labor market, arises. [6] It is to this point that Blau and Jusenius (1976) are speaking when they say:

In contrast to our formulation, it [that is, dual labor market theory] is not helpful in elucidating the differential treatment accorded to women and men within the primary sector, that is, within reasonably highly developed internal labor markets. [P. 197]

On the other hand, despite the placement of professional jobs in the primary labor market, each of the main dual labor market theorists (Montagna 1977; Piore 1974), makes reference to the fact that women generally, as well as women in the professions, are often in the secondary labor market. The main reason for this seems to be based on the fact that women's primary responsibility is said to be to their individual families. Therefore, women are said to not have a major commitment to market activity, thus leading to job instability in the form of high turnover rates. *

The author's analysis found that an application of the secondary market characteristics to women's professional jobs is possible, with some important exceptions. First and most important, dual labor market theory was developed in an attempt to understand operating experiences in low-income markets. Professional women clearly

*In citing this view, it in no way suggests that it is correct. To the author's knowledge, no evidence exists to support the idea that, other things being equal, women have higher rates of turnover and/or absenteeism than men. In fact, they are the same and sometimes lower (see Blau and Jusenius 1976, p. 194, n. 33). For further evidence, see the single daggered footnote on page 40, above.

fall into this category. This is not to say that professional women are as disadvantaged as nonprofessional women (or as many nonprofessional men). It is to say, however, that well-educated women are closer in income to the traditionally low-income worker in the United States than to their highly educated male counterparts. One need only compare average incomes of female professionals and male professionals; female professionals, especially semiprofessionals and male nonprofessionals; and female semi- and nonprofessionals to see this.

Nationally, female professionals make $0.67 for every $1.00 that male professionals earn (Ehrlich et al. 1975). Not only do women in typically women's professional job categories (like teaching and nursing) make less money than men in typically male categories (like doctors and lawyers), but women make less money than men even when both sexes work in women's professions. Again, teaching and nursing are examples (Deckard 1975).

It goes without saying that women also make less money than men when they work in typically male professions. This is reflected in the fact that while 20 percent of male professional and technical workers make over $15,000 annually, this applies to only 1 percent of all full-time, year-round employed women in professional and technical jobs (Deckard 1975; Keyserling 1972).

Second, the distinction between professional and semiprofessional job categories further helps differentiate high- from low-income well-educated men and women. Most women classified as "professional" by the Bureau of the Census are really "semiprofessionals" in the "helping" industries of education and health. Very few women actually work in typically male, high-status, high-paying, decision-making professions. As noted earlier, whereas 75 percent of all semiprofessionals are women (schoolteachers, nurses, social workers, and librarians), this is true for only 10 percent of all so-called professions (physicians, lawyers, architects, accountants, college professors, scientists, and so on) (Theodore 1971).

Sociologists distinguish professionals from other job holders on the basis of their specialized knowledge and its connection to exclusive control over their professions (Bloom 1971; Freidson 1973; Pavalko 1972). Semiprofessions, on the other hand, are said to apply knowledge derived from a profession instead of creating knowledge (Simpson and Simpson 1969). Therefore, semiprofessional workers lack exclusive control and autonomy over their own work. In fact, the tasks performed by semiprofessionals have a direct and dependent relationship on a profession. This is seen in nursing, which is regulated by physicians. In the health care industry in general, physicians control numerous other semiprofessions, almost all of which are overwhelmingly female; and many are newly created as women have increased their labor force participation in the past 30 years. In C. Brown's

(1974) analysis of women workers, who comprise 80 percent of the health care industry, she writes:

> The top male occupation, physician, controls the female occupations, not only on the job but in the educational programs. The American Medical Association and its affiliate medical societies have the right to set the curriculum, direct the training programs, control professional certification, and sit on the state licensing boards of (at last count [1974]) sixteen other occupations. [P. 7]

Semiprofessions act in the service of the professions. The fact that it is women "serving" men is of crucial importance to understanding why <u>women</u> work in these areas and why male professionals have accepted large-scale female employment in these areas. According to Etzioni (1969), if men occupied the semiprofessions currently occupied by women, many of the relations between professionals and semiprofessionals would certainly not be possible. As he says:

> It is difficult to believe that many of the arrangements we found in the relations between doctors and nurses, social workers and their supervisors, teachers and principals, would work out if, let us say, 90 percent of the nurses and of the supervised social workers were male, especially lower middle class, as are so many of the females employed in these positions. [P. viii]

Third, semiprofessionals work in bureaucratic settings where they are held accountable for their performance by administrative superiors. Professionals, on the other hand, are accountable to no higher authority within their field of expertise. * The fact that semiprofessionals work in highly bureaucratized administrative structures makes them eligible for inclusion in the primary labor market. However, the question arises as to whether appropriate career ladders

*Instead, they are said to be governed by an internalized code of behavior, thus not requiring administrative procedures and rules to tell them how to behave. Even within the bureaucratic setting, such as the hospital, doctors are considered to be indispensable and therefore autonomous. Medical peer review systems are said to operate where necessary but usually do not operate in practice for physicians (Freidson 1973). In theory, professionals have more control than semiprofessionals, even though in practice this is hardly absolute or as great as it sometimes appears on the surface.

really exist for semiprofessionals to be able to reach positions of au-
thority and control in the field. While this area has been inadequately
investigated, scattered evidence suggests that only short or limited
career ladders exist. As one author suggests, bureaucracies in the
semiprofessions may be only rudimentary in nature (Bidwell 1965).
On this basis, semiprofessionals may actually fit some of the require-
ments of secondary labor markets—especially for women.

First, many of the jobs in the nursing industry are not connected
to the existing nursing career ladders. Moreover, nursing itself is
not appropriate training for the high-level medical positions that are
the basis of power and decision making in the health care system.
Thus, the nursing career ladder that does exist is "caught in the mid-
dle" and often goes nowhere.

Next are issues that emerge once one is in the semiprofessional
career ladder. The higher up the career hierarchy one goes in the
semiprofessions, the more administrative the jobs become. Thus,
people are rewarded more for their administrative tasks than for their
major work tasks, which do not provide the necessary training to be
administrators (Etzioni 1969). Just the opposite is true for profes-
sionals: it is performance of their main tasks and not organizational
position that brings the highest rewards (Montagna 1977). In a sense,
one could say that it is recognized professionals who become eligible
to be elite administrators, but the in semiprofessions, administration
is what gives one the recognition.

The question of whether administrators are typically recruited
from the ranks of the semiprofessionals or are specifically trained
as administrators in the semiprofessions has not been adequately in-
vestigated. According to one set of authors (Grimm and Stern 1974),
men are more likely to be recruited into administration in the semi-
professions and generally at a faster rate than women. However,
men are beginning to increase in numbers in the semiprofessions,
too. In part this is the result of active recruitment of men in an at-
tempt to "professionalize" the semiprofessions (Gross 1971; Wilensky
1964). However, continue Grimm and Stern (1974):

> Further research is necessary on the manner in which
> people enter administrative sectors of these fields. Are
> men promoted from "the inside" at the expense of equally
> qualified women? Are male "outsiders" with little or no
> formal training or experience in the "female" semi-pro-
> fessions enticed to become administrators[*]? A signifi-

*In the early 1970s, male police officers were actively recruited
to become nursing administrators when they finished their police ser-

cant contribution to our understanding of why men do
dominate the higher echelons of the semi-professions
will come when systematic empirical studies are con-
ducted to determine how available administrative posi-
tions in these fields are filled. [P. 703, emphasis added]

If men are actively or subtly recruited for administrative posts,
do the types of mobility chains as specified by Piore (1974, 1975),
exist for women in the predominantly female semiprofessions? Or
are there relatively short mobility chains, which really do not allow
for the kind of career movement that is a distinguishing characteristic
of primary markets?

While evidence is limited, what does exist tends to support the
idea of differential recruitment into teaching and administration by
sex. For example, Gross and Trask found that 34 percent of their
male principals never taught in an elementary school, while this ap-
plied to only 3 percent of the women (as reported in Howard 1975, p.
10). Moreover, men who are schoolteachers advance faster and with
less experience than women in elementary school administration
"simply because they are men" (Howard 1975).

In fact, Dreeban (1970) suggests that while the literature por-
trays the image that a career ladder exists in elementary education,
in reality it does not. Teaching is a completely different job than ad-
ministration; and administrators are recruited on the basis of differ-
ent criteria. Essentially, women are blocked as semiprofessionals,
trapped in dead-end jobs. [7]

In teaching the only vertical mobility available to most teachers
is in the form of a limited number of principalships and superinten-
dent posts. They are almost exclusively male (Howard 1975). This
fosters a great deal of dissatisfaction and high turnover. This is the
fourth feature of women's semiprofessional activity that is essentially
secondary in nature.

High turnover rates exhibited by women generally are said to be
characteristic of women semiprofessionals, too (Etzioni 1969). This

vice and were training for "second" careers. Advertisements to re-
cruit these officers were often geared toward promising them admin-
istrative positions in a field trying to become higher in status and pay
—both requirements of which are encouraged by recruiting male ad-
ministrators. In the Grimm and Stern data, although very few men
are in nursing, about 2 percent, half of all male nurses, are admin-
istrators. For an opposing position, which says that administrators
in the semiprofessions are recruited from within the appropriate
ranks, see Etzioni (1969, introduction).

high turnover must be understood as a function of several phenomena, not the least of which is the dead-end nature of the job women work in as well as the total responsibility for child care that is assumed by women. Thus, for example, the nature of the job for women in teaching is often instrumental in fostering dissatisfaction with their work. The routine jobs in teaching provide little recognition or rewards for competence, excessive work loads, and punitive and close supervision. It is the nature of this work that drives many women out of these jobs. Thus, Cohen (1975) suggests:

> For women who have no wish to leave the classroom, but who are professionally oriented, there is a lack of reward and reinforcement for merit. There are many women in this sample who could be described as "ambitious" in an absolute sense, by our attitude indices; they are highly dissatisfied with teaching. The structure of elementary school teaching may well drive some of these women out of the profession. [Pp. 242-43]

Different studies in teacher turnover rates range from about 11 percent to 17 percent for school systems, with higher turnovers within individual schools. However, turnover rates are about the same for men and women in teaching—but for different reasons: men leave the school to change jobs or leave teaching for administrative posts; women to find more comfortable or safer teaching positions (Becker 1952) or to stop work (Simpson and Simpson 1969). Annual personnel losses in libraries and social work agencies are as high or higher in comparison with losses in schools (Simpson and Simpson 1969). The same similarity in turnover rates for men and women exists here, too, with men again leaving for professional advancement and women for family reasons. [8]

Moreover, an unpublished study conducted by Applebaum and Koppel (1976) shows quite conclusively that the fact that women get lower wages than men is not based on their lack of commitment to the labor market. In their analysis of the Parnes data, Applebaum and Koppel found that more committed women (that is, those more committed to remaining in the labor market) have lower initial wages than so-called uncommitted women; that committed women earn less money than uncommitted women in their early careers as well as less money than men with similar background skills; and that although committed women increase their incomes in comparison with uncommitted women over time, their wages never reach that of men with comparable skill and experience. In short, the issue of labor market commitment does not determine wages. Sex discrimination still exists with committed women in comparison with men.

Also, with respect to teachers, V. K. Oppenheimer (1970) finds that male teachers are not much more committed to teaching than female teachers. In fact, she says, one could argue that women's commitment is greater than men's to the teaching profession.

Further, the idea that women's attitudes limit their performance and/or rewards in the market is addressed by Kanter (1975a). Her comparison of male and female administrators in a large business enterprise showed that people in less favorable positions in the administrative power structure both felt and acted like the stereotypical "female boss." Thus, instead of concluding that sex role attitudes and behaviors limit women's possibilities in promotions and careers, she suggests that sex role attitudes and behavior may be a function of disadvantaged placement in the job itself. Men disadvantageously placed are found to be as likely to have the same attitudes and behaviors as women disadvantageously placed: limited aspirations, low work commitment, dream of escape, and so on. Thus, it is location in the job structure, not sex, that determines job commitment and other worker attitudes and behaviors.

In short, the notion that women are irregular workers with little career commitment and deserving of lesser responsibilities and rewards than men appears to be highly exaggerated at best. Although women move in and out of the labor force more than men, it is not true that on the average women leave their jobs any more often than men do. The returns on company or agency investment in a worker are not necessarily greater for men than for women. [9]

While it is true that men and women classified as "professional" by the U.S. Bureau of the Census stay on at a particular job or in a particular institution longer than lower-status workers (Montagna 1977; V. Oppenheimer 1970), it is also true that the reason for turnover is always more acceptable for men than for women. The reality, though, is that their behavior is not very different. Thus, despite the similarity in relatively high turnover rates for men and women in the semiprofessions, it is the imputed motivation for job change that is seen as more acceptable for men than for women in these fields. [10] The issue of job stability is much more complicated than most discussions seem to indicate.

According to Coser and Rokoff (1971), the idea that semiprofessions must adjust to women's high turnover by making jobs easily replaceable and without a high degree of responsibility stems from the fact that it is women who are in these jobs:[11]

The difference between occupations in which women are well represented and those in which their participation is conspicuously rare seems to be that irrespective of . . . requirements of schedule, women are in occupations

in which each individual worker is "replaceable or defined as replaceable," and are not in occupations that are seen as demanding full commitment allegedly based on individual judgment and decision making.

What is important here is not so much the technical nature of the task as the sociological fact of normative requirements. High-status positions are said to require the commitments necessary for exercising individual judgment. In these positions, people allegedly control their own work; they are said to be in charge of defining its nature so that hardly anyone can do it for them. . . . It is not that women are not expected to work; it is only that they are not expected to be committed to their work through their individual control over it; if they did, they would tend to subvert the cultural mandate, thereby allegedly causing disruption in the family system, and would risk disrupting the occupational systems as well. [P. 544, emphasis added]

The fact that women are seen as easily replaceable where men are not is institutionalized in the public schools with "substitute" teachers and in the hospitals with "floater" nurses. On the face of it, a grade-school teacher is as much in control of her/his class as a college teacher and, therefore, should be as "irreplaceable" as the latter. However, when a teacher is absent from grade school, "her" class is taken over by a "sub"; when the college instructor is absent, "he" can select someone to fill in for him or "his" class is canceled, since it is believed that no one can fill in for him. (Other issues are obviously involved, such as babysitting functions of elementary school, which are not needed in college.) Thus, women as teachers in elementary school are easily replaceable; men, as college teachers, are not (Coser and Rokoff 1971).

The irreplaceability of the male physician is seen in turn in the medical establishment. As far as the work on a hospital service is concerned, interns and residents could replace one another because they usually know one another's patients and have the necessary training and skills. However, the house staff is supposed to learn the importance of individual responsibility for control over individual patients during training. Thus, absences due to anything other than serious illness or death in the immediate family would not be tolerated. The young intern or resident is not considered replaceable. The nurse who "floats" from one floor to another in the hospital, though, is a regular substitute for any nurses or any service that happens to need a substitute for the day (Coser and Rokoff 1971).

In short, predominantly female semiprofessions are bureaucratized and supposedly organized along clear and rational principles,

carried out in an organized and noncapricious manner. These jobs are stratified by rank, supposedly indicating a long career ladder to be climbed by those who perform their jobs well and encouraging job stability. These types of features should qualify the semiprofessions for inclusion in the primary sector of the labor market.* However, there are numerous features of the semiprofessions that lead the author to question whether highly educated women do in fact fall into the primary sector of employment. This statement is not meant to imply that the issue is resolved—only that the issue is much more complicated than advocating that women semiprofessionals be included in either the primary or secondary sector of the labor market without further clarification and analysis.

On the basis of the following characteristics of the semiprofessions, usually reserved for the college-educated female, one can argue that these jobs fulfill some of the criteria of jobs in the secondary labor market. They are relatively low income (especially in comparison with their educational input); they are lower status in their respective institutions (nurses as opposed to doctors; teachers as opposed to principals and superintendents); they sometimes exist in "rudimentary" bureaucracies; and they have high turnover rates as well as short or limited mobility chains. And it is questionable whether recruitment into the higher-level administrative positions is not somehow separated off from achievement in the job performance of a semiprofessional. Moreover, they are usually nonunionized and not well organized to protect their members.

CRITICISMS OF DUAL LABOR MARKET THEORY

At this point it is important to briefly clarify what this theoretical approach does <u>not</u> do. First, although dual labor market theory acts as a critique of the idea of equality existing between men and women in jobs and wages, the discussion remains basically descriptive. It does not explain how labor markets came to be structured in the first place to segregate women from men. Instead, it simply assumes that this happens and describes the existing structure.

Second, although dual labor market theory often recognizes that it operates within the context of an advanced capitalist society, this theory neither explains how capital continually benefits from these arrangements nor does it necessarily question the legitimacy of the existing social arrangements. Furthermore, like status attainment

*The issue that many semiprofessionals are employed by the government (thus providing greater stability and tenure) and not by private profit-making companies has not been dealt with here. This is clearly an important issue. It is only in the monopoly capital theory (Chapter 3) that certain aspects of this issue become clarified.

theory, dual labor market theory focuses only on those who work in the labor market per se. This approach provides no direct connection to those who "pay the workers" (that is, the capitalist class in Marxist terms). In short, this approach is severely limited on the basis that the totality of forces affecting one's relations in the market is not clearly understood, creating inadequate frameworks by which to interpret women's activity in the labor force. Moreover, like status attainment theory, it fails to deal with the issues of property ownership and power (or lack thereof) for the workers themselves.

Third, the tendency to polarize workers into primary and secondary categories in the dual labor market approach is often too rigid. For example, the difficulties in explaining the experiences of highly educated women in the labor market still require greater clarification. A better understanding of the processes of class and stratification in the labor market is needed to deal with women's experiences there, rather than the descriptive and sometimes oversimplified dichotomization of primary and secondary markets.

Fourth, the distinction between primary and secondary markets helps to clarify some of the ideological components of such classification systems as white-collar and blue-collar jobs. Clearly, the fact that women are in white-collar jobs, which are secondary and therefore more disadvantaged in nature, is important in challenging those researchers who claim that women are benefiting from being able to work in more prestigious white-collar, as opposed to blue-collar, work. On the other hand, one must question the meaning of combining high-level professional jobs (such as physicians, lawyers, and accountants) with factory workers in stable jobs, as is done in the primary sector. Is this not a blurring of lines between traditional working-class and other relatively more elite and privileged sectors of the society? Does this not have ideological components to its analysis also? How does such blurring of distinctions between certain occupational groups differ for men and women? Moreover, how does the increase in government or state sector jobs help us to understand women's increased employment in secondary labor markets? As was suggested earlier, this connection is not worked out by dual labor market theory.

Fifth, like status attainment theory, dual labor market theory may be criticized for failing to integrate women's roles in the home with their labor market participation in general. This is at least in part a function of the fact that this theory comes out of economic theory, which focuses on "economic institutions" as if they could be studied separately from other institutions in society.

On the other hand, dual labor market theorists do sometimes mention different subcultural environments where varying worker traits are encouraged in response to segmented labor market demands (for example, Piore 1974). But little more than gross generalizations

or "ideal-type" pictures of lower-class, working-class, and middle-class family and community life are offered as explanations for segmented worker behavior. Thus, as two critics of this theory suggest, labor market divisions become "anchored in" (Piore's words) differences in "individual characteristics, although the characteristics are themselves rooted in class 'subcultures.' What is itself an outcome of the production process (class 'subcultures') is used to explain labor market activity" (Steinberg and Beneria 1978, p. 4).

Although this theory is being developed by economists primarily, it has been suggested throughout this chapter that it is akin to some of the literature in sociology focusing on sex stratification and sex-typing of occupations. In this branch of sociology, recognition is given to needed changes in women's roles at home as well as in the segmented labor market (for example, Ericksen 1977; Hunt and Hunt 1977; Kanter 1977b; Pleck 1977; Theodore 1971; Vanek 1977; Weill 1971). But this understanding is generally quite unconnected to the larger political economy.

Discussion often revolves around the "equalization" of men's and women's roles in the family and in the labor force—especially for professional women. (It is probably in part due to the fact that women's occupational activity is not connected to the political economy that occupational sex stratification literature in sociology does not deal effectively with, and most often stays away from, analyzing the dual roles of poorer as well as nonprofessional women.) But there is little understanding of its organization in relation to the systems of capital and male domination. It underestimates the difficulty of changing the system itself and, thereby, the possibility of equalizing many of men's and women's tasks and rewards in both the family and the labor market.

These major weaknesses notwithstanding, this theoretical framework does provide an important critique of human capital theory and a set of concepts for understanding one aspect of women's lives: their secondary status and rewards in the labor market in comparison with men within an advanced capitalist society.

To the degree that this theory fails to understand women's dual roles as homemaker and employee, and the relationship of both to the system of production, dual labor market theory is only a partial explanation of women's market activity. It is to radical theory that the discussion now turns in order to understand those larger connections that are preeminent in explaining women's home and market activity in a male-dominated and monopoly capitalist society.

NOTES

1. Montagna (1977) uses this approach to the labor market in general, while he and other feminist sociologists use it implicitly or explicitly with regard to women. Included here are works by V. K.

Oppenheimer (1970, 1973a), Kanter (1975a, 1977a), Almquist (1977a, 1977b), Grimm and Stern (1974), Hudis, Miller, and Snyder (1978), Snyder, Hayward, and Hudis (1978), Sexton (1977), and Bibb (n.d.). One might label these sociological uses of dual labor market theory. It is very much akin to those sociologists who, slightly earlier, focused on the socially structured institutional constraints to explain women's disadvantaged market position (for example, Bernard 1971; Epstein 1971; Gross 1971; Knudsen 1969; Theodore 1971). What was important to them was that the way in which occupations were structured to rank women's jobs lower than men's was seen as a "constitutive" relationship of the system of occupational stratification. It is this approach that is here referred to as the occupational sex segregation theory in sociology.

2. See Blaxall and Reagan (1976). This entire issue of Signs was devoted to "Women and the Workplace: The Implications of Occupational Segregation." It is based on a Conference on Occupational Segregation held May 21-23, 1976. See especially the section in "Economic Dimensions of Occupational Segregation." An excellent summary of dual labor market theory as it affects women is given by two economists, Blau and Jusenius, in this issue. Also see articles by Oaxaca (1973), Stevenson (1975), F. Blau (1975), and Lloyd (1975). Further, see the fine review by two British sociologists, Barron and Norris (1976), with particular reference to women in Great Britain, which did not come to the author's attention until this analysis was completed.

3. V. K. Oppenheimer (1970) expands the idea of duality to that of multiplicity of the labor market. She also talks about a variety of female labor markets based on skill and education/social status (p. 121).

4. The best single source of data is V. K. Oppenheimer (1970). Also see Gross (1971), Williams (1975), Theodore (1971), Knudsen (1969), Bernard (1971), Pinchbeck (1969), Waldman (1970), Stevenson (1975), and Howe (1977). Several radical analyses include Deckard (1975), Glazer (Malbin) and Waehrer (1973), Kessler-Harris (1975), Szymanski (1976), Dubnoff (1979), and Kolko (1978).

5. See Aronowitz (1974) for an alternative approach to interpreting recent developments in the garment industry.

6. In 1970, 80 percent of all college-educated women worked in professional jobs, mostly as schoolteachers (V. K. Oppenheimer 1973a). This is equally true for black and white women (Teresa Sullivan, as referred in Almquist 1977b; also see Kilson 1977; Project on the Status and Education of Women 1974).

7. Poll (1978) investigated mechanisms by which men and women in New York City public schools earn administrative positions. Her evidence indicates women are discouraged from taking the first step, which is necessary to enter into the administrative hierarchies. Thus,

career ladders for women elementary schoolteachers in New York
City are quite attenuated and separated from the decision-making po-
sitions. Men, on the other hand, are recruited in a different way into
the administrative hierarchies. This is supported by Howard (1975)
in her analysis of public schoolteachers. As she says:

> Climbing the career ladder in education means getting out
> of the classroom. Teachers who wish to advance in educa-
> tion must leave teaching and move into administration.
> Out of class assignments (e.g., assistant to an administra-
> tor, grade advisor, hall patrol) often give a teacher status,
> a title, and a much lighter teaching load. Most of these
> positions are held by men and are the first step in getting
> jobs with real power and authority (41:1-3). Despite the
> fact that women far outnumber men in the teaching pro-
> fession, few advance into administrative positions and
> their number has been steadily declining. [P. 5]

Further light will be shed on this process as we study women's career
paths within firms and factories. Hartmann and Remy have been in-
volved in a long-term study of career mobility in industrial organiza-
tions for the Department of Human Rights, Civil Rights Commission,
Washington, D. C.

8. Turnover is highest among the youngest men and women—
the women beginning families, the men beginning career mobility.
It is even suggested that many men may leave for better jobs that have
been vacated by women interrupting their careers (Simpson and Simp-
son 1969). Furthermore, the idea that men "interrupt" their careers
is hardly confined to the white-collar professional. Thus, Kanter
(1975a) reports on thsoe studies that show that blue-collar men leave
organizations to start small businesses and then return when (as is
statistically likely) the business fails (p. 8).

9. See V. Oppenheimer (1970, pp. 111, 114) for a discussion
of the difference in job leaving, which involves moving from one com-
pany to the next, versus job changing (including advancement) within
a particular company.

10. This even applies to high-status male professions. In the
American Council on Education study (1968-72) of college faculty,
men were more likely to take more than one year off from teaching
than women for "personal" reasons: family and military. Whereas
this applied to 25 percent of the men, it included only 20 percent of
the women (Maeroff 1973).

11. Also see Barron and Norris (1976) who emphasize dispos-
ability as well as replaceability.

3
MARXIST THEORIES OF
THE LABOR MARKET:
MARX AND MONOPOLY
CAPITAL THEORISTS

INTRODUCTION

Both status attainment and dual labor market theories derive
from mainstream sociology. One stresses the equality of women
in the labor market, while the other focuses on women's systemati-
cally disadvantaged position in a sex-segmented labor market. This
is the first of three chapters that look to a radical analysis to under-
stand women's position in U.S. society. All groups within this radi-
cal framework understand that the social arrangements in our society
severely disadvantage women in the labor market. This chapter shows
how Marx and one group of contemporary followers of his—twentieth
century theorists of monopoly capital—understand women's disadvan-
taged position in modern capitalist society.

To understand both occupational stratification and sex stratifi-
cation, a necessary first step is to ground these issues in the histori-
cal development of modern capitalism itself. To look only at the in-
terconnected systems of occupational and sex stratification in the
labor market—whether defined as just or unjust—is to look at the sur-
face manifestations of underlying processes in the production and re-
production of society. One goal of a radical social science is to ana-
lyze the factors that underlie phenomena experienced and observed in
the market.

As one analyst of the radical method suggests:

Sex differentiation and sex stratification as levels of analy-
sis deal with only the level of "visible" or "conscious" re-
lationships: i.e., relations of which men and women are
aware in terms of specific activities and "sexual bargain-
ing," or power confrontations with other individuals within
and outside the family.

From a Marxist perspective, the key to understanding
these processes of structural and functional differentiation,
and their specific effects on the position of women through
sex differentiation and stratification, is to be found in levels
of social reality which are not readily available to con-
sciousness but which can only be discovered through sci-
entific analysis. According to Marx, ". . . all science
would be superfluous if the outward appearance and the
essence of things directly coincided." This key princi-
ple of Marxism has been reformulated as follows:
". . . a structure is part of social reality but not of
visible relationships." [Gimenez 1975, pp. 63-64]

Thus, while mainstream social science systematizes and ex-
plains the experiences of sexism in terms of general social processes,
innate sex differences, or their mutual interaction, Marxists argue
that both "common sense" and mainstream social science understand-
ing take for granted precisely that which has to be explained: capital-
ism and its associated form of sexism.

In this chapter, first to be discussed will be the general con-
tributions of radical theory to the study of women's life experiences
—particularly their labor market and home activities, as well as their
specific occupations in the market. Basic assumptions made by Marx
himself, and elaborated on by certain groups of present-day Marxist
theorists, provide a context and totality in which to understand women's
position in contemporary U.S. society.

Second, to understand women's disadvantaged labor market con-
ditions specifically, one must look to three different building blocks
for a theory that can adequately explain women's work in contemporary
U.S. society. These are:

1. Marx—the classical writings of Karl Marx, most especially
the labor theory of value;

2. Monopoly capitalism—large-scale theoretical works that
have developed in the mid-twentieth century to help explain the sys-
tem of advanced monopoly capitalism; and

3. Marxist feminism—recent writings of feminists within radi-
cal theory, particularly the intimate relationship between patriarchy
and capitalism as they influence women's lives.

This chapter will deal specifically with Marx and mid-twentieth
century monopoly capital theorists and how they help to explain what
has happened to women in the labor market in the twentieth century
United States.

In the next two chapters, Marxism will be looked at in the home
as well as how the relationship between home and market in monopoly

capitalist and male-dominated society influences women's disadvantaged position in the labor market.

CONTRIBUTION OF MARX'S GENERAL ASSUMPTIONS

Radical theory is of course associated with Karl Marx. Marx's underlying assumptions about capitalist society are essential for explaining the disadvantaged position of women in U.S. society. However, the women's movement must be credited with the recent efforts by Marxist Feminists to develop "the woman question" beyond its earlier generalizations and potential.

Marx's contributions to a theory of women in the labor market include the following. First, he provides a much needed context and totality to the analysis of women's position in U.S. society that is missing from the other two theories already mentioned. Second, he stresses the importance of a materialist methodology that is both historical and dialectical to examine contemporary relations among groups of people in capitalist society. It should be understood that Marx himself does not focus his attention on "the woman question" and does not direct himself to an intricate analysis of women's labor market activity. However, an application of insights from Marxist methodology to an understanding of women in contemporary U.S. society creates the conditions for moving to a new level of analysis not available in Marx's time.

Marx was specifically interested in explaining how class inequality arises and changes in a historically evolving capitalist system. With regard to his methodology, one can say that Marx's theory of class is more an analytical tool than a description of existing stratificational arrangements, although he certainly did deal with empirical descriptions of class stratification in several places.[1]

Grounding women's position in the historical material relations of production in society forces one to go beyond the allegedly unbiased theorizing of mainstream social science.[2] Moreover, understanding the dynamics of class conflict in capitalist society leads to an analysis of power relations as well as to the potential for (revolutionary) change. While Marx applied his theory to class relations, it is now being used, with certain modifications, to understand the development of relations between the sexes in a class society.

The dialectical method stresses the movement that comes out of contradiction. According to Marx, the moving force of capitalist society is class conflict. Class conflict emerges out of the fundamental contradiction between wage labor and capitalist appropriation of profits—profits that are generated by the wage laborers themselves in production organized in the social arena but that becomes the "pri-

vate property" of the capitalist class. Therefore, the essence of class conflict is the struggle between capitalists and wage laborers over the expropriation of surplus value. However, at the same time that the capitalist class amasses wealth, it produces "the seeds of its own destruction"—that is, the working class. This is a most potent example of the meaning of dialectical theory: an approach to problems that visualizes the world as an interconnected totality undergoing a variety of changes due to internal conflicts of opposing forces with opposing interests.

Another important example of dialectical thinking is the relationship between "existence" and "essence." As one writer says, "What is crucial for the application of Marx to the 'woman question' is this way of thinking which does not limit people's capacities to what society may form them to be" (Eisenstein 1977, p. 4). That is, while workers may be cut off from their creative abilities in a capitalist society, they are still creative beings in terms of their potential:

> What you can be is not necessarily what you are. . . . This contradiction of existence and essence lies, therefore, at the base of the revolutionary proletariat, as well as the revolutionary woman. One's class position defines consciousness for Marx, but, if we utilize the revolutionary ontological method, it need not be limited to this. [P. 5]

Within this framework, the following strengths of Marxist theory provide the context and totality needed for the author's topic. First, Marx's classical theory stresses that the mode of production is the basic organization of society within which the various social relations of society operate. (The mode of production refers to how a society's production is realized and organized. The two broad principal components of the mode of production are the social relations of production and the forces of production.) This has a double consequence in the analysis of women's market position within the context of capitalism.

Anyone who does not own the means of production and works for those who do can be said to be included in the capitalist labor force. It follows that women's as well as men's occupational behavior can be explained by this theory. Moreover, the occupational stratification that emerges within the context of a capitalist society does not cause women's inequality but rather is a reflection of its operations. Thus, while Marxist theory would understand the occupational stratification within the context of a class analysis, its major focus would be on the relationship to the means of production that the members of the occupational groups have and the contradictions inherent in such a system. Occupational stratification must first be anchored in the political econ-

omy. The Marxist method changes one's focus from asking questions about occupational mobility within existing structures to asking how occupational stratification is connected to the political economy in the first place.

The fact that the various social relations of a society are influenced by the mode of production also explains the need to look not only at the labor market but also at the family for understanding women's market position. Both the family and the labor market are determined by the mode of production. (These ideas were developed by both Marx and Engels.) Thus, while patriarchy—a system of male dominance—probably existed before capitalism,[3] it is nevertheless true that the type of family and women's position in it—the isolated form of the patriarchal, monogamous nuclear family, where mothering is a full-time responsibility for women—are associated with certain stages in the capitalist mode of production in society.

The second crucial contribution of Marx's theory to women's labor suggests the absolute necessity to integrate into a totality the relationships between seemingly different parts of a society—primarily the institutions of the family and the occupational systems in our case. Thus, it is impossible to understand the working of the labor market itself and women's occupational position without looking at their relationship to the family within the system of capitalism. What this means, at the very least, is that asking questions about women's position in the labor market, without likewise asking questions about women's home activities as both of these are constructed by capitalist social relations, will only lead to a distorted view of women in the labor market.

Marx's focus is on the social order as a whole rather than on its separate parts particularly. He tries to explain the broader picture of how capitalist societies work and where they are going. In so doing he adopts the Hegelian idea: "The truth is the whole."

Too often critics, as well as some followers, misunderstand Marx to say that the economic relations of society are its only determining force. On the contrary, Marx was not an "economic determinist" as so narrowly conceived by those who do not understand his concepts as well as his goals—to analyze as well as to change. Marx was not only interested in quantitative exchange ratios but also in the social relations that underlie and are masked by market phenomena. Understanding the mode of production is crucial to understanding the seemingly segregated institutions in any society.

Thus, for example, Marx's larger conception of economy, as specified in the preface to A Contribution to the Critique of Political Economy (1904), defines the "economic structure" as the "real foundation of society." In so doing, he wrote that the economic structure was the "total ensemble of social relations entered into in the social

production of existence." Thus, it has been argued that in the broadest Marxist sense, this conception of the economic structure includes sex, reproduction, and the family, just like food and shelter, since they are all forms of material necessity or part of the "total ensemble of social relations entered into in the social production of existence" (see Zaretsky 1976, pp. 25-26).

A third and final contribution of Marx to an understanding of women in the labor market is that radical theory is a theory about people as social and creative beings rather than a more simplified notion of people as role players. Marx asserts that the elements of reality are determined in relations with each other. As in grammar where the influence of words in a sentence is reciprocal—each helps determine the meanings of the others, while it is itself determined by those others—so in social relations, the influence of individuals and society are reciprocal. Thus, Marx emphasizes the relational aspects of society and human potential.

The first premise of society in this framework is that people produce their means of existence. Neither history nor society is an abstraction apart from people—both are products of human actions. For Marx, one can understand the individual only in a social context, arguing that human needs appear only in relation to a product and the way that product was produced. Human needs in general are generated by the products of others:

> Production not only supplies the want with a material, but
> supplies the material with a want. . . . The object of art,
> as well as any other product, creates an artistic public,
> appreciative of beauty. Production thus produces not only
> an object for the subject, but also a subject for the object.
> [Marx 1973, p. 24; as quoted in Rubinstein 1977, p. 103]

What this means, of course, is that the system of production—social, cultural, as well as economic—is important in determining human needs themselves. Thus, greed or desire for profits is not inherent in human beings but is associated with the capitalist mode of production. The culture and values of the capitalist system of production are not produced sui generis by themselves but in relation to human beings in a class society.

In short, Marx was interested in the total process of social production and the development of creative and social human beings. However, his theory of what the author calls people as social and creative beings in large part really focuses on the laborer in relation to the direct creation of surplus value in the market place. Thus, classical Marxism excludes much of women's labor outside the production of surplus value directly.

A theory of women as social and creative beings was not adequately developed by Marx himself. It has been up to the feminists in the Marxist tradition to develop this aspect of Marxist theory.

MARX'S LABOR THEORY OF VALUE AND WOMEN'S LABOR FORCE PARTICIPATION

How does one apply the Marxist method of analysis to understand women's position in the labor market today? In classical Marxist theory, the labor theory of value and the continually polarizing two-class system of workers (proletariat) and capitalists (bourgeoisie) lead to an interpretation of women as "workers." That is, women who work in the paid labor force are producers of surplus value in a manner similar to men. Marx's categories are, so to speak, sex-blind here.

The main difference is that women are "superexploited" in comparison with men. Women are a cheap source of labor, according to Marx, thereby allowing them to be used in the lowest-paying jobs as well as to act as part of the reserve army of labor.

The starting point in Marx's analysis of society and social relations is the recognition of the centrality of human beings in material production—as the producers of their own material existence. In any system of production there is both (1) a labor process—nature is appropriated by human beings, and there is a production and reproduction of products—and (2) the social conditions of labor—social relations between people are set up in the production process. These relations of production refer to both who controls the product (the appropriation of the surplus) and who controls the immediate process of production itself. As Steinberg and Beneria (1978) suggest:

> In any case, the process of production can only be adequately understood as the unity of these two processes: the production and reproduction of products, resulting in the appropriation of nature, and the production and reproduction of a system of social relations, resulting in the appropriation of surplus labor. [P. 7]

Thus, production is not an eternal category and it cannot be analyzed without reference to social relations. In general, according to Marx, capitalism is a system of production where the private accumulation of capital (for profit by a few) is dependent on the collective (as opposed to privatized) production of waged laborers, which is controlled by the capitalists. This is the underlying essence of class conflict.

What Marx called the labor theory of value is most important in understanding men's and women's labor market activity as carried out in a capitalist society. According to this theory, human labor is ultimately the source of all value.

According to Marx, capitalism had the salutary effect of "freeing" serfs from their feudal lords—that is, workers were free to sell their labor in the market to a capitalist. * However, under these conditions, workers have only their labor power to sell, since they own no private property; they own no means of production—other than their own labor. Once they sell their labor, they increasingly lose control over it, the conditions of their work, and the products they produce.

Being paid a wage, however, does not ensure the worker of being paid a sum commensurate with the total value of what the worker has produced. In fact, Marx points out, the worker is really paid according to the amount of time required to ensure his/her return to the job the next day. In Marx's language, this is equivalent to the worker's necessary labor. In general, workers sell their labor power to the capitalist for which they are paid a wage. The worker's labor is made up of two parts: necessary labor and surplus labor. Surplus labor is the amount of time laborers work beyond the time they need to reproduce themselves. As they are paid only enough to reproduce themselves, the extra is appropriated by the capitalists. Socially necessary labor is an aggregate of all the labor power in society—an average of labor time spent in self-reproduction. Thus, the capitalist pays wages to workers that are equivalent to their necessary labor. The capitalists then use the workers' surplus labor to make profits and maintain control over the labor process itself. This was one of Marx's major contributions: human labor power is the only commodity that is worth more after it is bought than before. According to Marx, though, workers should have full disposal and control of what they have produced together.

Thus, the capitalist pays the laborer wages sufficient to permit the worker to continue to work and live at the prevailing level of subsistence—as a given time and place treats it. Contrary to his critics, Marx (1967a) took cultural and historical phenomena into account in his discussion of wages (p. 171). Not only must the worker be paid enough to keep him/her alive for the next day's work but the wage

*While Marx's analysis has been criticized by feminists in this area, suffice it to say here that capitalism did not "free" all individuals in the same way. It really "freed" primarily male individuals. However, it is important to note that to the degree women enter wage labor, they too become "freed" from precapitalist forms of production in Marx's terms (I will return to this issue in Chapters 4 and 5).

given the worker is supposed to ensure that the worker's family is capable of reproducing and becoming the next generation of workers. [4]

In short, the labor theory of value holds that the only agency capable of creating more value than it represents (that is, surplus value) is labor, or more accurately, human labor power. Labor power refers to just the time needed to perform the labor that under capitalism is bought and sold as a commodity. The capitalist system of production consists of the efforts by the capitalist class to expropriate ever greater quantities of surplus value. This process is in constant flux.

As the mass of surplus value increases, with the help of machinery (past, congealed, or "dead" labor), so does surplus population. Here Marx brings out a basic contradiction in advanced capitalism: the simultaneous increase in productivity brings with it a decrease in the need for human labor power. More and more profits are able to be made while using less and less necessary labor. On the other hand, productive capacity is so great that more and more people must earn a wage so that they can spend it in order to consume the products. Without such ever greater consumerism, the capitalist is unable to realize and raise his profits.

Within this context, women act as a cheap source of labor for an expanding capitalist system. Marxist theory provides two basic explanations for this. First, with the introduction of machinery, Marx asserted, capitalists could use physically weaker segments of the labor force—women and children—in place of men (1967a, p. 396). In addition to women's and children's cheaper labor due to alleged physical weakness, capitalists were eager to employ them because they were more docile and lacked a tradition of craft organization (see Lazonick 1977, p. 114, n. 6).

A second plausible explanation of women's cheaper labor is based on the idea that it is cheaper to reproduce women's daily existence than men's. Thus, women were considered to require lower wages because, for example, they ate less and were expected to have fewer luxuries than men. (This, of course, reflects women's lower social status, not their nutritional or other "natural" requirements.)

To summarize, Marx's labor theory of value refers to women as well as to men when women enter the paid labor force. As waged labor they are exploited directly by capital. In the most general sense, women's market activity is similar to men's because they sell their labor power on the market for a wage; their wages reflect necessary labor—that is, they are supposed to be paid enough to reproduce themselves; the value of their surplus labor also goes into the product; and capital sells the products for full value and realizes profit from the workers' surplus labor. *

*The value of one's labor is based on the cost of production and reproduction of labor power, not the specific products created by one's

Unlike men, however, women act as a cheap source of labor within the context of the theory of surplus value because they are said to be not as strong as men, more docile, and less organized and the reproduction of their labor power costs less. Thus, women are said to be worth less but able to work machines. In these ways, capitalists can make more surplus value from their labor than from men's. Finally, it is important to add that as a cheap supply of labor with little organization, entering the lowest-skill and pay rungs of waged labor, women are an important part of the reserve army of labor. Women's participation as a cheap source and reserve army of labor acts to decrease wages generally as well as to keep all workers "in line," with the fear that others (that is, women) could be substituted to take over their (that is, men's) jobs if they become unruly or too demanding. In short, so long as their labor power creates profits for the capitalist, women's labor market activity is directly explainable by the labor theory of value.

MONOPOLY CAPITALISM'S IMPACT ON WOMEN'S EMPLOYMENT

Marx's own writings have led to a series of critical questions asked by a variety of writers using Marx's method of analysis. Of the numerous kinds of neo-Marxist tendencies that have emerged over the years, two developments of the past dozen years are important for the author's topic. These are monopoly capitalism and Marxist Feminism. While certain themes unite each, neither should be thought of as unified or solidified wholes. Quite the contrary. Rather, each is made up of a new set of debates that are in the process of being created, modified, and understood.

Monopoly capitalism develops from classical Marxist theory and deals with women in the labor force as part of all paid workers.

labor. What is important to the system of capitalism is the social form of labor—that one's labor power is sold to the capitalist who sells the resulting commodity on the commodity market, thereby creating a profit for the capitalist. Therefore, whatever surplus is created, either directly or indirectly (in terms of women working in areas that absorb surplus value) is expropriated by the capitalist class, not the worker herself.

There is much debate about the "productive" or "unproductive" nature of women's work—in the labor market as well as in the home. For reference to these debates, see Braverman (1974), M. Oppenheimer (n.d.), and Fee (1976). I will not deal with these debates, except as they become directly relevant for the analysis.

This perspective stresses the nature of the labor market and the types of jobs created by monopoly capitalism. Within this context one can explain the process of female incorporation into certain sectors of twentieth century wage labor, most particularly the most disadvantaged sectors. Marxist Feminism reflects more specifically feminist concerns. It directs itself more to the relationship between women's nonmarket (home) activity and her market activity, as both are grounded in the historical development of capitalism. The remainder of this chapter deals with monopoly capitalism. (As already noted, the following two chapters will deal with Marxist Feminism.)

The monopoly capitalist tendency focuses on advanced or later capitalism of the mid-twentieth century. In terms of women, this theory extends Marx's analysis that women are workers (waged laborers) in the system of creating and realizing surplus value for the capitalists. Its focus, however, is on the ever more integrated and exclusionary system of production, the greater divisiveness among workers, and the increasing roles of the state and consumerism. Women's unpaid nonmarket (primarily home) labor is usually acknowledged but not analyzed. Certainly its connections to male-dominated and sexist practices and beliefs are not adequately questioned.

Despite these weaknesses, the main contribution of contemporary Marxists' understanding of monopoly capitalism for women's labor resides in the overall context of monopoly capitalism in understanding women's labor and the understanding that the nature of the labor market and the types of jobs that are created by monopoly capitalism recruit women into certain positions that automatically disadvantage them in comparison with men. It is monopoly capitalism that created the secretary, salesperson, financial clerk, and elementary schoolteacher as we know them today. That women are employed in these jobs in a sex-segmented labor market is described by dual labor market theorists (Chapter 2). Why and how the dual labor market arose in the first place and why it is women who are employed in these less powerful, unstable, and lower-paying jobs are explained, at least in part, by the monopoly capital theorists.

Some of the major and best of these works include: Baran and Sweezey (1966), Braverman (1974), Anderson (1974), Aronowitz (1973), O'Connor (1973), Gordon (1972), Edwards, Reich, and Gordon (1975a), J. Hill (1975), Steinberg and Beneria (1978), Freedman (1975), and K. Stone (1974). Of these writers, it is primarily Braverman who discusses how women in particular are used in certain ways in the labor market to ensure increased profits and control for capital. However, in the past several years, a small but growing literature has begun to emerge focusing on the particular experiences of women in the monopoly capitalist market. These include analyses of clerical work (Davies 1974; Glenn and Feldberg 1977; M. Oppenheimer n.d.,

Sandler 1977), telephone company workers (Hacker 1978), department store saleswomen (Benson 1978), women health care workers (C. Brown 1974; Navarro 1975), and domestic service workers (Strasser 1978b), along with more general pieces by Kessler-Harris (1975), Dixon (1977),[5] Glenn and Feldberg (1979), Dubnoff (1979), and Kolko (1978).

It has been accepted by both mainstream[6] and Marxist social scientists for some time that the atomized and competitive model of capitalism prevalent in the nineteenth century no longer exists. The individual owners of capital (be it a family or small group of partners) and the capitalist firm used to be thought of as identical. A substantially different structure has emerged in the era of monopoly capital, with new and different types of workers. Marx anticipated this development in part with the idea of "joint-stock" companies*— a forerunner of what is now called advanced or corporate or monopoly capitalism—in place of family or individual capitalism. Baran and Sweezey (1966) elaborate on this new stage of development in their pioneering Monopoly Capital. Although they do not address the issue of women in their book, Baran and Sweezey were instrumental in clarifying certain basic ideas in the development of monopoly capitalism essential to an understanding of what happens to women in today's labor market.

In the United States, industrialization has been marked by two phases: from about 1820 to 1890 the United States experienced an economy of essentially small competitive units (competitive capitalism). From approximately 1890 to the present has been a period of concentration, as Marx anticipated, to large monopolistic units with national and international effects (monopoly capitalism). During this period, suggest Baran and Sweezey, "big business" dominates the market in the interest of maximizing profits. Small corporations exist but always in the shadow of the giants who organize the relations of production.

In the United States, the top corporations represent less than 0.5 percent of all corporations; yet they control 72 percent of all profits (Anderson 1974). Thus, while a very small number of capitalists control a very large share of the market, they dominate profits, but they do not take them over completely. In fact, the monopoly capital phase continues to regenerate parts of the less profitable secondary

*The nature of corporate capitalism is described as follows: "The producers on a large scale in a particular branch of industry in a particular country unite in a trust, a union for the purpose of regulating production. They determine the total amount to be produced, parcel it out among themselves, and thus enforce the selling price fixed beforehand. The whole of the particular industry is turned into one gigantic joint-stock company; internal competition gives place to the internal monopoly of this one company" (Engels 1975, pp. 143-44).

or competitive industries, without which a large population of under-employed and unemployed workers would seriously threaten the system. For an analysis of this process, see O'Connor (1973).[7]

The long corporate time horizon and rationalization of manage-ment are two features of monopoly capitalism, which, according to Baran and Sweezey, generate much greater security for the corpora-tion. They promote a "live and let live" attitude—but only toward other members of the big business corporate world. What this means is that monopoly capital uses all available methods—organizational and technological—to carefully evaluate their moves, thereby decreas-ing their risks and losses. By controlling prices among the few ma-jor corporations in a field, the giant companies are all able to maxi-mize their profits.[8] Of course, under these conditions, many more decisions about production and sale of commodities are under monop-oly control, too—prices, type, quantity, and quality of products; man-agerial forms of organization over the work process itself; and so on. Further, profits are increasingly higher.

One of the consequences of this type of monopolistic control is the production of tremendous amounts of surplus value, from which profits are expropriated. Thus, it is Baran and Sweezey's (1966) ar-gument "that under monopoly capitalism, owing to the nature of the price and cost policies of the giant corporations, there is a strong and systematic tendency for surplus to rise, both absolutely and as a share of total output" (p. 79). They then become concerned with how that surplus is used or "absorbed" in monopoly capitalism.

Baran and Sweezey point to the development of completely new industries in the twentieth century—like advertising and sales efforts, finance and real estate, as well as the growth of the state—in both its welfare and warfare aspects, in the absorption of surplus value. They argue that much of the surplus was drained off into branches of labor such as these, which were nonproductive in the classical Marxist sense—that is, did not produce surplus value directly but were essen-tial for the realization of profits. (Realization refers to the trans-formation of commodity values into money form. Only in this way are profits possible.) Thus, the production and absorption of ever greater surpluses is an ever spiraling condition in monopoly capital-ism.

Corporate monopoly capitalism, present-day Marxists stress, faces a constant crisis of overproduction. Mechanization decreases the numbers of workers needed in certain parts of the labor force. However, it simultaneously creates demands for workers in new and existing production branches as well as a vast army of unemployed (Marx 1867 [1967a in bibliography], pp. 592-93; as referenced in Braverman 1974, pp. 253-54). Thus, for example, as twentieth cen-tury monopoly capitalism developed in the United States, fewer workers

FIGURE 1

Trends in the U.S. Labor Force Composition

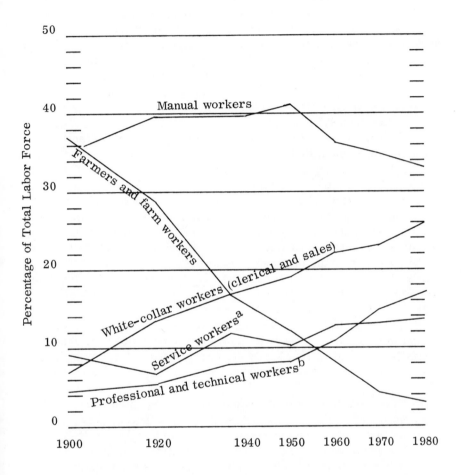

a"Service" workers in this figure only include low-level service workers, such as beauticians, bartenders, waitresses, and nurses' aides.

bIncludes self-employed.

Source: Adapted from Freedman (1975), p. 55.

were needed primarily in the farm* and later in the manufacturing sectors (Figure 1). On the other hand, more and more workers became employed in what is known as the "services": clerical and sales, professional and technical workers, and low-skill "service" or maintenance jobs. However, not only did "newly formed branches of production" materialize (for example, plastics industry) but also, as Baran and Sweezey had suggested, so did new branches of nonproduction—"entire industries and large sectors of existing industries whose only function is the struggle over the allocation of the social surplus among the various sectors of the capitalist class and its dependents." This creates a "new distribution of labor [and] has created a social life vastly different from that of only seventy or eighty years ago" (Braverman 1974, p. 255).

Hence, I want to argue, it is precisely the nature of these new areas of employment that begins to explain the incorporation of women into paid labor during the twentieth century as well as their low wages (as described in part in Chapter 2).

While Baran and Sweezey studied the creation and absorption of value and surplus value in monopoly capitalism, it became the task of others to study the surplus of labor, where it was directed, how it was divided, and the changing nature of the working class itself. Two of the most important and best-known works in these areas are Edwards, Reich, and Gordon's Labor Market Segmentation (1975b)[9] and Braverman's Labor and Monopoly Capital: The Degradation of Work in the Twentieth Century (1974).

Edwards, Reich, and Gordon argue that a redivision or segmentation of labor occurred during the development of U.S. monopoly capitalism, resulting in a highly divided working class. According to these labor market segmentation theorists:

> The central thrust of the new strategies [to "divide and conquer" workers] was to break down the increasingly unified worker interests that grew out of both the proletarianization of work and the concentration of workers in urban areas [in the nineteenth century]. As exhibited in several aspects of these large firms' operations, this

*Farm production dropped from 50 percent of the working population in 1880 to 4 percent in 1970. In nonfarm industries devoted to production of goods, a drop began in the 1920s from its traditional 45 to 50 percent of urban employment to 33 percent in 1970. An example of this is dramatized in a recent article (Reinhold 1977). The steady decline of the farm population is shown as productivity and farmland under cultivation climb higher and higher under modern agribusiness.

effort aimed to divide the labor force into various segments
so that the actual experiences of workers would be different
and the basis of their common opposition to capitalists
would be undermined. [P. xiii]

In this way, the segmentation of labor has had the effect of "forestall-
ing the efforts of U.S. workers to build a unified anticapitalist work-
ing-class movement" (p. xiii). Thus, it is not accidental that a dual
or segmented labor market has developed. Rather, they argue, it is
that capitalism requires a peripheral or secondary market of workers
during its monopoly phase of development to maximize its profits and
maintain control over the labor process and the workers. This divi-
sion of workers is said to have interacted with preexisting differences
by race and sex "to produce persistent objective differences" between
women and men, as well as between blacks and whites, in the market.

Given the huge capital investments made by the monopoly sector
capitalists, argue Edwards, Reich, and Gordon, the stability of mar-
ket demand and long-term planning horizons had to be complemented
by a stable work environment with job structures and internal rela-
tions reflecting that stability. It was in the interest of the monopoly
or primary sector capitalists to have a well-disciplined, homogeneous
labor force. However, since ensuring stability often becomes expen-
sive (like providing employee benefits, on-the-job training, cost-of-
living clauses in contracts, and so on), it is "more efficient for em-
ployers to confine those extra expenses to the narrowest range of jobs
they can." Given that stability is not important for many jobs, in fact
is undesirable, employers "balkanize the labor market, defining dif-
ferent clusters of jobs for which they establish quite different entry
requirements. The entry requirements, in turn, will emphasize or
deemphasize potential stability depending on the job cluster" (Gordon
1972, p. 71). Thus, more marginal firms employ secondary workers
in less stable jobs, where greater risks and less profits are possible
for these businesses. As was seen in Chapter 2, it is precisely in
these kinds of jobs where women have increasingly been employed
over the course of the twentieth century.

In short, the development of the segmented labor market was
very much a function of the "divide and conquer" strategy of the mo-
nopoly sector capitalists against all workers. The stratification and
segmentation of the labor force through this strategy was accomplished
in several different ways: (1) by changing the nature of work relations
within the monopoly firm (for example, by creating highly bureaucratic
and hierarchically controlled "internal labor markets" that exclude
women entirely from the job ladders themselves), (2) by creating some
segments with less stable jobs and some with more and by segmenting
groups even within more stable job sectors (for example, separating

blue-collar workers in the same industry so as to discourage identi-
fication among these workers, as well as to discourage demands for
better working conditions by those with less desirable jobs), and (3)
by balkanizing the external labor market and dividing groups within
it (for example, using blacks, women, and immigrants as strikebreak-
ers or transforming jobs into "female" jobs so as to render them less
susceptible to unionization by men). For an analysis of these process-
es, see Edwards, Reich, and Gordon (1975), Gordon (1972), and Aron-
owitz (1973). In all cases, segmentation of the working class weakens
its potential as a class against capital.

Two additional features of the social relations of monopoly cap-
italism help these theorists to explain the incorporation of women into
wage labor in the twentieth century, as well as their low wages and
limited power. These are, first, the application of scientific man-
agement principles and the "deskilling" of labor power and, second,
the development of new types of jobs, industries, and markets. Bra-
verman (1974) provides an excellent analysis of both of these pro-
cesses as he documents the changing nature of the working class in
monopoly capitalism.

According to Braverman, twentieth century modern U.S. cap-
italism is characterized most specifically by mass production, sci-
entific management, and increasing specialization and subdivision of
tasks in the labor process. He shows how these features of the mo-
nopoly era affected the nature of work itself, while creating a new
type of working class.

Traditionally, mainstream analyses of the division of labor (see
Durkheim 1964) argue that technology had advanced so much that it is
necessary to specialize—if only to deal with the volume and complexity
of knowledge. Braverman, on the other hand, shows that this so-
called specialization in the labor process is simultaneously a "degra-
dation" of labor: a breaking down and simplification of a task in such
a way as to allow the use of less skilled labor in one or more sub-
portions of the task as well as to wrest more and more control out of
the hands of the laborer.[10] This leads to increased production,
cheapening of the cost of labor power, and, thereby, increased prof-
its, as well as increased control by capital and its representatives
(management) over the labor process.

In fact, the assembly line production and the organization of the
large-scale, formal bureaucratic enterprise of the monopoly capital
era at the turn of the century were organized specifically for these
purposes: increased control and profits for capital. Under the rubric
of "scientific management," assembly line production is described as
a process that systematically applies the scientific principles of man-
agement—efficiency, rationality, and specialization—to the running of
large-scale bureaucratic organizations. It began to emerge as a

dominant organizational form between 1890 and 1910, the emerging period of monopoly capitalism.

Frederich W. Taylor, an engineer, was the creator of the idea of scientific management, which is alternatively called "Taylorism" by many in the field. He was one of the first theorists to discuss the importance of taking mental skills away from the worker. He insisted that employers must gain absolute control over the worker's knowledge. "All possible brain work should be removed from the shop and centered in the planning or laying-out department" (Taylor 1911; as referenced in K. Stone 1974, p. 142, n. 75).

In short, Taylor (1911) separated the technical ability to perform a limited task from the cognitive ability to abstract, plan, and logically understand the whole process. The former made the worker a cog in the machine—limited in knowledge and skill, uninformed of the totality of the process, and unable to exert control over it. The latter was the special ability assigned to management. While management became the representative of the capitalist, the only ones knowledgeable about the totality of the production process, foremen became the disciplinarians on the shop floor. Within management, then, the discipline function became divided from the task of directing, planning, and coordinating the work. "This is the basis for today's distinction between 'staff' and 'line' supervision" (K. Stone 1974, p. 151).

The application of the principles of scientific management should be understood as part of the class struggle: Taylor's ideas influenced and supported professional management precisely at a time when unions were gaining strength and employers were waging militant anti-union campaigns (Cochran 1957; as reported in Kanter 1975b, p. 44). This is documented specifically for the steel industry by K. Stone (1974) in her analysis of the deskilling of the steelworkers and the increasing decision-making control and technical knowledge of the professional managerial sector.

Moreover, emphasizes Kanter (1977a), managers sought legitimation of their new roles in the increasing professionalization, which

gave ideological coherence to the control of a relatively small and exclusive group of men over a large group of workers, and that also differentiated the viewpoint of managers from that of owner-entrepreneurs [the earlier capitalists]. The managerial viewpoint stressed rationality and efficiency as the raison d'être for managerial control. Without the power of property to back them, the new managers created and relied instead on a claim of "efficiency," in order to justify the unilateral exercise of power by management. [P. 20]

Thus, organizing the assembly line along Taylor's principles of scientific management does two things at the same time. First, it takes decision-making control out of the hands of the workers themselves and puts it in the hands of management. Second, and most important for capitalism, it also allows the production process to become more efficient—simultaneously replacing the workers with cheaper labor.

Contrary to the idea that specialization increases the skills needed by each worker so that they may be more knowledgeable and in greater control of the production process, Charles Babbage shows that in a society based on the purchase and sale of labor power, dividing the craft actually cheapens its individual parts (as reported in Braverman 1974, p. 80).

The rationalization of labor, the separation between planning and organizing, the separation between conception and execution, and the continual breaking down of the labor process into more simplified parts have helped to create the volume of jobs in industry. However, as some workers are laid off, they may become incorporated into the more simplified jobs in industry. New entrants to the labor market are also employed in these deskilled jobs. Moreover, new forms of labor in other areas emerge, too. In short, workers are increasingly incorporated into more simplified tasks that are cheaper to reproduce in their more broken-down forms[11] and into new labor areas that are not mechanized but, rather, are labor intensive, requiring the numerous workers to compete with each other, further decreasing the wages needed to staff these jobs.[12]

An example of this degradation process is shown for clerical work—as women became employed in the labor market. Not only are women employed in large numbers as the demands of capital change —that is, the need for clerical support services are obvious in the newly created bureaucratic organization of the monopoly era—but also as the need for a large pool of educated and cheap labor is clarified: literate people are needed for clerical and secretarial skills, and cheap labor is needed for degraded tasks.

In fact, the entire nature of clerical work changed with the development of the monopoly capital enterprise. In this regard, both Braverman (1974) and Davies (1974) help us to understand what has happened to a large segment of women workers in the United States.

Clerical work has become one of the largest categories of employment during the twentieth century, but particularly so for women. In 1870 only 0.17 percent of gainfully employed workers were clerical workers according to the U.S. Bureau of the Census; and in 1900 only 3 percent. But by 1970, 18 percent of the employed population were clerical workers. However, when the clerical labor force was small, virtually all the workers were male. In 1870, 97.5 percent of all

clerical workers were men. Today, with almost one-fifth of the labor force working in clerical jobs, almost four-fifths are women (U.S., Department of Labor, Bureau of Labor Statistics 1975). Moreover, the largest single category of employment for women in the United States is clerical work—and comprises one-third of all female employment. Today, this continues to be an expanding occupation for women.

In the nineteenth century, during the period of competitive capitalism, when offices were almost exclusively staffed by men, they were very small and personal. Prior to the Civil War, most offices usually contained two or three clerks in addition to the owner. The small size meant that the relationship between employer and employee was a very personalized one. Moreover, the nature of work in the clerical stratum during this period was likened to a craft. It represented a "total occupation," as Braverman (1974) calls it, "the object of which was to keep current the records of the financial and operating condition of the enterprise, as well as its relations with the external world." Moreover, as he continues, clerical jobs were avenues of mobility and prestige:

> Master craftsmen, such as bookkeepers or chief clerks, maintained control over the process in its totality, and apprentices or journeymen craftsmen—ordinary clerks, copying clerks, office boys—learned their crafts in office apprenticeships, and in the ordinary course of events advanced through the levels by promotion. [P. 299]

However, with the expansion of large corporations beginning in the last decade or so of the nineteenth century, business operations became more complex and were met by a large increase in office size, correspondence, record keeping, and office work in general. Signaled by developments in banks, insurance companies, and public utilities, these changes spread to manufacturing enterprises by the turn of the century. To fill the ever-increasing need for clerical workers, employers turned to the large pool of educated women. To quote Davies (1974):

> Women were originally employed in offices because they were cheaper than the available male labor force. As corporations expanded at the end of the nineteenth century, they were forced to draw on the pool of educated females to meet their rapidly increasing demand for clerical workers. But the expansion of capitalist firms did not entail a simple proliferation of small, "nineteenth century" offices. Instead it meant a greatly-expanded office structure, with

large numbers of people working in a single office. The situation was no longer that of the nineteenth-century office, where some of the clerks were in effect apprenticing managers. The expanded office structure, on the contrary, brought with it a rapid growth of low-level, dead-end jobs.

It was largely women who filled those low-level jobs. By 1920, for instance, women made up over 90 percent of the typists and stenographers in the United States. [P. 20]

The office became stratified: the lower-paid clerical and secretarial functions were increasingly held by women; and the better-paid accountant and semimanagerial jobs (to say nothing of professional managers themselves) were held by men, many of whom had been clerks earlier. Compulsory education made room for women in teaching (so that they came to replace men) but not in the professions. Thus, it simultaneously created a large pool of literate women ready to enter the expanding office work force.

Along with the change in the sex of the clerical worker was a change in the nature of the work itself. No longer were clerical workers the small and privileged stratum of the past. Monopoly capitalism changed all that. Clerical jobs became dead-end, with a high degree of replaceability and virtually no career ladder to prestigious and managerial jobs. Work became routinized, repetitive, and boring, with little independent judgment left to the clerk. Pay was low and the work was degraded: tasks were subdivided and simplified, the labor process was cheapened, and clerical workers had little or no control over their work.

The cheapening of labor power can be seen in the difference in pay given to clerical workers at the beginning of the century and today. In 1899 the average clerical pay was double that of production and transportation workers' average pay. By 1971 the median weekly wage for full-time clerical workers was lower than that in every type of blue-collar work (Braverman 1974, p. 297).

This same process of the lowering of the wage for the second major area of occupational growth in twentieth century monopoly capitalism can be seen in the wage rates of service workers today. The service sector has become typically female work (see Chapter 2). Mainstream social scientists frequently applaud the growing importance of service industries in Western industrialized societies as a sign of their progress.

In fact, if all occupations considered to be services are included, approximately 60 percent of the employed labor force today can be said to work in the service sector. According to Fuchs (1968), a major

mainstream economist, these jobs include wholesale trade; retail trade; finance and insurance; real estate; housing and institutional employment; professional, personal, business, and repair services; and general government including the armed forces (as reported in Braverman 1974, p. 394). This is in contrast to the industry sector —including mining, construction, manufacturing, transportation, communications and public utilities, and government enterprises— and the agriculture sector, both of which have been stagnating or declining. The service sector, in contrast (as defined by Fuchs), grew from approximately 40 percent of total employment in 1929 to over 55 percent in 1967. (For more recent figures, see Montagna [1977] and Chapter 2.)

However, Fuchs's most striking finding is the growing gap between the pay levels in the industry sector and those in the service sector. As Braverman (1974) reports:

> With remarkable consistency, the average rates of pay in the Service sector each year slipped further behind the average rates of pay in the Industry sector, so that by 1959 Industry rates were on the average 17 percent higher, and thereafter the gap continues to widen. [P. 395]

The cheapening of labor power in the service sector in comparison with the other sectors of the economy is clearly evident. As one analyst suggests:

> The growth of the services sector . . . with its apparently insatiable demand for lower-level office skills, by now sex stereotyped, explains the large number of women office workers—together, of course, with their availability through public education. [M. Oppenheimer n.d., p. 5]

A further investigation of these data by Braverman (1974) shows that about half of the gap is explained by "the well known fact that blacks, women and young workers, etc. receive less pay" (p. 395). However, Braverman continues:

> This proves to be only part of the explanation: the differing compositions of the two sectors of employment "explain" only about one-half the great and growing spread in pay. This means that while the Service sector contains a disproportionate share of those who, throughout the whole economy, get lower pay, and this pulls down the average for the sector, at the same time all kinds of workers in the Service sector, no matter what their age, color, or sex, receive on the average lower rates of pay. [P. 395]

The increase in service work, and thus of low-wage industries and occupations, is part of the service economy. Even increases in levels of educational attainment in a monopoly capital service economy do not provide adequate protection from low wages. Thus, in an analysis of college-educated workers between 1950 and 1975, more recent entrants to the labor force have obtained lower-paying entry jobs and are experiencing more difficulty moving up the job ladder than earlier college-educated employees (Jaffe and Froomkin 1978). This is true for college graduates as well as those who have attended college but did not graduate. Moreover, Jaffe and Froomkin found this applied to both men and women, with women being more severely affected.

Finally, as Montagna (1977) argued in Chapter 2, an increase in a service-oriented society is an increase in secondary, not primary, types of jobs. Furthermore, it is important to recognize that

> the levels of pay in the low wage industries and occupations are below the subsistence level, that is to say, unlike the scales of the highest paid occupational groups, they do not approach the income required to support a family at the levels of spending necessary in modern society. But because these industries and occupations are also the most rapidly growing ones, an ever larger mass of workers has become dependent upon them as the sole source of support for their families. [Braverman 1974, pp. 395-96]

This is confirmed by a recent analysis of the growth of female employment in the United States between 1940 and 1970. Dubnoff (1979) found that the growth of female employment was "above all an expansion of low wage work, of work which does not pay the social cost of reproducing the next generation of workers" (p. 18). That is, women were recruited into jobs that paid below the minimum necessary wages—below subsistence as defined by government standards. Further, his analysis of national census data showed that women increased employment not only in traditionally female sex-typed occupations (defined as 80 percent female in 1940) but also in mixed-sex occupations (defined as 40 to 80 percent female in 1940). In this regard, Dubnoff found that over one-half the growth in female employment between 1940 and 1970 had been in occupations that were less than 60 percent female in 1940. What this means is that it is necessary to study not only the growth of the female labor force in traditional sex-typed occupations but also the dynamic processes by which sex composition of occupations change. This dynamic process is related to the deskilling of occupations.

Thus, Dubnoff found that women have been increasingly employed in occupations that were low in complexity, low in autonomy, high in

supervision, low in educational and training requirements as measured by the functional nature of the work rather than the educational attainment of the incumbents, and, above all, low paid. In short, increased female employment is due to much more than simply the growth of "women's jobs"—or the stability of occupational segregation and tradition. Rather, suggests Dubnoff, it is more so due to the growth of deskilled, low-wage jobs, lacking authority, supervision, and control, all of which is in the interest of capital in the development of the monopoly phase. *

Finally, it is important to add that this is far from a static process. Thus, while women in general have been increasingly pulled into the labor force over the twentieth century in low-waged and simplified tasks, some women have simultaneously been pushed out. In an analysis of the technological displacement of workers at the American Telephone and Telegraph company (AT&T), Hacker (1978) argues that technological change may draw women in or push them out of work, depending on whether work is being simplified or simplified work is being automated. As AT&T shifts to a higher level of process technology, operators, low-level clerical, and low-level supervisors of these two groups—typically female jobs at AT&T today—are being automated, thereby pushing women out. Further, as formerly male craft work is being simplified for automation, women are pulled into these jobs, but they will soon be reduced by the next level of technological change. Hacker finds this process continuing at other levels of the organization, too, interacting all the while with racial divisions. In sum, while monopoly capitalism has pulled women increasingly into the labor force, new levels of technological development organized around the profit motive have multiple and contradictory consequences for women's labor.

In conclusion, the era of monopoly capitalism has ushered in a new type of working-class population in general. The nature of work itself has changed. This changing nature of work has been a large part of the reason why women have been increasingly incorporated into wage labor—as they have been—during the twentieth century. The

*In addition, Dubnoff asks whether this increase in female employment is beneficial only to capital or to employed men also. His analysis of the 1940-to-1970 data leads him to unconditionally conclude that both employed men as a group and capitalists as a group are able to benefit from the increased employment of women. According to him, changes in the sex composition of jobs find men moving toward more favorable jobs and women toward less favorable jobs throughout this 30-year period. In this regard, Dubnoff fits more appropriately with Marxist Feminist theorists discussed in Chapter 5.

demand for a large supply of cheap literate labor was made available to capitalists in large part through the use of women. Thus one can conclude, not only was there a demand for "female" labor and specifically cheap female labor (as suggested by dual labor market theorists in Chapter 2), but the demand for cheap labor to maintain profits and control for capitalists in the expanding monopoly capital system led to increasing female employment in the twentieth century.

The change in the nature of work from an industrial to a service economy is based, according to Braverman (1974), on the development of the "universal market." In its attempt to expand its markets, monopoly capitalism first conquered goods production by the commodity form and then by increasing services and their conversion into commodities so as to allow capitalists direct access to profits from services typically performed in the home. Finally, there is a "product cycle," which invents new products and services, some of which become indispensable as the conditions of modern life change to destroy alternatives. Thus, the development of commodity goods and commodity services from which there is little possibility of escape in a society such as ours is reinforced from the other side by an analogous development in workers' work: "the atrophy of competence," the deskilling of labor.

It is in this regard that Braverman's conclusion is quoted at length:

> It is characteristic of most of the jobs created in this "service sector" that, by the nature of the labor processes they incorporate, they are less susceptible to technological change than the processes of most goods-producing industries. Thus, while labor tends to stagnate or shrink in the manufacturing sector, it piles up in these services and meets a renewal of the traditional forms of pre-monopoly competition among the many firms that proliferate in fields with lower capital-entry requirements. Largely nonunion and drawing on the pool of pauperized labor at the bottom of the working-class population, these industries create new low-wage sectors of the working class, more intensely exploited and oppressed than those in the mechanized fields of production.

> This is the field of employment, along with clerical work, into which women in large numbers are drawn out of the household. According to the statistical conventions of economics, the conversion of much household labor into labor in factories, offices, hospitals, canneries, laundries, clothing shops, retail stores, restaurants, and so forth, represents a vast enlargement of the national product.

The goods and services produced by unpaid labor in the home are not reckoned at all, but when the same goods and services are produced by paid labor outside the home they are counted. From a capitalist point of view, which is the only viewpoint recognized for national accounting purposes, such reckoning makes sense. The work of the housewife, though it has the same material or service effect as that of the chambermaid, restaurant worker, cleaner, porter, or laundry worker, is outside the purview of capital; but when she takes one of these jobs outside the home she becomes a productive worker. Her labor now enriches capital and thus deserves a place in the national product. This is the logic of the universal market. [Pp. 282-83]

In short, the theory of monopoly capital helps to explain the incorporation of women into certain low-waged and deskilled jobs in an increasingly divided labor market. The discussion above has included an analysis of clerical and low-level "service" jobs. Below, the position of the higher-level service-oriented jobs in which college-educated women in today's labor market are employed will be analyzed.

ROLE OF THE STATE AND COLLEGE-EDUCATED WOMEN'S EMPLOYMENT

The study of monopoly capitalism as a system has the added advantage of being able to understand the role of the state and the relation of its heavily female (and nonwhite) employees in the absorption, indirect accumulation, and legitimation of surplus value. And, it is in the monopoly capitalist era that the idea of a reserve army of labor is expanded to include a myriad of employed, underemployed, unemployed, and unpaid home laborers (that is, housewives). This has direct implications for women's labor market activity.

In the analysis of college-educated women, use will be made of the tripartite model of the economy developed by O'Connor in The Fiscal Crisis of the State (1973). Although O'Connor himself does not deal with the issue of women in the labor market in any detail, his model helps show where and how women are employed in monopoly capitalism, especially women in so-called professional and semiprofessional jobs.

O'Connor begins by analyzing the fiscal crisis of the state (that is, the tendency for government expenditures to outrace revenues). This is caused in large part by the increased "socialization"* of the

*Of course, Marxists use the term socialization differently than mainstream sociology. In mainstream sociology, socialization refers

TABLE 6

Characteristics of Production and Labor Force in Each Sector of the U.S. Economy

Characteristics of Sectors	Monopoly Capital Sector	State Sector[a]		Competitive Capital Sector
		Contractual	Service	
Characteristics of production	Primarily manufacturing Economic concentration Highly monopolistic Vertical and horizontal integration (conglomerates) National and international		Primarily services Economic deconcentration Monopolistic Vertical and sectorial Federal, state, local	Primarily trade and service Economic deconcentration Competitive Vertical and sectorial Regional and local
Social makeup	Corporation owners and controllers Plus professional (technocracy) Plus blue-collar–industrial working-class-unionized Plus white-collar–technical and administration	—	—	Small-business executives (industry and local services) Plus small percent blue-collar Plus small percent white-collar Plus large percent service plus auxiliary and ancillary workers Weak labor force—low unionization
		—	—	
Characteristics of labor force	Predominantly male Nonwhites—underrepresented Unionized Salaries—relatively high		Predominantly female[b] Nonwhites—proportionally represented Nonunionized Salaries—medium	Predominantly female[b] Nonwhites—overrepresented Nonunionized Salaries—low

[a] Contractual (17 percent) and service (4 percent federal and 12 percent state and local) each accounts for about one-half of the labor force of the state sector.
[b] Men still dominate decision-making positions here.

Note: Each of the three sectors of the economy accounts for about one-third of the labor force.

Source: Adapted from O'Connor (1973).

costs of production along with the maintenance of private profits. This leads him to suggest that there are primarily three areas to the economy in monopoly capitalism: monopoly, competitive, and public ("state" or government) sectors. (Definitions and descriptions of these three sectors are presented later in this section. Also, see Table 6.)

Women are underrepresented in the most profitable sector (monopoly) and overrepresented in the least profitable (competitive), as well as in the government (state) sectors. This last sector, however, does not create surplus value directly but rather absorbs it or accumulates it in the interest of private property. The most educated women—that is, those identified as professional and technical workers by the U.S. Bureau of the Census—are employed most frequently in this last sector.

Several general principles of the system of monopoly capital require presentation before the role of women in each of the three sectors is explicitly examined. First, O'Connor suggests that each of these sectors are interdependent. The monopoly sector, which dominates the economy, generates technical innovation and growth—but under state stimulation. This, in turn, pushes certain workers out of the monopoly sector and makes them available for the other two sectors: competitive and state.

Second O'Connor shows that monopoly growth is created by state-financed technological developments (through tax reductions, direct outlays in the form of contracts or public services paid from "working-class" taxes, and so on), not through expanded employment. Although the state acts in the interest of the dominant class in any society, its role is greatly expanded in monopoly capitalism. Weber, as well as Marx, stressed this. This does not mean, however, that the state is a conspiratorial monolith or a puppet. Rather, it is a complex structure of authority relations with many of its own internal contradictions. The state needs to legitimate as well as to enrich the monopoly sector. The complicated interrelationships between monopoly and competitive sectors (for examples, see below) impose a number of contradictory requirements on the state. "Fundamentally, the state must both sustain profits and hold the society together" (San Francisco Bay Area Kapitalstate Group 1975, p. 150).

to the inculcation of attitudes, values, beliefs, ideals, behaviors, and so on in the process of training people to become members of groups and society. In Marxist terms, socialization refers to collective, public responsibility for activities that were formerly the responsibility of individuals or corporations. For example, schools now assume much of the burden of labor-training costs, which saves corporations tremendous amounts of money.

Third, O'Connor emphasizes that the monopoly sector does not drive out the less profitable competitive sector but actually regenerates it. Thus, the competitive sector employs a large population of "underemployed" workers who would otherwise comprise a surplus population of crisis proportions. As Edwards, Reich, and Gordon (1975) have argued, a structured relationship of underemployed workers is built into monopoly capitalism via the secondary or competitive capital labor force.

Moreover, this is precisely what Braverman (1974) has suggested when he says that monopoly capitalism has completed the "conquest of all goods production by the commodity form" along with the displacement of labor from these industries and "brings into existence the labor force required by capitalism in its new incarnations." Monopoly capital, in other words, renews "the traditional forms of pre-monopoly competition among the many firms that proliferate in the fields with lower capital-entry requirements" (pp. 281-82).

Fourth, the problems of monopoly capitalism are shifted continuously to the competitive and state sectors. For example, the competitive sector not only employs monopoly workers as a "hidden" reserve army of labor but it also provides a market of "secondary" or "used" goods and services for those who cannot afford the continual high-priced markets of the technologically advanced monopoly sector. (See O'Connor's (1973) examples on secondhand car dealers needed and small independent gas stations.)

The state does pretty much the same. First, it absorbs the surplus population (through welfare as well as through government employment) and surplus goods (through warfare as well as buying goods and services from private industry to supply government bureaucracies). Second, it also provides direct subsistence and direct contracting to private monopoly interests and takes over private failures when they are no longer sufficiently profitable for the capitalists. Thus, for example, New York State bought two unprofitable electrical plants from Con Edison and then rented them back to Con Edison at reduced rates (Newfield 1975).

The intensification of the government sector is evident in the following account of whom it employs. According to one author's estimates:

> Government has become the single most important generator of employment, directly or indirectly accounting for one-quarter of existing jobs. . . . Adding together the unemployed, the military-employed or -dependent, and the government-employed, we are talking about thirty-four million people, 40 per cent of the officially defined labor force. Take these jobs away and the Depression of the

1930s would perhaps seem like a mere recession. [Anderson 1974, p. 153]

Clearly, the boom in the U. S. economy since World War II (until the mid-1960s), the era of strengthening monopoly capitalism, has in large part been caused by an increase in government spending and employment, not the independent expansion of private industry.

O'Connor specifies the properties of the three economic sectors and whom each employs as follows. Each sector employs about one-third of the labor force. The monopoly capital sector is characterized by large-scale production, fueled by government-supported technical innovations, located in national and international markets (oil, steel, automobiles, and so on). Large amounts of fixed capital and administered or controlled prices ensure a high level of profits and thus allow workers better wages—although wages increase only enough so that the workers can buy the monopoly-priced goods. The job stability, unionization of labor, and internal markets of the primary markets characterize the monopoly sector. It employs predominantly white males, appropriately for each of the hierarchical levels of employment (for example, management and blue-collar workers). Labor in this sector has dominated the development of U. S. trade unions. While it has won certain advantages for its workers, it also acts to keep them in line. Women are sorely underrepresented in this relatively high-paying and stable economic sector.

The competitive sector, on the other hand, consists of small-scale production located in regional and/or local markets (such as small businesses, grocery stores, service stations, restaurants, and clothing stores). Competitive sector profits are made through the process of absolute surplus value production. It can increase profits only by paying low wages, maintaining poor working conditions, and keeping long hours. New firms more easily enter the competitive than the monopoly sector, limiting any firm's ability to expand the scale of production. However, they are almost as likely to fold. Thus, 75 to 80 percent of all small businesses close within three years. But they keep entering. In fact, this is where women are most likely to enter the business world when they enter (Bender 1976).

For workers in this sector, wages are low; employment is commonly casual, temporary, or seasonal. Workers are weakly organized, with minimal unionization. Workers usually wanting but unable to find full-time, year-round, well-paid work in the monopolistic sector accept employment here on almost any terms. This sector employs women (and nonwhites) in proportions much greater than their representation in the labor force. Despite the huge increase in female employment in the United States, only 42 percent of all employed women work in jobs that are both full-time and year-round. (The

women's rate is 67 percent that of men's in this case.) Many married women work only part-time. This is encouraged by employers in the competitive sector because fringe benefits and overhead costs are much lower for these workers. Full-time, year-round female employment is more likely to exist in monopoly sector clerical work as well as state sector clerical and professional/technical work.

The state or government sector is seen as an integral part of the employers of labor power and cannot be excluded as dual labor market theory does.* The state sector is primarily service oriented in its employment. It operates on federal, state, and local levels. Part of the state activity is at least indirectly productive for capital (such as in roads, state-financed industrial parks, manpower development programs, public schooling, social security, medicare, and workmen's compensation); while some of it is not even indirectly productive (this includes expenditures for internal and external social control). Like competitive capital, this sector is heavily female, although men, of course, dominate decision-making positions.

It is precisely in this sector (government) of the economy that women with college educations have been primarily employed. Men are more likely to be employed by the federal government, mainly in the civilian establishment for administering the military. Women are more likely to be employed by local and state government, concentrated in education. Thus, by analyzing the role of the state in monopoly capitalism, one will be better able to explain the incorporation of highly educated professional (and semiprofessional) women workers into the U.S. labor market.[13] This was extremely problematic for dual labor market theorists whose analysis only provided for a dichotomy between primary and secondary markets, which could not account for the differential treatment of educated women and men within the primary sector. This is in large part due to the fact that the vast majority of women who could be included in relatively more stable primary types of jobs are in fact employed by the government, not by highly successful private profit-making industries. By contrast, analyzing government employment of college-educated women as secondary employment was also found to be inadequate.

Although professional women have not increased at the same rate as clerical and low-level service workers during the twentieth century in the United States, there was an increase from 8 percent to 15 percent between 1900 and 1970. However, this increase has

*A distinction should be made between the primary and secondary markets of dual labor market theory and O'Connor's tripartite model, which also includes the state sector in addition to monopoly (akin to primary) and competitive (akin to secondary) capital sectors in general.

occurred in the government and not the private sector. Thus, according to a recent national survey (utilizing the Parnes data), the overall figure obscures the fact that only 8 percent of all white women employed in private industry were professional and technical workers, while a full 43 percent of the white women in government were so classified. The figures for black women are similar: 2 percent in private industry and 34 percent in the government sector (Shea et al. 1970, p. 107).

Why is it the state that employs so many of these well-educated and highly qualified women? The activities in which one finds educated women in the government sector—such as public schooling and health care—service the system of production as a whole and in so doing reduce labor costs (the costs of reproducing the labor force) for private capital. Thus, many tasks previously performed in the home have become socialized and performed primarily by women semiprofessionals in the labor force at the expense of public taxes. Private corporations, of course, reap the benefits from the adequately trained, socialized, and cared-for population who produce surplus value for them. Moreover, as the state extends a large array of services to the population at large through women's "professional" services, not only are the costs of private industry lowered but large numbers of women workers are employed who would otherwise constitute a surplus population of large proportions for private industry to handle.

Traditionally, such professionals are described as part of the petite bourgeoisie along with other male professionals. However, as J. Hill (1975) indicates, many of the so-called professional and technical jobs of educated women (mostly semiprofessions as discussed in Chapter 2) "in the past would have been considered petit-bourgeois, but the march of monopoly capitalism has forced these occupations downward in a trend of proletarianization" (p. 48).

Contrary to the widely held belief that both the capitalist and working classes are dissolving into a single amorphous "middle class" in affluent U.S. society (an idea held by many mainstream stratification theorists [for example, Centers 1949; Mayer 1956, 1963]), some of the neo-Marxist theorists assert that in advanced capitalism educated workers are becoming proletarianized in their relations to the productive process:

> Rising levels of income and the proliferation of new and different forms of wage labor thus reflect not the growth of a diffuse middle class but the stratification and diversification of a working class which has expanded in recent years to include technical and supervisory workers in addition to the classic industrial proletariat. [David Smith 1974, p. 173]

This is the thesis of the "new working class."

The new working class theory states that technological advances have transformed the nature of production so that an increasing amount of educated (especially college-trained), technical, and scientific requirements and workers have become aligned with the traditional proletariat. The working class has expanded to include the more highly educated worker through the alienation, exploitation, and degradation of their labor, similar to that of the industrial proletariat. This is reflected in the lower-paying entry jobs and the increasing difficulty in moving up the job ladder experienced by more recent college-educated entrants to the labor market (Jaffe and Froomkin 1978).

This educated, technical, and professional strata is not representative of a new bourgeoisie or a new middle class replacing the free professional and small businessperson of the petite bourgeoisie. Instead, the degradation of labor; the intense breakdown and specialization of tasks and knowledge; the routinization, mechanization, and standardization of a great deal of work; the factorylike conditions under which labor performs and is supervised; the powerlessness and loss of authority and decision-making control; and the lack of control over one's labor power, the tools, the process, and the goods and services produced—these all create a proletarianized educated new working class. Along with this has occurred a rising educational level in the traditional working class.

In sum, one might say that, instead of an "embourgeoisment" of the blue-collar worker or the traditional working class, as suggested by most mainstream stratification research, a "proletarianization" of the educated worker has been evolving in modern capitalism. This helps to explain, in part, the nature of work among highly educated female technical and professional workers and their inclusion in the contemporary U.S. working class of monopoly capitalist United States.

Finally, it is important to remember that the increase in the state sector is neither stable nor permanent. It expands in times of boom (as in the 1960s' "war on poverty") and contracts in times of recession (as in the 1970s). One of the greatest upheavals over cutbacks in the past five years has been in public employment—visualize the crisis of the state in New York and California as primary examples. This unemployment affects women as much as, if not more than, men. It seriously calls into question the belief that if only women were adequately educated, they would be eligible to compete for the best jobs in the country. Thus, for example, the overall unemployment rate for new Ph.D.'s in mid-1975 was up to 20.5 percent. However, for women it was over one-fourth (26.2 percent) of all new Ph.D.'s despite all the equal opportunity legislation since the 1960s (Jones 1977).

IMPORTANCE OF WOMEN AS A
RESERVE ARMY OF LABOR

The issue of women acting as a reserve army of labor is central to an understanding of the workings of monopoly capitalism both in its beginning stages as well as today. It was Marx's assumption that women were a cheap source of readily available labor, based particularly on their limited strength and lack of organization. Thus, the introduction of machinery allowed employers to invest more in technology and less in human labor power by employing women in certain sectors of the market. While it is debatable that women's limited strength[14] was the cause of their lower-paid market labor in capitalism, it is probably true that women's lack of organization and cheap labor keep them particularly vulnerable to being pulled in and pushed out of jobs according to the needs of capital. Hence, it is important to understand women's functions not only as employed members of the market but also as a reserve of labor.

In the remainder of this chapter, the ways in which women have served as cheap reserves of labor will be documented. Hence, women will be looked at in their positions as low-wage full-time employees (especially among the vast number of competitive workers who act as a "hidden" reserve to the monopoly capital sector); part-time and underemployed workers; and discouraged and unemployed workers. Most important, it is the key hypothesis here that women's role as "housewife" makes them a "reserve" to the reserve army of labor as it is traditionally understood. The housewife is a key, yet "hidden," back-up force for monopoly capital. What follows is a description of how women in these various positions fit into a picture of the reserve army of labor in contemporary monopoly capitalism. This description makes clear just how monopoly capital theorists have failed to directly analyze the implications for a reserve army of labor of some of women's market labor in terms of its relation to the reserve army and, much more important, women's unpaid labor in the home. These are crucial to an understanding of women's position in the labor force today.

The functions of a reserve army of labor are to keep down the wages and demands of the currently employed with the threat of job loss or reprisal and to provide capitalists with the ability to manipulate the system of production and output according to their own interest in profits.* This assumes that the reserve army is both cheap and available in numbers. Women fit these descriptions well.

*In 1975 factories were operating at about 74 percent capacity. By 1978, after the bottom of the recession, factories operated at only 84 percent of capacity ("Productivity Slowdown" June 1979).

While the proportion of women in the labor force has increased to over half of all adult women (18 to 65 years old) in the 1970s, it should be clear that the way in which women have been employed in this society has still been to act as a reserve army of cheap and available labor. However, as Braverman (1974) makes very clear, the employed and unemployed are united in the accumulation of capital:

> Thus the mass of employment cannot be separated from its associated mass of unemployment. Under conditions of capitalism, unemployment is not an aberration but a necessary part of the working mechanism of the capitalist mode of production. It is continuously produced and absorbed by the energy of the accumulation process itself. And unemployment is only the officially counted part of the relative surplus of working population which is necessary for the accumulation of capital and which is itself produced by it. This relative surplus population, the industrial reserve army, takes a variety of forms in modern society, including the unemployed; the sporadically employed; the part-time employed; the mass of women who, as houseworkers, forms a reserve for the "female occupations"; the armies of migrant labor, both agricultural and industrial; the black population with its extraordinarily high rates of unemployment; and the foreign reserves of labor. [P. 386]

In all cases, women are prime candidates for the reserve army of labor, although they fit certain instances better than others.

Women's inclusion in the labor market has always depended on the fact that they were a cheap supply of readily available labor in both competitive and monopoly stages of U.S. capitalism. This is documented by V. K. Oppenheimer (1970), Braverman (1974), and Dubnoff (1979).

V. K. Oppenheimer (1970) analyzes the sex-segregated occupational structure in the United States between 1900 and 1960, the active period of monopoly capital in this country. She stresses the fact that the inclusion of women into waged labor was based on two factors. First, women were a cheap source of available labor, especially when there were (male) labor shortages. And, second, this inexpensive labor had the added attraction of being skilled (like a seamstress) or endowed with special advantages—such as a relatively high level of education, like teachers and clerical workers (pp. 98-99). Thus, women were more likely to come to the job already trained, so that the capitalist did not have to invest in their training (p. 104). One example to show the difference between men's and women's labor even today is seen in the use and care of the typewriter: women enter

a typing job already having learned how to use this machine; men, on the other hand, who repair the typewriter are trained on the job, at the expense of the company.

In addition, as seen in the discussion on the degradation of clerical work, changes in the job structure itself occurred that reduced its attractiveness to men. Here the labor process was divided and machines were introduced to raise output, cheapen production, and increase management's control over the process. This led to an increase in the number of jobs for relatively educated women. At the same time, the relative privileges of premonopoly clerical work, which was male dominated, were eliminated: with expansion, the jobs became dead-end. They became too low-paying for men. As Roby (1972) describes the pattern of female employment in primary education, the shift from male to female employment in the mid-1800s was to characterize U.S. labor force practices: "Women were hired to fill a new job [or newly structured job] when men were not available, and the job soon became too low-paying even for men who needed work to be able to take it" (p. 122).

Women's constant availability as a cheap supply of labor is related to their availability as a reserve army of labor. The most commonly documented use of women as a reserve army occurs in times of war. Beginning with the Civil War, stories are legion about the inclusion and later expulsion of women in paid employment (see Quick 1972). The most famous stories are those of "Rosie the Riveter" during World War II (Tobias 1973; Trey 1972). When women were pushed out of high-paying "war-related" jobs, they were often employed in low-paying, low-status "female" work, mostly in competitive capital industries. Or they were sent back home to become housewives. In both instances, women functioned as a reserve of labor.

Roby (1972) also documents that women are not only more likely to be employed in the labor force but they are also more likely to pick up economic slack in schools of higher education by becoming students when men enter the armed forces. In fact, the only time women have outnumbered men in college, according to Roby's data, was during World War II (p. 129). In addition, in the current recession, it has been reported that just about an equal number of women and men are enrolled in college. This again, during a fiscal crisis (Roark 1977). However, an educated female population does not ensure women either permanent jobs or respectable pay (when jobs are available) after they have "consumed" these educations.

The formal and informal methods used by employers (private and government alike) to convince women to give up their jobs once men returned from overseas after World War II are much less well documented. However, the recent historical analyses by concerned feminists are beginning to bring these practices to light (see Milkman 1976; Quick 1972; Trey 1972).

It has been suggested by one Marxist that the principle of women acting as a reserve army of labor is no longer applicable today, since women comprise approximately 40 percent of the labor force in the United States (Szymanski 1976, p. 43).[15] It is his argument that married women "have been freed from the requirements of housework by the mechanization and socialization of housework and by the reduction in the socially necessary time for child care" (p. 43). Their labor is increasingly profitable for advanced capitalism by having them work as "regular" rather than "marginal" workers in the paid labor force.

While Szymanski is correct that women have expanded in their paid employment, women's value as a reserve army must not be overlooked today. There are a variety of ways in which women act as a reserve army of labor. (One could say there are a variety of female reserves of labor in monopoly capitalism.)

First, after World War II, while there was wholesale elimination of women from men's factory and administrative jobs, there was an increasing trend of female employment in "female" jobs. Why did this kind of female expansion occur at this time? On the one hand, recruiting women into low-level, easily replaceable "female" jobs —particularly in the competitive sector—keeps women as a reserve to the monopoly sector, especially in times of disaster (such as war). On the other hand, as one group of writers suggests, there was an increased demand for workers due to the conversion of markets from war goods to consumer goods, the savings of U.S. workers due to food and goods rationing in the war, and the opening up of foreign markets. This pushed up wages. To keep wages down, capitalism encouraged women's working. This has seesawed back and forth according to the economy's demands (Women's Work Study Group 1975). Thus, in the 1970s, a sharp increase in overall unemployment was seen; and women's unemployment remains higher than men's (see data in Szymanski 1976). This is true despite the contradictory finding that wives of unemployed men are the most likely to be in the labor market (for an analysis of this situation, see Kolko 1978).

Second, as pointed out in the discussion of O'Connor, women generally and educated women especially are heavily employed in government jobs today. However, the current fiscal crisis of the state has led to an increased instability and impermanence in these jobs. Thus, jobs that are disproportionately female (and nonwhite) are oftentimes more likely to be cut back during economic crises than jobs in the more stable monopoly capital sectors.

Public services are often seen as luxuries. Cutbacks in these goods and services mean lost jobs for government employees, who typically are not even covered by unemployment compensation. Special legislation must be passed and renewed each time state, local,

and federal employees are covered by unemployment compensation. This includes teachers, social workers, and nurses[16] among the female-dominated services,[17] which are subject to heavy cutbacks today. In male-dominated public service jobs, this includes such jobs as police work, where women were just beginning to make a small dent under affirmative action laws of the 1960s boom period. However, in the recent fiscal crisis, women were laid off in accordance with the principle "last hired, first fired" (see Kempton 1975).

None of this is to deny that male workers' jobs in the monopoly sector are not hit—visualize the automobile industry. However, it is important to remember that these industries are often heavily unionized—auto workers were paid 95 percent of their wages when they were out of work.

Third, as was indicated in Chapter 2, women and men generally tend not to compete with one another for the same jobs. Therefore, they require separate reserve armies if capital is to have an effective weapon against workers. Despite this need of capitalism's for separate gender-related reserves of labor, the threat of changing-gender categories is used against men to discipline them. In this sense, women are always potentially a reserve for men.

As Marx noted, to maintain capitalism, there must be competition among the workers for jobs. The more competition, the lower the wages and the higher the potential profits. The sex segregation of labor markets protects certain men's jobs from competition by women workers. Because competition from those jobs is artificially reduced, pay is higher. How is this possible in an economy geared toward profit for the capitalist class only?

It is possible primarily in the monopoly sector of employment. This means that men, like women, in competitive and government sectors do not experience the same benefits as men in the monopoly sector. Again, as O'Connor (1973) explains, the increases paid to workers in the monopoly sector (which is primarily unionized white workers in national and multinational conglomerates) are based, since World War II, on a cost-of-living contract clause that does two things: it allows monopoly workers to be able to buy these higher-cost goods, but it raises the prices of the commodities for everyone. The prices, remember, are "fixed" or "administered" in this sector. Therefore, it is the buying public who pays for cost-of-living increases, not the capitalist through his profits.

Thus, workers in all sectors of the economy (monopoly, competitive, government) must now pay the increased prices, even though they have not all obtained the relative increase in wages. This means that women and minorities, more likely to be employed in nonmonopoly jobs (government and competitive sectors) are paid lower wages but must still pay higher prices, which support monopoly capital and

monopoly sector workers. This helps maintain sexual and racial segregation in the labor market itself. *

Fourth, it is certainly true that women are essential to the operation of the labor market today, not just as a reserve of labor. However, if women were paid wages equal with men, it is the author's hypothesis that a significantly large number would lose their jobs and become part of the unemployed reserve of labor. The women could be replaced by machines or by lower-status and thus upwardly mobile men; or their work might be exported to cheaper labor in different parts of this country as well as to other countries all together. In all these cases, women would be an active reserve army of labor.

Fifth, I want to argue, the inclusion of women as part-time workers, which has burgeoned since World War II, has been done in large part to cut costs, to maintain women at miserably low wages, and to incorporate women as a readily available reserve of labor.[18] This is true whether women are voluntarily socialized or involuntarily forced into taking part-time work in the labor market.

In the past decade, fully half of the 7 million women entering the labor force did so as part-time workers. More to the point, among the major group of employed adult women in the United States today, women aged 25 to 54 outnumber men seven to one in part-time jobs (Flint 1977). In addition to part-time work is the temporary-help sector.† Here most of the jobs (70 percent) are clerical, and the vast majority of temporary workers are women, particularly housewives (Samuelson 1977).

Finally, it is important to remember that there are a very large number of women who work full-time but not year-round. (Only 42

*When agreements with monopoly sector workers are not profitable to capital, even these concessions are lost by the workers. Also, this is a complicated process. O'Connor explains how monopoly sector workers' taxes pay for welfare. Thus, each sector is used against the other as a measure to "divide and conquer."

† The temporary-help industry was minuscule in size until after World War II. It grew in large part because of the tight labor markets after World War II and the growth of the part-time labor force in general. "Hence, the temporary help industry does not represent secular growth but rather, a response of business firms to a service and marketing strategy that would help to make their work force problems more manageable and less costly" (Gannon 1974, p. 44). The two major goals of capital identified earlier—profits and control over labor power—are precisely those identified by Gannon.

While 70 percent of the temporary jobs are clerical, 28 percent are in the industrial sector and 2 percent are in the professional-technical sector (p. 45).

percent of all employed women work both full-time and year-round.) Many cannot find jobs year-round and settle for those jobs where they can at least take home a weekly paycheck. However, it is not infrequent that these women are laid off for certain periods of time (and even get their jobs back later) yet are not counted as permanent employees and, thus, are not eligible for employee benefits and higher wages and power.

Despite the obstacles facing women in the labor market, employers frequently argue that women will work only certain hours due to child-care needs, and thus it is women's "fault" for not working more steadily in the market. A recent analysis of part-time labor in particular, by Flint (1977), makes it clear that the needs of the labor market often encourage such attitudes to the degree that they exist.

Thus, "part timers provide a low paid but eager work force, which delights employers. They are hard to organize, which disgruntles unions" (p. 1). Moreover, "they are easy to fire" (p. 56). However, instead of being integrated by unions, they are usually excluded from equal benefits. Companies use all this to their advantage. As one manager of a Detroit area department store said, even though the company is not firing full-time workers, "rather we are hiring part-time people to replace those full-timers we lose through attrition" (p. 56). Since fringe benefits account for approximately 35 percent of labor costs, this obviously cuts down on the companies' costs. In the case of the example of the Detroit department store, "the part-time force is already 65 percent of the total and growing" (p. 56). A book bindery factory in St. Paul, Minnesota, claims to be a totally part-time facility. In the long run this affects all workers.

The issue of part-time worker's instability disappears when it is economically worthwhile to the company. Thus, according to the vice-president of personnel of the Prudential Insurance Company, which employs about 1,000 part-timers working out of its Newark, New Jersey, headquarters:

> The thing I've always liked about them [part-timers] is their stability and conscientiousness toward the work. They really make an effort. The housewives appreciate our efforts to tailor work to their schedules. The advantage is that they are on call, in and out. It is a very good substitute for costly overtime. [As quoted in Flint 1977, p. 56]

Finally, it should not be forgotten that low wages for women drag down the wages of all workers to some degree in the long run—because employers can always threaten to replace their traditional male labor force with women. The resistance to implementing af-

firmative action can be understood in this context. The cries of "reverse discrimination" (Roberts 1977; M. Stone 1978), especially in academia (see the Bakkee decision [Sindler 1978]), and unions' chauvinist interest in favoring male over female workers feed directly into this situation. In the short run, it may be solidifying to male workers; but in the long run it is a typical divide-and-conquer tactic that benefits capitalists, not workers. For example, none of the estimated $63 to 109 billion that women would have received if they had been paid wages equal to men in the same occupational categories went to individual male workers (Blakkan 1972). It went, instead, to the capitalist class. Keeping women's wages down acts, on some levels, as a buttress against men's wages, too.

In summary, these arguments should help to convince skeptics that women act as a viable reserve army of labor in a variety of ways. Further, women in the home, as homemakers, act as a "hidden" reserve source of labor—as a "reserve" to the reserve army of labor. Most important, women who become unemployed are presumed capable of being reabsorbed into the home without including them in unemployment statistics. Only 44 percent of all homemakers with husbands present at home are currently employed in the United States. A majority of married women (56 percent) still do not work for wages. This effectively acts to suppress wages in the market and encourage worker conformity.

Finally, it is important to remember here that since women are paid so much less than men on the average, it is still believed to be more reasonable for a women to do child care and housework than her husband who is more likely to be better paid[19] and thus better able to support the family. Since the daily care of children is still "women's work" (as is domestic maintenance generally), and since child-care centers are hardly adequate to demand, it is unlikely in the foreseeable future that women will not act as a hidden reserve to the reserve army of labor under capitalism.

The separation of the family (which was women's sphere) from remunerated labor (which was men's sphere), and the creation of the "housewife," was to help guarantee the ready availability of women as a constant source of cheap labor who could be "attracted and repelled" without much protest, according to the needs of capital. This is specific to the period of industrialized capitalism and has been felt most acutely in its monopolistic phase in the United States.

In the next chapter will be shown how women's unpaid home labor becomes a primary explanation for women's disadvantaged labor force position in contemporary monopoly capitalism—as either low-paid full-time or part-time workers. This is a key point that Marxist and monopoly capital theorists have failed to adequately incorporate into their analysis of today's labor market. It has been the Marx-

ist Feminists who have best attempted to understand this process.
It is to these theorists that the discussion now turns.

NOTES

1. See, for example, Marx's discussion in Capital: A Critique
of Political Economy (1967c, vol. 3), and The Eighteenth Brumaire of
Louis Bonaparte (1963), as well as The Communist Manifesto (Marx
and Engels 1954). For an excellent application of Marx's theory of
classes and their component strata in contemporary society, see J.
Hill (1975).

2. A sociology of knowledge of mainstream and Marxist theory
can be seen in Gouldner (1970), Blumberg (1978), and Glazer (Mal-
bin) (1975).

3. Engels (1972) stressed the importance of matriarchy prior
to class society. While his analysis of the origins of patriarchy in
class society do not appear to be correct, his main assumption that
women's position varies from society to society according to the pre-
vailing political economy leads him to legitimately conclude that
women need not always be subordinate to men. See Chapters 4 and 5
for further elaboration of the work on the family by Marx and Engels
and contemporary Marxist Feminists.

4. However, it was not until the late 1800s that the "family
wage" as it came to be understood came into existence under capital-
ism. Prior to that time, it was expected that working-class (and
elite) married women would support themselves. This point will be
elaborated on more fully in Chapter 5. Look specifically at the work
of Hartmann (1974, 1976) and Hartmann and Bridges (1977).

5. While Dixon strongly supports Braverman's analysis in ex-
tending it to women, critiques as well as extensions of Braverman's
theory have begun to appear with regard to women. Two recent cri-
tiques are those by Baxandall, Ewen, and Gordon (1976) and Phillips
and Taylor (1978).

6. See, for example, Parsons's article on social stratification
(1949b).

7. In a capitalist society, people own no property but their own
labor power, which they must sell in order to survive. In the United
States today, almost nine out of ten employed people are wage or sal-
ary earners. Only one in ten is self-employed. And only a small
percentage of these self-employed people employ large numbers of
personnel (see Anderson 1974; Braverman 1974; Freedman 1975).
Although waged labor was known in antiquity, a substantial class of
waged laborers did not begin to form until the fourteenth century and
did not become numerically significant until the rise of industrial

capitalism in the early eighteenth century. But it has been the nu-
merically dominant form of labor for little more than a century, and
only in a few countries at that. Thus, in the early 1800s in the United
States, four-fifths of the population were self-employed. By 1870 it
dropped to one-third; by 1940 to one-fifth; and by 1970 to one-tenth
(Braverman 1974, p. 52).

8. See where the Popular Economics Press (1977) reports that
the top four companies in each industry control 75 percent of the mar-
ket in automobiles, oil, tobacco, and so on.

9. Labor Market Segmentation is an edited book of readings,
with an important introductory essay by Edwards, Reich, and Gordon.
In addition, see Gordon (1972) for further clarification of some of the
issues presented here.

10. Moreover, Marglin (1974) suggests that the concentration of
workers in factories was an outgrowth of the putting-out system "whose
success had little or nothing to do with the technological superiority
of large-scale machinery." The key to success, and the inspiration
of the factory organization of work, was the "substitution of capital-
ists' for workers' control of the production process; discipline and
supervision could and did reduce costs without being technologically
superior" (p. 84). This capitalist division of labor is intensified in
its own special way in monopoly capitalism. See discussion on Frede-
rich W. Taylor below.

11. Money is put into machines instead. See examples of recent
changeovers in the production process of the New York Times news-
paper (Browne 1978; Winfrey 1978); and retooling of automobile plants
(Stuart 1977). In both cases, layoffs of workers, or "attrition" as they
call it, are tremendous, while new technology is exorbitantly costly.

12. Over time, these labor-intensive jobs likewise undergo the
process of bureaucratic organization and deskilling. See Greenbaum
and Cummings (1978); Braverman (1974).

13. An analysis of the relationship between the state and women
has only just begun. See, for example, the British publications by
Wilson (1977) and McIntosh (1978).

14. Hartmann (1976) reports that although men and women worked
at different jobs in waged labor in seventeenth and eighteenth century
England, their jobs very often required the same strength and similar
skills. It was their wages that were less. Also, it should not be for-
gotten that after a century of differential socialization aimed at making
women less capable than men and building machines to conform to this
ideology, women's strength is still measured today at 65 percent that
of men's (Gubbels 1973).

15. More recently, Szymanski's position has been challenged by
Marxist Feminists in both the United States (Simeral 1978) and England
(Bland, et al. 1978; Beechey 1977, as referenced in Bland et al.).

These references became available to this writer only after this manuscript was completed. However, they support several important arguments presented here, including: married women in the home are an important part of the reserve army of labor today, and women as a reserve of labor are an internally differentiated grouping, not a single monolithic group.

16. It was recently reported in the Nation's Health ("Health Professions" 1977), an American Public Health Association publication, that "by far the largest casualty in the FY 78 budget recommendations is the nursing program. Of the $139 million decrease Carter recommends for health training, $100 million comes out of nursing, an 80 per cent cut in funding. Carter documents say, 'the supply of nurses is adequate'" (p. 5).

17. Both V. K. Oppenheimer (1973b) and Rossi (1973) voice fears about the increasing employment of women, but in lower-status jobs primarily. Moreover, the Ph.D. unemployment rate is increasing and is significantly worse for women.

18. Again, this position is supported by the very recently available publications by Bland et al. (1978) and Beechey (1977), as referenced in Bland et al. and Kolko (1978).

19. An analysis of women's wages in the family in comparison with their husbands' is found in the U.S., Department of Labor, Wage and Labor Standards Administration (1968) and Hayghe (1976).

4

EARLY MARXIST FEMINISM:
THEORIES OF THE HOME

INTRODUCTION

In the 1960s feminist consciousness reasserted itself among women in the Left as it did among other women. [1] Within the Marxist framework, a variety of tendencies of feminist thought began to emerge. Two of these basic tendencies will be dealt with here: Marxist Feminist theorists of the home (or Early Marxist Feminists) and Marxist Feminist theorists of patriarchal capitalism (or Later Marxist Feminists). The former will be the subject of the current chapter; the latter of Chapter 5. [2]

Marxist Feminist theorists of the home are similar to the Marxist theorists of monopoly capital (Chapter 3) in that they see women's problems as constructed specifically by capitalism. They contribute to one's understanding, however, two additional key concepts: women as a group in the home have a definite relation to capital itself; and, as such, women's home labor has economic importance for capital, thus allowing for the development of profits in a capitalist society.

Traditionally, the economic aspect of women's labor in the home has been mystified or hidden, for Marxists as well as for non-Marxists, since a woman's home labor was said to be outside social production (that is, outside the direct exchange of labor power for wages). Marxist analysis stressed her ideological, biological, and social reproduction of labor power but not her economic contributions to capital. The Marxist Feminist theorists of the home challenged this view.

Most important, this school leads to a basic building block in this analysis of women's labor market activity: an understanding of the influence of women's home labor, as constructed by capitalism,

on her market labor is absolutely necessary if one wishes to compre-
hend women's disadvantaged position in the labor market. *

This chapter is organized in the following way. First, the vari-
ety of approaches and features of Early Marxist Feminist thought will
be discussed. Second, Marx and Engels's heritage to the Early Marx-
ist Feminists will be focused on, specifically on issues of importance
to feminists, either erroneous or slighted by Marx and Engels. The
Early Marxist Feminist critique is able to build on and go beyond their
analysis of women's position in the home under capitalism. And
third, the major contribution of Early Marxist Feminism to an
analysis of women's home labor in contemporary U.S. society will
be shown under four headings: the economic contribution of women's
domestic labor, under the dual nature of capitalist production; women's
domination under capitalism; women's home labor as a hidden source
of labor for capitalism; and housework as a crucial factor to under-
standing women's place in the labor market.

EARLY MARXIST FEMINIST THOUGHT

The Early Marxist Feminist analysis includes both (1) those
whose analysis is a direct extension of Karl Marx and Friedrich En-
gels and revolves around the fact that women's home labor is outside
market production directly (even though it produces use-values for
consumption in the home) as well as (2) those who reject the idea that
women's work is unproductive of surplus value (profits) and instead
stress a broader conception of production, which includes both public
and private domains.

The first group is called here the orthodox Marxist Feminists
and is best represented by the work of Margaret Benston (1973).[3]
They call for the socialization (collective social production) of house-
work and child-care tasks along with the elimination of private prop-
erty and the inclusion of women into the newly constituted labor mar-
ket. Thus, women's domestic labor must become socialized, women
must participate in wage labor (at the point of surplus value produc-
tion directly), and they must identify and unite with men in the de-
velopment of a working-class consciousness.

*For these reasons, this group is designated as Marxist Feminist
theorists of the home. It should be clear that this in no way means
that the labor market is not discussed. Quite the contrary. But wom-
en's position in the market is understood as dependent on her home
labor. Since the issue of women's home labor under capitalism was
the first focal point for contemporary Marxist Feminist theory, these
theorists are also designated here as the Early Marxist Feminists.

The second group of Early Marxist Feminists are called here the housework Marxist Feminists. They are more commonly known as those seeking "wages for housework" as the strategy or solution to women's problems in capitalism and are best represented by Dalla Costa (1972). This group also includes James (1972), Federici (1975), and the Cleveland Modern Times Group (1976). This group asserts, in opposition to orthodox Marxist thinking, that women's work in the home is itself directly "productive" of surplus value* and is alleged to be the key to the reproduction of capital. This tendency suggests that since all women are defined by their reproductive and homemaking functions in capitalism, one must in some way organize housewives to assert themselves against capitalist oppression.

Although the debates engendered by these two Early Marxist Feminist groups cover much of this literature and deserve careful consideration, here they will only be referred to as they help to clarify the topic: an explanation of women's position in the capitalist labor market. In general, these two groups appear to be more united than in opposition to one another—they each assume that the position of women in the home is determined by their relation to capital. In their emphasis on capitalism as the primary causal factor, they assign to patriarchy an essentially ideological role. (Excellent summaries of these and other Marxist Feminist positions may be found in Eisenstein 1977, n.d.; Guettel 1974; Hartmann and Bridges 1977; Malos 1978; and Young 1978.)

In short, Marxist Feminist theorists of the home include writers from a variety of social science disciplines and from numerous countries. The focus of their work has been to develop a theory of "the political economy of housework."

Before continuing, it should be mentioned that because of the newness of the debates that have emerged among these Marxist Feminists, much of the writing is both scattered and unfinished. Most of it comes out of a movement committed not only to change but also to organizing to make these changes. Debates are grounded in the Marxist sense of using theory as a tool for action. This may mean that any attempt to systematically analyze a specific topic—for example, in this case

*In contrast to writers who see women's home labor as productive as the housework Marxist Feminists do, all the orthodox Marxist Feminists include those who see women's labor as unproductive, nonproductive, or outside of these Marxist-defined economic categories —even though it is important economic behavior. Some theorists representing both orthodox and housework Marxist Feminists agree that an understanding of women's work must encompass a broader notion of production and labor than has previously occurred.

women's labor market activity in contemporary U. S. society—may
not be clearly dealt with by one or all of the groups mentioned. For
example, one of the greatest problems found with much of the Early
Marxist Feminist literature is that so much discussion has focused
around the debate over the productive or unproductive nature of wom-
en's home activity as affected by early industrial capitalism; as a
result, not enough attention has been paid specifically to women's
home and especially market positions in contemporary mid- to late-
twentieth century advanced monopoly capitalist United States and how
they are interrelated. While the latter builds on the former, they are
clearly not identical. [4]

However, it should be understood that the Early Marxist Femi-
nists were grappling with a serious issue that had previously been
left unanalyzed: how to understand the long-forgotten and misunder-
stood economic contribution of women at home in addition to their
ideological and biological contributions to capitalism.

Finally, it is important to remember that it is often difficult to
categorize a writer in the variety of Marxist Feminist tendencies that
are emerging, even those specified here. Much of this is due to the
fact that the work of later, current Marxist Feminists often is an ex-
tension of, or arises out of, the Early Marxist Feminist thought—be
it orthodox, housework, or some other variation. To make matters
even more complicated, some of the same people can be classified
within more than one variety, depending upon the stage of development
of their analysis and of the whole movement of thought. Clearly, then,
much overlap exists among the groups or schools of thought.

MARX'S HERITAGE TO THE
EARLY MARXIST FEMINISTS

In this section certain ideas of Marx's will be dealt with, which
constitute the heritage with which the Early Marxist Feminists began
in trying to clarify women's specific relation in the home to capital-
ism. It is important to remember that Marx's own work focuses
around a critique of the social division of labor, not the sexual divi-
sion of production and reproduction.

In fact, Marx himself did not deal with the position of women
per se in any great detail. When he did, it was primarily in terms
of their relation to production. According to Marx, as later elabo-
rated in Engels, the historic exclusion of women from the social pro-
duction process gave rise to both the specific oppression of women
by men and their superexploitation when part of production.

From Marx himself, specifically, the feminist analysis of the
1960s inherited a tradition that revolved around the following major
points:

1. The exclusion of women from the social production process led to both the special oppression of women by men, as well as women's superexploitation once in market production.

2. In capitalism women are the private property of men. In any society the social relations between the sexes is grounded within the system of production. Thus, the capitalist mode of production includes both the home and the market. In other words, both sex inequality and class inequality are traced to property relations. Whereas capital is the property of the ruling class, women are the property of men in the home.

3. Patriarchy develops as a consequence of the institutionalization of private property. However, as capitalism matures, fewer people have private property, which becomes more concentrated in the hands of the ruling class. This is claimed specifically for the changes in industrial and monopoly capitalism (see Chapter 3) when more and more women of the working class enter wage labor. This, Marx and Engels felt, eroded patriarchy's control in the home.

4. Every system of production contains a system of reproduction, of reproducing itself. In capitalism not only must the working class create surplus value, but it must replenish itself, its own labor power. The way the worker maintains himself on the job is to consume off the job that which is needed to replenish him to come back to work the next day. Thus, wages, "the capital given in exchange for labour-power is converted into necessaries [the means of subsistence] by the consumption of which the muscles, nerves, bones, and brains of existing labourers are reproduced, and new labourers are begotten" (Marx 1967a, p. 572). Although Marx does not talk about women at home doing the consuming side by side with and for the individual male worker outside the market, this is clearly what his analysis comes to mean in the context of "the maintenance and reproduction of the working class . . . as a necessary condition to the reproduction of capital" (p. 572). It is the housewife's daily consumption of the individual male breadwinner's wages that allows for the reproduction of the working class as a whole. For Marx this is important primarily as it relates to the reproduction of capital itself.

Based on these assumptions, the liberation of women in capitalist society requires both the abolition of private property (or the call for a "socialist revolution") and the full-scale entrance of women into the labor force. In the first instance, women's position as private property of men (patriarchy) would have to be eliminated, along with the demise of capital's control over surplus value (profits for the ruling class). In the second case, women's entrance into the labor force would, among other things, eliminate her economic dependence on men, as well as her primary role as consumer in capitalism. This,

in brief, was the socialist or Marxist position inherited by Early Marxist Feminists of the 1960s.

Women's Exclusion from Social Production

The critical assumption of the sex division of labor in the family for Marx is that it is "natural" or biologically based. The first division of labor is the natural division of labor in the family through the sex act, a division of labor that "develops spontaneoulsly or 'naturally' by virtue of natural predisposition (for example, physical strength), needs, accidents, and so on. "

In Marx's early writings, this division of labor in the family extends outward to structure the society and the total social division of labor. But this link is soon dropped from his analysis (see Eisenstein n.d., p. 11). Although it does give one an inkling that Marx understood that male dominance goes more deeply into man's past than capitalism, the state, or even private property, this is never clarified. Draper's (1972) interpretation of this suggests that perhaps the social attitudes that result from the division of labor between the sexes "will be most resistant to uprooting"; and if capitalism came after sex dominance, then perhaps eliminating capitalism is a precondition for eliminating sexism—the typical Marxist argument.

It is not, according to Marx and Engels, until the later stage of social development and the development of classes that one sees the division of labor in the family become determined by the economic structure that defines and surrounds it (as in The German Ideology [Marx and Engels 1947]; The Communist Manifesto [Marx and Engels 1954]; and The Origin of the Family, Private Property and the State [Engels 1972]). In The German Ideology, a materialist conception of history is well developed and, along with it, the idea that the family is a historically changing product of the changing material conditions of society. This is reflected later in Engels's The Origin of the Family, Private Property and the State (1972), based on his collaboration with Marx. According to Engels, the determining factor in a materialist conception of history is "the production and reproduction of immediate life. " This includes both the production of the means of subsistence, of food, clothing, and shelter and the tools necessary for that production as well as the production of human beings themselves, the propagation of the species:

> The social organization under which the people of a particular historical epoch and a particular country live are conditioned by both kinds of production: by the stage of development of labor on the one hand and of the family on the other. [Pp. 71-72]

Although acknolwedging the productive quality of both the means of subsistence as well as human beings, Engels goes on to say that the sex division of labor "dominates" communal societies with "less developed labor": here, public and private domains are not separated. In such a society, though, the productivity of labor increases so that new social elements can emerge. In societies with "more developed labor," the sex division of labor no longer determines society, but society determines the sex division of labor. These are societies where public and private spheres are increasingly separated from each other. The historic exclusion of women from social production occurs, subordinating women to men. Thus, he continues that

> the old society based on sex groups bursts asunder in the collision of the newly-developed social classes; in its place a new society appears, constituted in a state, the lower units of which are no longer sex groups but territorial groups, a society in which the family system is entirely dominated by the property system [emphasis added] and in which the class antagonisms and class struggles, which make up the content of all hitherto written history now freely develop. [Pp. 25-26, as referenced in Delmar 1976, p. 271]

Women as Private Property

A couple of years after The German Ideology (1947), marriage became an economic relationship to Marx and Engels, most often an exploitative arrangement, as suggested in The Communist Manifesto (1954). This economic relationship established women's dependence on man, not her economic contribution to capitalist society.

In his early writings, Marx (1967d, 1967e) stresses the theory that "species" life implies the possibility for marriage between men and women to be an equal and nonexploitative relationship in noncapitalist society. However, a description of the actual bourgeois family, * which later was to define the working-class family in twentieth century United States (see Kelly [Gadol] 1976b), makes it clear that the nature of the society's mode of production (that is, private prop-

*In this regard, Marx and Engels focus in their writing on the bourgeois family, not the working-class family. For them, since working-class men do not own private property other than their own labor power, it is believed that there is much greater equality within the working-class family itself.

erty) has reduced the woman in the family to private property of man and a "mere instrument of production" to him. Woman's labor power is not her own to sell, as is man's in capitalism.

She is first and foremost an "instrument of production." The relations of private property are the mode of exchange. The family relationships are transformed by the system of capital. Private property and possession become the most pervasive concern of man-woman relations. "The species-relations itself, the relation between man and woman, etc., becomes an object of commerce. The woman is bought and sold" (Marx 1967e, p. 246).

Development of Patriarchy

If, as Marx and Engels suggest, women's problems are due to their ownership by men and as mere instruments of production for men, the solution to women's problem is to be found in the destruction of private property and, therefore, simultaneously, of woman's relation to man. According to The Communist Manifesto (1954), "The bourgeois family will vanish as a matter of course" with the disappearance of capitalism. (The more modern-day interpretation of this is that socialism must come first, as a necessary, but not necessarily sufficient, condition for women's liberation [see Draper 1972, p. 91].) Private property in the hands of men and the accumulation of capital are said to have led to the emergence of patriarchy and, along with it, "the world historic defeat of women."

In this analysis, class relations and the institution of private property are the cause of patriarchy, monogamy, and the nuclear family form. (Here ownership of the means of production "happens" to be in the form of cattle, and later slaves, which "happen" to be in men's control, leading to sufficient surplus that could be accumulated and appropriated as wealth.) Together with class division, private property, and the state emerges monogamy—a system organized to pass on this individually owned heritable wealth to male offspring. Women provided male heirs so that their husbands could pass on their individual family wealth. Children, like women and other property, no longer belong to the community at large, as in societies where production and reproduction of goods, services, and human beings are all done in the public domain. In fact, while some men have more wealth than other men, all women become the private property of their husbands, thereby transforming women's labors into a private service for their husbands rather than a public contribution to the community as a whole. Thus, in this analysis, if one eliminates private property, one eliminates patriarchy simultaneously. (See Draper [1972] for his interpretation of monogamy.)

While Marx and Engels have been criticized for their anthro-
pology (Delmar 1976; Gough 1973; Grabiner and Cooper 1973; Anne
Lane 1976; and Sacks 1975) and understanding of the rise of patriarchy
(especially as a defeat of matriarchy), the fact that family structure,
sexuality, and gender obligations vary in conjunction with variations
in the material base of society has never been disputed. Most impor-
tant, their work establishes the importance of women's oppression as
a problem of history, in relation to the material conditions of produc-
tion, rather than of biology, philosophy, or religion.

Relationship between Production and Reproduction

Production and reproduction as defined by Marx do not refer to
a split between social (production) and biological (reproduction) forces;
rather, every system of production has its own form of reproduction.
In his major work, Capital: A Critique of Political Economy (1967a,
1967b, 1967c [3 vols.]), Marx was concerned with the production and
reproduction of capital itself. He saw production and reproduction
as interdependent parts of an integrated whole. Thus, when viewed
"as a connected whole, and in the constant flux of its incessant re-
newal, every social process of production is at the same time a pro-
cess of reproduction" (1967a, p. 566).

In his discussion of "simple reproduction," Marx was clearly
talking about the reproduction of the wage labor-capitalist relation-
ship. The production of surplus value, out of which profits were ac-
cumulated by the capitalist class, depended on the reproduction of the
entire mode of production as well as its constituent parts:

> Capitalist production, therefore, under its aspect of a con-
> tinuous connected process, of a process of reproduction,
> produces not only commodities, not only surplus value, but
> it also produces and reproduces the capitalist relation;
> on the one hand the capitalist, on the other the wage-la-
> bourer. [P. 578]

It is up to the worker to maintain and reproduce himself as well
as the surplus to be appropriated by the capitalist. Marx talks about
this reproduction of the worker on the job in terms of the "necessary
labor" expended by the worker as well as the variable capital (wages)
"which the labourer requires for the maintenance of himself and fam-
ily, and which, whatever be the system of social production, he must
himself produce and reproduce" (p. 568). It is in this sense that
Marx refers to the maintenance and reproduction of labor power at
the expense of the working class, not capital. In the second volume

of Capital (1967b), Marx talks about two departments in social produc-
tion—both of them in the labor market. Thus, capitalist production
has a capitalist form of reproduction in the market. But Marx him-
self does not talk about the form of reproduction outside the market
—that is, he leaves it to the working class.

In short, the labor theory of value (see above Chapter 3) purports
that both necessary and surplus value were created by wage laborers
in the market—that is, to Marx in "social production." Thus, when
Marx talks about the production and reproduction of capital, he is
talking about how both occur in the labor market itself. (This does
not mean that he excludes reproduction outside of the labor market
itself. See below. But he focuses on the primacy of capital in mar-
ket reproduction.) When Marx says "If production be capitalist in
form, so, too, will be reproduction" (1967a, p. 566), surely he does
not mean that children are reproduced capitalistically. In fact, Marx
says that the reproduction of the species is left to the worker himself
and is outside social production (pp. 572-73). Thus, for Marx

> variable capital [wages] is therefore only a particular his-
> torical form of appearance of the fund for providing the
> necessaries of life, or the labour-fund, which the labourer
> requires for the maintenance of himself and family, and
> which, whatever be the system of social production, he
> must himself produce and reproduce. [P. 713]

However, while Marx is clear about his discussion of production
and reproduction occurring in the market in capitalism, he does not
carry this "connected whole" over into the production and reproduc-
tion in the home. Rather, he talks about the "individual consumption"
of the worker—as that part of the worker's activity outside the market
that is needed in the maintenance and reproduction of labor power.
This is what Marx means when he talks about reproduction outside
social production.

Thus, in Capital, Marx himself does not talk about the work of
women as a group in the production and reproduction of capital itself.
To the degree that he talks about women's labor in the home and how
it is conceived in relation to wages, he focuses on the individual con-
sumption of the wage earner. According to Marx (1967a), "The la-
bourer turns the money paid to him for his labour-power, into means
of subsistence: this is his individual consumption" (p. 571). It is
primarily the tasks of his wife, in the process of consumption, that
turn the money paid to the worker into the means of subsistence. In
this case, says Marx, the worker "performs his necessary vital func-
tions outside the process of production [that is, outside surplus value
production]" (p. 571). The reproduction of the wife's labor power, it

is suggested, is included in the worker's wage, even though it requires the additional labor of the wife to transform that wage into a meaningful package of goods and services for individual consumption.

Despite his understanding that necessary labor is performed outside the social production process in capitalism, Marx never acknowledges in his discussion of "simple reproduction" (Capital [1967a, 1967b]) that the conversion of the worker's wages into individual consumption in the maintenance and reproduction of the working class is mainly done by women—whether their husbands or they themselves are the wage earners. This is because Marx takes as a given women's role in the daily and intergenerational reproduction of the working class outside social production—in the home. As he says:

> The capital given in exchange for labour-power is converted into necessaries, by the consumption of which the muscles, nerves, bones and brains of existing labourers are reproduced, and new labourers are begotten. Within the limits of what is strictly necessary, the individual consumption of the working class is, therefore, the reconversion of the means of subsistence given by capital in exchange for labour-power, into fresh labour-power at the disposal of capital for exploitation. It is the production and reproduction of that means of production so indispensable to the capitalist: the labourer himself. The individual consumption of the labourer, whether it proceed within the workshop or outside it, whether it be part of the process of production or not, forms therefore a factor of the production and reproduction of capital; just as the cleaning of machinery does, . . . The maintenance and reproduction of the working-class is and must ever be, a necessary condition to the reproduction of capital. But the capitalist may safely leave its fulfillment to the labourer's instincts of self-preservation and propagation. All the capitalist cares for is to reduce the labourer's individual consumption as far as possible to what is strictly necessary. [1967a, p. 572]

Therefore, Marx's discussion of reproduction focuses on the production and reproduction of capital itself, although it assumes the absolute necessity of the maintenance and reproduction of the working class through the family and women's work in the family. As Vogel (1973) concludes: "Marx rarely acknowledged that individual consumption is a social process operating through a relatively stable social form, the family" (p. 31). His failure to focus on the work of women in the home in the production and reproduction of labor power

has been the focus of much Marxist Feminist debate over the past decade or so.

Thus, the tradition that Early Marxist Feminists inherited was a situation where any demands for women required a clear class content rather than one related to their oppression as women specifically. Until the work of the Early Marxist Feminists, the unique situation of women to production was ignored by Marx and his followers in favor of the general class perspective.

So, although Marx and Engels provided the Early Marxist Feminists with a certain heritage, they also slighted certain issues. These include:

1. The relation of women in the home as a group to the system of social production in capitalism;

2. The sex division of labor itself—it is never challenged;

3. Why it was women in the first place who became responsible for child care and housework in a capitalist society—unless one reverts to Marx's early idea of women's greater weakness, which was refuted later by Engels as the source of women's problems when he showed women did harder labor than men in many societies,[5] or to Engels's idea that women were the private property of men—even though evidence now exists to suggest that women were subordinate to men prior to class society;*

4. The unstated assumption that women's labor in the home is simply part of the individual consumption of the worker—most specifically the male breadwinner's individual consumption; and

5. How to desegregate the sex-stratified nature of the labor market and jobs that might well emerge if children were reared collectively and household tasks were socialized.

In short, one might say, Marx's work contains a critique of the social division of labor, not the sexual division of production and reproduction.

As Malos (1978) suggests, since the late 1920s, the typical Marxist approach in Western societies has been to avoid asking questions about the relationship between sex and class. This was possible through a definition of the task for Marxists as that of reaching and mobilizing only women of the industrial working class. With the decline of working-class living standards during the depression, Communist parties focused on defending the working class itself—that is, primarily organizing women in and around trade unions on economic

*This is an area of unresolved debate among Marxist Feminists today and will be discussed further in Chapter 5.

issues. This meant that despite their belief in the importance of the entry of women into industry and their struggle for equality in the workplace, major emphasis was placed on defending the working-class family "in which, inevitably, the stress lay on the man's role as breadwinner and the woman's as housewife." This actually led to a swing back and forth between the demands for "socializing housework" and the need to build "labor saving houses for women" as the answer to the question of housework, "because no leading Marxist theoretician had yet [by the early 1970s] questioned the domestic division of labor" (p. 49).

Likewise, much of the twentieth century socialist literature has either neglected women's home labor in industrial capitalism or has equated women's gender-assigned domestic labor with the biological, social, and ideological reproduction/consumption of the working class without acknowledging its productive nature—as Engels clearly did. Instead of dealing with the production and reproduction of both the family and capital, Marxist literature has erroneously tended to link "labor and men to the production, and women and family to the reproduction, of the essentials of life," narrowing both concepts and detaching them from each other (Kelly [Gadol] 1975-76, p. 471). In such an analysis, women and their domestic tasks are seen as outside production (that is, surplus value production) and therefore in need of being incorporated on a large scale into social or market production in order to free them from capitalist oppression. After many examples of modern mid-twentieth century incorporation of women into paid labor, in both capitalist and socialist societies, the sexual division of labor steadfastly persists.

It is to the work of the Early Marxist Feminists that the discussion now turns in an attempt to deal with the issues slighted by Marx, now requiring unmasking and analysis.

CONTRIBUTIONS OF EARLY MARXIST FEMINISM

The Early Marxist Feminist analysis takes as its starting point where Marx, Engels, and their traditional followers leave off. The goal of the Early Marxist Feminists is twofold: first, to change the terms on which women's home labor is analyzed; second, to "bring women into" the analysis of capital.

First and most important was to show the vital economic contribution that women in the home made to capitalism. Thus, the issue of the dual nature of production under capitalism emerged as a direct extension of Engels's arguments in The Origin of the Family, Private Property and the State (1972). Early Marxist Feminists focused this key issue on the market production of exchange values and the domestic production of use-values.

Within this context it became possible to understand women's unique and definite relation to capital as a group, in their role in the home, which defines initially the responsibility of all women—as women —in capitalism. The particular situation of women, within the general class perspective, is thereby addressed. Moreover, this analysis provided the necessary link to understanding that women in the home were economically as well as ideologically integral to the production of capital, not outside it. The acceptance of the idea that women in the home are marginal or unconnected to social production attests to the hidden "mystified" nature of women's economically essential and necessary work in the home.

This leads to the second basic issue developed by the Early Marxist Feminists: without women's home labor as constructed by capitalism, profits could not possibly be made as they currently are by the capitalist class. Thus, instead of simply doing individual consumption work for the individual man in the family, women in the home are doing economically essential work for capitalism itself. Just as Marx spoke of machines, women's home labor is "congealed" in the labor that men and women bring with them to the labor market, which is exchanged for wages with the capitalist.

Third, and most crucial, the analysis of the Early Marxist Feminists leads to the conclusion that women's hidden, mystified, devalued, and unwaged labor in the patriarchal home, as constructed by capitalism, is vital to an understanding of women's disadvantaged place in the labor market today. The two are intimately connected.

Dual Nature of Capitalist Production and the Economic Contribution of Women's Domestic Labor

Benston's "The Political Economy of Women's Liberation" (1973) is an early attempt at dealing with many of the problems confronting the Early Marxist Feminists. Her analysis of the family's relation to production is a culmination of Marx's[6] own position with regard to women's position in the family being outside social production (wage labor). Simultaneously, it is the beginning of the reconceptualization offered by the Early Marxist Feminists that says that women's home labor is an important economic contribution to the production of surplus value and is thus not outside the development of capital as a process.

Benston argues that capitalism contains within it two modes of production: commodity and domestic; waged and unwaged; or more specifically, exchange value and use-value. She moved the discussion of women's labor in the home from that of consumption/reproduction of the male breadwinner to the production of housework and child care.

In so doing she goes beyond the earlier work of Marx by showing that even though women's home labor may not be exchanged against the variable capital (wages) of the market, it nonetheless is useful, essential, and economically necessary for the creation of profits in social production.

Benston's analysis was important for articulating that women were neither economic parasites nor marginal—that is, less important workers in comparison with men. Furthermore, she specifically asked: What is women's relation to the means of production in society?

She shows in her analysis that "women as a group" have a definite relation to the means of production. Women's special relation to production is that they produce use-values. That is, the work of women in the home—buying food, preparing meals, cleaning clothes, taking children to school, picking up after husband and children, sustaining them emotionally, and so on—is not bought by anyone. Rather it is produced and consumed in the home—it is production for consumption or "useful" but not "profitable." Thus, as Benston says:

> In arguing that the roots of the secondary status of women
> are in fact economic, it can be shown that women as a
> group do indeed have a definite relation to the means of
> production and that this is different from that of men.
> . . . If this special relation of women to production is
> accepted, the analysis of the situation of women fits nat-
> urally into a class analysis of society. [P. 119]

The difference between men and women in capitalist society is defined in terms of their relation to production: women are defined as "that group of people who are responsible for the production of simple use-values in those activities associated with the home and the family" (p. 121). She continues, "Since men carry no responsibility for such production, the difference between the two groups lies here" (p. 121). Further, she writes:

> Notice that women are not excluded from commodity pro-
> duction. Their participation in wage labor occurs but, as
> a group, they have no structural responsibility in this area
> and such participation is ordinarily regarded as transient.
> Men, on the other hand, are responsible for commodity
> production; they are not, in principle, given any role in
> household labor. [P. 121]

Thus, the material basis of women's inferior status is due to the fact that in a society in which money determines value, "women are a group who work outside the money economy" (p. 121).

While Benston looks at the special position of women in the role of housework as it relates to social production, she also analyzes women's material basis for exploitation in capitalism in terms of the fact that they are outside the process of exchange value but not outside of capitalist production, which is dual in nature. The _private_ character of women's domestic labor, and the capacity to produce only use-values, is therefore defined as the basis of women's inferior position in capitalist society.

To summarize Benston here, the roots of women's secondary status are _economic_—not biological, cultural, or ideological. Second, women's home labor is a material necessity for capital. And, finally, women in the home are not marginal to the production of surplus value but rather have a definite relation to the means of production, even though they are outside wage labor itself.

Primacy of Capital over Patriarchy

Early Marxist Feminists look to the system of capital and the material basis of women's domestic labor to locate women's disadvantaged position in U.S. society. This analysis can be extended to apply specifically to women's labor market activity. However, as a group, most of the Early Marxist Feminists do not typically talk about women's relation to men within the home in the terms used by Marx —that is, that women are the property of men and under male domination. According to the Early Marxist Feminist position, women are dominated first and foremost by capital; only secondarily by men.

This appears to be a consequence of two assumptions. First, class relations in general and capitalism in particular create patriarchy and women's disadvantaged position within it. So focus should be on primary rather than secondary contradictions—in other words, on the capital-wage labor relations rather than the relations between men and women. In this way men are seen to be the victims of capitalism almost as much as, if not equal to, women.

As one author says, "Capitalism constructed the female roles, and has made the man in the family the instrument of this specific exploitation which is the exploitation of women" (Dalla Costa 1972, p. 29). Ths husband is the "first foreman," the immediate controller of her labor, behavior that is concealed by the figure of the boss. "However," she continues, "the woman is the slave of a wage slave, and her slavery ensures the slavery of her man. Like the trade union, the family protects the workers, but also ensures that he _and she_ will never be anything but workers" (p. 39).

In short, the patriarchal family does limit women's potential, but transforming the family is not the solution. Rather, the solution

is to revolutionize the relations of production that determine the form of the family and women's place in it in the first place.

If sex were the primary contradiction, and not class, argues a second Early Marxist Feminist, all men would own the means of production and all women would work for them. "But," she continues, "almost all males and females under capitalism work for <u>some</u> males, not by virtue of the latter's maleness, but because they own property" (Guettel 1974, p. 49).

Thus, the transformation of women's economic, personal, political, and sexual life, although under the domination of men, is caused by capital, not patriarchy, in this analysis. [7]

The second assumption that tends to preclude an adequate analysis of women's domination by men under capitalism by this group of Marxist Feminists is that as capitalism advances patriarchy becomes undermined in the home. After the early development of intense patriarchal control over women in the development of private property and the state, the bases of patriarchy are eroded with the increasing control of capital. As capitalism matures, fewer people have private property. Today, for example, 85 to 90 percent of the U.S. public are engaged in waged labor. More and more women—married and single—of the working and "middle" classes enter wage labor, too. Thus, the underlying assumption of Marx's (and Engels's)[8] writing was the breakdown of the traditional sexual division of labor in the working class as married women entered into paid labor in "public industry." This is reflected in the writings of a variety of Early Marxist Feminists (Bridenthal 1976, 1977; Dalla Costa 1972; Rowbotham 1973; Zaretsky 1976). Even when patriarchal relations are understood more dialectically (for example, male domination is simultaneously weakened and strengthened as women enter wage labor), Early Marxist Feminists do not analyze the material conditions of patriarchal relations in the labor market.

However, the Early Marxist Feminists do take as their underlying assumption that under capitalism women are the property of men, and in this position they are economically dependent on men. Only with socialism, a redistribution of wealth, can private property —and thus women's economic dependence on men—have a chance of being eliminated.

In short, it was class relations and specifically capital that arranged women's economic dependence on men as it isolated domestic from industrial labor. Women's oppression as a sex is rooted in their economic position—the material base of their labor is mystified, while they remain wageless, or paid lower wages once in the market, and dependent on men.

Capital's Hidden Source of Labor

Up to this point, two interpretations of women's domestic labor have been explored. First was Marx's idea that women are consumers of their husband's wages in the reproduction/consumption of labor power, which is essential for capitalism. Second was Benston's idea—representative of the orthodox Marxist Feminists—that women in the home have a special relation to capitalism that is defined by their production of use-values, which are outside the exchange of wages for labor, even though they are economically integral to the creation of surplus value.

A third position is that of Dalla Costa (1972)—representative of the housework Marxist Feminists—who not only defines women's work in the home as economic but suggests that domestic labor produces more than use-values: it produces surplus value itself. (In an early version of her work, she says it is "an essential function in the production of surplus value." Only later does domestic labor itself become productive of surplus value.)[9] Unlike orthodox Marxist Feminists who define housework as use-value and therefore outside the direct relation to exchange value, housework Marxist Feminists define women's home labor as central to capitalist production. In this way housewives are also central to the class struggle. This position is more commonly known by its demand of "wages for housework." It is the goal of this group that women may refuse to enter wage labor but instead should be paid the value of their labor already done in the home.

Dalla Costa suggests that the question What is the housewife's relation to the means of production? should be answered specifically in class terms. Housewives constitute a class, in this position, since housework is an economic relation to the capitalist class. Dalla Costa argues that it is women's work in the family that produces the commodity labor power. She quotes Marx's statement that "the value of labor power is determined, as in the case of every other commodity, by the labour-time necessary for the production, and consequently also the reproduction, of this special article" (Marx 1967a, p. 170). Without the production and reproduction of the salable work ability in human labor power in husbands and children (future workers)*, there would be nothing for the capitalist to buy or to

*Dalla Costa says she is only dealing with the underlying role of women, but of all women, in capitalism— that of housewife. "We assume that all women are housewives and even those who work outside the home continue to be housewives" (p. 19). But women who work outside the home are not included as such in her analysis (p. 20).

exploit. Since labor power is a commodity, produced in the home by women, housewives produce not only use-values but exchange values or surplus value—the all-important criteria for being included in social production. In this way, Dalla Costa argues, housewives are direct members of the working class and thus have revolutionary potential based on their own work, not that of their husbands.

The most obvious criticisms of this approach are that the housewife does not rent her labor power directly to the capitalist for wages—in her work in the home; nor does she sell her products (husband's and children's labor power) to the capitalist for profits. Since she does neither, housework in strict Marxist terminology, is not directly productive of surplus value.

On the other hand, this attempt to better understand the commodity labor power is crucial, since women's main task in the home in capitalism is the production and reproduction of labor power, which is in fact the source of capitalist profits. Moreover, the fact that housework and child care have been understood as work—that is, women's first job—has helped to legitimate women's home labor as "real work" and to enlarge the idea or meaning of production.

This group of Early Marxist Feminists moves us one step further in understanding the importance of women's home labor for market production by focusing on the hidden source of women's labor to the capitalist, which is congealed in the commodity labor power that reaches the market. Moreover, they suggest, this home labor is reproduced below its cost, not totally provided for out of the breadwinner's wages. This idea will be expanded on below.

Even if one argues, in strict Marxist terms, that productive labor is that labor that is exchanged directly with capital, women's labor must be seen, according to housework Marxist Feminists, as productive of surplus value. Part of the labor power that is exchanged with capital is women's domestic labor, a congealed mass of past labor embodied in the wage earner's labor power. Not only does the separation of waged and unwaged labor in industrial capital mystify this process, but housework Marxist Feminists argue that the value of women's labor is not fully reimbursed through the husband's wage.[10]

That is, the housewife produces far more than what she receives as her subsistence through her husband's wages from the capitalist. The costs of the reproduction of labor power are hardly equivalent to the portion of the wage that is allocated to women for their labor in the home. Several independent estimates between 1918 and 1968 agree that if women were to be paid the value of their services as housewives, they would earn about one-fourth of the GNP (Kreps 1971, pp. 67-68). However, this would require a massive redistribution of profits, which capital would not and could not allow under present circumstances.

As Dalla Costa (1972) states in her discussion of women as con-
sumers, "Thus unless women make demands, the family is functional
to capital in an additional sense . . .: It can absorb the fall in the
price of labor power. This therefore is the most ongoing material
way in which women can defend the living standards of the class" (p.
43; see also p. 32).

In short, women's domestic labor should be understood as sur-
vival below the level of historically determined subsistence for which
the capitalist does not sufficiently compensate through his wages to the
housewife's husband. This is seen most easily in times of crisis,
when women take up the economic "slack" in the home by performing
more and more tasks and services that get cut back in the market
(such as education, care of the sick and elderly, and types of food
preparation). However, this should not detract from the point that
the production of domestic labor below subsistence is generally op-
erative in capitalism—whether in times of crisis or not.

Understanding that women's home labor is a congealed mass of
past labor embodied in the commodity labor power of husbands, chil-
dren, and themselves for which they are not fully reimbursed is im-
portant for understanding the hidden source of women's free labor to
capital. However, it does not require a definition of women's home
labor as productive of surplus value. [11]

Thus, an important contribution of this second group of Early
Marxist Feminists is that when a breadwinner goes into the market,
he is free to sell his labor power, not only because a woman takes
care of certain tasks at home for him but also because it is labor
power that includes his and her labor! This wage is given to him to
reproduce his own labor power at work, but only part of hers. Women
do much more productive and reproductive work in the home than for
which they are paid by the capitalists. Moreover, this assumes that
the husband, who has control over the distribution of the wage, gives
his wife a fair share in the first place for the reproduction of her own
labor power. However, this is not necessarily so. Wives in the
working class often do not know how much their husbands earn. This
is also increasingly so for women whose husbands are professionals
(for a discussion of this issue, see Milkman 1976; Oren 1973).

In short, Marxist Feminist theorists of the home generally
agree that it is women's relation to capital in the home that is the
basis for understanding her secondary position in U.S. society.
Therefore, the Early Marxist Feminists focus most of their analysis
on women's home labor, not her market position. It is "the other
half of capitalist organization, the other area of hidden capitalist ex-
ploitation, the other, hidden, source of surplus labour" (James 1972,
p. 7). They reconceptualize women's home labor as the economically
essential unwaged domestic labor done by women in terms required

for the maintenance and reproduction of labor power for capitalism, which is done at the expense of working-class women, not simply the "working class"—that is, wage labor.

Capital further institutionalized women's economic dependence on men as it isolated domestic from industrial labor. Whether women in the home are considered outside commodity market production (as in orthodox Marxist Feminism) or central to the production of the commodity labor power, and therefore surplus value (as in housework Marxist Feminism), the problems faced by women as a group are those caused almost exclusively by capital. This is the basis of the productive-unproductive labor debates. Men are seen as the passive instruments of capitalist domination. While patriarchy, or a sex division of labor of male dominance, is sometimes acknowledged to have existed before capitalism, capitalism is said to forge its own particular brand of sex discrimination. Women's oppression as a sex is therefore rooted in their economic position—they are wageless in their work at home and dependent on men.

Despite the difference among the Early Marxist Feminists, they would all assert that the solution to the problems faced by women as a group in the home can be dealt with in part by making them less economically dependent on men. This is equally true for Benston as for Dalla Costa. However, the method of solution or strategy is radically different for each of them.

For Benston, the way to decrease women's dependence on men is through market employment, along with the socialization of household and child-care labor. With socialism women would be free to work just like men—for wages in collective production. While this certainly does not solve all of women's problems (in fact, it simply makes women equal to exploited men), it is the necessary groundwork, according to this group, in order for further changes to occur. For Dalla Costa, though, the strategy is to pay women wages for labor already done in the home—the production and reproduction of the commodity labor power. This would allow women the ability to refuse to participate in the labor market, which would only constitute a second job. Women must "refuse the myth of liberation through work" (Dalla Costa 1972, p. 47). Their aim must be to get rid of the first boss. Wages for housework would in turn free women to collectively organize household tasks under the control of women—for pay and not in isolation.

In short, both groups of Early Marxist Feminists want women to be given monies (in their discussions, in the form of wages) [12] to recognize the value of their work and to free them from economic dependence on men. *

*The larger issue, of course, is that of changing the relations of production, not the male-female relations, which derive from the

Criticisms about both of these solutions are numerous and can be found in the debates on productive-unproductive labor. What is important to remember here, though, is that both groups of Early Marxist Feminists agree that women's hidden labor must be remunerated so that they are not dependent on men in the family. They must have control over the economic rewards for their economically necessary labor in the home.

Housework and Women's Place in the Labor Market

The thrust of the arguments made by the Early Marxist Feminists leads to the conclusion that women's home labor as constructed by industrial capitalism is intimately connected with their devalued position in the wage labor market. Women's domestic work, it can be argued, is essential in shaping women's position outside the home. This connection is not always acknowledged as a direct link, however.[13]

The fact that women's economically essential labor in the home is unwaged has certain significant consequences for her position once she enters the labor market. In this regard, she is a cheap source of wage labor for the capitalist precisely because she is not adequately remunerated for her labor in the home. *

In short, women's economically and ideologically valuable unpaid labor in the home actually lowers the value of labor power on the market, especially her own. A woman's labor power is hidden or congealed in the labor power that reaches the market and for which she is neither fully nor directly paid. Her social and work force status, job definitions, work conditions, and wages and benefits—or lack thereof—are all largely determined by her domestic status as developed within the processes of capital accumulation.[14]

It is in large part on this basis that women can be understood as a cheap source of readily available labor that can be unemployed or underemployed according to the needs of capital in low-wage full-time

former and require change in primary contradictions before secondary contradictions. That is, this whole analysis is always considered in the context of the capital-wage labor relation for Marxist Feminist theorists of the home.

*In capitalism no one is paid the total value of what they produce. That is, wage laborers are only paid for the reproduction of their labor power—their necessary labor—not for the production of commodities that beget surplus value. In the home, however, women are not even paid the total value of the reproduction of their own labor power, according to the analysis by most Early Marxist Feminists.

or part-time jobs or can be reabsorbed by nonpaying institutions (for example, homemaking and child care, tending aged relatives, volunteer work, and so on) when not needed by the labor force.

It is on this basis, it has been agrued here, that women's work in the home is understandable in terms of its ability to be used by capital to disadvantage women in the labor market—both in terms of the types of jobs they will enter (lower-status "female" jobs) as well as the wages they will get (approximately half that of men). The full-time employed women in the mid-twentieth century United States continue to make three-fifths to one-half of what their male counterparts make in the paid labor force. In 1975 a woman employed full-time, year-round made $0.59 for every $1.00 earned by a man (see Chapters 2 and 3).

This makes clear that those unemployed and underemployed women who are ready, willing, and able to work for wages in the paid labor force act as a reserve army of labor to capital. Furthermore, a far less recognized problem is that those women who are not even considered part of the labor force—housewives—act as a hidden reserve to the reserve army of labor: they are the back-up forces who can be incorporated into the labor market when necessary and excluded according to the needs of capital (as in World War II). Moreover, they can substitute or intensify their own labor power in the home for purchaseable commodities in times of economic hardship (as in the Great Depression). The degree to which each method is used depends on the nature of the economic circumstances in the broader society (see Milkman 1976, p. 85).

Whatever the circumstance, Early Marxist Feminist analysis makes clear that women as a group are a cheap source of labor for capital precisely because they are not paid the value of their labor in the home.

There are at least four ways in which a woman's unpaid labor in the home is used against her when she enters wage labor. These emerge directly from the Early Marxist Feminist analysis and, I would argue, provide a major contribution to the understanding of women's disadvantaged occupational and wage experience in the labor market.

First, the value of her labor is lowered by the fact that her time, energy, and labor are already spoken for by her husband and children. Thus, women's useful labor at home is demanding, time-consuming, and unpaid—therefore "worthless" in the exchange market. To quote Mitchell (1973):

Under a system whose defining characteristic is that it reduces the majority of the population to have nothing to sell but their labour-power—hers, to a large extent, is

already spoken for. Women have little labour time to sell
and consequently get a bad bargain even if they put in 42
hours a week at a factory. Given the degree of exhaustion
produced by two jobs, it cannot be as productive a time, as
employers are quick to point out. The women's labour is,
for this reason alone, less valuable and must be sold
cheap. . . .

The socially useful work of women in the family thus les-
sens the value of her labour-time in the exchange-value
capitalist mode of production. She is thus a constant source
of cheap and sporadic labour. [P. 29]

Second, the fact that women's primary responsibility is sup-
posed to be to their families, rather than their jobs, is used against
them as they are falsely claimed to be more likely to be tardy or ab-
sent, to leave jobs, or to generally be unreliable because of family
obligations. It is true that women have more family responsibilities
than men. However, turnover rates, absenteeism, job leaving, and
so on are amazingly similar for men and women (see Chapter 2).
Each of these variables, on the other hand, is inversely related to oc-
cupational status. That is, the higher the occupational status, the
lower the turnover, absenteeism, job leaving, and so on. Women,
though, are more likely to be employed in lower-status occupations
and therefore are more likely to be in jobs conducive to tardiness,
job instability, and so on. This is because of their low status, not
their sex. In fact, men in low-status jobs are equally as likely as
women in those positions to experience high turnover rates and the
like (Kanter 1977a).

Third, the fact that women's work is an extension of the work
in the home is used against her in the labor market: she is employed
as a "woman" rather than as a "worker" in professional as well as
nonprofessional jobs (Epstein 1971; Theodore 1971; U.S., Depart-
ment of Labor, Bureau of Labor Statistics 1977). In the former, her
tasks require nurturing, helping, and inculcating the necessary skills,
values, and beliefs of the society, while in the latter they consist of
cooking, cleaning, sewing—tiring and dirty tasks with little status or
pay. Today, women do reproductive services (that is, reproduction
and maintenance of labor power) in the market that they themselves
previously did in the home (see Bridenthal 1976).

Thus, with industrial capitalism in nineteenth and early twen-
tieth century United States, many of the goods that had previously
been produced in the home by women (for example, soap, candles,
bread, pants, dresses, cooking utensils, and so on) were now made
in the factories (increasingly under male control), for which they had
to pay. While production of material goods became more public or

social, reproduction (social and biological) and the family became more privatized and individualized. [15] As the mode of production developed further, it became more capital intensive and less labor intensive. The distribution and service sectors employed more and more people, while the industrial sector stabilized and even shrank in some places. The emergence of women in the public sector was increasingly in terms of the maintenance and reproduction of labor power rather than production of goods. Moreover, much of it has been done in the employ of the state rather than private industry itself.

With the development of the human services industries (teaching, nursing, social work, psychotherapy, and so on) in advanced capitalism, many of these services, like goods production earlier, are transferred from the home to the market. These are the jobs into which mid-twentieth century U.S. women have increasingly been going in massive numbers. Now women must work in the paid labor force to be able to afford to buy these services for their families and themselves—which were previously part of their useful production in the home—and for which they must now pay! The variety of economic functions within the household, however, do not simply disappear: they become changed, not eliminated. Women's home labor is extensive indeed, as they are required to interact with far greater ranges of people—in supermarkets, schools, clinics, welfare offices, and so on. The overlap of these jobs in the home and market is seen specifically in times of economic hardship, when public funding for services declines. At such times these tasks are pushed back into the home on women's shoulders, intensifying their double burden of homemaker and employee. As Weinbaum and Bridges (1976) comment, in times of recession

> day care centers close; schools go to double sessions (making it harder to coordinate children's school hours with parents' work hours); Mayor Daley even encourages neighborhood vegetable gardens! Since women are usually both the consumption workers and the wage laborers in the distribution of goods and services, it is especially clear that capital shifts between paying and not paying for the same work. [P. 95]

Fourth and finally, the rationalization that women need not be given stable jobs as well as not be paid the same wages as men, since men are the breadwinners in the family, has a double effect: it cements her economic dependence on her husband, while simultaneously forcing her to take more unstable, unskilled, and lower-paying jobs. These are the only jobs available to women in large numbers in such

a system (see Chapters 2 and 3). It is, in short, on the presumption that the reproduction of her labor power is already largely paid for through the male breadwinner's wage that she is paid as a secondary worker. This creates the illusion that women are marginal to the economy.

In summary, the Early Marxist Feminist analysis makes clear that to interpret women's market activity, one must look at both home and labor force as constructed by capitalism and how the former interconnects with the latter. Nothing less will do as a first step.

NOTES

1. In terms of key writings, the contemporary mainstream feminist movement begins with the publication of Friedan's The Feminine Mystique in 1963, while the Marxist Feminist community takes as its starting point Mitchell's "Women: The Longest Revolution" (1971b).

2. For an alternative way to clarify Marxist Feminism since Mitchell (1971b), see Kelly (Gadol) (1976a) who identifies two general trends that cut across the distinction made here between Early and Later Marxist Feminists: (1) the political economy of housework in capitalism and (2) psychoanalysis and Marxist Feminism.

3. The names given to each of the two Early Marxist Feminist subgroups here are a matter of degree. The reference to this group being more "orthodox" simply means that their understanding of women's work emerges more directly out of some of the traditionally accepted ideas of Marx and Engels than the housework Marxist Feminists below. The designation "orthodox" in no way means that this group is necessarily "conservative." Far from it, as the remainder of this chapter will show.

In addition to Benston, this group further includes such theorists as Morton (1971), Gerstein (1973), Weir and Wilson (1973), Secombe (1973, 1975), Juliet Mitchell (1971a, 1971b), Vogel (1973, 1977), Rowbotham (1973), Quick (1972, 1977), Guettel (1974), D. E. Smith (1975/76, 1977a), Sacks (1975), Bridenthal (1976, 1977), Muelenbelt (1978), Humphries (1977), Glazer (Malbin) (1978), Larguia and Dumoulin (1973, 1975), Fee (1976), Gimenez (1975, 1978), Gardiner (1975), Women's Work Study Group (1975), and Zaretsky (1976).

According to Kelly (Gadol) (1979), "The finest synthesis of much of this thinking is Sheila Rowbotham's Woman's Consciousness, Man's World. . . . All these studies are contemporary but find their forerunner in Mary Inman, The Two Forms of Production Under Capitalism . . ., originally published in . . . 1939" (p. 226).

Finally, several of these writers can be understood as standing as a transition between the Early and Later Marxist Feminists (for

example, Gardiner, Rowbotham, Women's Work Study Group, Zaret-
sky). Depending on the criteria emphasized, others might classify
them in Chapter 5, instead of in this chapter.

4. In the last year or so, however, this has begun to change
significantly. See, for example, Glazer (Malbin) (1978), Bland et al.
(1978), and Beechey (1978), none of which were available when this
book was first written. The article by Beechey comes closest to the
author's work in critically analyzing both mainstream and Marxist
sociological theories of women's work, although important differences
in interpreting Marxist Feminist theories remain.

5. For discussion of this issue, see Draper 1972, p. 85.

6. For followers of his tradition and what each adds—Engels,
Lenin, Luxembourg, Goldman—see the excellent analysis by Eisen-
stein (n.d.).

7. To be sure, certain Early Marxist Feminists do discuss in
some detail the importance of patriarchy in capitalist society—notably
Mitchell, Dalla Costa, Zaretsky, and Rowbotham. However, while
Mitchell, for example, suggested the autonomous influence of the
family (1971b) and of patriarchy (1974), she still concludes that what
must change for women's liberation is the economic structure of so-
ciety—as the fundamental material base of society. Patriarchy is un-
derstood as ideological, not as part of the fundamental material or
economic base of society, the ultimate source of liberation for women.
Even in her later work, Psychoanalysis and Feminism (1974), while
Mitchell calls for a cultural revolution that calls into question the
Oedipal complex, she still separates out the cultural mode of produc-
tion from the economic mode of production, thereby disconnecting
women's work from the political economy in important ways. Like-
wise, Zaretsky (1976) understands that patriarchy predates capital-
ism. However, since patriarchy is seen as ideological, what is
needed for women's liberation is to abolish capitalism in favor of
socialism—which recognizes a personal side of life, too. For a re-
cent analysis and critique of the Marxist Feminist positions distin-
guishing between patriarchy as mainly ideological or material in
form, see I. Young (1978).

Finally, one should not confuse the fact that Early Marxist
Feminists see women's work in the home as economically essential
labor for capitalism with the fact that they still define patriarchal re-
lations between men and women in the family as primarily ideological.

8. In addition to Marx's Capital: A Critique of Political Econ-
omy (1967a, 1967b, 1967c [3 vols.]), see Engels's The Condition of
the English Working Class in England in 1844 (1958) and The Origin
of the Family, Private Property and the State (1942).

9. See Malos (1978) and Silveira (1975) for discussion of these
changes in Dalla Costa's analysis.

10. This is in contrast with most of the orthodox Marxist Feminists who argue that while women's domestic labor is mystified by men being paid a wage that includes women's labor, the women's domestic labor is fully paid back, at least enough to reproduce herself or itself. See Bridenthal (1977) for discussion of the difference between orthodox and housework Marxist Feminist ideas on this point.

11. For example, see the work of Zaretsky (1976), Larguia and Dumoulin (1973, 1975), Gardiner (1975), Women's Work Study Group (1975) who talk about women's free domestic labor for capital. Among Marxist Feminists discussed in Chapter 5, see Silveira (1975), Benjamin, Joslin, and Seneca (1976), and Malos (1978).

12. For a discussion of the issue of different forms of monies being demanded for women and their implications to a Marxist Feminist analysis, see Malos (1978).

13. Earlier pieces—like Dalla Costa (1972), Larguia and Dumoulin (1973), and Gerstein (1973)—are less likely to thoroughly deal with this issue since focus was on developing the political economy of the housewife's role and, less so, on the relation between home and market or the influence of women's market work back on her home labor. However, more recent analysis, such as Glazer (Malbin) (1978), focuses on women's domestic work in the home as a core position for all women and essential in understanding what happens to women outside the home. She further argues that the social relations outside the family are organized on the presumption that a wife/mother worker is in the home.

Moreover, some of the Early Marxist Feminists clearly and convincingly made some of the necessary connections between women's home and market work in a capitalist society (for example, see Grabiner and Cooper 1973; Mitchell 1973; Morton 1971; Women's Work Study Group 1975). Coulson, Magas, and Wainwright (1975) even argued that the central feature of women's position under capitalism is the contradictory nature of women's work as both domestic and wage laborers.

One of the best-developed and most articulate statements about the importance of women's home labor for what happens to her in the market is given in the very recent work of Bland et al. (1978). Thus, they conclude: "Female wage labour is always premised on women's position economically and ideologically in the family. As we have already argued, it is the patriarchal family in its relations within the processes of capital accumulation which is the site of women's subordination" (p. 55). This piece, which deserves further consideration, draws heavily on the work of Beechey (1978), who clearly argues that the sexual division of labor that consigns women to the family "is determined in the last instance by changes in the mode of production" (p. 196). In her analysis, Beechey clarifies not only the material

basis of the family and women's work in it but also the benefits capital receives from women's domestic labor and their wage labor as they enter the market.

14. It is in response to this situation that Morton (1971) early on explained that women do not play a peripheral role in the labor force. Rather, she says:

> The sense in which women's role in the labor force is peripheral is that women's position in the family is used to facilitate the use of women as a reserve army of labor, to pay women half what men are paid, but women's work in the labor force is peripheral neither to the women's lives nor to the capitalist. [P. 214]

Her devalued position once she enters the labor market, due to her domestic status as organized by capital, is clearly understood here.

15. See, for example, Zaretsky (1976) and Bridenthal (1976).

5
LATER MARXIST FEMINISM:
THEORIES OF PATRIARCHAL CAPITALISM

INTRODUCTION

In this chapter, the basis is laid for the argument that it is
capitalism in combination with patriarchy that together make home
labor a gender-assigned category in contemporary monopoly capitalist
societies like the United States. As such, home labor is not only
gender specific but economically and emotionally disadvantageous to
women.[1] This, in turn, is used against women in the market today.
Moreover, it is capitalism in combination with patriarchy, again,
that together make for the sex-segregated nature of the labor market
itself. This disadvantages women in the labor market and is then
used to justify their position in the home. Thus, a vicious cycle be-
tween home and market labor is established for women.

In short, it is argued in this and the next two chapters that any
attempt to understand women's labor market activity in contemporary
U.S. society must explore not only the dynamic relationship between
the home and the market but also the influence of both patriarchy and
capitalism—as they collaborate and clash with one another—in each
of these spheres of daily living. This provides us with two more
basic building blocks in the analysis of women's labor market activity.

First, what happens to women in the labor market depends not
only on capital's construction of women's economically mystified do-
mestic labor (see Chapter 4) but on the accommodation and conflict
between patriarchy and capital in this process. This means that
both men as a group (including working-class men) and capitalists as
a group (that is, capitalist men) benefit in certain ways—materially
or economically as well as ideologically—from women's home labor.

Second, patriarchy and capitalism operate not only in the con-
struction of women's home labor but likewise work together in creat-

ing women's disadvantaged market labor. Again, both men as a group and capitalists as a group tend to benefit in economic and emotional terms from the sex-segregated job and wage structure in the labor market. It should be clear that this does not mean that working-class men "have it good": in relation to ruling-class men, they are clearly exploited. Relative to working-class women, however, working-class men are materially and emotionally advantaged. This does not mean, however, that the benefits to both capital and patriarchy are based on some theory of conspiracy. As this chapter shows, quite the contrary seems to be true.

These building blocks are an outgrowth of what is important in the most recent thought of Marxist Feminist theorists of patriarchal capitalism. Like the Early Marxist Feminists, this second group of Marxist Feminists is both interdisciplinary and international in scope. It is best exemplified by the work of Heidi Hartmann (1976) and includes several other very recent works.[2]

It is important to understand here the newness and incompleteness of this method of analysis, which is very much in the process of developing. Most of the published materials have appeared only since the mid-1970s; and many of the articles reported on in this chapter are still in unpublished manuscript form. In fact, as this chapter was being written, several of the unpublished pieces on which the analysis is based were published in 1978 in the first full-length book on Later Marxist Feminism: Capitalist Patriarchy and the Case for Socialist Feminism (1978c), edited by Eisenstein.[3]

Marxist Feminist theories of patriarchal capitalism (or Later Marxist Feminism) is itself a second major tendency that has been developing in the 1970s among Marxist Feminist thinkers. This tendency suggests that the Early Marxist Feminists (see Chapter 4) are too limited in focusing solely on the Marxist assumption that women's subordinate position in U.S. and other European societies reflects basically capitalist arrangements. In addition to capitalist arrangements, say the Later Marxist Feminists, one must understand the role of patriarchy as it interrelates with capitalism in the analysis of women's home and market labor.

However, Marxist theory in general does not systematically deal with patriarchal structure and ideology as influential in their own right. Therefore, Later Marxist Feminists have had to incorporate thinking from both Marxist Feminists (whether orthodox or housework or other tendencies) and from a further school of thought—that of radical feminists. Radical feminists (such as Daley 1973; Dinnerstein 1976; Firestone 1970; Millett 1970; Rich 1976) generally assume that the patriarchal organization of male-female relations is the primary determinant of women's inferior position in all societies, not economic relations as defined by Marx.

It is the Marxist Feminist theorists of patriarchal capitalism alone, however, that suggest how one might link up radical feminist thought with Marxism. Later Marxist Feminists do so when they try to show that it is the <u>material and ideological</u> bases of <u>capitalism and patriarchy</u> and their mutually reinforcing and dialectical relationship that provide the greatest understanding of women's inferior position. Not only is women's home activity economically useful to capitalism (as suggested by the Early Marxist Feminists), but women's activity in both the home and the labor market is economically important for patriarchy, too.

The centrality of reproduction in explaining women's disadvantaged position in our society, in general, and in wage labor, in particular, is basic to the feminist analysis. The forms of reproduction are determined in the last instance by changes in the mode of production for Early Marxist Feminists and by male domination for radical feminists. It is only the Later Marxist Feminists, however, who try to show that all the work women do with and through their bodies (physically, emotionally, and socially), not only their biological and social reproduction in the home, is materially essential to patriarchy, the maintenance of male power, as well as to capitalism.

Capitalism operates through a certain kind of male-dominated sexual division of labor. As one Later Marxist Feminist puts it, the sexual division of labor as it is understood can itself be seen as a synthesis of patriarchal and capitalist forms of domination (Eisenstein n.d., p. 44). This is as true for the labor market as for the home.

Thus, the fact that it is women who are responsible for the home in our society, in devalued positions materially and ideologically, is not simply a function of capitalism but of patriarchal capitalism— the interconnection between patriarchy and capitalism as they are formed in a specific historical context. The same can be said with regard to the sex-segregated nature of the labor market itself. The fact that it is women who are recruited into low-status, low-waged, female-dominated occupations in industries with low capital, poor job mobility, limited job security, and little decision-making power is intimately connected to patriarchal capitalism, not capital alone.

In short, it is the author's reading of the Marxist Feminist literature that, on the whole, the earlier group sees the home as constructed by capital and the sexual division of labor in the home as causal of women's problems in the labor market. The later group, on the other hand, sees the sexual division of labor, as constructed by patriarchy in collaboration and conflict with capital in both the home and the market, as essential in understanding problems in each sphere of living. Only by better understanding this two-way relationship can one begin to evaluate more clearly women's activity in the labor market of contemporary U.S. society.[4]

Marxist Feminist theorists of patriarchal capitalism are in-
debted to earlier groups of thinkers—especially Marx and Engels,
writers in the monopoly capital tendency, Early Marxist Feminists,
and radical feminists—for clarifying certain issues. Without the
questions asked by these groups, Later Marxist Feminists never could
have so carefully begun to explore the interacting effects of patriarchy
and capitalism not only on women's home labor but also on their
market labor. However, they do not simply add together the findings
of all these different tendencies of thought. Rather, they reformulate
questions in an attempt to bring the analysis of women in patriarchal
capitalism to a new level.

The multiple, interrelated solutions to women's problems sug-
gested by Later Marxist Feminists revolve around the development
of both feminist and class consciousness. They treat as essential
for the liberation of women changes in the material and ideological
bases of both patriarchy and capitalism—in the home, in the commu-
nity, and in the market. This leads to a call for the elimination not
only of the division of production between home and market or the
division of labor within the market but of the sexual division of labor
as a whole.

The remainder of this chapter is organized in the following way.
First, several key ideas of Marx's that Later Marxist Feminists deal
with and criticize will be specified. Then the major contributions of
Later Marxist Feminism to the author's topic will be shown under the
following four headings: (1) dialectical relationship between home and
market, (2) autonomous influence of patriarchy, (3) women's economic
contribution to patriarchy, and (4) crucial interaction of patriarchy
and capitalism in both the home and market.

HERITAGE OF MARX AND THE EARLY
MARXIST FEMINISTS TO THE
LATER MARXIST FEMINISTS

In Chapter 4, it was concluded that Marx's work contains a
critique of the social division of labor itself, not of the sexual division
of home and market production per se. It was further suggested that
the Early Marxist Feminists dealt with several issues slighted by
Marx and Engels. Several underlying assumptions by Marx and
Engels, however, are neither challenged nor clearly specified by the
Early Marxist Feminists. These include the following two questions.
First, Why was it women in the first place who became responsible
for child care and housework in a capitalist society? That is, the
sexual division of labor itself is never questioned but is taken as a
given. Second, How can one desegregate the sex-stratified nature of

the labor market and jobs that might well emerge if children were reared collectively and household tasks were socialized?

Thus, the sexual division of production within the labor market and the way in which patriarchal relations operate to assign women to subordinate positions in the labor hierarchy of the market are never really questioned either. In short, the sexual division of labor in the home, in the market, and in the society at large is taken as given. It is precisely this problem with which the Later Marxist Feminists deal.

Here, briefly, are each of the key assumptions that the Later Marxist Feminists inherited from Marx and that they now challenge.

Patriarchy as a Function of Capitalism

According to Marxist theory, private property in the hands of men at a particular period in historical development and the accumulation of capital lead to patriarchy—and thus the "world historic defeat of women." In particular, capitalism intensifies women's economic dependence on men as it dramatically isolates domestic from industrial labor in modern capitalist development. Thus, capital almost exclusively causes the problems faced by women as a group. Women's oppression is but another consequence of the class division of labor: the "wage labor slave" and the "domestic slave." On this basis, according to Marx and Engels, the exploitation of men and women derives from the same source and hence is understood in the same structural terms.

Marx and Engels understand patriarchy as dependent on the rise of private property, the state, and class relations. They did not understand that male domination had any real autonomous influence on the lives of women. The overthrow of capitalism, so they argued, would lead to the elimination of the family and women's role in it along with the relation between wage labor and capital.

Sexual Division of Labor as "Natural"

While sharply opposing sexual inequality up to a point, Marx and Engels at the same time treat the sexual division of labor as natural. To them, it flows from the sex act itself. In preclass society, they see this division of labor imposed by the family as natural and extending outward to organize the rest of society. But only the development of class society transforms the family and the sexual division of labor into an economic unit that itself reflects a new economic order that defines and surrounds it. This two-way dynamic

(between the family and the larger society and between the economic order and the family) is never developed in the Marxist analysis of "the woman question." In an excellent analysis of this problem, Eisenstein concludes (n.d.):

> It appears contradictory that Engels acknowledged male/
> female relations within the family as defining the division
> of labor in society and yet completely subsumes them un-
> der categories of analysis related to production. He of-
> fers no explanation that could dissolve this dilemma be-
> cause it stands outside the terms of his analysis. [P. 13]

One needs, continues Eisenstein, to understand the sexual division of labor as a feature of patriarchy. In turn, that allows women's oppression to be "understood as similar although distinct from the 'general' oppression of the proletariat" (p. 9).

It is important to note here that one must understand the sexual division of labor not in biological terms alone but also socially and historically, within the context of certain social constraints. This can lead to a truly dialectical Marxist Feminist theory of the interconnection between family and society. The point is not to deny the importance of material relations in understanding the position of women (as stressed by the Early Marxist Feminists) but to realize that the opposite likewise holds true: just as class creates kin, family, and the sexual division of labor, the family and the sexual division of labor create class. One without the other would make capitalism and the position of women in it impossible.

Women's Inherent Physical Weakness

Marx's assumption about the sexual division of labor was based in large part on the ascription of the supposedly inherent physical weakness of women in early society (Marx and Engels 1947) as well as in capitalist society (Marx 1967a). Although this idea was later rejected by Engels, it is clear that Marx did not have available contemporary studies of women's greater strength and stamina in many societies. (See S. Goldberg [1973], a traditional functionalist sociologist who even agrees with this. He says that it is inherent male superiority—aggressiveness—that gets women to do the heavy work—when that is the case.)

True, Marx (1967a) pointed out that in industrial capitalism women's labor was cheaper not only because of their greater physical weakness. It also cost less because they did not have a tradition of craft organization as the men did as well as because they were said to be more docile (p. 402).

All the same, Marx's argument that machines allowed the weaker labor of women and children to be utilized rests on his notions about women's inherent physical weakness and is basic to his argument. As he says,

> In so far as machinery dispenses with muscular power, it becomes a means of employing labourers of slight muscular strength, and those whose bodily development is incomplete, but whose limbs are all the more supple. The labour of women and children was, therefore, the first thing sought for by capitalists who used machinery. [P. 394]

Weakening of Patriarchy in Advanced Capitalism

Classical Marxist theory asserts that the traditional sexual division of labor would be eliminated in the main with advanced capitalism. The causes are multiple. Only two are mentioned here. First, Marx argued that sex and age differences within the working class would be eliminated in advanced capitalism, where a basic requirement of the labor force would be as much homogeneity as possible.

The greatest profit is possible by creating simplified tasks with little decision-making power, where workers are readily substitutable for each other. This does not mean that the workers are unskilled. To the contrary, the logic of Marxist theory is that the types of laborers to be required for the changing needs of monopoly capitalism would be more skilled blue-collar, white-collar, and professional workers—with fewer agricultural, unskilled blue-collar, and traditional service workers and domestics (see Szymanski 1974b). The homogeneity of the labor force that is anticipated by Marx and Engels with modern industry is addressed in several places. Two are quoted here. First:

> The less the skill and exertion of strength implied in manual labour, in other words, the more modern industry becomes developed, the more is the labour of men superseded by that of women. Differences of age and sex have no longer any distinctive social validity for the working class. All are instruments of labour, more or less expensive to use, according to their age and sex. . . .
> The various interests and conditions of life within the ranks of the proletariat are more and more equalized, in proportion as machinery obliterates all distinction of

> labour [that is, sex and age here], and nearly everywhere
> reduces wages to the same low level. [Marx and Engels
> 1954, pp. 19-21]

And next:

> That mighty substitute for labour and labourers [that is,
> machines], was forthwith changed into a means for in-
> creasing the number of wage-labourers by enrolling, un-
> der the direct sway of capital, every member of the work-
> man's family, without distinction of age or sex. Compul-
> sory work for the capitalist usurped the place, not only
> of the children's play, but also of free labour at home
> within moderate limits for the support of the family.
> [Marx 1967a, pp. 394-95]

In this way, Marx believed the increasingly homogeneous work-
ing class would be able to achieve a greater class consciousness,
leading to an understanding that the hope for a humane and decent so-
ciety lies in struggling against capitalism, not men.

Second, Marx believed that the traditional sexual division of
labor was being broken down in the working-class family as more and
more married women entered wage labor. While this made women
less totally economically dependent on their husbands, Marx did not
understand that even if women enter wage labor—even in a socialist
society—they continue to be materially and psychologically exploited
as women.

Two problems emerge in Marx's understanding of the diminish-
ing importance of patriarchy in capitalism. They will simply be men-
tioned here. On the one hand, Marx and Engels lament the passing
of the working-class family as capital expands its influence and brings
women and children into wage labor. For them, since there was lit-
tle or no private property in working-class families to begin with,
there was believed to be little if any inequality between husbands and
wives. Male advantage and domination was not seen as an integral
part of this analysis. Moreover, as fewer and fewer people held pri-
vate property in a society dominated by wage labor, they believed,
the decline in patriarchy in the working-class family was seen as
most probable.

On the other hand, it was mainly in the bourgeois family—where
women were used as "instruments" owned by, or at least controlled
by, men to reproduce the heirs who would inherit wealth—where sex-
ual inequality was believed to exist. However, as the twentieth cen-
tury advanced, the extension of the bourgeois ideal to the working
class occurred, while wage labor was simultaneously extended. While

Marx believed that patriarchy would diminish—almost to the point of vanishing—the later Marxist Feminists show that although patriarchy has certainly been transformed since Marx's time, it is alive and more or less well in the family and outside it.

A second problem exists in Marx's thinking of which he is never aware. This problem, too, points to the need to understand patriarchy and capitalism as working together. Marx asserts that women do not have control over their bodies and their labor power under capitalism. This is a consequence of the fact that in capitalism women are the private property of men. The social relations between the sexes is grounded within the system of production. Thus, when a woman enters wage labor, according to Marx, she is owned and controlled by her husband as he exchanges her labor power with the capitalist. Marx (1967a) writes:

> Taking the exchange of commodities as our basis, our first assumption was the capitalist and labourer met as free persons, as independent owners of commodities; the one possessing money and means of production, the other labour-power. But now the capitalist buys children and young persons under age. Previously, the workman sold his own labour-power, which he disposed of nominally as a free agent. Now he sells wife and child. He has become a slave-dealer. [P. 396]

So contrary to Marx's general assumption that capitalism frees the worker (see Chapter 3), when a woman enters the labor market, she is not free to sell her own labor power in the same way as a man because it is owned by her husband, not herself.

The fact that men are freed by capital to sell their labor to the capitalist is much more complicated for women. Even Marx recognizes this but glosses over it in his analysis and does not deal with the problems inherent in this analysis. Only by applying the Later Marxist Feminist approach can one deal with such problems.

Women's and Men's Reproduction of
Their Own Labor Power

In capital's quest for expansion, all spheres of activity are affected—including the home. As just noted, Marx held that the goal of reducing all people to the status of paid workers in a homogeneous labor force leads to the treatment of men and women as equals in this regard.

Marx and Engels believed that the working-class population would become wage laborers where everyone would be exploited indi-

vidually as wage laborers reproducing their labor power through their own individual means of consumption/reproduction. With the introduction of women and children into the labor force, they thus believed that each person would reproduce their own labor power on the job and that the individual male breadwinner's consumption through his wife at home would no longer be the primary means of replenishing labor power for capital. In this way, the whole family would be brought into the labor market under the control of the male head— that is, under patriarchal control. This would permit cheaper labor (women and children) to be brought under the direct control of capital, paying them less so that the more skilled laborer (presumably the adult male family head) would not spend so much time on lesser tasks. As Marx (1967a) says:

> The value of labour-power was determined, not only by the labour-time necessary to maintain the individual adult labourer, but also by that necessary to maintain his family. Machinery, by throwing every member of that family on to the labour-market, spreads the value of the man's labour-power over his whole family. It thus depreciates his labour-power. To purchase the labour-power of a family of four workers may, perhaps, cost more than it formerly did to purchase the labour-power of the head of the family, but in return, four days' labour takes the place of one, and their price falls in proportion to the excess of the surplus-labour of four over the surplus-labour of one. In order that the family may live, four people must now, not only labour, but expend surplus-labour for the capitalist. Thus, we see that machinery, while augmenting the human material that forms the principal object of capital's exploiting power, at the same time raises the degree of exploitation. [P. 395]

Thus, each member of the family works directly for capital, which obtains profits from their surplus labor. Simultaneously, the labor power of all family members—irrespective of age or sex—is reproduced at a cheaper cost to the capitalist.

The logic of this analysis, if carried to its extreme, would lead to the meeting of all human needs through the wage labor-capital relation and thus eliminate both women's role and the family's in their separate economic and psychological functions for capitalism. This is what Marx actually feared—as did capital.

But the family was not destroyed, and the role of women in the family has not been eliminated. A hundred years later, one can now see why not. The Later Marxist Feminists do just that by stressing

what takes place between patriarchy and capitalism in our own time and place. The discussion will now turn to this topic.

The rest of this chapter focuses on the dialectical relationships revealed by Marxist Feminist theory between the major building blocks of patriarchal capitalism as they relate to women's work.

DIALECTICAL RELATIONSHIP
BETWEEN HOME AND MARKET

The Later Marxist Feminists challenge the sexual division of labor between home and market taken for granted by the Early Marxist Feminists, along with Marx and Engels. In a sense, one could say that instead of asking about the "political economy of housework" or the "political economy of sex," itself a major step forward in thinking contributed by Early Marxist Feminists, Later Marxist Feminists are now beginning to ask questions in terms of the "sexual political economy of production" (Weinbaum 1978), the "gender-class structure" (Hartmann 1979), and the "sets of social relations" of work, sex, and race (or class, sex/gender, and race) (Kelly [Gadol] 1979).

For example, several Later Marxist Feminists early on looked at the sexual division of production itself (see New American Movement Political Perspective 1972; Somers 1975) in explaining the two-way relationship between home and market responsibilities of women and men. Analyzing the organization of society in this way makes clear that capitalism operates through a sexual division of labor. In this perspective, the sexual division of production occurs between the home and the market, whereas the sexual division of labor occurs within both home and market. The two are so inextricably interconnected that they are oftentimes experienced as one and the same. Thus, "A housewife is a woman: a housewife does housework. A housewife is a woman who manages or directs the affairs of her household; the wife of a householder. . . . A man cannot be a housewife. A man who says he is a housewife is an anomaly" (Oakley 1974, p. 1). In fact, a man may do housework, but he is never considered a housewife.

Another way that Later Marxist Feminists have of understanding the sexual division of production is as follows: the industrial phase of capitalism is clearly responsible for the intensified division of the home and the market into two spheres as they have come to be experienced and understood. However, it was not capitalism that kept and put women in the home and placed men in the labor market as their primary responsibilities. Rather, it was patriarchy, the product of alliances and struggles between ruling-class and working-

class men, which in turn affects the lives of the vast majority of
women. By the same token, patriarchy made the home "woman's
place." Thus, Engels's characteristic workers—the proletariat and
the housewife—have as their underlying social relations the sexual
division of production as organized by patriarchy within a specific
historical period of capitalist development.

To say that the home and market are gender-assigned spheres
of responsibility with serious disadvantages to women is not to deny
that men and women are found in those spheres where the other sex
holds prime responsibility.[5]

Thus, for example, as industrialization was emerging in the
mid-nineteenth century United States, women and children were prom-
inent among the first factory workers, especially in the New England
clothing mills (see Baxandall, Ewen, and Gordon 1976; Pinchbeck
1969). As the factory system was developing, men were still mainly
involved in agricultural production. However, as wage labor became
more important in the period of developing capitalism (late nineteenth
and early twentieth century), the transition of female to male wage
labor, on the whole, is documented (Hartmann 1976). This is ex-
plained by one Marxist Feminist in the following way: women are al-
lowed more control or responsibility in those areas of lesser impor-
tance (C. Brown 1979).*

Moreover, it should be clear that men and women have always
had certain tasks and responsibilities in each other's spheres. That
is, while the home and market are predominantly gender-assigned
areas of social relations, within each sphere the sex segregation of
labor maintains itself in very clear terms. That is, sex roles exist
within each sphere of the home and the market. Thus, not only had
women been, and still are, assigned certain jobs and payments on
the basis of their gender in wage labor before industrial capitalism
(for example, the bye system or in agriculture) (see Bridenthal and
Koonz 1977; Pinchbeck 1969), but men were also allocated certain
gender-assigned tasks in the home. In her manuscript, Ascher
(Lopate) (n.d.) suggests the importance of fathers as disciplinarians;
they had legal responsibility for their children (see also Aries 1962).

*Based on this principle, Brown also argues that, at the begin-
ning of industrialization in the United States, when children were
economically productive members of the family in agrarian society,
men claimed them and were given legal priority in contested custody
cases. But as children became unproductive, in fact costly to care
for, women suddenly became absolutely necessary for a child's
proper growth and development, and mothers were granted legal pri-
ority in custody cases.

With the expansion of markets and the introduction of increas-
ingly larger numbers of women into wage labor and of men in doing
certain limited household tasks in the twentieth century,[6] two features
have become increasingly clear: women are found in the male world
of work; and men are found in the female world of the home and family.
(The author will not address men's home and market activity in any
great detail. Both are essential in understanding what happens to
women and must be further explored in a Marxist Feminist analysis.)
This holds true despite the fact that the vast majority of employed
women are likewise homemakers and mothers and thus experience
the "double day." Further, men who engage in domestic labor are
likewise heads of households and considered the major or primary
family breadwinners. Men do not experience the double day as women
do. And as women enter wage labor, the sexual division of labor does
not disappear. In sum, despite the fact that women and men are
found in each others' spheres, the gender-assigned nature of domes-
tic and market labor makes women's primary responsibility the
home—even when she is in the market. The reverse is not true for
men. What is important to study here, according to the Later Marx-
ist Feminist analysis, is both the sexual division of production be-
tween the home and market as well as how the two spheres interact,*
all the time understanding full well the gender-assigned labor that
likewise occurs within each sphere of daily living, too.

To conclude, the relationship between the home and market
must be understood as dynamically interdependent or two-way. One
must understand not only how the home influences women's experiences
in the market but also how the market influences women's experiences
in the home. To do this, one must learn more about the nature and
influence of patriarchy in modern capitalist society. This topic is
discussed in the next section.

AUTONOMOUS INFLUENCE OF PATRIARCHY

Even if one argues that patriarchy is a function of class rela-
tions, say the Later Marxist Feminists, once it is clearly established,
patriarchy takes on a life of its own. (This is in contrast to those

*Recall that the Early Marxist Feminists only dealt with the re-
lationship between home and market in one direction: how the home
influenced the market position of women. Later Marxist Feminists
now suggest that one must look at both directions: in addition to the
home affecting the market, the market affects the home, and on and
on.

Early Marxist Feminists who understood patriarchy to be autonomous but primarily ideological.) The institutions of patriarchy have real consequences—not just ideological but material, too—for women's lives. In relation to present-day capitalism, in no way should one treat it simply as an epiphenomenon or as a superstructure. Patriarchy must be analyzed as a force in its own right.

Early Marxist Feminists made clear that women in the home provided economically essential labor for capital. Marxist Feminists have spent much time in making understandable the material as well as the ideological forms of patriarchy. They show that women provide economically important labor for patriarchy as well as certain emotional, psychological, and sexual services and support for men.

Patriarchy is a set of social relations of power that enables men to control women; this power is grounded in the hierarchical relations between men, who benefit materially and ideologically from the exploitation of women's labor.[7] This definition includes the idea that patriarchy is a system of hierarchy, order, and control both among men and of men over women. By referring to both economic and cultural components of these relationships, it allows one to understand such hierarchy and control in the family, in the polity, in the economy, and so forth.

Men as a group share not only the material beneifts from the exploitation and control of women's labor but also a gender interest in maintaining their position of dominance. This aspect is usually referred to as sexism or male chauvinism.

Thus, patriarchy is more than hierarchy.[8] Just as Marx's categories of class are more than hierarchy and refer more appropriately to class conflict (including a material base and class consciousness), so, too, patriarchy is more than hierarchy. It could be said to refer to gender conflict, including a material base of women's labor and gender consciousness. In this way, one can understand contemporary and historical patriarchal societies to consist of a system of relations establishing interdependence and interest among men that enables, and even requires, them to dominate women.

Several cautionary notes are important here. First, patriarchy —as an institutionalized form of material and ideological male benefit and dominance, whereby men are hierarchically related and thereby given control over women—is not a simple idea. Some men clearly have more benefits accruing from women's labor than other men. Thus, the benefits a man gets from patriarchy vary by his class position. But within the different social classes and strata, all men have privileges over women. While only some men (those of the ruling class) are granted privileges over all women, all men (men from all classes and strata) have privileges over some women. As C. Brown (1977) says:

The higher a man is in the class structure the greater his
benefit from other men's production and from the repro-
ductive services of his wife, his servants, his female em-
ployees and all the pretty girls whose job it is to please
businessmen. The lower a man is in the class structure,
the less his direct benefit from production and the fewer
women's services he can command. [But benefit from
women's services he does do.] [P. 4]

Second, male gender interest shared by men throughout the
hierarchy should not lead to the conclusion of conspiracy. Just as
one understands that the ruling class maintains itself through the sys-
tem of capital and not through conspiracy, so, too, it should be clear
that the male gender interest maintains itself through the socially in-
stitutionalized system of patriarchy—as a part of the normal function-
ing of the system of patriarchy itself and not through a set of plots.

Third, patriarchy cannot be understood as an ahistorical gen-
eralized universal phenomenon unto itself. Rather, just as one must
understand the class struggle in different historical periods—feudal-
ism, capitalism, socialism—and how this influences women's lives,
one must likewise understand patriarchy in different historical periods
and how it varies over time.* Contemporary monopoly capitalist re-
lations of patriarchy developed from industrial capitalist as well as
precapitalist forms of patriarchy. One must understand how the
forms arising from each are maintained and transformed within our
own historical period.

Radical Feminists on Patriarchy

Later Marxist Feminism has taken from radical feminism the
idea that patriarchy has real and important consequences for women's
lives in capitalism. The autonomous contribution of patriarchy to
women's position in Western society was not part of the Marxist

*In fact, while the term patriarchy is used for the remainder of
this book (in contrast to such terms as gender subordination, sex/
gender system, sexism, and sexist structures), a debate is now on-
going as to the appropriateness of this term. For two different ap-
proaches, see Hartmann (1976) and G. Rubin (1975) later in this chap-
ter. Whatever the differences in terminology, all Marxist Feminist
theorists of patriarchal capitalism agree that patriarchal relations
must be grounded within their particular historical circumstances
and must not be dealt with as ahistorical, generalized universal phe-
nomena.

framework. It was the radical feminist community, clearly anticapitalist but not Marxist in its thinking, who, early on in the contemporary women's movement, suggested that the way to end economic class exploitation is to eliminate what it calls the "first class exploitation" on which capital rests. By this they mean the biological mother-child relationship, the biological family, or the biological male-female distinctions that determine social functions as well as power in society—in short, the system of patriarchy itself. Thus, as Rich (1976) concludes in her analysis of motherhood as the essential patriarchal institution in society: "The repossession of women of our bodies will bring far more essential change to human society than the seizing of the means of production by workers" (p. 285).

One of the earliest and major treatments of patriarchy by the radical feminists was that of Millett's Sexual Politics (1970). In her "Notes toward a Theory of Patriarchy" (chapter 2), Millett argued that men dominated women both as individuals and as a group. Thus,

> the fact [of patriarchy] is evident at once if one recalls
> that the military, industry, technology, universities,
> science, political office, and finance—in short, every ave-
> nue of power within society, including the coercive force
> of the police, is entirely in male hands. As the essence
> of politics is power, such realization cannot fail to carry
> impact. [P. 25]

This made it clear that for women the personal is political. Among other things, this means that the social relations between women and men, although they may be due to larger social and economic forces beyond individual control, are played out at the level of the individual. Women's discontent is not just in their minds but is oppression felt at a personal level owing to the patriarchal attitudes and structures of our society.

Millett further understands the principles of patriarchy as twofold: "that male shall dominate female" and "elder male shall dominate younger" (p. 25). Prior to the radical feminist reintroduction of the term patriarchy, the contemporary relations between the sexes were treated by mainstream social science as simply sex (biological) or gender (social) differences—not necessarily sex or gender differences that implied hierarchical relations among men along with hierarchical relations of men over women.*

*This is particularly interesting since recent analysis of Max Weber's definition of patriarchy indicates that "the concept of patriarchal authority, in Weber's use, refers to cross-familial social in-

A second major early figure in radical feminist theory was Firestone (1970). According to her, patriarchy is a biologically rooted power structure of men over women, which is translated into gender identities. The reason that women end up doing child care and housework in our society, according to Firestone, is because of their biological reproductive function—that is, because of motherhood. Moreover, she highlighted the relationship between biological maternity, "mothering," and the socially developed gender differences based on it. Her attempt was to get at the underlying material base of patriarchy itself.

Thus, according to Firestone, instead of the underclass (proletariat) seizing the means of production to end economic classes, what is necessary for the

> elimination of sexual classes requires the revolt of the underclass (women) and the seizure of control of reproduction: not only the full restoration to women of ownership of their bodies, but also their (temporary) seizure of control of human fertility—the new population biology as well as the social institutions of childbearing and childrearing. [Pp. 10-11]

In this way, she continues, "not just the elimination of male privilege but of the sex distinction itself [would occur]: genital differences between human beings would no longer matter culturally" (p. 11). The solution is possible through a technology that would no longer require women to reproduce babies by means of their own bodies—"since this is the basis of patriarchal power for men" (p. 11).

Firestone's analysis revolves around the idea that it is genital and reproductive differences between men and women that cause women's subordination to men in all societies. These biological differences are based on inherent female biological inferiority, accord-

tegration into the manor or Household, and only by inference to relations within families. It is, thus, primarily a referent for relations between men, the relation between Master and serf. It is, thus, a term which refers to the ordering of political and economic action, not familial action" (Jacobson and Kendrick 1978, p. 9). Although the use of the term patriarchy in this way clearly limits it in relation to women in the family system and not in the labor force, it is interesting that mainstream sociology has again typically misused (or disregarded) much of Weber's contributions with regard to an understanding of patriarchy as they did in terms of social class (see "A Critique of Status Attainment Theory," Chapter 1).

ing to Firestone. She argues that historically pregnancy made women weaker, leading to male dominance. Thus, it was not male strength but the weakening factors of female pregnancy that led to women's domination by men.

The major criticisms of Firestone's analysis are, first, that while more than biology is used to oppress women, she sees woman's biology as inherently oppressive rather than defined as such by the socially constructed world around her. Thus, while Firestone tries to establish women's sexuality and biological maternity as the material base to patriarchy, a perspective long avoided by orthodox Marxism, she fails to understand the importance of the society's evaluation of that biology, which varies in time, space, and historical period.

And, second, while her analysis zeroes in on women's oppression as a product of female sexuality, it does not view such oppression as a dimension of a complex social oppression. Not only does she fail to deal with the context in which women operate; but, as one commentator suggests, "the thrust of Firestone's analysis is to isolate sex oppression from the economic organization of society" (Eisenstein n.d., p. 33). Further, she says, Firestone's "insistence on seeing women as either sexual beings or economic beings moves her away from dealing with the complex mix of woman's existence" (p. 29). Instead, what is needed is an understanding of the dialectical relationship between the sexual and economic oppressions experienced by women.

In general, however, radical feminism fails to see that capitalism has its own autonomous roots and oppression, just as patriarchy does. The class oppression and exploitation of capitalism is not a mere evolutionary offshoot of sexism. It has its own independent historical causes.[9]

In sum, what the radical feminists did for Marxist Feminists trying to understand the basis of women's position in contemporary society was to raise the issue of the importance of patriarchy as a system that must be contended with in its own right to understand women's position in capitalism. They saw the importance of trying to understand the relation of the family itself to the economy, as well as the importance of gender socialization to culture and the maintenance of a conservative society. It is Later Marxist Feminists, however, who have raised the issue of how the institution of patriarchy varies with the slave, feudal, capitalist, and socialist stages of society as well as the legacy that is left in moving from one stage of organization to another (see Bridenthal and Koonz [1977] for one set of readings on this subject).

Furthermore, the radical feminists provided a materialist context or conception of sexuality in which it was said to be important to explore the social relations of reproduction—that is, to understand

that the material base of patriarchy is the work women do in reproduc-
tion. Finally, it has been the radical feminists who have eloquently
explained what it feels like to be oppressed as a woman in contem-
porary society. Thus, the recent work of Dinnerstein (1976) and
Rich (1976), as well as parts of Firestone (1970), describe the inten-
sity and power with which love, motherhood, and sexuality are inter-
nalized within our psyches to reproduce the very system of female
oppression that feminists so ardently oppose. (It is here that the ref-
erences to Freud have become so abundant in much of the radical
feminist analysis.)

Origins, Development, and
Historical Change of Patriarchy

Several Later Marxist Feminists have found it necessary to ex-
pand on the concept of patriarchy: from that of male power over fe-
males (especially in its social as well as its biological constructs)
to a more historically differentiated understanding of relations both
among men and between men and women and the interrelationship be-
tween these two features of hierarchy and domination. The movement
and relationship of patriarchy between public and private hierarchies
in specific historical periods is also an important aspect of their
analysis that is singled out here.
Mitchell (1971a, 1971b) was the first of the Marxist Feminist
community to bring to light the autonomous influence of sex/gender
systems and the family in capitalist society. Mitchell is not a Later
Marxist Feminist as defined in this book.[10] She has nonetheless
helped guide the work of many Later Marxist Feminists by suggesting
that Marxist Feminists must take into account the independent contri-
butions of women's sexuality, the family, and kinship—that is, con-
temporary patriarchal structures and relations—in any analysis of
women's position in capitalist society.
This became further clarified in work by G. Rubin (1975). Her
analysis of the political economy of the sex/gender system led to the
following two conclusions. First, sexuality, gender, and family
systems "are themselves social products" with their own historically
determined relationships in which material production, wealth, ex-
change, power, and dominance exist, as well as thoughts, feelings,
and sensibilities. And second, "Not only do reproduction and kinship,
or the family, have their own, historically determined products, ma-
terial techniques, modes of organization, and power relationships,
but reproduction and kinship are themselves integrally related to the
social relations of production and the state; and they reshape those
relations all the time" (quoted from Petchesky [1978, p. 377], in her
comments on Rubin).

Among the Later Marxist Feminists, at least two major groups have begun to emerge around the question of the origins of patriarchal forms of sex/gender systems. The two groups split from each other on the issue of the timing and dynamics of the origins of patriarchy.

One believes that preclass, prestate societies were differentiated on the basis of sex and age but were nonetheless marked by a primitive form of communism in which egalitarian economic, social, and sexual organization existed. It is only when a single hierarchical system emerges between the sexes that the one becomes male dominant. Women and men both engage in productive and reproductive relations. The entire group shares decision making and responsibility for food, shelter, and children (see Leacock 1977b; Muller 1977; Reich 1966; Sacks 1975). In the few cases that hierarchies have been said to exist within each gender group, they were parallel, not female subordinate.

The other group argues that even in prestate, preclass societies, women do not have control over their own labor power or their bodies. Men give and take women as gifts. A woman is the conduit of a relationship between men, the link but not a partner to it. Thus, it is the men who have power over the women. Kinship and marriage are organization, and organization gives power. Women are the property of men and are thereby subordinate to them—even before the development and institutionalization of private property and capitalism (see Hartmann and Bridges 1977; Ortner n.d.; Rosaldo and Lamphere 1974; G. Rubin 1975).

However, these debates about the origins of patriarchy are less important than the main point on which the two groups agree as Later Marxist Feminists: whatever the specific origins of patriarchy in general, one must analyze the particular patriarchal relations that exist within each historical period within society.

What is in fact known about the origins of male-dominated sexual hierarchies is summarized by Rapp (Reiter) (1976, 1977) as she looks at the suggested effects of capitalism, the pristine state, and the qualities of life in original primitive society.

She concludes that the research is in a state of emergence and that the answers are not yet known. However, several tentative conclusions are possible with current knowledge, especially learned in the past decade or so with active feminist questions and concerns being investigated. Her review focuses mainly on the work done by anthropology.

First, prior to modern political economic hierarchies of capitalism, which oppress women, there exist more ancient layers of gender differentiation and discrimination. However, research has a long way to go before it is known when, under what conditions, and in whose specific interest the sexual division of labor in preclass

societies is a relation of male domination and when it is simply a division.

Second, the devaluation of the roles, activities, and ideologies associated with women is part and parcel of the process of the destruction of kin-based organization and the origin of the state as a major solidification of class and gender differentiation in which virtually all forms of kingdom and empire have ultimately been founded. As Rapp (Reiter) (1977) says, although anthropologists disagree on the degree of women's autonomy in precapitalist society, all agree "with the rise of civilization and the state, women as a social category were increasingly subjugated to the male heads of their households. That is, civilizations are properly described as patriarchal" (pp. 7-8).

Third, while studies of primates, archeological materials, and contemporary foraging populations do not eliminate the issue of male dominance in primitive society, they certainly do suggest that a great deal more flexibility in gender roles exists than was formerly believed.

Various attempts have been made to better understand the development of patriarchy in different historical periods. Several of these are examined here. Specifically, the work by Ortner (n.d.), Petchesky (1978), Hartmann and Bridges (1977), Hartmann (1976), C. Brown (1975a, 1975b, 1977, 1979), and Silveira (1975) will be looked at.

According to Ortner (n.d.), even in the most primitive known societies, some sort of asymmetry between the sexes existed, giving men some edge of authority or charisma or status.[11] While women may have their sacred ceremonies (in slightly more complex band societies) from which men are excluded, the male ceremonies are considered to be for the group welfare, the women's specific to welfare of women. The diffuse authority of charisma is transformed into the beginnings of real power and control through male control of the marriage system, in the exchange of women and goods, in the most complex known band societies. In such societies, male-female relations remain within the range of band societies: from relatively mutualistic and balanced to extreme cases of real sex antagonism—with male self-segregation and strong expressions of fear of women as dangerous. In this case, women are excluded rather than systematically dominated and controlled (according to Ortner), allowing them considerable autonomy and parallel social power.

The power of males in these groups is founded on the basis of their collective adult maleness—embodied in secret cults, men's houses, warfare, exchange networks, ritual knowledge, initiation procedures, and the like—not individual male control over an individual woman.

With the rise of the state, the domestication of both men and women began to occur in the form of the patriarchal extended family.

Here, instead of collective male advantage is begun to be practiced individual male control within the extended family. Thus, Ortner suggests, the beginnings of the domestication of men—as husbands/ fathers and sons—is part of a larger pattern of systematization of hierarchy and control in the evolution of state structures themselves. This, in turn, is the foundation of the "domestication of women, . . . wherein women, like plants and animals, were brought under control in the service of the race" (p. 12).

Ortner continues:

> What I think was at issue was the gradual deepening of in-
> volvement of individual males in responsibility as husbands/
> fathers, for their specific family units, not just economic
> responsibility, for that was always accepted, but also what
> might be called political accountability. The family became
> in a sense an administrative unit, the base unit in the polit-
> ical economic structure of the state. The husband/father
> was no longer simply responsible to his family, but also
> for his family vis-à-vis the larger system. It became the
> base, and often the only base of his jural status. [Pp. 16-
> 17][12]

Moreover, concludes Ortner, the idea that males were to be legally and politically as well as economically responsible for the proper functioning of the family unit—seen as a unit—appears to have been part of the "systematic extension of principles of hierarchy, domination and order in the evolution of states as a whole. Responsible husbands/fathers are better subordinated in the system" (emphasis added). Likewise, patriarchal husbands/fathers are then responsible for keeping those under their jurisdiction in line (p. 17).

Thus, patriarchy refers to a system of control by elder males over younger males—who, if they are kept in line until their own maturity, will work their way into the rewards of the patriarchal system —and all women. This occurs within the context of the development of the individual family (extended or nuclear) along with the separation of public (social) and private (domestic) spheres, increasing surpluses, and the emergence of the state—its hierarchy, order, and control. With the virtual disappearance of male initiation rites in state society, suggests Ortner, marriage itself typically becomes the rite of passage. Manhood becomes equated with responsibility for wife and children. In our own society, manhood is associated with being the family breadwinner; womanhood with being a mother (see Pleck [1976] for a modern-day interpretation of this).

Finally, Ortner tells us, the crystallization of patriarchal family corporations was a precipitate of larger political and economic

processes. Once patriarchy "got going, it became a social form in its own right, affecting not only the further evolution of sex role relations, but the economic and political evolution of the larger system itself" (p. 19).

As Petchesky (1978) also suggests, just as the state upholds the man as the head of the household, so, too, patriarchy in the home underwrites an emergent state power. It is a two-way relationship. Once more, as capitalism takes shape, a patriarchal family system molds it as much as capitalism changes that family.

Here one must consider not only the material importance but also the ideological power of male dominance. In the course of Western state development, it appears that antiwomen ideologies and the material exploitation of women attempt to resolve disorders arising from severe class division and social instability, or from heightened militarism and warfare, in which the state develops as a general antidote to social disorder. The method of resolution of the disorder among men is "by unifying groups of men across class lines around the abstract notion of 'citizenship'" (p. 384). Hence, the state is based on both class and sexual footholds.

Petchesky suggests this was true in fifth century Athens as well as in the rise of the modern bourgeois state. She quotes C. Hill (1967) and Zaretsky (1976) to show that the commonwealth emerging from the English civil wars represented a victory for male heads of households, all the while "obscuring both the exclusion of the majority of men from liberty as well as the economic and social contradictions within the citizen body itself" (p. 385). By the eighteenth century, the definition of citizen was solidly male, with a silent partner who is female—dependent, docile, and domesticated. As Petchesky concludes:

> I am suggesting that misogynistic ideology and institutions help to legitimate the bourgeois political ideology of "liberty and equality" for all males, serving thus to secure national (male) unity, loyalty, and military service, among other things. The ideology of legitimate and illegitimate birth itself not only functions as one prop or patriarchal control over the means of reproduction, discussed above; it also helps to elevate and mystify the very notion of citizen. [P. 385]

As a third example of Later Marxist Feminist thought on the historically specific development of patriarchy, Hartmann and Bridges (1977) may be cited. They provide two examples that illustrate the development of systems of dependence and hierarchy with a material base among men and the importance of these relationships

in vastly different societies in helping men to dominate women. It is their desire to develop a meaningful historical analysis of specific forms of patriarchy.

First, they analyze the work of Meillassoux (1973) on primitive agricultural societies in West Africa. Second, through the work of C. Hill (1967), they illustrate a patriarchal form of society in Puritan England. The author's interest in their work focuses around the particular ways in which they show how emergent industrial capitalism utilizes or organizes the hierarchical relations among men in the process of male domination over women, as well as how this intensifies in the monopoly capital era.

Hartmann's particular task has been to understand how the hierarchical division of labor among men and between men and women has been extended to wage labor in the modern period. She moves forward the understanding of the meaning of patriarchy by showing how the gender-divided nature of the labor force, as well as the gender-assigned nature of the home in industrial capitalism, is as much a function of patriarchy as capitalism.

It is her basic argument that patriarchy existed long before capitalism. Thus, capital inherited a patriarchal system in which men controlled women's and children's labor in the family (Hartmann 1976). In the family, then, men learned the techniques of hierarchical organization and control, which they then applied more and more to a separate public realm—the state, an increasingly centralized economic order, and wage labor—that in time turned into capitalism.

With the advent of public-private separations—such as those created by an emerging state apparatus and economic systems of wider exchange and larger productions units—men's problems became one of maintaining their control over the labor power of women. Individual control by men in the home had to be translated into social control of men over women in the world outside the home, mediated by societywide institutions. The mechanisms available to men were the traditional division of labor between the sexes and techniques of hierarchical organization and control. Hartmann argues that these mechanisms were crucial in the second process: the extension of a gender-ordered division of labor to the wage labor system itself during the period of emergence of capitalism in Western Europe and the United States.

What is particularly important to Hartmann is to show that the average male worker has been influential in maintaining the sexual divisions in the labor process and benefits materially from the forms patriarchy takes in contemporary U.S. society. As she says, "Marxist economists tend to attribute job segregation to capitalists, ignoring the part played by male workers and the effect of patriarchal social relations. In this paper I hope to redress the balance" (p. 140).

The final examples of Later Marxist Feminist concern with the development and change of patriarchy are the work of C. Brown (1975a, 1975b, 1977) and Silveira (1975). They emphasize that the extension of the gender-ordered division of labor to the labor market —the wage labor process—is not only in the interest of individual men (in the home and in the market) but is also in the interest of male capitalists and the male state in contemporary monopoly capitalist society.

To Brown and Silveira, a class society based on patriarchy is essentially a society whose class relations are relations among classes of men. "Since the major Marxist classes are predominantly male, sex is already in the economic base" (Silveira 1975, p. 12).

For Brown, what is important to understand is that in modern capitalism, patriarchy refers to much more than the individual male-headed family unit in relation to the state. It is true that the form of the feudal patriarchal family is inherited by the emergent capitalist system. The patriarchal family laws that are made by men for men in the economic, political, religious, and other sectors of the larger society give each individual man the right to power over an individual woman in the home. Today, however, struggles over the private patriarchal control of women within the family continually erupt with the increasing consolidation of power, control, and benefits of the public male hierarchies headed by an elite class of men who control business, government, education, and social services in advanced capitalism.

Hence Brown (1975a) suggests that patriarchal controls over women's labor occurs "less through husbands in families and more by ruling class men, to the benefit of themselves and all other men" (p. 3). Thus, the increasing contradiction between men as men versus men as members of different social classes becomes important in an analysis of women's lives. Further, Brown asserts that one must recognize that "patriarchy also includes the collective exploitation of the female sex by the male sex, and the exploitation of the female sex by ruling class men for the ruling class's economic and social benefit" (p. 1).

It is her goal to be able to understand the increase in female-headed families in the United States today, as well as the increase in married women employed in wage labor. As she says:

> Beginning in the twentieth century, and developed now to
> the point where the trend is clear, a major transformation
> took place in the structure of patriarchal capitalism.
> [One finds more employed women, women marrying less,
> and increased female-headed households.] . . . These
> women [that is, women who are heads of households] are

> not working for, or under their male relatives. Although
> the growth of female-headed families through the voluntary
> departure of men might appear to be the result of a decline
> of patriarchy, we will show that it is in fact merely the
> transformation of the dialectic of sex within patriarchal
> capitalism from family-centered exploitation of women to
> industrial-centered exploitation of women. The benefits
> continue to flow both to individual men, who obtain the
> benefit of the cheap services of women, and to capitalist
> men who obtain both the surplus value and the services.
> [P. 2, emphasis added]

In short, patriarchy is far from outmoded. For Brown, it is trans-
formed from a private to a public form—which continues to benefit
most men, even as individual men may lose control over individual
women in the household.

In closing, it is suggested that an analysis of patriarchy in ad-
vanced capitalism clearly calls for this kind of historical differentia-
tion from previous forms of patriarchy that Later Marxist Feminists
have recently begun to explore.

Today, in a period of developed monopoly capitalism, one finds
patriarchy of two kinds and on two planes operative. On the one hand,
there are collective forms of male domination in the larger, public
society in addition to private forms of individual male control over
women within the family. Further, one finds that collective male
domination operates not only to the benefit of the male ruling class
and the male-dominated state but also to the benefit of men workers
as a group over women workers as a group in the labor market.

At different points in time, the features of patriarchy may come
into conflict with each other. The conditions under which male domi-
nance in the home and male dominance in the larger society are antago-
nistic or supportive, for instance, need to be evaluated more closely.
This is done in a limited way in the next section and in Chapter 7.
This is clearly an important area for future investigation.

WOMEN'S ECONOMIC CONTRIBUTION TO PATRIARCHY

Just as the Early Marxist Feminists understood the material or
economic contribution of domestic work by women for capital, so, too,
the Later Marxist Feminists make clear the material or economic
contribution of women's labor—both domestic and market—to patri-
archy in a capitalist society. They treat patriarchy as much an eco-
nomic phenomenon as they do capital.

Thus, women in the home do unwaged necessary labor for their
individual husbands as well as for the benefit of capitalist men. And

women in the labor market work in gender-assigned tasks at lower wages than men, thereby not competing with male workers for their sex-related, more powerful, and higher-paying jobs and simultaneously providing cheap labor power for capitalist men. Women's work serves the dual purpose of perpetuating both male domination and capitalist production.

In what follows, the argument is presented that the social relations of patriarchy powerfully determine the position of men and women (both inside the family and in the labor market) at the point of capitalist industrialization in both England and the United States. Focus will be primarily on the development of the following three social phenomena during the nineteenth and twentieth centuries as patriarchal methods of subordinating women to men in the family and the labor market: the family wage, protective legislation, and the sex-segregated nature of the labor market.

Development of the Family Wage: Women's Labor Is Part of the Man's Standard of Living

Marx's analysis of women in industrializing England was filled with certain problematic assumptions and understandings about the nature of women in relation to patriarchy in a capitalist society. On the basis of several of his underlying assumptions, which are at times inconsistent in their implications, the Later Marxist Feminists have sought to understand the material benefits of patriarchy: for men only. In this context specifically, one can question his underlying assumptions about the family wage and the role of women in the home in the reproduction of labor power.

On the one hand, Marx feared the breakup of the working-class family, itself under the pressures of increasing industrialization in capitalist England. This was based on his understanding that the whole of the working class—men, women, and children—was being forced into wage labor. This meant that each person would become exploited individually as wage laborers, responsible for reproducing her/his own individual means of consumption/reproduction. What he did not foresee was the development of the family wage as a remedy to this situation.

On the other hand, Marx intimates some sort of understanding of the development of the family wage. He did so by assuming that a housewife is part of the standard of living belonging to the male head of the household, in the industrial phase of capitalist development in England.

Prior to the Industrial Revolution, women were expected to support themselves and their children economically.[13] In eighteenth

century England, working-class married women typically contributed either earnings or produce to the family budget. In fact, for men engaged in wage labor, "public opinion expected women and children to earn at least sufficiently for their own maintenance, and men's wages were based on the assumption that they did so" (Pinchbeck [1969], as quoted in Oren [1973, p. 108]).

The family wage was supposed to change all that. It was supposed to provide a man with "a wage sufficient to allow the woman to stay home, raise children and maintain the family, rather than having all members of the family out at work" (Zaretsky 1978, p. 211).

Hence it was only with the development of the family wage that it was possible for men to be paid a wage that was supposed to be sufficient to reproduce their labor power through the consumption/reproduction work of their wives. It was the industrial phase of capitalism that created a separation of families and market activities, never before so totally experienced. Thus, as Hartmann (1976) and Hartmann and Bridges (1977) claim, the family wage is "the cornerstone of the present sexual division of labor . . . and thus allows the existence of the family as we know it" (Hartmann and Bridges 1977, p. 24). It was through the family wage that conflicts between patriarchy and capitalism were resolved and thereby can be said to have cemented the identity of women and nature and her "natural" role in the family.

In order to understand the contradictory nature of the family wage, however, it is essential to point out that the family wage was also a demand of the working-class family—both men and women—as a basic form of resistance by the working class "which recognized in the erosion of traditional family structures a threat to its standard of living and position from which it engages in class struggle" (Humphries 1977, p. 27). While this was clearly the case, such an analysis, by itself, fails to account for the patriarchal base of the family wage and the fact that it is male workers who benefit materially more than women from such a set of social relations. If it were not in the material and emotional interest of working-class men—as men—to struggle for the family wage, then it should not matter if men were in the home or women were the breadwinners. Obviously, this, in fact, is not what happens.

Concretely, much of the work performed by women in the home was taken out of the home and produced primarily by men and secondarily by unmarried women. Men were paid wages, the means of subsistence in a capitalist society. Women were dependent on men for wages with which to then go to the market and buy these goods. Once purchased, women had to convert and maintain these goods and services into items usable by their families.

Initially, the Industrial Revolution caused the employment of male and female workers, adults, and children. However, as the

Industrial Revolution progressed, male workers viewed the large-scale entry of children and women into the labor force as an economic threat. This they clearly were, since an increased supply of workers lowered men's wages. Thus, it was patriarchy operating in the context of capitalist development that relegated women to the full-time responsibility of caring for children, as if this were a natural condition.

As male factory workers called for limiting the hours of employment for older children and forbidding the employment of younger children, difficulties in training and supervising children emerged outside the realm of paid labor. To remedy this, male workers as well as higher-class men and women all began to recommend women's removal from factories to the home. Women in the home would inculcate the necessary discipline and ideology required of children by the new hierarchical social relations developing in a society organized for mass production and consumption.

Thus, the role of women in the patriarchal capitalist family became to produce and reproduce labor power. In so doing, women would act as consumption and maintenance workers. They would act as well to produce and reproduce the social relations of production and of patriarchy.

Marx, however, never clearly recognizes the inclusion of women's labor as a right to male breadwinners—through the family wage—in his analysis of the wage. Instead, it appears that Marx assumes that the wage is determined in accordance with the acceptable standard of living at the time—subsistence as a given time and place treats it. This is what he calls the historical and moral element in the determination of the value of labor power (1967a, p. 171). What he does not take into consideration, though, is that a wife is considered to be part of the acceptable standard of living for a wage earner in industrial capitalism—but only for a male wage earner. As G. Rubin (1975) says, "It is precisely this 'historical and moral element' which determines that a 'wife' is among the necessities of a worker, that women rather than men do housework" (p. 164).[14] In short, the material base of patriarchy that Marx takes for granted is the work women do in the home for men.

A careful reading of Marx clarifies that he never analyzes the reproduction of labor power per se or the definition of the value of labor power itself. One Marxist Feminist suggests that the labor theory of value in Marx's terms would lead to the argument that the wage—represented by the necessary labor of the worker—is meant to equal the value of the commodities consumed by the worker's family necessary to reproduce his labor power. It does not include the value of domestic labor. Therefore, the overall standard of living is not determined by wage labor-capital relations alone (as Marx says)

but also requires the contribution of domestic labor. In this way, it can be argued, domestic labor's contribution to surplus value is to keep wages (or necessary labor) at "a level that is <u>lower</u> than the actual subsistence level of the working class" (Gardiner 1975, p. 54, emphasis added).

In addition to the fact that men receive wages for labor that includes women's (hidden) congealed domestic labor power (as suggested in Chapter 4) and that women do much more work than for which the family wage remunerates their husbands, thereby lowering the wage that capital need pay men (as Gardiner suggests), Marxist Feminist theorists of patriarchal capitalism now add a further key point: women also do work reproducing <u>themselves</u> for which capital does not pay them sufficiently—either through the family wage or when they enter the paid labor force. Chodorow (1978a) captures this problem when she says, but only in a footnote, "Hidden in most socialist feminist accounts is the fact that women also reproduce themselves, physically and psychically, daily and generationally" (p. 106, n. 43).

This idea is supported by the work of Silveira (1975) and Oren (1973). In her analysis of the exploitation of the housewife, Silveira argues that the housewife is doubly exploited because she is paid neither the full value of the work she does for others nor the value of the work she does reproducing herself. Moreover, the wage is for necessary labor only, and the housewife also reproduces the leisure labor of the worker.

This problem of the double exploitation of the housewife as specified by Silveira is clarified best when one sees that the same problem exists for wage-earning women, too. Thus, employed women have to do the labor involved in their own maintenance and daily reproduction. They do not earn enough money to obtain a housewife to reproduce their own labor power, as men do, because it is assumed that they themselves will do such reproduction work. In short, women need no housewife to reproduce their own labor power, or so the argument goes.

The reason they must do their own reproduction work is that their wages are so low. (This statement is not meant to underestimate the poor jobs, wages, and living conditions of men in many families—in earlier times as well as today. The author only wishes to clarify the greater hardships experienced by women because of the patriarchal benefits they lack.) And their low wages are due to the problems associated with the family wage: women are paid such low wages on the belief that they are the second wage earners, that their husbands are the primary breadwinners, and that the women do not need as much money. However, this leaves them incapable of buying the services of a housewife on the market. As Silveira (1975) concludes: "To own labor power is to be paid enough to obtain a house-

wife whom one can then exploit" (p. 90, emphasis added). The impress of patriarchy is clear here.

What Silveira does not understand is how women's double exploitation in our society is grounded in the social relations worked out through the family wage in industrial capitalism rather than symptomatic of a universal condition of all women at all times. In this regard, Oren's (1973) analysis of the distribution of the wage within the household economy among male breadwinner laboring families in industrializing nineteenth century England is illuminating. Her analysis makes clear that working-class women—in families where only husbands were allowed waged jobs or women's wages were so low that they could not support themselves, let alone their children—received a disproportionately small share of the household's material benefits: food (especially meat), medical care, leisure goods and time, and so on.

For example, the elastic item in the family budget was food, but it was women's (and children's) food allotments that suffered in most of the poor and working-class families, not the husbands'. This statement should not be misconstrued to mean that the husbands were well fed. They were not. As Oren states, "It is difficult to assess the significance of these sexual inequalities in diet. The families discussed in this essay were inadequately fed in general" (p. 111). Many families lived from hand to mouth. But it was also clear that the women suffered much more than the men within these often miserable conditions. Oren cites an author writing in the 1800s who found that as family size increased, the added requirements for the baby's needs came out of the mother's standard of living, not the father's. Thus, as more and more children are born, "the unvarying amount paid for the breadwinner's necessary daily food becomes a greater proportion of the food bill, and leaves all the increasing deficit to be met out of the food of the mother and children" (p. 112). Moreover, it is important to point out that this problem of women reproducing their own labor power at a cost lower than what they received from the breadwinner's wage continues in the twentieth century.

In an analysis of the household budgets between 1850 and 1950, Oren finds that the family wage has typically been divided between the "housekeeping allowance" or "wages for the missus" and "pocket money" for the male breadwinner. However, she claims, women today, like their mothers and grandmothers before them, frequently did not know how much their husbands actually earned.

> As earlier, husbands gave up some of their pocket money
> to the needs of a growing family, although their share of
> the family income did not fall in proportion to the cost of
> maintaining the extra children. Young [an author of the

earlier period in the 1850s] remarked that the financial
burden of an extra child fell especially upon the mother
and other children. Some husbands, in fact, "behaved
like employers. They did not increase their wives' wages
as the size of the family increased." [P. 117]

However, she continues, while the men were slow to adjust pocket
money for themselves downward in time of need,

twentieth century working class men seemed quick to aug-
ment it when times were flush. Higher wages apparently
allowed the breadwinner to devote a larger proportion of
them to his personal use. Wages for the missus, in fact,
generally lagged behind any advances in men's earnings.
. . . [And] higher wages and greater prosperity in this
century, then, did not eliminate the uneven distribution
of income between husbands and wives. On the contrary,
. . . the disparity was at least equivalent, if not greater.
[P. 117]

While the standard of living may have gotten better in the twen-
tieth century, it rises for men much more than for women—and in
the very same household. Material benefits, while they may increase
for all members of the family, increase more so for men. This rep-
resents an essential set of material benefits for patriarchy.

In short, the lower standard of living for women (and children)
established earlier on becomes part of the patriarchal base that fol-
lows women into modern industrial labor. It is not based on their
lesser nutritional needs but on patriarchy giving priority to providing
able-bodied male workers for capital.

Material Benefits of the Family Wage to Men

It is Hartmann (1976) who documents the process of the develop-
ment of the family wage in England and the United States. (See also
Zaretsky [1978] for information specific to the United States.) She
emphasizes the role of male workers and their unions, along with
the male capitalist class, in the development of the family wage and
women's position in the home. She argues that while working-class
and ruling-class men are antagonistic toward one another with regard
to the wage labor-capital relation, they act cooperatively with regard
to maintaining their privileged position over women in capitalist so-
ciety.

In the first instance, the capitalist men, as capitalists, would
prefer there to be an abundance of women and children as cheap labor

in the labor market, interchangeable with men's labor, thereby lowering everyone's wages. This is obviously not to the advantage of working-class men, who viewed the employment of women and children as a threat to their jobs as well as to patriarchal family life, which it is.

Looking at men as men, however, in the second instance, the cooperation of ruling-class and working-class men leads to the continued subordination of women in the individual family. This is materially beneficial to both groups of men. It provides the individual working-class male with an inexpensive servant who artfully stretches the budget and typically lives at a lower standard of living than her husband. She not only cares for his needs but also relieves him of caring for his children's needs. He need not do unwaged and devalued reproduction of labor power. Moreover, her economic dependence gives him greater power in their relations. It is not an equal exchange between them. Finally, without her, he cannot sell his labor power to the capitalist. But part of his labor power includes her labor power, too.

Capitalist men, in addition, benefit from the use and exploitation of their own wives as reproducers and maintainers of their own and their children's labor power and family wealth. They are free to exploit the surplus value of male workers without having to pay fully for their reproduction and maintenance—since this is done through the hidden work of their wives. Furthermore, since the family wage was never really sufficient for poorer women, capitalist men benefit from the exploitation of the labor of working-class women as low-paid factory workers, servants, prostitutes, secretaries, and the like.

Finally, the family wage, given to men only, is based on the idea that the wage should be sufficient to support the man and his family. This is true even if a man does not have a family. Thus, while women rarely ever receive a family wage—even if they are the heads of their households—men invariably do—even if they do not have a family to support. [15] On this basis, men receive the benefit of women's domestic labor either through the direct labor of their wives or by being able to buy the cheap labor of women in the labor market whose services substitute, at least in part, for the labor that would be done by wives if they had them. This obviously includes the cheap labor of women restaurant workers, garment workers, launderers, hospital workers, prostitutes, girl friends, and the like (C. Brown 1975b).

Women, on the other hand, rarely if ever receive wages substantial enough to buy these same services for themselves. In essence, one could say, women are always responsible for reproducing themselves, whether they are full-time homemakers or wage laborers, too. Men, on the other hand, are supposedly paid enough wages to reproduce themselves through the labor of their wives. In short,

the material base of patriarchy benefits the working-class man—in the home* and outside today—as well as the capitalist man. This is patriarchy at its finest.

The Sex-Segmented Labor Market and
Its Material Benefits to Men

For Hartmann (1976), analyzing the development of the family wage and protective legislation leads to the conclusion that job segregation by sex was the primary mechanism that allowed the maintenance in capitalist society of the inherited superior position of men over women. [16] The English historical literature strongly suggests that "job segregation by sex is patriarchal in origin, rather long-standing, and difficult to eradicate" (p. 159).† Men's ability to organize in labor unions, she suggests, perhaps stems from greater knowledge of the technique of hierarchical organization in precapitalist state and family forms. This ability of men to organize, as manifested in labor unions, "appears to be key in their ability to maintain job segregation and the domestic division of labor" (p. 159).

Hartmann's basic analysis seems to be correct. However, it seems important to emphasize that the ability of working-class men to secure greater benefits for themselves through the sex segmentation of the labor market would probably not have been possible without the mutual benefit that such an arrangement simultaneously served for the capitalist class of men.

Thus, the early exclusion with industrialization of women from paid labor as their primary responsibility is counterbalanced by the increasing demand for women's skilled and educated labor in certain

*Again, this is a contradictory situation. The fact that working-class men receive certain material benefits at home to strengthen patriarchy does not negate the fact that other aspects of patriarchy in the home are simultaneously weakened as women enter wage labor.

†It is here that Hartmann documents the struggle of male unions in calling for protective legislation "for women only." This protective legislation restricted women's activity when in the labor market and supported "the gradual withdrawal of all females from the factories" because "home, its cares, its employments, is woman's true sphere" (p. 155). The Webb-Rathbone-Fawcett-Edgeworth debates in the Economic Journal, outlined in Hartmann's analysis, support the argument that job segregation was detrimental to women and tended to reinforce it (p. 156).

"female" sectors of the economy as twentieth century monopoly capital-
ism has progressed.

What is the connection between the sex segmentation of the labor
force and the development of the family wage? What thereby shapes
women's position in the home as full-time wife and mother?

Job segregation by sex, argues Hartmann, maintains male su-
periority in capitalism because it enforces lower wages for women in
the labor market. Not only are the jobs different, but they are gener-
ally in cheaper markets. Thus, women are paid only half of what a
man is paid. (In 1975 a full-time, year-round employed woman earned
57 percent of a comparably employed man [see Chapter 2].) These
low wages keep women dependent on men by encouraging them to marry
and thereby to be supported by their husbands' family wage. Since
married women must perform domestic chores for their husbands and
their husbands' children, "men benefit, then, from both higher wages
and the domestic division of labor. This division of labor, in turn,
acts to weaken women's position in the labor market" (p. 139). In
short, the material base of patriarchy in the labor market is the in-
credibly low-waged market work that women do.[17] This keeps women
from competing with men for their sex-assigned jobs and allows men
higher-waged and more powerful jobs, which at the same time ensures
women's position in the home.

Hartmann is suggesting that patriarchy is a major feature of the
capitalist labor market and that the sex segregation of the labor mar-
ket is both the cause and effect of women's problems in the market.
Any study that attempts to understand how women operate in the labor
market must consider the role of its sex segmented nature, which en-
courages women to become married and in turn punishes them eco-
nomically when they later enter into the market as waged workers.
Hartmann concludes:

> Thus, the hierarchical domestic division of labor is per-
> petuated by the labor market, and vice versa. This pro-
> cess is the present outcome of the continuing interaction
> of two interlocking systems, capitalism and patriarchy.
> Patriarchy, far from being vanquished by capitalism, is
> still very virile; it shapes the form modern capitalism
> takes, just as the development of capitalism has trans-
> formed patriarchal institutions. The resulting mutual
> accommodation between patriarchy and capitalism has
> created a vicious circle for women. [P. 139]

U.S. Experience with Protective Legislation

In the United States, the institutionalization of the family wage
developed at the same time as the era of protective legislation. In

the early part of the twentieth century, the struggle for the family wage and protective legislation was intertwined (in addition to Hartmann [1976], see Zaretsky [1978]).

In addition to the features unique to the United States—especially those regarding the sex segmentation of the labor market (Hartmann 1976, pp. 159-60)—Hartmann documents the critical importance of the male working class and their unions in restricting the jobs women do in the labor market and forcing women into the home. In her examples of the cigar and printing unions, she makes clear that much of the fear of the male workers was based on a fear of the skilled workers for the unskilled, who could undercut their jobs and wages. (It is important for one to explore the practices of a variety of unions —both historically and today—to see how well their patterns fit those described by Hartmann in her selection of unions that she analyzed.) Yet, male unions denied women skills that they offered to young boys. Both women and young boys, however, were unskilled workers in the trade. Patriarchy, not simply the desire to protect their jobs from the unskilled, was clearly a motivating force here.

In short, "unions did not support protective legislation for men, although they continued to do so for women. Protective legislation, rather than organization [that is, organizing women into unions], was the preferred strategy only for women" (p. 165).

An analysis of the typographical union in the mid-nineteenth century showed that the union backed equal pay for equal work as a way to protect the men's wage scale, not to encourage women (Abbott 1969). This was based on the fact that women had fewer skills and did not have equal jobs, thereby making it impossible for them to demand or expect equal wages. What is so striking about this feature of earlier protective legislation is that it is remarkably contemporary: the Equal Pay Act of 1963 was backed by those who wanted to keep women's wages down and men's up. Thus, in 1963 testimony on the Equal Pay Act was about evenly divided between those emphasizing women's needs and those emphasizing the protection of men (Baker 1964, p. 419, as cited in Hartmann 1976, p. 164).[18]

The establishment of the family wage in the United States was clearly a function of the partnership between patriarchy and capitalism. However, in addition to working-class men who wanted "their women" out of the factories, so, too, did middle-class reformers and capitalist men. "A chorus of concern arose from reformers, ministers, conservative feminists, doctors and other representatives of bourgeois morality, all bent as well on 'preserving' the family" (Zaretsky 1978, p. 211). Not only male factory workers but the concerned public called for forbidding the employment of young children. When this caused parents difficulty in training and supervising children, male workers and middle and upper classes began to recommend that women, too, be removed from factories to remedy this.

By the end of the Progressive era (1900-17), the twin pillars of state policy toward the family were very clear: (1) the idea of a family wage, so that a husband could support a family, and (2) the idea of the full-time mother within the home. Both compulsory education (more as norm than reality) and the abolition of child labor were important in establishing the family as the central focus of child development— not only for the infant but also for the older child and adolescent. As Zaretsky concludes:

> It is important to remember that these policies not only reflected the outlook of the bourgeoisie but also the aspirations of both men and women within the working class. The idea that such a family would be maintained privately and voluntarily conformed to the desire of the working class to keep the state out of traditional family functions, and to preserve the voluntary, kinship-based character of the care of the sick, the aged, the unemployed and, with the exception of education, children. [P. 212, emphasis added]

Moreover, as Humphries (1977) argues, one needs to remember that protective legislation and the development of the family wage represent resistance by the working class. Workers recognized, in attempts at the erosion of traditional family structures, a threat to their standard of living and position from which they engaged in class struggle. As she says:

> In certain periods of capitalist development labour's defence of the family, a defence motivated by the family's role in the determination of the standard of living, the development of class cohesion and the waging of class struggle, was an important reason for its [the traditional family's] survival. [P. 25]

It is no less important to understand that this element of the class struggle is at the expense of women. By struggling for the family wage by means of protective legislation, men got what they wanted: to keep the price of their labor higher and to control women, both in the home and the market, and the family, too.

CRUCIAL INTERACTION OF PATRIARCHY AND CAPITALISM IN BOTH THE HOME AND THE MARKET

The work of the Early Marxist Feminists produced a crucial understanding of the connection between women's home and market

labor. Their analysis led to the conclusion that women's devalued, unwaged, and economically mystified home labor, as constructed by industrial capitalism, is the cause of their low-waged and less powerful position in the labor market. To this, the Later Marxist Feminists add two essential points without which the position of women in the labor market cannot be fully appreciated.

First, it is not capital that constructed women's home labor but patriarchy in collaboration and conflict with capitalism. This in turn causes women to be severely disadvantaged in the labor market when they enter, as they have increasingly done during the twentieth century.

Second, struggles and alliances between patriarchy and capitalism in the labor market as well made it possible for them to mold women's wage labor in large part as they did. This is experienced through the sex-segmented nature of the labor market and the sex-determined nature of wages.

In sum, the Later Marxist Feminist analysis leads to the conclusion that one must understand not only the dialectical nature between the home and market in U.S. society but the dialectical relationship between patriarchy and capitalism in both the home and the market as well. Only in this way, as shall be emphasized from now on, can one hope to understand and change women's disadvantaged position in the labor market.

Today, more and more women are found in both the home and the labor markets. While the vast majority of women in our country marry, and therefore have primary responsibility for reproducing themselves, their husbands, and their children, these women are likewise employed in the labor force. Approximately 60 percent of the women employed in the labor force are married with husbands present; another 20 to 25 percent are either separated, widowed, or divorced. However, it should be noted that over 50 percent of all married women are not currently employed in the labor force (for data, see Chapters 2 and 3).

As more and more women are living in the "men's world of employment" as well as in the "women's world of the family"—as more and more women experience the double day—it becomes increasingly clear that the social relations of class and sex (and race) structure our experience in all spheres of life. In each case, the material and ideological conditions shape social relationships.

Hence, women's place is increasingly experienced not as a separate sphere but as an oppressed position within the society at large—in the family and in the larger society; in reproduction and in production; and in wage labor and in the home.[19] Men and women both experience each of these sets of social relations, but differently. Moreover, there is a mutual interaction among these social relations:

thus, sex segregation, as well as other forms of male interest in the labor market, influences women in the home in addition to the fact that what happens to women in the home influences sex segmentation and wages in the labor market.

This means that not only is women's unwaged domestic labor used against her in patriarchal capitalism when she enters into market relations, but her market labor is also used against her in patriarchal capitalism to force her into gender-assigned roles in the home. The basis of such a vicious cycle comes back once more to the main point here: the inextricably intertwined relationship between patriarchy and capitalism in each sphere of living.

The pioneering work of the Early Marxist Feminists left us with a split vision between the world of work and the world of the home. The analytical insight of the Later Marxist Feminists, however, has shown that

> "production" and "reproduction," work and the family, far from being separate territories like the moon and the sun or the kitchen and the shop, are really intimately related modes that reverberate upon one another and frequently oc-cur in the same social, physical and even psychic spaces. This point bears emphasizing, since many of us are still stuck in the model of "separate spheres." . . . We are now learning that this model of separate spheres distorts reality, that it is every bit as much an ideological construct as are the notions of "male" and "female" themselves. . . . One implication of this theoretical breakthrough (and I don't think that's too grandiose a term) is that the two tasks of analyzing patriarchy and analyzing the political economy—whether capitalist, precapitalist, or socialist —cannot be separated. The very process of developing a Marxist-feminist mode of analysis will necessarily deepen the Marxist dialectic and enrich its ways of seeing and re-flecting the world. [Petchesky 1978, p. 377]

Overcoming the split vision of sex-assigned spheres of labor—even while understanding their historical reality—one can look at all of women's work. This is what Kelly (Gadol) (1979) calls a "unified, 'doubled' view": while each sphere of labor (domestic and market) was understood as gender-assigned at one phase of capitalist develop-ment in conjunction with the socially acceptable sexual division of production, such neat distinctions no longer fit social reality. Today women must be looked at in both spheres.

Through one eye, women's labor in the home can be seen and through the other eye, her labor in the market. It is only by trying to

interrelate what is seen with both eyes simultaneously—a newer, more integrated vision—that one can hope to understand the dialectical relationship between women's home and market labor and how they relate to men's home and market labor, too. Thus, in any particular experience, individuals are shaped by their relations of class, sex, and race, whether at home or in the market.

The goal of Later Marxist Feminists, a _dialectical_ as opposed to a _dual_ understanding of human social relationships, has led one Later Marxist Feminist to summarize the problem in the following way:

> One studies _either_ the social relations of production _or_ the social relations of reproduction, domestic _or_ wage labor, the private _or_ public realms, the family _or_ the economy, ideology _or_ material conditions, the sexual division of labor _or_ capitalist class relations, as oppressive. Even though almost all women are implicated in both sides of these activities, "woman" is dealt with as though she were not. Such a conceptual picture of woman hampers one's understanding of the complexity of her oppression. Dichotomy wins out over reality. . . . [Instead, one must] replace this dichotomous thinking with a dialectical approach. [Eisenstein 1977, p. 3]

In this way, Marxist Feminist theories of patriarchal capitalism lead us two steps forward. First, it helps one to understand the predominantly gender-assigned nature of tasks in the sexual division of production. At a certain phase of industrial capitalism in the nineteenth-twentieth century United States, woman's place was in the home. Unlike the Early Marxist Feminists, though, they do not understand this as defined solely by capital. Rather, it is understood in terms of the dialectical relationship that emerges between capital and male-dominated sex/gender systems.

Second, this leads one to understand that the underlying social relations of the sexes occur in both spheres of home and work as do the social relations of class. Their interconnections become basic to the analysis. Hence, more important than analyzing separate spheres today are how each sphere is intimately connected with the other and how each set of social relations—of class and sex in this case—interrelates within and between each sphere. Only in this way can what women do in the labor market be analyzed.

It has been shown in this chapter that labor market segmentation by sex, the family wage, and protective legislation can all be seen as products of the dynamic relationship between patriarchy and capitalism: what might better be now called patriarchal capitalism. The

material benefits accruing to patriarchal capitalism are the work women do in the home and the market. Thus, the division of labor based on gender—both between home and market and within the home and the market—allows for the perpetuation and transformation of material and ideological benefits both to men and to capital. This is, of course, not a static but a dynamic and changing relationship. How it relates to women's market labor in the present raises a new set of questions that are just beginning to be asked by feminists. Chapter 7 will return to these issues.

NOTES

1. That this assigned labor is not only biologically based in contemporary society but also, and perhaps primarily, culturally determined has now been amply demonstrated by Brown (1977), Liebowitz (1975), Rosaldo and Lamphere (1974), Mead (1935), and Rapp (Reiter) (1975). See S. Goldberg's (1973) objection to this position.

2. See Hartmann and Bridges (1977); C. Brown (1975a, 1975b, 1977, 1979); Weinbaum and Bridges (1976); Somers (1975); Eisenstein (1977, 1978c); Rapp (Reiter) (1975, 1977); G. Rubin (1975); Silveira (1975); Baxandall, Ewen, and Gordon (1976); Benjamin, Joslin, and Seneca (1976); "Berkeley-Oakland Women's Union Statement" (1978); Red Apple Collective (1978); "Combahee River Collective" (1978); Petchesky (1978); Muller (1977); Weinbaum (1978); Phillips and Taylor (1978); Flitcraft and Stark (n.d.); Kelly (Gadol) (1979); Dubnoff (1979); and Rothschild (1979).

3. As the title of Eisenstein's book indicates, Marxist Feminist theories of patriarchal capitalism are most commonly referred to in the literature today as socialist feminist. Although, earlier, socialist feminism was often said to include all Marxist Feminists (those in the early as well as the later groups), more recently it seems to refer particularly to those who see both patriarchy and capital as autonomous and interacting influences in society. Further, racism, imperialism, and the state are all seen as independent and interacting forces that must be understood if one is to deal with women's position in society (see, for example, C. Brown [1975a] and Red Apple Collective [1978]). The author will deal only with patriarchy and capitalism as autonomous and interacting influences in women's labor market activity in this discussion of Marxist Feminist theories of patriarchal capitalism. It has been a major weakness of these writings, however, that they have not yet included racism and imperialism in a meaningful way in their study of women in patriarchal capitalism. For a beginning statement on this much needed approach, see the "Combahee River Collective" (1978).

4. In response to this position has developed an even newer group of Marxist Feminist thinkers, who fall somewhere between the Early and Later Marxist Feminist schools (Barrett 1978; Beechey 1978, 1979; Bland et al. 1978; Molyneux 1979; Young 1978, 1979). All but Young are British. As the dates imply, these writers were discovered by the author only after she had already distinguished her categories as between the Early and Later Marxist Feminists. This should reinforce for the reader the newness and continually changing nature of the debates that are emerging in Marxist Feminism.

This newest group of Marxist Feminists are critical of the functionalism inherent in Early Marxist Feminism and the problems associated with seeing patriarchal relations as primarily ideological or limited only to the family. Instead, they have learned much from the Later Marxist Feminists and opt for a materialist understanding of patriarchy as well as of capitalism. However, unlike the Later Marxist Feminists, this newer group questions the autonomy of patriarchal and capitalist social relations as well as the independence of the material relations of patriarchy from the material relations of capital. They see this as a "dual systems" approach (Young 1978). The tendency of this in-between group is still to see women's subordination in the last analysis as determined by changes in the mode of production (see, for example, quotes from Beechey [1978] and Bland et al. [1978, p. 188, n. 1]). However, they clearly critizice the approach that women's subordination is attributable to some simple or single causality.

Further, while the material relations of patriarchy in the family are discussed, the material relations of patriarchy in the labor market are less so. Patriarchy in the market is typically considered more in ideological terms than in terms of male benefit (for both capitalist and working-class men) from women's labor in the market itself. And while one of the English authors (Molyneux) clearly does explicate material male benefit in the market based on women's labor there as well as in the home, she never uses the term patriarchy and suggests that one move the analysis of women's subordination in capitalism to a different level—that of the social formation: this includes both the distinctive mode of production and the conditions of its existence, conditions necessary to secure its reproduction. The danger here is that the patriarchal relations and women's domination by men will be subsumed under the mode of production in the narrower sense, as has occurred with the Early Marxist Feminists.

Despite these and other differences within this newer in-between group and between it and the Later Marxist Feminists, they are all trying to broaden the concept of labor and its process of development in order to understand how gender subordination or patriarchal relations are part of all aspects of social life—including the home and market.

5. Nor, by the way, is it to say that women are only negatively affected by such a set of circumstances. Glazer (Malbin) and Waehrer (1973) make it clear in their introductory comments that one must not eliminate the dialectical nature of women's home labor itself in the zeal to set the record straight about patriarchy. Also, see Zaretsky (1976).

6. See Pleck (1977), Blood and Wolfe (1960), Barry, Bacon, and Child (1957), Vaneck (1974, 1977), Keniston and the Carnegie Council on Children (1977). This is not to say that men in any way share tasks equally with women in the home comparable to women sharing the labor market tasks with men. In fact, the data are quite clear that (1) women work a "double day" when they enter wage labor—beneficial to both capitalist men and the individual working-class man alike—and (2) men typically "help" women in their domestic labor when they are employed. It is still "women's" work. However, men are engaged in certain child-care, household, and self-reproduction tasks at home also.

7. The author's definition of patriarchy is partially derived from that of Hartmann (1976, p. 138). She says that patriarchy is a "set of social relations which has a material base and in which there are hierarchical relations between men, and solidarity among men, which enable men to control women." For Hartmann, what is crucial is that the relation of men's interdependence to their domination of women be examined in historical societies. In capitalist societies in particular, "we must discover those same bonds between men which both bourgeois and marxist social scientists claim no longer exist or at the most are unimportant left-overs" (Hartmann and Bridges 1977, pp. 15-16). Hartmann provides us with a richer, more meaningful understanding of patriarchy than the unspecified notion of male dominance, as well as the way it is worked out in industrial capitalism in the "family wage." This latter notion will be perused in the following section on the material benefits of patriarchy to men.

8. Hartmann and Bridges (1977) clarify this in another way: "Patriarchy is not simply hierarchical organization, but hierarchy in which particular people fill particular places" (p. 24). That is, men are higher and women are lower in the hierarchy.

9. For an excellent analysis of another radical feminist, Morgan (1977), in the terms just discussed, see Clavir (1978).

10. For Mitchell (1971a, 1971b), women's powerlessness is rooted in four specific structures, all of which must be transformed if women are to be liberated: (1) production, (2) reproduction, (3) sex, and (4) socialization of children. The first structure refers to social production and the last three to the reproduction of labor power in the home.

However, Mitchell does little more than describe the four ways of looking at women and the family. The thrust of her work more ac-

curately identifies her with the orthodox group of the Early Marxist
Feminists (see Chapter 4). She ends up by suggesting that the prob-
lem for women is their separation from social production. As with
the orthodox Marxist Feminists, the solution to women's problems
is that they must enter wage labor to be liberated. For Mitchell,
the mechanisms of such change are the educational system and the
way children are socialized into their gender identities (see Malos
1978).

In her later work, Psychoanalysis and Feminism (1974), Mitch-
ell presents patriarchy as an important and basic ideological struc-
ture. Thus, while patriarchy is independently influential for Mitchell,
only the economic structure of society has the fundamental material
base of society to it—not the patriarchal structure too.

11. Ortner defines patriarchy as the system of absolute author-
ity of senior males over all others. This includes notions of institu-
tionalized fatherhood of "old testament patriarchs of pastoral, no-
madic societies—like Abraham" as well as that of male wardship over
females (see here also G. Rubin 1975). In the latter case, Muller
(1977) defines patriarchy as a social system in which the status of
women is defined primarily as wards of their husbands, fathers, and
brothers. The parameters of wardship are conceptualized as (1) ex-
ploitation of women's labor, (2) their differential access to basic re-
sources, (3) restriction of their decision-making powers, and (4) ab-
sence of jural responsibility for their acts.

12. Ortner's work is substantiated in Muller's (1977) analysis
of the development of patriarchy with the emergence of the state as
Anglo-Saxon and Welsh tribal customs were undermined.

13. Between the fifteenth and eighteenth centuries in England,
this was accomplished through bye work, the domestic putting-out
system, tending of small plots, gardens, orchards, and dairies,
spinning and weaving, tenant farming, wage earning on larger farms,
family industry, and guild work in towns and cities, as well as taking
in boarders or lodgers (Hartmann 1974, 1976; Pinchbeck 1969).

14. This is supported by Weinbaum's (1978) recent analysis of
Marx's sexist assumptions about the nature of the "average laborer"
in the market. Her analysis of "The Patriarchal Component of Marx-
ism" (chapter 4) came to the author's attention only after this section
was written.

15. This is strongly supported by Dubnoff's (1979) recent analy-
sis of available data on the types of jobs in which men and women were
deployed in the United States between 1940 and 1960. During this
time, men increased in occupations that returned a wage above the
socially necessary costs of subsistence; women, in contrast, were
increasingly and overwhelmingly concentrated in jobs that did not pay
a wage that met the requirements of basic subsistence. Thus, male

employees decreased from 43 percent to only 19 percent who were in occupations that paid a wage less than the level of "minimum adequacy" as defined by the U.S. government. (The figure of minimum adequacy was established as $3,875 and reflects the costs in 1959 for a four-person, nonfarm, male-headed family. See Dubnoff's footnote 23, pp. 24-25.) For women, however, as many as 87 percent were employed in jobs with wages below the level of minimum adequacy in 1960; and more than four-fifths (84 percent) of the growth in female employment was due to the growth of these overwhelmingly low-wage jobs. Women were increasingly employed in jobs that did not pay a family wage.

16. For an extension and modification of this position, see Phillips and Taylor (1978). They argue that "as a concrete material process, capitalist production employs labours which are male and female, and hence in a relation of power to one another. There are no pure 'economics' free of gender hierarchy" (p. 4).

17. For contemporary support of Hartmann's hypothesis, see Dubnoff's (1979) post-World War II analysis again. In his conclusion he states: "The trends in occupational sex composition delineated here clearly worked to the detriment of females and to the benefit of males in general and capitalists in particular. The growth of women's employment was, above all an expansion of low wage work, of work which does not pay the social cost of reproducing the next generation of workers. From the point of view of capital such workers are a bargain—workers at below cost. From the point of view of women such low wage work institutionalizes a dependence on men and reinforces patriarchy in general" (p. 18).

18. For such problems today, see Kleiman (1977).

19. The author is indebted to Kelly's (Gadol) several public lectures for clarifying this position. See her recently published article (1979) for an explication of these ideas.

It is here that Young's (1978) call for "a theory of society as one system in which the oppression of women is a core attribute" begins to be addressed. This would involve "a theory of material systems of production and social relations . . . which, unlike traditional Marxian theory, provides an integral theoretical place for analysis of the condition of women qua women" (p. 2). In contrast with Kelly (Gadol), Young suggests that instead of looking at the interaction or dialectical relations between patriarchy and capitalism, what is needed is a theory of the "sex division of labor of capitalism."

6
SUMMARY AND REVIEW

The thrust of this book has been to understand that any attempt to analyze women in the contemporary U.S. labor market must relate the position of women in the market to the position of women in the home. Moreover, such an analysis requires that one become familiar with the social forces of both patriarchy and capitalism as they relate to one another in both the home and market.

In this chapter, the major theoretical contributions of each school of thought outlined in Chapters 1 through 5 will be reviewed. To repeat, these include the two mainstream theories of status attainment and the dual labor market as well as the three radical theories of Marxism and monopoly capitalism, Marxist Feminism of the home (or Early Marxist Feminism), and Marxist Feminist theories of patriarchal capitalism (or Later Marxist Feminism). In this summary, the focus will be on the most crucial explanatory factors or variables presented in each theoretical perspective and how they help to explain what happens to women in the contemporary U.S. labor market (see Table 7).

The five explanatory factors that emerge as important in these theoretical perspectives are as follows:

Sex roles—the sexually differentiated attitudes and behaviors that men and women are trained to assume in society, especially with regard to the home and market;

Labor market structure—the institutionally organized ways in which the jobs, industries, and markets operate in society;

Capitalism—a system of production of goods and services (and labor power), where a small number of owners and managers of the means of production make profits from the labor of a large number of workers;

Homemaking structure—the institutionally organized ways in which housewifery and motherhood operate in society; and

Patriarchy—a set of social relations of power enabling men to control women, which is grounded in hierarchical relations among men who accrue material as well as ideological benefits through the exploitation of women's labor.*

All perspectives but one, status attainment, conclude that women are disadvantaged in the labor market, but not necessarily for the same reasons. Both mainstream and radical analyses of women in the labor market were developed on a male model. That is, the same underlying assumptions used to analyze men's market work were initially applied to women's market work. To the degree that women have been included in these models, however, it has primarily been feminists in each of these currents who have argued for an expansion or refocusing of the analysis itself.

STATUS ATTAINMENT THEORY

Status attainment theory (Chapter 1) has been the most commonly used intellectual current underlying most of U.S. sociology, stratification theory, and, in particular, studies on occupational prestige. In trying to explain women's participation in the contemporary labor market, this perspective assumes that what women bring with them to the labor market is the major determinant of their position in the U.S. occupational structure. According to this approach, therefore, to the degree that women's qualifications do not match those of men, women will be occupationally disadvantaged.

Accordingly, this school of thought argues that changing individual women's cultural or normative attributes—the "supply" characteristics of human capital theory—is essentially what is necessary to improve or equalize women's opportunities in the labor market. Thus, values, attitudes, and experiences related to sex roles (educational aspirations and achievement, occupational aspirations, work attitudes

*It is important to differentiate here between sex roles and patriarchy. Sex roles refers more to the social psychological and behavioral dimensions of individuals' experiences. Patriarchy refers to the larger set of social relations organized around and through the benefits to men from women's work—both materially and ideologically. Thus, patriarchy can be said to include, but is not limited to, the power relations between men and women involved in each of the concepts of sex roles, homemaking structure, and market structure.

TABLE 7

Explanatory Factors Stressed by Each Theoretical Perspective

Factor	Status Attainment (Chapter 1)	Dual Labor Market (Chapter 2)	Marxism and Monopoly Capitalism (Chapter 3)	Early Marxist Feminism (Chapter 4)	Later Marxist Feminism (Chapter 5)
Sex roles	O				
Labor market structure		O	X		X
Capitalism			O	O	O
Homemaking structure				X	X
Patriarchy					O

Note: O refers to the most important causal variable in this theoretical perspective explaining women's participation in the labor market. X refers to explanatory variables deriving from the most important causal variable in this theoretical perspective; these derivative variables are particularly emphasized in this theoretical approach.

Source: Compiled by the author.

and training, values and behaviors toward childbearing and rearing, years and continuity of labor market experience, and so on) are understood as the causal variables in explaining women's lack of success in employment, when and where it occurs.

Both the labor market structure and the homemaking structure are taken as given by these theorists: that is, neither occupational stratification nor women's responsibility for child care in the home is adequately challenged. This holds true even when proponents of this school of thought recognize that women's responsibility for child care and homemaking are "one of the major bases of sexual inequality of socioeconomic opportunity" (Featherman and Hauser 1976, p. 463). Even then, such considerations are not included in the actual empirical analysis of behavior in the occupational structure of society, because, as Featherman and Hauser continue, "our conventions lead us to ignore these roles in our studies of socioeconomic stratification" (p. 463). Most important, this has been due to the inability to include such variables in the models used to explain occupational status attainment.[1]

At best, women are said to be held back from achievement by a socially structured role conflict between their home and labor force responsibilities. But this premise also accepts that the underlying responsibilities for the home are women's. Thus, patriarchal relations of the home that are instrumental in determining sex role socialization in society are treated as problematic for the analysis, instead of being seen as one of the fundamental causes of women's inferior market status, which must be changed in the first place. Such an approach has the tendency to end up "blaming the victim."

In general, neither patriarchy nor capitalism is seen as an important independent factor or variable. They are either taken as given, factored out, controlled for, or otherwise dismissed. Most often, they have simply not been analyzed as part of the explanation for women's position in the labor market. In short, status attainment theory assumes some of the most important features that need to be explained.

Based on an analysis of status attainment theory's underlying assumptions, one can conclude that this theory is not helpful in explaining women's position in the labor market. Even using the criteria established by the status attainment theorists themselves, the model only explains one-third of the variance in either women's or men's occupational prestige. Its prescription—to change supply-side variables—therefore must be questioned. Despite its shortcomings, several of status attainment theory's contributions have proved useful to the author's analysis.

First, and most important, this school of thought has raised concerns and provided rich descriptive materials about women in the

occupational system neglected by sociology far too long. (All too of-
ten, however, this material is used as prescriptive or explanatory
in mainstream sociology rather than as what it is: description.)
While empirical data are always bound by the underlying construction
of those data, it is possible to reinterpret much of the descriptive ma-
terials within contexts more meaningful to a critical analysis. Second,
the concern of status attainment theorists and mainstream sociology in
general with sex roles is extremely valuable for an alternative radical
perspective when put into a meaningful context. (Both of these issues
will be elaborated on in Chapter 7.)

DUAL LABOR MARKET THEORY

Dual labor market theory (Chapter 2) is the major competing
perspective to status attainment theory in the mainstream current to-
day. (Dual labor market theory, as outlined here, is distinct from
the more radical labor market segmentation theory, which is included
with the Marxist theorists of monopoly capitalism.) Its proponents
argue that men and women are recruited into different labor markets
that are structurally organized to be disadvantageous to women.
Thus, women are recruited into the secondary market—where jobs
are much more likely to be unstable and found in industries with low
capitalization, small profits, low wages, poor organization among
workers, limited or nonexistent job mobility or advancement, and
high turnover rates. Men, on the other hand, are much more likely
to be recruited into the primary market. By contrast, the primary
market offers jobs with stability and upward mobility, structurally
encouraged by high capitalization and good profits, relatively high
wages, good working conditions, job security, opportunities for ad-
vancement through clear and available career ladders, and adminis-
tration of work rules on the basis of equity and due process.

In this case, _even if_ women's human capital characteristics
were to be altered, dual labor market theory argues, little would
change for women in the market unless the structure of the market it-
self were reorganized and/or women were increasingly incorporated
into the primary job structures. In sum, the causal factor in this
analysis that explains women's disadvantaged market position is the
sex-segmented or dual structure of the labor market.

Although originating in economics, recent attempts to develop
this perspective have emerged in sociology, too. This approach is
akin to theories of occupational sex segregation and stratification in
sociology. Feminist sociologists from this school support the argu-
ment that socially structured institutional constraints determine
women's disadvantaged market position, not their sex role socializa-

tion per se. Moreover, some of them have recently begun to argue
that occupationally related sex roles can be seen as an outcome of,
or response to, secondary market placement or demands: for exam-
ple, men disadvantageously placed in the job hierarchy are found to be
as likely to have the same so-called female-typed attitudes and be-
haviors as women disadvantageously placed in the job market. These
include limited aspirations, low work commitment, dreams of escape,
high turnover, and the like. In general, however, dual labor market
theory either takes sex roles as given (that is, women are socialized
to be interested in certain kinds of jobs and homemaking activities
from childhood on) or does not incorporate them into this approach.

While it is not uncommon for this theory to acknowledge that a
specific phase of capitalism is correlated with this type of market
structure, it focuses on changing the structure of the labor market
itself (and its people), not capitalism, to better the position of disad-
vantaged groups in the market. The manner in which capitalism in
general, and its specific monopoly phase, is related to the develop-
ment of the dual labor market is taken as given.

Dual labor market theory also takes as given the homemaking
structure, which makes women responsible for children and home
care, not incorporating its relevances into what goes on in the labor
market. To the degree that home as well as market structures are
said to require change (especially by feminist occupational sex segre-
gation and stratification theorists in sociology), they neglect to con-
nect such change to the larger political economy. Finally, dual labor
market theory does not deal directly with the issues of patriarchy,
though it sees occupational sex segregation as discriminatory against
women.

MARXIST THEORIES OF THE LABOR MARKET

Marxist theories of the labor market (Chapter 3) begin with the
work of Karl Marx. It is further developed by mid-twentieth century
Marxist theorists of monopoly capital who focus particularly on the
development of modern or advanced capitalism and its impact on the
labor market. The causal factor explaining the position of women in
the modern labor market for these theorists is capitalism (and its
specific monopoly form in twentieth century United States). The first
order of change, this school argues, is the capitalist political econ-
omy itself.

To Marx the occupational stratification and the sex stratifica-
tion of the labor market are understood in terms of the class relation-
ships that exist in a capitalist society. They are the surface mani-
festations of the underlying social relations of production. To him

the moving force of capitalism is class conflict, which emerges out of the fundamental contradiction between wage labor and capital's appropriation of value that is generated by the workers themselves. As profits this value or surplus value becomes the private property of the capitalists. To Marx the only agency capable of creating more value than it represents (that is, surplus labor, which leads to profits) is human labor power. This is the labor theory of value and applies whether it is men or women who do wage work in the market. That is, women who work in the paid labor force are producers of surplus value just as men are. In this sense, Marx's theory is said to be sex blind.

In sum, what determines the structure of the labor market, the relationship between workers and owners of the means of production and among workers themselves, including men and women wage earners, is capitalism. Hypotheses about the reserve armies of labor and the surplus population apply equally well to women as to men, although not in exactly the same ways. The main difference is that women are superexploited in comparison with men. Women are a cheap source of labor, according to Marx, thereby allowing them to be used in the lowest-paying jobs as well as to act as part of the reserve army of labor.

Whereas dual labor market theorists primarily described the sex-segmented or dual labor market, seeing it as the cause of women's problems, the monopoly capital Marxist theorists of mid-twentieth century United States see instead the structure of the monopoly phase of capitalism as explanatory of the dual or segmented labor market as well as women's disadvantaged position in it. Understanding the development of monopoly capitalism leads to an analysis of why and how the dual or segmented nature of the labor market arises and is used by capital to divide the working class (including men against women), why certain jobs and sectors of the economy emerge and change, and how women primarily are incorporated into certain newly developing and changing sectors of the economy. Moreover, the nature of the labor process itself changes, demanding the inclusion of more and cheaper labor power, though at the same time other people are thrown out of work and both unemployment and underemployment increase.

Thus, it is not accidental that a dual or segmented labor market exists. Rather, these theorists argue, it is that capitalism uses this peripheral or secondary market during the monopoly phase of development in order to maximize its profits.

The social relations of monopoly capitalism that help these theorists to explain the incorporation of women into wage labor in the twentieth century, as well as their low wages and limited power, are the following: the divide-and-conquer strategy used by monopoly sec-

tor capitalists against all workers, the application of scientific management principles and the deskilling of labor power, and the development of new types of jobs, industries, and markets.

On the one hand, dividing the workers weakens their potential as a class against capital. On the other hand, in a society based on the purchase and sale of labor power, dividing the craft cheapens its individual parts and increases productivity, both of which increase profits for the capitalists, and increases management control over the labor power itself. Women are used in certain ways in the labor market in this effort to ensure profits and control by capitalists. Only very recently, however, has a specific and detailed focus on women by Marxist theorists of monopoly capital begun to appear.

In sum, while capitalism is seen as causal, the structure of the monopoly capital phase of the labor market is also analyzed in great detail by this set of writers. There is little or no discussion of sex roles and the institution of homemaking and motherhood. These are instead typically taken as given and not analyzed. Patriarchy is usually not discussed but is assumed to be a function of capitalism, based on the work of Marx and Engels in particular. This particular aspect of Marxism, its view of patriarchy, is discussed more specifically in Chapter 4. Here, this section concludes by noting that like their predecessors in mainstream sociology, women's work at home has generally been considered secondary by Marxist theorists of monopoly capital, since in this case it does not fit into wage labor. Therefore, if it is not neglected, it is typically assumed to fall within traditional Marxist assumptions about the family and women's position in it— that is, women in the home are said to be outside social production and therefore capitalist social relations because they do not earn wages and do not create surplus value directly for the capitalists.

MARXIST FEMINIST THEORIES OF THE HOME

Contemporary Marxist Feminist theories of the home (or Early Marxist Feminism, Chapter 4) also begin with Marx's class theory but attempt to develop the work begun by Frederick Engels of including the reproduction of human beings in the Marxist concept of the mode of production. It takes as its starting point the idea that, in any society, the mode of production includes the production and reproduction of both (1) the means of subsistence and tools necessary for that production and (2) human beings. These Marxist Feminist theorists see the capitalist mode of production as the basic organization of society, which determines the social relations of both the labor market and the family. Marxist Feminist theorists of the home argue that capital has a dual mode of production: wage labor and domestic

labor. This dual mode of production—which in its totality is capitalism—becomes, for this group of Marxist Feminists, the major explanatory factor in understanding women's disadvantaged position in U.S. society in general and in the labor market in particular. Like Marxist theorists of monopoly capitalism, this group of Marxist Feminists argues for completely changing capitalism itself. However, it argues further that it is necessary to focus on women's position in the home in capitalism in order to significantly alter women's disadvantaged market position. Thus, the first group of contemporary Marxist Feminists discussed in this book can be said to have developed a much needed theory on the "political economy of housework."

Furthermore, they generally accept the argument by Marx and Engels that patriarchy is a function of private property and developing class and state relations and, in particular, of wage labor relations in a capitalist society. With the development of class society, women's labor becomes transformed from a public contribution to the community as a whole to the private property of their husbands. In capitalism both sex inequality and class inequality are traced to property relations and the mode of production. Little further mention is made of patriarchy by most of the Early Marxist Feminists. However, even when it is understood by some Early Marxist Feminists as independently important and existing before the origins of private property and class relations, patriarchy is still understood as ideological and not material in form as well as primarily a set of relations operating within the family. In short, it is assumed that women are dominated first and foremost by capital, as are men, and only secondarily by men, when it is discussed.

For Early Marxist Feminists, the basis for changing women's exploited and oppressed position in the labor market today ultimately revolves around changing her position in the patriarchal home as constructed by and for capital. The two most common solutions or strategies suggested by the Early Marxist Feminists are the (1) socialization, collectivization, or transference of women's domestic tasks to the labor force and entrance of women into wage labor or (2) the more controversial idea of paying women wages for their housework. This suggests that women's disadvantaged position in capitalist society is grounded in the economic or material conditions of women in the home, not their biology, upbringing, culture, and so forth.

Although the emphasis on capitalism as the primary causal factor has the consequence of assigning an essentially ideological role to patriarchal relations between men and women in the family, Early Marxist Feminists go beyond Marx and Engels by emphasizing the material nature of women's domestic labor. They do this in two essential ways: first, theirs is a major attempt to change the terms on

which women's home labor is analyzed; second, they try to "bring women in" to the analysis of capital.

In the first case, they focus on the role for industrial capital of women as a group in the home as the major cause of women's problems in contemporary society. That is to say, it is women's position in the home—women as housewives, not simply as members of the working class as traditionally defined by Marx—that is the basis for understanding women's secondary position in capitalist society. In contrast with traditional Marxist theory, Early Marxist Feminists insist that this relation is economic or material at its core, not superstructural or only ideological in form.

The Early Marxist Feminist emphasis is on the construction of the full-time homemaker/mother by industrial capital as the material basis of women's disadvantaged position in U.S. society. Despite the fact that women's work is unwaged necessary labor, it is still economically essential labor for capitalism. Although not always an explicit part of the Early Marxist Feminist analysis, their argument leads to the conclusion that women's unwaged but economically vital labor is a primary reason for women's low-waged and less powerful position in the labor market.

In the second case, for this early group of Marxist Feminists, this disadvantaged position in the labor market is based on the all-important mystification of women's labor in the home. Women's disadvantaged position is not only economically determined; it is also economically essential work that women do for capital in the home. Profits made by the capitalist class are impossible without women's home labor as congealed in the labor power of husbands (children and the women themselves) that enters into the wage relationship in the market. This is rarely acknowledged even by many contemporary Marxists. To the degree that Marx himself discusses women's work in the home for the reproduction of labor power for capital, it is in terms of the individual consumption of the (presumably) male head of the household. It is presumed that the wage given the family bread-winner covers the necessary labor of the housewife, too. The Early Marxist Feminists add, however, that the wage is only given for a portion of her necessary labor, not all of it. In short, women and their home labor are integral to market profits; they are not marginal to it.

The fact that women's unwaged, devalued, and cheap labor is hidden in their own (and that of men's and children's) when they enter the market in turn cheapens the value of women's labor when they do so. It is on this basis that women are underpaid as secondary workers when they enter the market. Women become a cheap source of readily available labor, which can be unemployed or underemployed according to the needs of capital in low-wage full-time or part-time

jobs or can be reabsorbed by nonpaying institutions when not needed in the labor force.

Moreover, it can be concluded from the Early Marxist Feminist approach that this allows not only for the fact that women act as a reserve army of labor in the traditional sense but also for the fact that the homemaker herself is a hidden source of cheap labor—a reserve to the reserve army of labor, so to speak—providing necessary back-up forces for modern-day monopoly capitalism.

Further, when their labor cannot be paid for in the market, women substitute or intensify their own labor power in the home for market commodities and services, especially in times of economic hardship. Unlike traditional Marxist approaches to women's domestic labor, Early Marxist Feminism clarifies the fact that a variety of economic functions in the household do not simply disappear as some service production is relocated outside the home. Women's home labor is changed, not eliminated, as she interacts with a far greater range of people and institutions in a service-oriented society.

In conclusion, the Marxist Feminist theorists of the home generally agree that the relation of women as a group in the home—the structure of housework—to capital is crucial for understanding the disadvantaged position of women in the labor market today. While industrial capitalism is understood as causal, what is elaborated on is the material nature of work in the home for capital, not women's market position per se. The Marxist Feminist theorists of the home reconceptualize women's home labor in terms of the economically essential unwaged domestic work done by women, which is required for the maintenance and reproduction of labor power for capitalism and benefits capital through the patriarchally organized family. That women socialize children to the appropriate sex roles in the home is taken as given by the Early Marxist Feminists, although some do discuss the process of socialization of children to sex roles and obedience to authority structures as essential to the reproduction of capitalism. Just like the homemaking structure, the labor market structure and patriarchy are understood essentially as aspects of capitalist development.

MARXIST FEMINIST THEORIES OF
PATRIARCHAL CAPITALISM

Marxist Feminist theories of patriarchal capitalism (or Later Marxist Feminism, Chapter 5) assume, like Marx and the Early Marxist Feminists, that capitalism and the industrial capitalist construction of women's position in the home are major causes of the problems faced by women in the labor market. However, unlike their predeces-

sors, Later Marxist Feminists further assert that an analysis of
women's problems in modern capitalist society requires an under-
standing of the complex effects of the social relations of patriarchy
as well.

Patriarchy is understood as having autonomous as well as inter-
twined effects with capitalism. It is seen as both material and ideo-
logical and is understood as operating in the market as well as the
home. In short, the sexual division of labor—in the home, in the
market, and in the society at large—is understood by Later Marxist
Feminists as a synthesis of patriarchy and capitalism, not primarily
determined by one or the other alone.

Rather than taking the sexual division of labor as given, they
assert that it is precisely this problem that must be analyzed to un-
derstand what happens to women in a patriarchal capitalist society.
In order to ensure the liberation of women, their solution includes
the transformation or elimination of the sexual division of labor itself
as well as the elimination of class divisions.

It is useful to compare Marx and Engels, the Early Marxist
Feminists, and the Later Marxist Feminists on the positions they
take with regard to the sexual division of labor. Patriarchy is an es-
sential explanatory factor only to the last group. For Marx the sex-
ual division of labor—or more specifically woman's place in the do-
mestic sphere—was taken as a given: he did not question it. He as-
sumed that women were always disadvantaged by their lesser strength,
greater docility, more limited organization, and their social position
ensuing from the sex act. Engels, on the other hand, saw patriarchy
as an outcome of the "world historic defeat of women" by men with
the development of private property, class division, and the state.
Women's labor was transformed into a private service for their hus-
bands in the home.

In contrast, Early Marxist Feminists analyzed women's place in
the domestic sphere in terms of its derivation from capitalism and
showed how capital benefited materially as well as ideologically from
these sets of social relations. They failed, however, to ask why in
the first place it was women who became responsible for child-care
and housework in a capitalist society. (This is an area of great de-
bate among Marxist Feminists today and should not be thought of as
resolved.) That is, they did not recognize that an essential basis of
the split between home and market in industrial capitalism was hier-
archically differentiated, gender-assigned work for men and women
in their primary responsibilities.

In addition, the Early Marxist Feminists do not adequately
analyze the impact of women's disadvantaged market position on the
construction of their place in the home, which then acts on the posi-
tion of women in the labor market. In other words, the way in which

patriarchal relations operate to assign women to subordinate positions in the labor hierarchy of the market is not explicitly discussed. Women's disadvantaged position in the market is understood by Early Marxist Feminists as based on their position as private property in the patriarchal home in class society, not on the social relations of patriarchy in the market. At best, Early Marxist Feminists accept the analysis of the labor market as defined by Marxist theorists of monopoly capital (Chapter 3), who also look only at capitalism (that is, its monopoly phase) as the cause of women's position in the market, not patriarchal relations in conjunction with, and in struggle against, capitalism in the market.[2]

In comparison with the Early Marxist Feminists, Later Marxist Feminists do not accept as given, existing outside the problematic under discussion, either the sexual division of production (women's place in the home) or the sexual division of labor within the market (the sex-segregated dual labor market). Rather, they assert that the sexual division of production between home and market and the sexual division of work within the labor market must both be understood as the result of a synthesis of the social relations of the sexes (patriarchy) and the social relations of classes (capitalism).* Thus, this has been called the system of patriarchal capitalism by some Later Marxist Feminists. They attempt to demonstrate that an essential reason that women and not men were assigned to the devalued and unwaged home and to the systematically disadvantaged position in the labor force was as much a product of patriarchy as of capitalism.†

*Overcoming the split vision of gender-assigned spheres of labor so that one can look at all of women's work has been a major analytical insight of Later Marxist Feminists. This means women can no longer be treated (1) as if they were in one sphere of existence mainly (the home instead of the market), or (2) as if they were involved in one of the two major social processes in society (reproduction as opposed to production), or (3) as if they did only ideological work as opposed to material labor, too.

†In contrast to those who see patriarchy and capitalism as independent systems of social relations that merge and conflict with each other to form this synthesis is another more recently developing trend in Marxist Feminist theory. It questions both the autonomy of these two sets of social relations, generally, and a system of patriarchy whose material conditions are independent of the material relations of production in society, specifically (much like the Early Marxist Feminists). Unlike the Early Marxist Feminists, though, it does accept the material nature of patriarchy as well as its operation in the labor market (see, for example, Barrett [1978]; Hartsock [1978];

In short, the causal factors for Marxist Feminist theorists of patriarchal capitalism in understanding women's position in the labor market are both patriarchy and capitalism. Together they construct the labor market and the home, as well as men's and women's positions within each. That is, the structure of the labor market and the homemaking structure, both seriously disadvantageous to women, are in turn created by the interacting forces of patriarchy and capitalism. Women in the home and the sex-segregated nature of the labor market are a function not of capitalism as such—as suggested by Marx and the Early Marxist Feminists—but of patriarchal capitalism. Typically, sex roles are not discussed as causal by this group of theorists, since they understand sex roles as mechanisms perpetuating patriarchy and capitalism, not as causes of either.

In addition to these contributions, Later Marxist Feminists have made several further steps forward that are important to an analysis of women's work. First, their analysis leads to the conclusion that a dialectical rather than a dual relationship between home and market exists. For the Early Marxist Feminists, two forms of production— a duality—exist in a capitalist society: wage labor and domestic labor. It was the capitalist construction of the home and women's place in it that determined women's disadvantaged position in the labor market. For the Later Marxist Feminists, both the home and the market were constructed by capitalism in conjunction with patriarchy.*

Young [1978, 1979]). Despite their oftentimes sharp differences, they, like the Later Marxist Feminists, are trying to broaden the concept of labor and its process of development in order to understand how gender subordination (or patriarchal relations) is part of all aspects of social life—including the home and market.

*Interestingly enough, Later Marxist Feminists have been charged with being dualistic in their understanding of two autonomous systems —patriarchy and capitalism—as causal in influencing women's lives. Those who so criticize the Later Marxist Feminists have been described earlier as falling in between the Early and Later Marxist Feminist positions. This in-between position is especially taken by a group of British Marxist Feminists (but includes Americans as well as writers from other countries). Their understanding of patriarchy is much more complex than the Early group and has been enriched by the arguments of the Later group. However, the mode of production is still seen as the major determinant in understanding the contradictions in women's lives—as with the Early Marxist Feminists. Thus, they focus on the contradictions within capitalism and how this affects the dominance relationships of men over women rather than also looking at the contradictions between capitalism and patriarchy.

They stress the mutually reinforcing and conflicting relations between patriarchy and capital in both the home and market as explaining women's disadvantaged position in patriarchal capitalist societies like the United States. Women's place is increasingly experienced not as a separate sphere but as an oppressed position within the society at large, in the home and the market. This is because women are increasingly found in both "men's world of employment" and "women's world of the family"—what Kelly (Gadol) (1979) has called the "double, unified view."

The author proposes to further extend the work of Marxist Feminist theorists of patriarchal capitalism by stressing the fact that a dynamic set of reciprocally reinforcing and mutually contradictory relationships exists between the home and the market themselves, in addition to the dialectical relationship that exists between patriarchy and capitalism in both the home and the market. This relationship will be called the "dialectical relationship of women's work" (see Chapter 7).

Thus, not only is women's unwaged domestic labor used against them in patriarchal capitalism when they enter into market relations; but sex segregation, the payment of the family wage to men only, male chauvinist policies in unions, sexual harassment of women on the job, and other forms of male benefit in the labor market also influence women in the home, in addition to the fact that what happens to women in the home determines their recruitment into sex-segmented jobs and low wages in the labor market. Likewise, Later Marxist Feminist theorists lead us to conclude that women's market labor is used against them in patriarchal capitalism to force them into their gender-assigned role in the home—or at least to assume those home tasks as women's primary responsibility even if they are employed simultaneously. This vicious cycle is the product of the intertwining relations of patriarchy and capitalism.

Finally, it is important to add that Later Marxist Feminists make clear the material or economic contribution of women's labor—

Patriarchy is not understood as being independent or autonomous from the capitalist mode of production. One author talks about male domination and the sexual subordination of women without ever mentioning the term or concept of patriarchy; while another analyzes the term patriarchy and questions "whether the quest for a theory of patriarchy is a mistaken one, and whether the concept should be abandoned" (Beechey 1979). This in-between group that is just now developing clearly has features that agree with both Early and Later Marxist Feminists. Their arguments help us to further deal with the problems of understanding women's work in society. Their work represents a different level of questioning and analysis important to Marxist Feminism.

both domestic and market—to patriarchy in a capitalist society. This is in contrast with the Early Marxist Feminists who previously demonstrated the material importance of women's home labor to capital but not to patriarchy.

Thus, men as a group are relieved of doing most of the unwaged labor of producing and reproducing the family in the home. Because of this materially advantaged position, non-ruling-class men are likewise able to be available for the more stable, higher-waged, and better protected market positions. Thereby women benefit male workers materially in the market by performing a whole range of low-waged tasks and by not competing with them for their more powerful and higher-paying jobs, which they hold by virtue of patriarchy. At the same time, ruling-class men benefit from (1) their own wives' unwaged domestic labor and responsibilities for the home and children and (2) the free home labor provided by their male employees' wives, as well as from (3) the free home labor done by women employees for themselves and (4) women's cheap labor when they enter the market. While ruling-class men benefit from the work of all women, all men, regardless of class, benefit from the work of some women. In these ways, the material importance of women's work to patriarchy is established.

Furthermore, patriarchy is no longer confined only to the home. Rather, it is a major feature of the labor market, too, which helps explain why women are exploited there as well as in the home. Thus, Later Marxist Feminists have argued, patriarchal relations in capitalist society have been transformed from a primarily family-centered, individual exploitation of women (and children) by men (as suggested by both Engels and the Early Marxist Feminists) to include an industrial-centered, collective exploitation of women to the benefit of both working-class men and capitalist men. However, as has been seen, while all men benefit from the exploitation of women's labor, men of different classes benefit materially and ideologically in quite different ways.

Today, with the steady increase of women employed in the paid labor market in sex-segregated jobs, men's higher wages allow them the greater probability of being able to purchase women's cheap labor in the market if they cannot get it at home (especially if the men are single, separated, or divorced [see C. Brown 1975b]). The men can buy from poorly paid women cooking, cleaning, sexual, and other domestic services that substitute at least in part for the labor that would be done by wives if they had them. In this way, men receive the benefit of women's domestic labor either through the direct labor of their wives or by being able to buy the cheap labor of women in the market. Most women, on the other hand, because of their low-waged jobs, cannot afford such costs nearly as well as most men. This, of course,

202 / BETWEEN MONEY AND LOVE

varies by class and race. Women, however, must still largely reproduce their own labor power, even when they are employed.

In short, women's work—in both the home and the market—serves the dual purpose of perpetuating both male domination and capitalist production. Capitalist men benefit the most, but men in each class and stratum (including the working class) also benefit from women's work both materially and ideologically. Only by examining these relations is it possible to meaningfully evaluate and change women's disadvantaged position in the labor market today.

NOTES

1. Bose (1973) has incorporated <u>homemaker</u> in the classical occupational prestige studies of Inkeles and Rossi (1956). However, this ranks the homemaker as one particular occupation; it does not incorporate the work of the homemaker into an analysis of other occupational categories, the basis of the occupational hierarchy itself. Most recently, Marini (1979) has tried to improve on this approach by comparing the occupational prestige of men and women at their point of entry into the labor force and 15 years after the initial study, while taking into account the influence of the occupation of housewife in women's career cycles.

Further, ever since Bose's early attempts, and under the influence of much feminist criticism, some status attainment researchers have begun to include certain homemaking and child-care variables in an attempt to account for women's occupational status and rewards. However, the method by which women's family-related sex role responsibilities are typically incorporated in this model is to accept that which should be questioned: making these women's responsibilities in the first place.

2. The failure of Braverman (1974), among other Marxist theorists of monopoly capital, to understand the patriarchal nature of the modern labor market and the patriarchal components of the deskilling process has very recently been criticized by Phillips and Taylor (1978). They argue that a deskilling of certain tasks was accompanied by a feminization of the content of the tasks—clerical labor began to include personal services, not simply a cheapening of the tasks. In fact, Phillips and Taylor argue, in certain instances of the labor process, "the work is not so much feminised because it has been 'degraded' as degraded because it has been 'feminised' " (p. 6). Thus, like monopoly capital Marxists, Early Marxist Feminists fail to evaluate both the material and ideological influences and nature of the patriarchal component of the labor market itself in their analysis of women's position in society.

7

DIALECTICAL RELATIONS OF
WOMEN'S WORK

INTRODUCTION

As has just been seen, it is essential that one understands how the home and market continually interreact within the context of the dynamic relationship between patriarchy and capitalism. Of the five different theories that have been examined, Marxist Feminist theories of patriarchal capitalism most fully address this task.

In this chapter, five issues or questions for future study will be raised. With the help of a new concept, "the dialectical relations of women's work," one can both utilize the contributions provided by the five theories analyzed in this book as well as transcend each particular building block to perceive a larger pattern. In each case, the remarks made here should be seen as tentative first steps, not as final solutions.

The dialectical relations of women's work (see Figure 2) describes three interconnected levels of analysis and reality that are reciprocally reinforcing and mutually contradictory. These three levels of analysis are: (1) the relationship between patriarchy and capital; (2) the similar, yet analytically distinct, relationship between the home and market; and (3) the mediating relations between patriarchy/capital as a macrocosm and the everyday spheres of home and market; thus, while patriarchy and capital organize the home and the market, the fact that the home and the market exist is, in turn, essential to the continuation of both patriarchy and capital.

From this analysis, it becomes abundantly clear that women's careers include both homemaking and working in the labor market. Any attempt to analyze women's occupational attainment without fully incorporating her familial tasks in a patriarchal capitalist society would be analyzing less than half the picture. This point has been made many times in the first six chapters.

FIGURE 2

Dialectical Relations of Women's Work

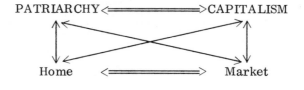

PATRIARCHY ⟨⟩ CAPITALISM

Home ⟨⟩ Market

═══════ Main relations _____ Mediating relations

Another way of conceptualizing this process is as follows:

	Patriarchy	Capitalism
Home	(1)	(2)
Market	(3)	(4)

Typically, Marxists understand class relations as they operate in the market (4), while patriarchy is thought of in terms of its operations in the home (1). The dialectical relations of women's work allow us to further ask about class in the home (2) and patriarchy in the market (3).

Source: Constructed by the author.

In the dialectical relations of women's work, the theoretical framework of Marxist Feminist theorists of patriarchal capitalism (Later Marxist Feminists) is the most powerful and inclusive for understanding women's work. Most important, this approach tells us not only that relations between the patriarchal capitalist home and market are interconnected but also that they are forever in a state of flux and change. Contained within the dialectic are mutually reinforcing as well as conflicting relations between patriarchy and capitalism, as women and men create and recreate their daily lives.

Analyses by Later Marxist Feminists have led to a focus on how partriarchy and capital have mutually accommodated to benefit each

other. In this chapter, this concept will be referred to as the "relations of reciprocal reinforcement" between patriarchy and capitalism.

However, these relations of reciprocal reinforcement may be understood as a subtype or as only one aspect of the dialectical relations of women's work. Another aspect of women's work is the "contradictory relations" between patriarchy and capital, as well as within and between the home and the market, that cause dramatic changes to occur within women's lives, as well as within patriarchy and capitalism themselves.

It is important to reiterate here that Marxist Feminist theory is in its infancy. As such, it has done a better job of understanding the relations of reciprocal reinforcement than it has of understanding the mutual contradictions between patriarchy and capitalism and between the home and market. This clearer specification of the relations of reciprocal reinforcement is reflected in the five issues to be explored below. However, the role of contradictions will also be indicated, although in a more limited fashion.

By focusing on the relations of reciprocal reinforcement, this approach is open to the criticism that it is functionalist in nature. It is true that Marxist Feminist theory does look at how patriarchy and capitalism contribute to the subordination and exploitation of women within all spheres of society—one might say, how patriarchy is functional for capital and capital is functional for patriarchy. (The Early Marxist Feminists have particularly been criticized for the functionalist nature of their arguments.) It is, nevertheless, the case that in contrast to functionalist theory an understanding of the dialectical nature of relations between patriarchy and capitalism is likewise the goal of Later Marxist Feminists. That is, because they understand society as an integrated whole that contains within it internal contradictions of ever-increasing severity, Marxist Feminist theorists are aware of the need to identify contradictions that emerge within a patriarchal capitalist society, which will lead to dramatic changes for women. It is within this context that the concept of the dialectical relations of women's work is offered.

In sum, Later Marxist Feminism has enabled the author to establish the multiple dialectical relations of women's work. In what follows, an endeavor will be made to show how the approach of Later Marxist Feminist theorists, as sharpened or carried further by the concept of the dialectical relations of women's work, opens up new questions and newly emerging issues.

The five issues or questions for future work singled out here are:

1. Sex roles: What is their meaning and effect?
2. The political economy of motherhood: What is its impact on women in the labor market?

3. The role of women in the home: How does the construction of class (and gender) take place?

4. The weakening of the family wage and the increased but less than total attachment of women to the labor market: What are the implications for patriarchy as well as for capitalism?

5. Patriarchy in the labor market: How can we better understand the patriarchal nature of the labor market? and Is patriarchy in the labor market growing rather than diminishing now?

All five questions help to elucidate some of the internal relations between entities or institutions that appear separate but that are not —for example, the home and the market. The first three emergent issues do not deal directly with the labor market itself but rather with the position of women in the home. However, as the dialectical relations of women's work makes clear, the two are intimately intertwined. Thus, consideration of one automatically leads to a better understanding of the other and of how the two are interconnected.

The last two questions for future exploration deal specifically with women in the labor market itself. They, too, however, depend for this analysis on the intimate relationship between patriarchy and capitalism as well as between the home and the market—and how these connections are, in turn, dynamically interrelated. Finally, the philosophy of dialectical relations emphasizes that what are ordinarily taken as different objects or institutions are, in fact, components of the same thing. Only in this way do the internal relations of women's work come into conflict with one another as patriarchy and capitalism confront and struggle both within and between themselves in the home, in the market, and in their interconnections. Although an analysis of these contradictory relations is not fully developed below, this is the direction in which Marxist Feminist analysis must go if it is to fulfill its promise of understanding women's situation and how to change it in patriarchal capitalism.

MEANING AND EFFECT OF SEX ROLES

By using the approach suggested by the dialectical relations of women's work, one can make use of and go beyond the traditional and often limiting notions of sex roles used in mainstream sociology (Chapter 1).

Here it is hypothesized that patriarchy in U.S. capitalism today takes the material form of sex roles themselves—the work women do both at home and in the labor market: cooking, cleaning, shopping, ego building, bringing up children, nurturing, and so forth in the home; and sewing, cleaning, typing, making coffee, protecting bosses,

nursing, teaching, nurturing, providing sexual services, and so forth in wage labor. Values of male domination, sex role stereotypes, and corresponding sexist myths make up the culture or ideological reality that defines, supports, and distorts what women actually can and do perform.

In short, what is being suggested here is that mainstream sociological analysis of sex roles, important as it may be in some respects, is insufficient to explain women's position in contemporary U.S. society. In addition to the gender-differentiated attitudes and behaviors that women and men are trained to assume (see Chapter 1) —that is, in addition to normative sex role expectations, beliefs, ideology, and even social structure in the abstract—sex roles must also be grounded in the material work women do for men and for capitalist profits. Only in this way can one begin to understand the impact and meaning of sex roles in a patriarchal capitalist society.

While Marxist Feminists in general (and particularly the later group) rarely discuss in any detail either sex roles, * the socialization process itself, or sex role ideology,[1] mainstream sociology has focused on the study of the form and content of sex roles (in the author's comments in this chapter, most of the references to mainstream sociology refer to the work done by those included in Chapter 1, although not exclusively so). Keeping in mind the Marxist Feminist attention to the concrete material and ideological forms of sex roles that reveal woman's special position in society, let us turn to the mainstream literature for clarification through sex role research.

In our society, men and women are expected to think and act in ways that are substantially different from each other. This is supposed to be reflected in gender-typed personalities, temperaments, and behaviors.

Despite the findings that indicate few differences in ability and temperament (see Chapter 1), the behavior and experience of men and women in the adult world reveal large differences between the sexes in terms of what people actually do. Whatever their IQ, academic training, religion, race, socioeconomic strata, or personality, it is women, not men, who are typically found in the home doing household, husband, self- and child-care maintenance (Lopata 1971). A wide variety of women both perform housework and identify themselves as homemakers.

Regardless of temperament, physical stamina, or intellectual capacity, comparatively few women hold positions of influence, de-

*The term sex roles will be used in this section since this is the term most commonly used in the mainstream literature. However, the more appropriate term is probably gender or sex/gender roles. See Lopata and Thorne (1978) for a discussion of this issue.

cision-making, and authority. In the labor market, women work in different jobs than do men—especially doing the "female tasks"—that are not only different but are also lower status, lower paid, less stable, and less powerful. When men and women work in the same field, the higher up the hierarchy one looks, the smaller the proportion of women and the greater the disproportionate representation of men one finds (see Chapter 2). This is true whether one looks at fields that are occupied predominantly by men (medicine and factory workers) or fields that are occupied predominantly by women (education, social work, and office work).

The differences in the actual behaviors of men and women contrast sharply with the relatively few differences in intellectual and social abilities described in mainstream research (see Chapter 1). What is so striking is that the behaviors of men and women reflect the cultural sexual stereotypes about men and women, not the actual biological sex differences.

Pervasive and persistent sex role stereotypes have been found to exist among people from many different backgrounds. The power of sex role stereotypes obliterates or distorts people's real capabilities by channeling them into behaviors and experiences that fit the stereotype. What is important for us to understand here is that the actual behaviors of women—in terms of the actual work they do—fit the sex role stereotypes remarkably well. Women may not be less intelligent or less capable, but they are not found in the better jobs. Women may not be more nurturing or better prepared for child care, but they are the ones who provide the nurturance and child care.

Sex role stereotypes mean much more than just what one expects from people. They make up the core of an ideology of male domination that defines, supports, and reinforces the devalued but critical and essential work women do—both in the home and outside it.

One problem with role theory for this analysis is that it assumes a certain kind of voluntarism on the part of the role players. Men and women are assumed to play their roles, to be sure, differently but to be able to enter and leave them, if not at will, then under certain conditions. If one changes the pattern of sex role socialization and training, it is argued, one can create men and women who are more alike. This approach ignores the power differential between actors in such roles as employer and worker, student and teacher, doctor and patient, father and son, or father and daughter. Much more is at stake in these roles than simply role players acting in certain ways. That is, certain people benefit from certain roles, especially those defined as masculine and feminine.

The notion of sex roles, furthermore, implies the objective and impartial enumeration of gender-linked differences. Frequently based on a biosocial idea of sex roles, male and female characteristics are

assumed to be different but equal. That is, men and women are as-
sumed to have specialized roles that are complementary to each other,
especially as society has organized men and women with primary re-
sponsibility into different spheres of existence: men into the world
of work; women into the home.

It is on this basis that mainstream research has described wom-
en's employment as disruptive to her family. But such an analysis
implicitly accepts the underlying premise that women's place and pri-
mary responsibility is and should be as wife, mother, and homemak-
er. How else could one even ask the question about the wife's employ-
ment disrupting family stability, which, no doubt, it often does in our
society?

Today, more and more feminists are beginning to see through
the earlier arguments of complementarity in sex role relations. At
the same time, the sex role stereotyping literature is now document-
ing the superior value of male-identified characteristics in our so-
ciety and the inferior value of female-identified characteristics. The
sex role system is much more than a belief system; an entire social
structure is dependent upon the work women do for men and for capi-
tal.

Traditional sex role theory assumes change is possible through
changing our socialization patterns and processes. In the social sci-
ences, changing the way boys and girls are treated at home and in
the schools is the most frequently mentioned solution to sexism. The
goal, at best, is to help men and women have the "best" of each
other's characteristics: women should be more assertive and self-
confident; men should be more nurturant and emotional.

Such an approach, however, ignores the political economy of
gender, class, and race within which socialization occurs. It is not
possible to change the socialization process by itself. The patriarchal,
capitalist, and racist ordering of society must be changed as well in
order to create equality.

Even if one suggests that men should take over equal responsi-
bility for child care, this cannot happen without dramatic changes oc-
curring in the labor force, the wage system, the family system, and
the system of benefits and privilege to men, capitalists, and the white
population. It is not simply the fact that women mother that is the
problem. Women have always mothered. The main problem is the
form and nature of mothering in our society: it is grounded in the
struggles and alliances created by patriarchy and capitalism, not
only in the home but in the market, the state, the church, and else-
where.

Instead, our attention must be refocused, as Later Marxist
Feminism (Chapter 5) suggests, on the construction of women's roles
by and for men and capital. One must look at the work women do in

the production, reproduction, and consumption of goods, services, and people—in the home, the community, and wage labor—to understand sex roles, their meaning, and their material and ideological grounding in our society.

Let us examine, first, how women's work benefits both men and capital. Women work for men and their children in maintaining their individual families; they simultaneously serve capitalism as consumption or maintenance workers. They reproduce labor power, both waged and unwaged, at the expense of the working class, not of capital; they simultaneously provide capital with a labor force, a reserve army of labor, and themselves: the hidden laborers whose work makes possible surplus value and male domination, their own work in the home, and their own potential and actual work in the labor market. In the home, their labor power is controlled by their husbands at the same time as it serves as a hidden reserve to the reserve army of labor for capital; in the market, their labor is purchased cheaply by and for capital. This is the role assigned to women: the ones who provide men and capital with children who are future heirs[2] and future waged and unwaged laborers and taxpayers. Further, they provide men and children with emotional support, comfort, and companionship as well as a place to let off steam and release their daily tensions.

If the home is a refuge for men from the alienated world of work, it is hardly the same kind of place for women. The facts that women (and children) are battered by men (Pagelow 1978; Strauss 1976), that marriage provides more benefits to men's than to women's physical and mental health (Bernard 1972; Gove and Tudor 1973), and that women are more commonly "unmothered" and unnurtured in marriage than men (Rich 1976) all attest to the less adequate role of the home as a refuge for women. Moreover, by providing men this arena in which to assert their privilege—material and psychological—capital siphons off worker discontent and ensures worker stability.

That women's work is beneficial to capital and to men in the home and in the market should not obscure the contradictions emerging in both places. Wage-earning women tend to demand more decision-making power and rights in the home, thereby challenging patriarchy in the home. The demands of employed women and the women's movement for equal employment opportunities and rewards also have resulted in federal legislation to prevent sex discrimination. This challenges both patriarchy and capital in the market. And with the encouragement of the women's movement, battered women and victims of rape and various forms of sexual harassment on the job are beginning to fight back against patriarchy and capital in both the home and market. Further, as women work in their sex roles as housewives and mothers, or as cheap part-time employees with primary responsibility for their families, their position as a reserve army of labor

is used by capital to drive men's wages down—in spite of the fact that men are materially better off than women because of their better-paying and more stable jobs. So, on the one hand, sex roles benefit men by maintaining better and higher rewards for them than for women. On the other hand, they are used by capital to cheapen men's labor and divide them from women—potential allies in the struggle against capital. Thus, in addition to these challenges to capitalist and male domination, contradictions are emerging between patriarchy and capitalism, all of which are potential sources of change.

In short, if one understands sex roles as grounded in the work women do—both emotional and physical—one can argue that sex roles are an important part of the social relations of patriarchy and capitalism. The sex role ideology surrounding the work women do is not simply a set of cultural beliefs attuned to the biological or social needs of men and women. Rather it is an ideology, a whole culture or a justificatory world view for patriarchal capitalism.

The ways in which men are expected to behave in our society—to be competitive, rationalistic, individualistic, dominant, aggressive, decisive, and independent and to work in the interest of the private profit-making enterprise—are very much a description of the dominant values in a capitalist society.

Capital, however, is unable to meet certain social needs (both individual and collective) through private, individual, competitive profit-making mechanisms, which separate people from each other. It depends upon so-called women's characteristics to fill in the gaps. Women's nonaggressiveness, nurturance, supportiveness, and emotional sensitivity serve social needs well. Thus, women's labor provides an undergirding to the capitalist system, which supports social connections outside of private profit-making enterprises, in the home and through government services (paid for by taxpayers' money). It was the Early Marxist Feminists (Chapter 4) who clarified the mystification and reality of women's home labor in monopoly capitalism: women's hidden labor in the home is economically essential to capitalist profits and to men's better position in the labor market. Although it is now recognized that women's physical tasks of housekeeping and family care were invisible due to the fact that they occurred within the individual family and for no pay, women's nurturance work remains invisible because it is viewed as emotional and passive, not as politically and economically valuable.

Likewise, much of women's wage labor can be understood as an economic undergirding of capital. Women are hired in the labor market as women in their nurturant, supportive, and maintenance (or domestic-type) services. As monopoly capital theorists (Chapter 3) make clear, much of women's work in health, in social services, in education, and in other government bureaucracies is paid for out of

the taxes of men and women employees—the costs are socialized at the expense of the working class—but the work serves to the benefit of capital. In these essential social services, women do women's work: nurturance, caring, ego building, child care, inculcating proper social values, taking orders from male bosses, cleaning, cooking, and so on.

While it is clear that women's sex-stereotyped characteristics of passivity, dependence, and emotionality are devalued in our society, the contradictory nature of women's sex roles is seen in the positive aspects of feminity: nurturance, warmth, and supportiveness. However, because men denigrate women's work, even the nurturing roles women occupy are oftentimes devalued (compare a nurse with a physician; a social worker with a psychiatrist). Moreover, the fact that these needs cannot be adequately provided for by private enterprise or personal independence, but must be provided for by public social services, means that these nurturant tasks can be denigrated in part because women perform them and in part because they do not fit the capitalist model of independence and private profit. (See Hartmann and Bridges [1977] for further comments on this issue.)

In short, if one understands female sex roles as the emotional and physical work women do, and the ideology that surrounds it, then it is possible to argue that women's sex roles are vital to the social relations of patriarchal capitalism. Sex roles are no longer abstract categories of gender-related normative expectations and behaviors. Instead of understanding sex roles mainly in the realm of ideology (as both mainstream and Marxist theorists often do), one comes to understand that women's sex roles are likewise grounded in the material work women do for men and for capital.

IMPACT OF THE POLITICAL ECONOMY OF MOTHER-HOOD ON WOMEN IN THE LABOR MARKET

It is not enough to look at the increasing participation of women in the labor market as do theorists of status attainment (Chapter 1) and the dual labor market (Chapter 2). One must look rather at the dual jobs women perform when they do join the labor market. It is possible to argue that patriarchal capitalism has made home work women's work whatever their employment status. Unlike the focus of mainstream social science on women's role conflict when they enter the labor market, the dialectical relations of women's work makes it clear that it is women's continuing responsibility for domestic labor that is at issue, not simply the degree to which they are able to solve their role conflict. (Those women who are capable of hiring household help are still responsible for the organizing of the family mem-

bers' affairs. And it is still women—in low-waged and devalued, sex-stereotyped employment—who perform these tasks.)

In this section will be raised, as a second emergent issue, a particular aspect of women's sex roles in our society: that of being mothers and how this influences their position in the labor market. The focus will be on the institution of motherhood and its political, economic, and sexual organization. Use will be made of information from both Chapters 4 (Early Marxist Feminism) and 5 (Later Marxist Feminism) with particular emphasis on the contribution of the non-Marxist, radical feminists (discussed in Chapter 5). Once more, the Later Marxist Feminist method of analysis will be utilized in this section, but then the analysis will go beyond it. The issue of the dialectical relations of women's work is sharpened as one sees how a woman's role as mother in the home molds how she is treated as a mother in the labor market, too. A unity of opposites—home work and market work—can be understood, in part, through an elaboration of women's work as mothers, both at home and in the market.

It has been not the Marxist Feminists but the radical feminists who have focused on women's specific role as mothers in analyzing women's exploitation. The material and ideological supports of women's oppression take the form of the work they do with and through their bodies and their labor—bearing and rearing children in society. Radical feminists, unlike many mainstream social scientists,[3] understand motherhood as an institutionally organized experience. Hence, it is neither the bearing nor the rearing of children that is oppressive; it is the institution of motherhood as organized by and for patriarchy that makes women into mothers as they are known in our society. It is, therefore, understandable that many women say they wish to be or enjoy being mothers but vehemently dislike the institution of motherhood as it is organized traditionally.

Although there are limitations to the radical feminist analysis, it does lead one to ask questions about the organization of the institution of motherhood in our own history and about what is needed to change it. This approach is quite different from saying that the institution of motherhood causes discrimination against women in the labor force and leaving it at that, as mainstream theorists often do. The radical feminist analysis, moreover, directs one's thinking to questions about the nature of the reproduction of motherhood itself.

The responsibility of women as full-time wives/mothers/homemakers is a uniquely twentieth century idea for the masses of women in the United States. The effort by male owners of industry, male workers, and male-dominated unions in the nineteenth and twentieth centuries to make market work "men's" work and the unwaged sphere of home work "women's" work was played out through the contradictory forces operating in protective legislation, child labor laws, the

intensified sex segregation of the labor force, and the creation of the family wage (see Chapter 5).

It was, of course, the outcome of these struggles and alliances between patriarchy and capitalism that led to the definition of women's arena as the personal world of the home and men's as the social, powerful world outside the home. Acceptance of the "spheres," in turn, allowed for the construction of the institution of motherhood as it is understood today. The ideological underpinning for this belief system was cemented by the identity of women with their "natural" role in the family. Most of all, it was woman's role as child-rearer that put her and kept her in the home. This new ideology emphasized her biological features (womb and breasts) and her allegedly innate maternal instinct in the social role of mothering.

Changes in the role of women as full-time mothers occurred "under the guise of a policy toward children" (Zaretsky 1978, p. 211). Culminating in the Progressive era (1900-17) and the Doctrine of the Tender Years (in the 1920s), the full-time work of motherhood and homemaking was assigned to women in the United States.

Children, no longer productive members of their families (as they were in agricultural times or in very early industrial times), had become an economic burden to their parents. Someone had to take care of them. Both men and capital chose women to do it. Capitalism needed a healthy, well-disciplined, and well-trained current and future labor force. Men in individual families needed to decrease competition with the large numbers of women and children working in the market (in the late nineteenth century); they also needed to have someone to take care of their household needs, especially children, and to perform whatever was necessary to enable their return to their jobs the next day. The family wage helped ensure that it would be women who continued to perform these tasks.

Making motherhood, domesticity, and subservience to men acceptable to women was a major development that took place beginning in the nineteenth century (Easton 1976). Women did not simply give up their direct production of domestic goods. They had to be convinced first of the importance of their new role devoted to the production of use-values, not exchange values (the mark of worth in capitalism). The elements of this new ideology that had to be asserted as natural fact were: children required full-time, undivided adult attention; women were specially endowed to provide this care, along with the homes their husbands needed to ensure the reproduction of their labor power; and domesticity would not only shield women from the evils of the outside world (they hoped that women would simply become larger versions of children [see Rowbotham 1973]) but would also bring them certain rewards of status that would be mediated through their families.

This all depended on a new conception of human nature: where Puritan parents were previously told that their children were fundamentally sinful, nineteenth century mothers were told that their babies were innocent and pure. These children had to be shielded from the corrupting influences of the outside world. As a palliative, women were told that they could exert a powerful influence over society through their sons without ever leaving home. Through this new role, which nature allegedly equipped only them to handle, women could reform the whole of society. Thus, the idea that children were innocent and malleable helped to explain and justify women's confinement to the home (Easton 1976).

In addition, women's relegation to the home in industrial capitalism was also supposed to result in an elevation of maternal qualities in women, as they served as nurturant supporters and moral models for both their children and husbands (Chodorow 1978a).

The ideal of full-time motherhood was clearly class and strata based. In the late nineteenth and early twentieth centuries, the ideal woman's role became exemplified by the wives and daughters of entrepreneurs and merchant capitalists of the northeastern United States. In fact, the cult of true womanhood—idleness, leisure, frailty, conspicuous and preferably wasteful consumption—depended on the hard labor of many immigrant and slave women who staffed households, acted as wet nurses and nannies, and were personal maids for these ladies of leisure. Furthermore, this cult of true womanhood also depended heavily on the bye work and factory work of certain miserably poor women who helped produce the goods bought for these fashionable homes. Ironically, the ideology of the cult was also in contradiction to the way poor working women were treated by the factory owners: their female biology (menstruation, childbirth, and nursing) was totally ignored by the factory owners. If these women attended to their biological needs, they were fired (Ehrenreich and English 1973).

Over the course of the twentieth century, however, for wives not to work for wages became the mark of class superiority for men of all levels of the working class. (This ideology should be separated from the fact that poor women have always had to work for wages.) The books that began to appear espousing these new values of "scientific motherhood" and "domestic science" were geared especially to the emerging "middling classes" of mass production monopoly capitalism (Ehrenreich and English 1975).

At the same time that this twentieth century ideology of individual and isolated motherhood was spreading, bolstered by the science of mothering developing in schools and literature, the employment of

women in the labor market was increasing.* The capitalists' need for continually increasing consumption by the working class (that is, ordinary people) became essential. By the 1920s, with the introduction of mass advertising, not only was mass consumption integral to the development of capitalism. So, too, was the need for women to do this consuming (Vogel 1978).

During the 1930s and after World War II, the intensification of specialization and the sexual division of labor reinforced attempts to keep women out of the labor force. In the late 1940s, the ideology of the isolated nuclear family served to stunt the social impact of a rapidly increasing participation of women, especially married women, in the labor force. Despite the fact that women were working in increasing numbers, they were supposed to believe their real identity lay in family duties. Even during the war, with its massive influx of women into factories and war work, women's wage work was projected as an extension of their family duties, to be revoked when the war was over. This ideology was supported with contracts and agreements for the women to give up their jobs—to their husbands and to their male neighbors—when the men returned from overseas.

Although more and more women have entered the labor force in the 1960s and 1970s, and it is no longer desirable to deny their presence, women are still employed as women and particularly as mothers. In fact, extensive research about working women in terms of role conflict or working mothers in mainstream family sociology as early as 1960 alerts us to the crucial importance of women being treated as mothers in the labor force.

Not only is the definition of women's work in the home as mother determined by and for patriarchal capitalism but it is crucial in de-

*A series of inconsistencies emerge as one tries to understand the demand for full-time mothering for women in our society. As noted above, women were becoming increasingly employed at the same time as full-time motherhood became the ideal. Second, women were being relegated to the home as their primary responsibility, just as technology made possible modern birth control and bottle feeding. Third, while women were increasingly convinced of their maternal instincts and the naturalness of their role as mothers, they were instructed by a whole movement of male experts on how to be good mothers. Fourth, today as middle-class women are more effectively able to control their family size with modern contraception, they must spend more and more time with their children. The expansion of children's individual needs takes over and controls more of women's time and energy. Women become specialists par excellence in mothering (see Chodorow 1978a).

termining what happens to women in the labor market as well. In short, one might argue, when women go into wage labor, they do so as mothers. This may be understood in at least the following ways:

1. Most important, women enter the labor market in order to fulfill their duty as mothers in the home—to secure money to buy goods and services for their families that previous generations of mothers produced in the home.

2. Once in the labor market, women—all women—are treated as mothers—former, actual, or potential.

3. As paid market workers, women continue to do mothering on the job.

Before each of these is explored in more detail, however, one needs a clearer understanding of the work that is mothering. Mainstream and Marxist social scientists alike agree that the tasks of women in the home include the physical care and reproduction of the children, husband, and home (daily and intergenerationally). This is usually referred to as housework, consumption work, or maintenance work by Marxist Feminists. In addition to the physical labor involved in work done in the home, there is the emotional or personal care of children and husband, which is variously referred to as mothering, nurturing, or caring. Finally, there is the inculcation of ideological premises and values. All together, the physical and emotional work of women in the home has been coined "motherwork" by Bernard (1974).

Motherwork can be said to consist of several different and interconnected features. Specifically, these are: (1) mothering, which consists of the emotional and physical care of infants and children: touching, rocking, smiling, feeding, teaching, diaper changing, playing, disciplining, and so on and (2) added housework caused by infants and children, which includes the extra cooking, cleaning, laundering, shopping, sewing, driving, waiting, and so on necessitated by caring for children. *

Neither the mothering nor the added-housework component is a simple phenomenon. The mothering component of motherwork is not

*It has been estimated that housework with no children at home consists of 1,000 hours per year. With a child over the age of six, this figure increases to 1,500 hours per year. But with a child under six, hours increase to 2,000. There are only 8,760 hours in an entire year (see Bernard 1974). Thus, 5.5 hours a day are spent in housework in a household with a child under six. This does not include bathing, diapering, disciplining, playing with, feeding, and soothing the child, and so on.

limited to infants and small children. As Bernard suggests, "The stroking, support, loving care and healing which women supplied to all family members in the home according to the Victorian model remains; it is still written into the role script of all women workers no less than mothers" (p. 116). With regard to the added-housework component, Bernard suggests that with small children the physical work involved in motherwork requires an enormous amount of housework. When the children are older, however, it may require part-time, outside jobs.

Now, let us return to each of the three explanations of the ways in which it is an extension of this motherwork that women enter the job market: that is, when they go into wage labor, they go as mothers.

First, women enter the labor market today to buy the goods and services they need in their jobs as mothers. Bernard argues that "labor force participation is mainly a different kind of motherwork; it provides college for grown sons and daughters and even helps in establishing themselves" (p. 130). Just as industrial capitalism pushed out of the home goods that had once been produced there by women, monopoly capitalism has increasingly pushed services out also. In post-World War II United States, women need jobs to pay for goods as well as services for their children that had previously been provided at home: education, health care, nursing, psychotherapy, birthing of babies, baby-sitting, food preparation, clothing, shoes, and washing machines. In monopoly capitalism, in sum, not only are goods and services increasingly found only in the market; it has also become cheaper to produce many of them in mass production than in the home (for example, clothing), resulting in our dependence on them.

It is in capital's interest to have women who work in the home be able to work in the market, too. Women become not only "finely tuned customers" but also "workers in the home, ready for integration outside the home" (Baxandall, Ewen, and Gordon 1976, p. 8). This is not to say that there are no tasks left in the home. Hardly. Hence, keeping women in the role of mother and employing them as such in the market is a reasonable solution for capital. On the one hand, women are employed to provide goods and services from which capital can profit directly. On the other hand, many other tasks remain for women to do in the home at no cost to capital.

Contradictions abound, however, between women's position as mothers and their position as wage earners. First, having children increases costs to the family and increases the likelihood of women having to work outside the home, just when they are supposed to be staying home and doing full-time child care. Second, while men are affirmed in their double relation of breadwinner and father, women's role as a good mother is often seen as jeopardized by her role as wage

earner, especially in relation to the emotional and physical well-being of her children. Further, while women's feminity is enhanced as mothers in the service of husbands and children, once in wage labor women's desirability as sexual objects comes into conflict with their feminity as mothers and wives at home (see Bland et al. 1978). Not only is patriarchy affected by this but so, too, is capital. One important mechanism for dealing with this contradiction has been the expansion of the sex segregation of the labor force through the threat of sexual harassment. For example, women are segregated off from men in lower-paid and less powerful jobs. On the one hand, this tends to protect them from being sexually harassed by male coworkers (although not necessarily from male supervisors). On the other hand, it reminds women of their dependence on men for protection outside this supposedly safe sex-segregated work space. More recently, however, all forms of violence against women (sexual harassment on the job and rape in marriage) are being challenged as the experience of women moves between motherwork at home and motherwork in the market.

A second major consequence of the extension of motherwork from the home to the market is that when women enter the labor market, they are treated as mothers—past, actual, or potential. This phenomenon is attested to by the increasing literature treating employed women as "working mothers" rather than as employees. Further, the old rationalization for not advancing women all too often still holds. If the woman is single or newly married and without children, she will not be given a responsible job with high wages since, it is said, she will probably leave when she has a chance to marry and have children. If she has children, the rationalization given is that she will be unreliable because of the need to be absent if her children are sick. This apologia persists despite the fact that male turnover and absenteeism rates are similar to women's, the crucial difference being that women have traditionally left the market for lack of child care and other family services, while men have left a particular job for personal advancement (see Chapter 2). Men's reasons for leaving are always more acceptable, for men are understood as workers; women, on the other hand, are understood as mothers.

More recently, during the economic crises of the mid- and late 1970s, the charge of women's instability and unreliability as workers has abated as it has become economically worthwhile for a company to exploit women as part-time workers (see Chapter 3). Mothers of school-age children are now said to be stable, conscientious, and appreciative of companies tailoring work hours to their family schedules. Mothers are still cheap labor, but at least mothers of school-age children have become reliable.

Furthermore, because women are mothers first and because only men are paid a family wage, women are always classified as

secondary workers in the family. This assumption holds true whether the woman is single, a grandmother, married, divorced, or whatever. Being viewed as a mother in a nuclear family rationalizes the low wages of all women throughout the life cycle.

This tendency to treat all women as mothers who are secondary workers in a family, however, does not go unchallenged. For example, with the help of the women's movement, itself an outgrowth of the contradiction of women's double day, hundreds of thousands of complaints have been filed with the Equal Employment Opportunities Commission alone. In the year ending June 1973, the commission received 24,300 sex discrimination complaints against companies and had a backlog of 65,000 cases (Bender 1974). Greater attention to the control of women's bodies, at home and at work (by fighting against voluntary sterilization of Third World and poor white women and, more recently, against forced sterilization of women workers in order to keep their jobs), has been a major part of the women's liberation movement since its rebirth in the 1960s.

In fact, today, women are more and more aware not only of the struggles they must wage against individual men at home in making decisions over their reproductive capacities but increasingly of the struggles between working-class men's resistance to ruling-class and government attempts at population control through women's bodies. Thus, while men try to maintain control over their own wives' reproduction, they object to capital's increasing attempts to take over this control. And while on the one hand, the husband's patriarchal right to control his wife's body is a core problem, on the other hand, men can be allies of women in their struggles against capital's control of their bodies. However, women's struggles for control over their reproductive capacities also demand better understanding and greater struggle to overcome class and race divisions among women themselves. In short, while many conflicts exist, it is through these conflicts between men and women, as well as between working-class and ruling-class men, and through alliances among all women that the potentials for change will occur.

Third, and finally, motherwork does not end at home. Women perform such mothering tasks on the job as nurturing, soothing, healing, teaching, and giving sexual comfort and ego support. Even unmarried women with no children of their own must mother men at work. These mothering tasks are sometimes paid for—as nurses, teachers, social workers, and so on—and are sometimes simply appropriated—boosting the boss's ego, making coffee, getting his reports into final shape before typing them, doing housecleaning tasks to help present the boss to the public, and so on.

Here, too, though, the contradictory patriarchal aspects of motherwork, hitherto private in the family, become publicly visible

in wage labor. Women both individually and collectively have begun
to challenge non-job-related demands, such as making coffee, sewing
up the boss's pants, and running personal errands for him. More-
over, they are increasingly becoming aware of the unwaged work done
at home in their mothering for which they are now being paid in the
market. Not only does this put pressure on capitalism, as women
learn that the unpaid work they do benefits the ruling class's profits,
but it intensifies the contradictions within patriarchy: on the one hand,
men and women have very similar interests at home in providing for
their families; on the other hand, in the market men's and women's
interests are very different. This in turn is threatening to men, as
all the while their wives must increase their labor force participation
to keep up with rising inflation.

In this section, it has been argued that as women have increas-
ingly entered wage labor in the twentieth century, their participation
can be understood as an extension of their roles as housewives and
mothers. In other words, this added wage labor is part of their
motherwork. Nonetheless, whenever women are employed for wages
in the labor market, they always have two jobs: one at home and an-
other in the market. Both can be said to represent motherwork. The
intimate connection between home and market labor, a basic premise
of the dialectical relations of women's work, is strikingly demonstrated
here.

Women's role as mother in the patriarchal capitalist home rein-
forces their treatment as mothers in a labor market organized to
benefit men and capital, which in turn reinforces again their work as
mothers in the home. These relations of reciprocal reinforcement
should not obscure the fact that a multitude of conflicts emerge in this
situation. Women's role as mothers is both in the interest of capital
and the outcome of class struggle; likewise, women's role as mothers
in the home is in the interest of men but simultaneously is the his-
torical outcome of struggles between men and women. Moreover, as
was seen with the family wage in particular (Chapter 5), it is not only
the contradictory relations within the analytically distinct systems of
patriarchy and capital but also the struggles between patriarchy and
capital that helped to create the full-time mother of the industrial
capital period and the normalization of the double day for the mother
of the monopoly capital period.

WOMEN'S ROLE AT HOME IN THE
CONSTRUCTION OF CLASS (AND GENDER)

Instead of seeing the home as women's sphere and the market
as men's sphere (as in Chapter 4), it becomes necessary to understand

that both the home and market are mutually interpenetrating and are organized by the dialectical relationship between patriarchy and capitalism. Patriarchy and capitalism operate simultaneously in each sphere of living; each strengthens the other through reciprocal reinforcement, at the same time that contradictory relations continually emerge to threaten their dominance.

Two features of patriarchal capitalism that the analysis of Later Marxist Feminists underplays are the development of class in the home and how patriarchy is played out in the labor market, both materially and ideologically. While Marxist social scientists have generally understood the operation of class relations in the market and patriarchy in the home, the concept of the dialectical relations of women's work will be drawn on to analyze class in the home[4] (in this section) and patriarchy in the labor market (presented later). (It may be helpful to refer again to Figure 2.)

The relationship between sex/gender and class systems, in other words, is a dialectical process experienced in the home as well as the market. Hence, in this section it is hypothesized that women's daily work in the family reproduces social classes (class relations do not operate only at the point of contact between wage earner and employer) and that the particular form of the family as it is experienced today reinforces and legitimates the relations between waged workers and capitalists. Finally, it is argued that Marxist Feminist analyses (Chapters 4 and 5) must incorporate more clearly an understanding of the sex/gender social relations produced and reproduced in the family.

Thus, the family and women's role in it is not only organized by patriarchy and capitalism but reproduces within itself both patriarchal and class relations. This is a two-way process: the work that women do in the family produces both sexed (or, more appropriately, gendered)[5] and classed workers, just as the labor market does. This is a core dynamic of our contemporary social order and a key issue raised in this book as a whole.

First, to understand how women reproduce class in the home, one must understand that the underlying activities in the home and market are not isolated from one another; rather, they are intimately interconnected.[6] The physical isolation of women from the labor market in their roles as mothers/homemakers has led sociologists to see men as the only point of articulation between the family and the larger society.

Thus, the social stratification literature (Chapter 1) traditionally sees men as linking women and children to the larger socioeconomic organization of society only through men's wage labor. However, even feminists doing research in social stratification—who argue that women's increased employment requires us to reevaluate the articulation of the family to the socioeconomic system—are missing an

important point: women as wives, mothers, homemakers, in their work in the home and in their daily activities, play an essential role in articulating the family to the larger society. This is equally true whether or not they work for a wage.

This leads to the second point: women work assiduously at linking their family members to the larger society. They do this in both obvious and subtle ways. In the former case, they establish networks for their children and husbands in the community. In the latter, they pick up slack in periods of economic crises. They tighten up the household budget, and they care for a vast array of people who can no longer be supported by public institutions. For example, women care for elderly family members released from hospitals and nursing homes, children unable to attend day-care centers or sent home from schools unable to remain open for lack of tax monies, teenagers and young adults unable to afford the costs of rising college tuitions, and unemployed mates and family members. These examples attest to a more hidden form of linkage that women make between the private life and the public life of the family created by a patriarchal capitalist society: between use-value and exchange value, between consumption/reproduction and production, between love and money.

Hence, the seemingly private relationship between husband and wife, and the personal sphere of the home, mystifies the role that women as wives and mothers actually play in the total process of social production and reproduction. In fact, one can argue, without women's work in the family as constructed by patriarchy and capitalism today, neither male wage labor, surplus value for the capitalist, nor social classes would be possible.

This mystification of women's role in the home is exemplified most clearly in an analysis of family budgets (Chapter 5). Such a study illuminates how the wage, through the wife's work in the home, gets transformed into unequal shares of food, health, leisure goods, and time. More to the point here, it further dramatizes how "the particular family form created by capitalism—woman, confined to monogamy, housework, economic dependence, man defined as bread-winner—itself helps to legitimate and stabilize the wage labor-capital relations" (Petchesky 1978, p. 379, emphasis added).

Moreover, one must distinguish between the family (a normative construct, as well as a more extended network of kin relations) and the household (a unit within which people pool resources and perform tasks), and one must note how the relationship between the two varies by class and strata (Rapp [Reiter] 1978). In this way, one can begin to unravel the way women articulate the family to the larger society. The family is an acceptable way to recruit people into households. As such the concept of the family carries a heavy load of ideology. It is

a socially necessary illusion which simultaneously ex-
presses and masks recruitment to relations of production,
reproduction and consumption—relations that condition dif-
ferent class sectors. Our notions of family absorb the
conflicts, contradictions and tensions that are actually
generated by those material, class-structured relations
that households hold to resources in advanced capital-
ism. [P. 281]

Furthermore, men and women enter these relations differently.

A third point demonstrating how class structure itself is af-
fected by kinship and family relations can be seen in historically spe-
cific patterns of marriages across lines of class or strata. For ex-
ample, marriage patterns themselves affected the identity and solidi-
fication of the upper class in eighteenth century France and England
(Petchesky 1978). Between male members of high commercial and
finance capital and the more enterprising elements of the aristocracy,
the exchange of daughters of the nobility and gentry was a primary
agent during the preindustrial capital accumulation in cementing a new
ruling class. Thus, patterns of endogamy and exogamy tell us much
about the process of class formation and the nature of class conscious-
ness. In our time, too, some people suggest that studies be done on
the "exchange of women" between men to learn more about class for-
mation (G. Rubin 1975). Others suggest the investigation of how the
advanced social division of labor in our society replaces the function
of the exchange of women in smaller, developing societies. Thus, in
small societies with limited development, the exchange of women
links several of these small societies, thereby serving as a mechan-
ism to create bonds between groups and to ensure the survival of the
group. In class societies, such as our own, where it is argued that
the degree of cohesion of the society is determined by its economic
organization, the traffic in women becomes a less important mecha-
nism in the bonding of different groups (except to cement ties between
high-level financial and political empires). In fact, the high degree
of marriage within one's class or cultural group suggests that through
endogamy (or marriage within one's group) women become a means
of integrating groups internally, instead of acting as a bond across
different groups (Young and Harris 1978). (The implications of this
distinction for understanding the patriarchal relations in our society
are not adequately drawn out in this analysis. More work is obviously
needed here. Both Rubin and Young and Harris provide insightful be-
ginnings.)

A fourth point is that women reproduce social classes through
their daily task of discerning patterns of consumption. Life-styles
are not simply a function of people's attitudes or values. Rather, only

certain life-styles are possible within the wages and property rela-
tions available to people in our society. All this means that women
tend to maintain family living spaces with the appropriate stratifica-
tion symbols and life-styles; to arrange friendships for their children,
husbands, and themselves, as well as to arrange social life; and to
articulate the family and its members to the class-, gender-, and
racially appropriate bureaucratic, educational, professional, and
retailing organizations (for example, welfare, school, dentist, super-
market, ballet lessons), thereby completing the cycle from production
to subsistence. All this is in addition to the traditional notion that
women reproduce class in the home through socializing children and
husbands with the appropriate culture, ideologies, attitudes, and
habits (see below).

In short, mothers are not only supposed to produce workers but
certain kinds of workers: workers who will discipline themselves on
the job, who will work efficiently without constant supervision, and
who will be submissive to organized authority (state, employers,
supervisors). However, such workers will vary by class and strata.
For example, authority structures may be internalized in highly mo-
tivated workers of the so-called middle classes or may be externalized
in the form of work rules and supervision among so-called working-
class people. (A large literature in mainstream sociology exists in
this area.) This process of appropriately socializing workers from
different socioeconomic strata, however, filled with contradictions,
is always being challenged.

Moreover, it is most important to recognize here that the orga-
nization of women's jobs in the family is mediated by their own par-
ticular relationship to the mode of production. The values, skills,
and socialization functions of different strata within working and rul-
ing classes are a product of the differences in their relation to the
capitalist enterprise itself. In mainstream sociology, this tends to
be dramatized by the voluminous research in socialization and social
class differences between working and middle-class or blue- and
white-collar groups. Excellent descriptions of personality types and
work attitudes and habits in these groups have been documented. How-
ever, these descriptions do not connect the people in these groups to
the political economy. * It is mainly in the work of certain Marxist
Feminists that one can begin to see these connections.

———————————

*Rather, they focus on the socialization of attitudes, values, and
skills and see these as causal—similar to the cultural determinists
of mainstream socialization theory, who suggest that if one changes
sex role socialization, one can change women's problems in society.
Changing the socialization process by itself cannot change the larger

They argue that the values, skills, socialization functions, and tasks of families, and particularly mothers, vary by class and strata. They also stress that this is a product of the difference in their relation to the capitalist enterprise.

The dialectical relations of women's work makes it clear that one must ask here not only about the reproduction of "classed" workers in the home but also about the reproduction of "gendered" workers. Very few Marxists of any kind (including Marxist Feminists, generally) deal with the crucial feature of the responsibility of women in their mothering for reproducing the gendered workers of the next generation. Rarely elaborated on, this is a taken-for-granted feature of the socialization process. This issue needs to be explored, analyzed, or stripped bare to understand that women produce not only class-linked (classed) workers but gender-linked (gendered) workers as well.

Instead, it has been both mainstream social scientists (nonfeminists like Blood and Wolfe [1960] or Parsons [1949a, 1955] and feminists like V. K. Oppenheimer [1970], Epstein [1972], Hoffman [1972], and Acker [1973]) and radical feminists (like Firestone [1970], Rich [1976], and Dinnerstein [1976]) who have focused on the development of gendered workers. For the mainstream social scientists this interest is embodied in their theories of sex role socialization; for the radical feminists it is more specifically focused on the role of women in their gender identity as mothers in the institution of motherhood.

The traditional notion of sex role socialization as a set of personality traits, which are changeable if one changes the socialization process, implies a set of options available to the people who play these roles. It implies a set of roles that one plays—one at home as mother, another out in the community as consumer, and yet another in the labor force as employee.

The radical feminists tell us, however, that the fact that women have been mothered and potentially can mother—due to the patriarchal construction of mothering—completely changes one's life. There is no such thing as a woman who can "put on" and "take off" the gender identity of mother. This is true whether or not a woman ever has a baby. Women are incredibly marked by the experience of growing up as potential mothers in our society. This does not mean, however, that women are confident that they can nurture. It means, rather, that women are expected to nurture when they become mothers. And

society. For example, if all working-class children were socialized to have the same attitudes and skills as ruling-class children, there would not be sufficient place for them among the ruling class in a capitalist society.

even that they are expected to nurture men to whom they are not married and to whom they have not borne children. *

It becomes incumbent on Marxist Feminist writers to attempt to understand the production and reproduction of the gendered workers, in both home and market,† if the system of patriarchal capitalist production and the role of women in it are to be truly understood. Moreover, it is important to understand how these gendered workers differ in the various social classes and strata as women's mothering helps to reproduce the next generation of workers, both classed and gendered.

The task of mothers is to socialize both sons and daughters to certain common requirements for market employment (requirements such as obedience and respect for authority). Mothers must carry out this socialization in ways appropriate to their class and strata, although girls will be socialized differently in order to encourage their submission to sex-stratified jobs in the market. The sexual division of production and the sexual division of labor is certainly challenged by the Later Marxist Feminists, but the process by which mothering itself is reproduced through women's work with their children has not yet been adequately explored.

In order to reproduce the social relations of production in a class society, home workers as well as market workers must be properly socialized. The process by which women reproduce home workers out of their daughters needs further investigation. ‡ More Marxist

*This has been an important contribution to the Later Marxist Feminists and explains, in part, why they have looked to radical feminism instead of traditional sociological theory on sex role socialization for an understanding of women in society. That makes sense to them despite the radical feminist failure to incorporate the social relations of class with those of gender as primary defining features of women's exploitation.

† Furthermore, one must begin to elaborate more carefully the engendering process that goes on in the labor market, too. Gendered workers are produced and reproduced in the labor market as well as the home. As men and women live out their daily lives, the molding and intensification of their gender identities occur as they interact in highly stratified and sex-segregated jobs, where sexual harassment, lower wages, and lesser authority for women are the context within which genders are continually produced and reproduced.

‡ It is important to note here that just as wage labor was considered sex-blind by Marx, so too has home labor been considered the province of women and therefore sex-blind. Concern with changing the relationships of the family and women's work in it to the larger society

Feminist discussion is needed of this highly complicated problem of training women to act interchangeably as both home and market workers, a process very different from that through which men are socialized in the family. In short, one must begin to understand the conditions that maintain a capitalist society via the gender system— and how this is related to the reproduction of mothering by women in the home and outside the home. [7]

To paraphrase a statement recently made (1977) by Eli Zaretsky in a discussion at a conference of historians: "Home and market are productive workshops for the making of men and women." The reproduction of class (and gender) through women's work is, in sum, a core dynamic of a society organized along the principles of patriarchal and capitalist relations.

IMPLICATIONS FOR PATRIARCHY AS WELL AS FOR CAPITALISM OF THE WEAKENING OF FAMILY WAGE

The inception of the family wage constituted the first time in modern history that a wage was, theoretically, paid to reproduce not only the labor power of the typical male head of the household but also that of the wife and children. The collaboration of patriarchy and capital made this possible (Chapter 5).

Twentieth century monopoly capitalism, however, has not been able to live up to its part of the family wage contract. * Rather, along with the erosion of the family wage and the cheapening of labor power has come the tremendous influx of women into the labor market, particularly married women (and mothers) since World War II (Chapter 2). One important way in which this influx of women has happened, I

must lead to a reevaluation of the sexual division of labor within the home too, an as yet unexplored problem in Marxist Feminist theory. The changing nature of work for <u>both</u> men and women in the home, the community, and the market throughout the monopoly capital period of patriarchal development must begin to be explored.

*In Chapter 5, it was seen that the family wage, even at its best, never paid the working-class husband enough to reproduce the labor power of the wife at home: women's labor power was produced below cost to the capitalist. The family wage continued the previously established double standard of living in the family: one for men and a lower one for women (and children). Here, it is argued that in addition to this double standard of living within the family itself, the family wage itself has lost ground.

want to argue, is by recruiting these women into less than full-time and year-round jobs. (The implications of this approach for patriarchy and capital will be clarified below.)

Women have entered the labor force, in large part, because of the family's inability to support itself on one income, as was promised by the family wage. Capitalism increasingly requires two adult workers, whereas before only one was presumed to be needed. Nonetheless, the impact of the family wage principle on women's market employment has been to justify the "myth of supplemental income": women need only be paid a small amount of money for their labor in the market, since they are considered to be only the secondary worker in the family.

The ability of capital to maintain a single-wage-provider family structure was undercut by structural changes in the economy, beginning especially with the Great Depression of the 1930s. The period immediately after World War II was one of high profits for U.S. corporations—both at home (because of workers' savings and overtime work, along with the elimination of rationing that had gone on during the war) and in Europe (due to wartime destruction and the need to rebuild). However, by the late 1950s and early 1960s, it became more difficult for capitalists to earn high rates of profits; profits were increasing at a decreasing rate.

These two periods of activity after World War II (first of high and then of lower rates of profits) revealed the inability of wages to keep up with the rising cost of living and demonstrated the increasing erosion in the ability of the wage earner to reproduce his costs (and those of his family) through the family wage. An analysis of post-World War II United States shows that real wages (wages controlling for inflation) increased by 2.5 percent between 1947 and 1962 but dropped to an increase of only 1.2 percent, or half as much, between 1962 and 1976 (see Table 8). This drop was in large part due to the dramatic increase in the proportion of income of working-class families required for food, clothing, and shelter (Aronowitz 1974). For the one-year period during 1973/74, the growth in real wages had begun to reverse itself with a 4 percent decline. The impact of inflation, from which there has been no respite since 1966, was lessened by wives' employment in two-wage-earner families to produce only a 1.3 percent decline in real wages in that same year (Hayghe 1976). On the whole, the fluctuating but eventually static post-1965 trend represents a slowdown in workers' real wages and a continuing need for women's wage labor. [8]

As the cost of products necessary for the maintenance of the working class increases, while the price of labor (wages) remains about the same, the purchasing power of the average worker decreases. Thus, as the single individual's wages are increasingly insufficient

TABLE 8

Average Annual Increases in Consumer Prices and Real Wages,
1947-62 and 1962-76
(in percent)

	Average Annual Increase in Consumer Prices	Average Annual Increase in Real Wages*
1947-62	2.0	2.5
1962-76	4.6	1.2

*For nonsupervisory workers.

Source: Adapted from Douty (1977, pp. 7, 8).

to support the reproduction and maintenance of the family, more and more men with inadequate wages are joined by their even more inadequately paid spouses in the labor market. In 1920 only 9 percent of all married women were employed in the labor force. By 1950 this figure had increased to 22 percent. And by 1975 labor force participation rates of wives doubled to 44 percent (Hayghe 1976, p. 13). Moreover, it has been wives of lesser-income and working-class (production or nonsupervisory) men who have been more likely to enter wage labor than wives of middle- and higher-income or supervisory (professional, technical, administrative, proprietary) men— although both groups have increased their participation over time.[9]

Since this is the case, one must ask What happened to patriarchy in this struggle? If the family wage was initially the outcome of a struggle between capitalist and working-class men, both of whom benefited through women's work in the home (as the argument goes), are not Marx and the Early Marxist Feminists correct in saying that patriarchy in the family has been eroding? Are not the Later Marxist Feminists wrong in saying that patriarchy is alive and well?

The traditional Marxist argument has been that as women enter wage labor, male domination in the home is weakened. Furthermore, if women are increasingly incorporated into the labor market, does not capital lose its unique reserve labor pool of housewives to be called on in time of need and returned to the home when no longer needed by capital? This line of reasoning would suggest that the tra-

ditional Marxist argument is correct, that patriarchy in the home would be weakened, while capitalist men would lose the benefits of women's free labor in the home.

While it is true that women gain certain economic and emotional independence and power in family relations vis-à-vis their husbands when they are employed, it is not the case that this necessarily happens at the complete expense of male domination. The matter is much more complex.

The author will try to show that patriarchy is both weakened and strengthened in the home, as women enter wage labor. And that despite the fact that female employment strengthens women's potential for struggling against and challenging patriarchal relations in the labor market itself, the fact that women are employed in a patriarchally organized labor market simultaneously reinforces and strengthens male domination in our society.

Surely, when women are employed, male domination in the home is weakened by working-class men having to depend on their wives' employment, as their own so-called family wage is increasingly unable to support their families. This is an important part of the contradictory nature of female employment in monopoly capitalism: as increasing numbers of women seek jobs to maintain the household, they become more independent by having control of a wage and may help to change the patriarchal nature of the household. While this is clearly the case to some degree, however, men benefit in numerous and important ways even when their wives are employed.

First, as stressed throughout this book, women's employment means women do a double day of work: they are not substantially relieved of family duties when they become waged laborers. While socioeconomic differences in husbands' "helping" wives with "their" domestic labor exist, men do not share homemaking and child-care tasks equally, or even nearly equally, with employed partners. They remain women's tasks—women are responsible for doing them or making sure they get done. Moreover, the cost of labor is spread without substantially alleviating women's work at home. In fact, she must make the budget go further! [10] This is especially intensified in periods of economic hardship.

Second, if men's labor is cheapened through the general deskilling process, through the vast increase of women in the labor force, through the internationalization of monopoly capitalism, through the increase in the cost of living, and so forth, then women's labor is cheapened even more (see Chapters 3, 4, and 5). Thus, for example, women's wages decreased relative to men's between 1939 and 1975. In 1939 women were paid, on the average, 60 percent of what men were paid in the same occupational category; by 1955 their wage increased to as much as 64 percent of men's. But by 1975 this has

eroded to 57 percent. [11] Further, women's employment increased at a greater rate than men's employment in those occupations considered undesirable by every measure possible, most especially in jobs that pay a wage below subsistence (that is, the socially necessary cost of reproducing one's self and the next generation of workers). In these ways, patriarchy still benefits men at women's expense. "While the expansion of female labor force participation has, in general, provided a material foundation for a greater independence of women from men, the fact that much of this work is low wage work has had the effect of reinforcing rather than attenuating the maintenance of patriarchal institutions" (Dubnoff 1979, p. 18). The impact on patriarchy in the family is clearly contradictory.

Third, the material and ideological reality of the family wage has allowed women—all women—to be treated as secondary workers. This is true even when they are the sole, primary, or equal breadwinners in their families—and even when the family wage of their husbands is increasingly inadequate to pay for their unwaged productive and reproductive home labor. Not only are women paid less as secondary or supplemental workers, but they are recruited into less stable, less profitable, more boring, and more powerless positions (on the basis of the argument that they do not need the jobs as much as men, will leave when they can, and therefore should not be given better jobs).

One of the major contradictions in capitalism today is as follows: on the one hand, monopoly capital needs more people to work and earn wages in order to buy goods. On the other hand, there is a need for fewer workers overall, because technology and machine production is so great. In the late nineteenth and early twentieth centuries, the family wage helped to solve this contradiction, at least in part, by forcing women and children out of the labor market and into the home and schools, respectively. Not only were a large number of women kept out of the labor market, but they did important and necessary consumption work, and men's wages were not eroded further. (See Chapter 5 for a discussion of how Marx and Engels understood early female and child employment in industrializing England.) However, as monopoly capitalism has expanded, it has become more and more dependent on the permanent attachment of women to the labor force. In recent years, this has become apparent by capital's resorting to the employment of women with very young children.

There are numerous ways that capital tries to solve this contradiction—through planned obsolescence, capital investment, government spending, and an expansion and diversification of commodity consumption, which increases the cost of labor power and "raises" the standard of living, and so on. As suggested above, in large part, the less than full-time and year-round employment of the majority of U.S. women has been another important solution to this problem. [12]

By employing so many women at less than full-time and year-round jobs,* capital is able to keep a larger number of people working, allowing the production of the same or greater quantities of goods and services† but at lower costs to capital, while simultaneously maintaining people's ability to buy the products. Thus, by cheapening the family wage (of the male) and by employing his very low-waged wife in a way that is less than total attachment to the labor force, the costs of the reproduction of labor power are spread even more thinly over the wife (and husband). The wife is kept as a powerful reserve labor force for capital and, in addition, as a somewhat better consumer.

The vast increase in the labor force during the 1960s was comprised of women and, most particularly, of married women living with their husbands. In the 1970s mothers with young children showed the most dramatic increase. However, most of these women entered either as part-time, temporary, or full-time workers who worked for less than a full year (for a summary, see Chapter 3 [the discussion on women as a reserve army of labor]).

What all these women have in common, in addition to low-waged, sex-segmented jobs, are (1) the failure of capital to pay them job benefits amounting to approximately 35 percent of wages (thus making their employment that much cheaper to capital) and (2) the inability to develop a reliable relationship to the labor force due to the unavailability of stable jobs and child-care, thereby keeping them as a meaningful reserve army of labor. Moreover, it should not be forgotten that more than half of all married women are not employed at all and that in more than two-fifths (41 percent) of husband-wife families, the husband is the only wage earner (Hayghe 1978). These women, in essence, continue to act as the hidden reserve to the reserve army of labor.

*The vast majority of employed women (75 percent) work on a full-time basis. On the other hand, only 40 percent of all employed women (and 42 percent of employed married women) work full-time and year-round. (For men, the figure is 68 percent.) See Chapters 2 and 3 for data.

† A hypothetical example may be: if instead of having 10 people work full-time, an employer hires 8 full-time equivalents of 16 people half-time, he could produce the same amount or more of goods but at a lower cost. In academia instead of hiring 1 person full-time, an employer may hire 3 or 4 people as part-time adjuncts, teach as many courses, and pay them less—both in salary and overtime. Furthermore, part-timers lack whatever influence and decision-making power full-timers might have.

All the same, in the case of the vast majority of employed wives living with their husbands, their employment is what keeps the family out of poverty or in the respectable "middle class." (For data, see government reports, some of which are summarized by Blumberg [1978].) In fact, in 1975, 84 percent of all women in the labor force either supported themselves or were married to men whose annual incomes were under $15,000. In that same year, an intermediate budget needed for an urban family of four, as estimated by the U.S. government, was $15,318. In husband-wife families, only if the wife was also employed could this intermediate budget be met: such families earned approximately $16,100. If the husband was the only family wage earner, the median family income was $13,000. And if the wife was the only wage earner in husband-wife families, this figure dropped to as low as $9,000 (U.S., Department of Labor, Bureau of Labor Statistics 1977).

While wages overall have increased in the twentieth century, the huge increase in married women's employment has not changed the relatively small contribution that these women's wages make to their own families' incomes. The average contribution of employed wives in husband-wife families was about 27 percent in both 1920 and 1975 (see Hayghe 1976). Thus, more and more paid work is needed by women to simply keep pace with the rising cost of living. Moreover, while capital increasingly incorporates women into wage labor, it does so in such a way as to maintain women's primary role as motherworker.

With the ever-increasing need for women to be employed to provide for basic subsistence for their families, along with the simultaneous increase in unemployment of both women and men, certain questions arise: Will women remain in the labor market as they are today? Will they be incorporated in new and different ways in the market in the future? Will they be forced back into the home as they were after World War II? Or will some combination of all these tendencies and others come to exist? Out of these conditions, what new contradictions will emerge?

At least two completely opposing tendencies have developed already in our society that make these areas crucial for future study. On the one hand, the contemporary women's movement has emerged in large part out of the contradictions facing women in their double day as homemaker and wage laborer. Women's consciousness has been raised in so many different ways—and differently for professional and business women than for working-class women. Still, it is true that women as a whole are much more aware of feminist issues and problems as they experience them in their daily living. With the support of the women's movement (and the increased need for certain types of cheap female employment), it will be much harder for patri-

archal capitalism to push women back into the home as was done after World War II.

On the other hand, in a society plagued with high unemployment and entering its seventh post-World War II recession, certain policies are beginning to encourage women to go back into the home. Most important, next to the backlash against affirmative action in the 1970s, recent protective legislation against health hazards on the job has been directed, as in the early part of the century, at women. In this case, at pregnant women. Thus, much of that legislation serves to "protect" pregnant women from high-paying, traditionally male jobs on the argument that toxic substances in the environment can harm the fetus, while ignoring the risks all workers suffer in these jobs (Carlton n.d.; Evanoff 1979; Stellman 1977). However, if women are pregnant and cannot stay on the job for protective reasons, it is unlikely that they will be hired elsewhere and so will be forced back into the home. If they are not pregnant but are eliminated from the better, male-dominated jobs because of the possibility of pregnancy, they are either forced back into the home or into less desirable female sex-typed jobs, if they are available.

In the next and last section of this chapter, more will be said in answer to the question posed here: What are the implications for patriarchy as well as for capitalism of women's changing place in the labor market?

PATRIARCHY IN THE LABOR MARKET— PAST, PRESENT, AND FUTURE

Mainstream social scientists (Chapter 1), Marx (Chapter 3), and Early Marxist Feminists (Chapter 4) all predict the breakdown of patriarchy in the capitalist family as more and more women work in the paid labor force. * Employed women, all theories assert, have more resources than full-time homemakers, relative to their husbands.

*Dual labor market theory (Chapter 2) does not address this problem. There is generally no mention of the family and thus no discussion of patriarchal relations there. Sex segregation is assumed to be firmly entrenched in the labor market. In order to decrease market sexism, dual labor market theory argues for a restructuring of the labor market itself (and/or an inclusion of women into the more favorable sectors of the existing market). Thus, while patriarchal relations of the family are not discussed, certain dual labor market theorists have begun to explore the operation of patriarchy in the labor market (see, for example, Kanter 1977a).

They are relatively more powerful in the family, and thus greater equality is established between husband and wife. Lower-strata families are even said to demonstrate greater sex equality than higher-strata families because the income of the wife is proportionately more important to the family than the income of women from higher economic strata.

On the one hand, it is most assuredly true that women have relatively more power in their families by entering into social production that is financially remunerated in a capitalist society. However, it is also the case that women still work for individual men and their children in families, making it possible for capital to extract surplus value from market workers. Women work a double day. While wage labor is potentially liberating, women are still doubly exploited: once by their husbands and twice by capital (indirectly in their husbands' and children's congealed labor power, as well as their own nonmarket labor power, and directly through the women's own market labor). On the other hand, as more and more women enter into wage labor, they are increasingly confronted by a capitalist labor market that is organized in the interest not only of capital but also of men. Hence, patriarchy in the labor market still fails to diminish. In fact, it is possible to argue that in certain essential ways, patriarchy grows instead.

The concept of the dialectical relations of women's work helped earlier to focus on the slighted issue of the development of class in the home. In this final section, it is now possible to sharpen another element of these various sets of relations: the operation of patriarchy in the labor market. A great deal of work must be done to unravel the reinforcing and contradictory relations between patriarchy and capital in the market, as well as between patriarchy in the home and patriarchy in the market, and so on. Here, however, the focus will be solely on the argument that patriarchy, a material as well as an ideological reality, is not confined to the home, as traditional Marxist theory would lead us to believe, but is a prominent feature of the monopoly capital labor market today. The discussion concludes by suggesting that patriarchal relations are in fact intensifying in certain respects.

In this section, only one aspect of patriarchy in the labor market will be elaborated on. The author's hypothesis is that the modern bureaucratic form of twentieth century United States is not simply organized in a manner to make profits for capital. It is likewise organized to ensure that material benefits accrue to men through the exploitation of women's labor. Verification of this hypothesis would provide an important demonstration of the material nature and solidification of patriarchy in the labor market.

Patriarchy (as defined in Chapter 5) is a system of virtually total authority of senior males over all others, including junior males

and all women. It is a system of hierarchical relations establishing interdependence and common interest among men, organized on the basis of the exploitation of women's labor. Thus, patriarchy is a system of domination, control, and order of some men over others, which in turn determines the system of power relationships of men over women.

In our labor market, the organization of certain men over all other men and all employed women can be said to occur in at least two forms. In the first case, the class relations between ruling-class owners (and their executives) and laborers seem patriarchally organized. This form of organization, like that in the family earlier (see Chapter 5), is premised on the idea that if subordinate men (working-class) perform in the interest of superordinate men (the owners of industry and their representatives), they will be rewarded economically and emotionally: they too will be dominant over women. These patriarchal benefits are more clearly seen in the monopoly capital sector for working-class white men than in the competitive capital sector, which is less stable, more nonwhite, and more female. The patriarchal relations among men ensures some sort of allegiance of the subordinate men to the superordinate men and the larger social, political economic system itself, as well as dominance over women. However, it does not in any way eliminate the exploitation of the male working class by ruling-class men.

In the second case, the hierarchically organized and interdependent social relations within executive/management ranks, as well as between management and workers, also seem patriarchally organized. This is grounded in the work women do in the bureaucratic corporation in at least three ways: first, through the sex segmentation of managerial tasks in the labor market in general; second, through the work women do in staff as opposed to line management; and third, through the work women do that is essential to management bureaucracy but that does not offer access to management careers (secretarial work). This is work done by women, whose cheap labor benefits men and capital, in particular male manager/executives.

The operation of patriarchal relations in large-scale bureaucratic organizations of the monopoly era can best be understood in terms of certain features of the capitalist mode of production (Chapter 3). In all Marxist theory, capitalism is made up of mainly the two increasingly polarizing classes of the bourgeoisie (ruling class) and the proletariat (working class). While capitalism frees laborers to sell their labor power on the market for a wage, the workers increasingly lose control over their products, the labor process itself, and their own skills.

The large-scale formal bureaucratic organization of the twentieth century, characterized by intense rationalization and a cadre of

highly specialized professional managers, is peculiar to the development of monopoly capitalism. Technical ability to perform a limited task becomes separated out from cognitive ability to abstract, plan, and logically understand the whole process. Management becomes the representative of the capitalist, the only one knowledgeable about the totality of the production process.

In looking at the class relations among men, one must consider that non-ruling-class men are subordinate to ruling-class men and thus are out of control of the decision-making processes and material benefits of capital accumulation. However, through their alliances and struggles with ruling-class men, working-class men are able to ensure certain material and psychological benefits to themselves. One crucial mechanism discussed earlier (in Chapter 5) was the sex segmentation of the labor force itself. The work women do in low-paying, low-status job markets with limited upward mobility, short career ladders, and dead-end types of jobs (see Chapters 2 and 3 for a discussion of the secondary or competitive capital labor market) is both essential for a developed capitalist society and relatively beneficial to the wage structure of working-class men.

The fact that women do these kinds of jobs at such low wages benefits not only male capitalists but also the male working class. It is the patriarchal relations among men of different social classes that solidify the control by men over men's jobs, which excludes women and makes them responsible for the work in sex-segregated, low-wage, and low-status sectors of the labor force as well as for unwaged domestic labor.

Thus, job segregation by gender maintains male superiority in capitalism because it enforces lower wages and less power for women in comparison with men in the labor market. At the same time, however, each of these measures contains a contradictory element: the working class had to struggle against ruling-class men for each of these reforms: the family wage, protective legislation, and so on. Hence, the material base of patriarchy in the contemporary labor market is the incredibly low-waged market work women do. This keeps women from competing with men for their higher-paid, gender-assigned jobs and allows men higher-waged and more powerful jobs. Simultaneously, this ensures women's position in the home.

If women are only paid about half of what men are paid, they remain dependent on men through marriage. But married women must, additionally, perform domestic chores for their husbands and their husbands' children. Today, men's higher wages allow them to receive the benefit of women's domestic labor either through the direct labor of their wives or by being able to buy the cheap labor of women in the labor market, whose services substitute at least in part for the labor that would be done by wives if they had them. Women, on the other

hand, with their lower-waged, sex-segregated jobs, cannot afford such costs. They must still reproduce their own labor power—even when they are employed. That this varies by class and strata should not obscure this point.

The patriarchal nature of relations in the upper reaches of the managerial system itself is most characteristic of the monopoly capital sector, the dominant sector in the U.S. economy. However, all large-scale bureaucracies in our society (including government and competitive capital institutions as well as monopoly sector enterprises —see Chapter 3) are organized along the model of formal organizations, which includes the "rational, efficient, expert manager."

How are junior men subordinated to senior men in management? How does this form of subordination allow men control over and rewards from women's labor in the bureaucracy? By applying the Later Marxist Feminist definition of patriarchy to the real world of management in large-scale bureaucratic corporations, these tentative answers are offered.

Sex Segmentation in Management

The managerial sector of a large bureaucratic organization is hierarchically organized on the basis of seniority and training (and ownership). First-line, middle-level, and top management positions are, typically, evident in all such organizations. Just as obvious is the fact that managerial positions are not simply hierarchically organized but are organized as relations among men. One finds a very small number of women managers in general and especially the higher up the managerial ladder one goes. [13]

Segregation by sex of managerial positions maintains male superiority in capitalism, because it enforces lower wages and less power and more dead-end managerial jobs for women in comparison with men. This prevents women from competing with men for their higher-paid, gender-assigned managerial and executive positions, allowing men higher wages and virtually total control over decision making for the organization. Further, it ensures that women managers remain responsible for their homes.

In the total labor market itself, if women are managers, they are more likely to be found in small, less powerful, lower-status, and less economically advantaged organizations—that is, in the competitive as opposed to the dominant monopoly capital sector of the economy. In Chapter 3, it was learned that the vast majority of women professionals are employed by the government, not by private industry. Now it is also seen that women managers are more likely to be employed in administrative positions outside the foremost sec-

tor, that of monopoly capital. In both cases, women professionals and managers are excluded from the "best" and male-dominated sectors of the economy.

Patriarchal Forms of Allegiance:
The Sponsor-Protégé System

Managers and administrators typically do not work themselves up the ranks of the organization from the level of working-class laborers.[14] Rather they are formally trained in business schools as managerial and decision-making experts (professionals) for the organization.

They are recruited into the organization specifically as professional managers. As long as junior managers stay in line and perform decision-making and administrative functions in the interest of the organization (private profits and capitalist control), they are promised career advancement in the ranks of management. The patriarchal relations of senior over junior executives and managers establish the allegiance of the former to the latter. If they mature in their careers according to plan, they will work their way into the rewards of the patriarchal system: wealth, resources, prestige, power, leadership, and dominance over junior male managers and workers and all women.

An important mechanism used to establish and perpetuate the patriarchal allegiance among junior and senior exeuctives is what is known as the "sponsor-protégé" system or "old boys' network." Sponsorship is identified here as a crucial mechanism by which junior men are recruited into the upper echelons of the patriarchal administration. The protégé is treated much like an apprentice, under the benevolent wing of a sponsor. "Crucial trade secrets" of the upper echelon are learned by the protégé, who simultaneously performs services for the sponsor.

The sponsorship system has been used by mainstream sociology (Chapter 1)[15] to describe how elite sectors of professions typically are able to recruit like-minded people to their profession. Important to sponsors in the recruitment of protégés is identifying people with similar values who will uphold the shared norms, attitudes, mutual understandings and common standards of behavior. A shared sense of social and moral solidarity is said to define the professions in general, and the sponsor-protégé system in particular. While classic studies mention the "proper" race, ethnicity, and sex as being necessary components for recruitment into the sponsorship system, it is clear that such a system is primarily interested in the maintenance of the class stratification characteristic of the professions.

In what follows, the implications of the sponsor-protégé system in terms of an analysis suggested by the dialectical relations of women's work will be explored.

Two basic arguments raised by several feminist social scientists[16] are important to this analysis: first was that the professional (and managerial) culture itself was organized around a "masculine ethic" and second was that the recruitment system in general, and the sponsorship system in particular, was not only elitist (and racist) but was also sexist (it recruited people and promoted them to the top on the basis of their gender as well as their class [and race]).

It has been argued, and rightfully so, that the masculine ethic is synonymous with bureaucratic or managerial culture and therefore excludes women on this basis. While rationality and efficiency were the keys to the modern bureaucratic organization of the monopoly era, it was also synonymous with and legitimated by ideas of male domination in the labor market. The consequence of this for women is that they are seen as temperamentally unfit for management—they are said to be "too emotional," or they are regarded as "deviants."

However, while the managerial culture is a powerful ethic operating against women's entrance into decision-making positions in the hierarchy, the managerial culture by itself would not have the power to exclude women. Such exclusion must be grounded in the patriarchal benefits that accrue to men through women's labor.

The identification of the managerial culture with a masculine ethic is not sufficient by itself to explain why women are left out of the decision-making positions of administration. More important, this type of analysis does not deal with the problem of how to change the bureaucratic hierarchy. Eliminating patriarchy in the labor market without any challenge to capitalist control of the managerial structure typically means that women would be trained to be more "like men."* This assumption generally is not challenged by status attain-

*In our society, eliminating patriarchy means eliminating the hierarchical control of a certain class of men over other men as well as of men in general over women. With regard to the issue of whether women should be trained to be more "like men," it is an empirical question as to whether women would act differently than men in management. One group of researchers suggest that it is location in the organizational structure that creates the personality types and behaviors typically associated with women in our society. That is, both men and women who are found in blocked, low-status positions of limited power exhibit personality characteristics of the stereotype of women in our society—devalued personality characteristics. Another group of researchers, on the other hand, suggest women's differential

ment theorists at all and is not challenged sufficiently by those re-
searchers recognizing sex stratification in the labor market.

For example, among mainstream researchers who recognize
sex stratification in the labor market, it has been suggested that cor-
porations create artificial sponsorship programs to move women into
management: develop "old girls' networks." Assuredly, women must
move into top decision-making positions, and it is much more effec-
tive for them to do this collectively rather than individually. However,
unless one changes the capitalist nature of the work organization it-
self, in addition to the male domination of work, the vast majority of
men and women will remain disadvantaged in our system of work—and
women more so than men at each level. In short, and most impor-
tant, putting more women, or more women who are "like men," into
management does not correct the condition of the masses of both
women and men who are left outside any decision-making control in
their jobs.

The second problem raised by these feminist sociologists in ex-
plaining the disadvantaged position of women in the labor market is
that the characteristics of the managerial hierarchy encourage man-
agers and executives to pick people much like themselves as their
protégés, thus ensuring continuity of leadership. Conformity pres-
sures and exclusive management circles closed to "outsiders," it is
argued, stem from the high degree of uncertainty in specifying all
contingencies in advance and the need for personal discretion sur-
rounding such managerial decisions—especially at the higher levels
of the bureaucracy. Clearly, women are different, just as are blacks
and those of lower socioeconomic origins. Choosing people like them-
selves (socially homogeneous candidates for rising in the patriarchal
management hierarchy) ensures loyalty, trust, conformity, and simi-
lar values and interests. Choosing people like themselves means
choosing men (and certain kinds of men at that).

The need for trust and loyalty among potential elite in the ad-
ministration of the corporation is essential. However, it is much
more than the reduction of uncertainty and the assurance of loyalty
that is in operation with regard to male domination in management.
Much more than norms, attitudes, and ways in which people think is
in question here. In addition, I am arguing, it is the material bene-
fits that managers get, both as men and as capitalists (and their rep-
resentatives), that are essential to the patriarchal nature of the man-
agerial group.

socialization and, hence, differential values might lead them to op-
erate differently when in power than do men. Clearly, this is an area
for further empirical investigation and theoretical integration.

How, one might ask, do women work for the male managers to provide both economic and emotional benefits to the male managers otherwise unavailable to them?

This question will be answered by looking at the work women are allowed to do as managers within large-scale bureaucracies and at the work women do as secretaries, the support-maintenance workers of the male bosses in these bureaucratic organizations.

Recruitment of Women Managers into Staff Positions

Although very few women are found in managerial positions in any large-scale bureaucracy in today's labor market, when they are, they are much more likely to be working in lower-paid staff positions, less powerful than line (or command) ones. Staff positions include personnel, research, and, more recently, affirmative action and equal employment officers.

While line positions are typically part of an internal labor market, offering career mobility and the possibility of movement up in the organization to top executive jobs, staff positions do not lead to decision-making positions within the organization. Typically, staff positions (often occupied by professional and technical experts) represent advisory or recommending bodies to the decision-making managers and executives. As such, women do the work to find out what is needed and make recommendations, and then men decide what is to be done with regard to these recommendations. Managers in staff positions very often have authority over an area of expertise but without power over that area.

The fact that women are placed in these positions is not simply a function of the male ethic, which is really a cultural component of the bureaucratic organizational style of leadership. Rather, it is because of the material benefits accruing to men by placing women in these positions.

This means that when women are in managerial positions in male-dominated organizations, they have little or no authority, they are outside the career ladders that lead to the top of the organization, and they are in more routinized and less trusted positions. Women, however, do much of the needed work of the organization—at lower wages, with fewer resources, and with less power than male managers, thus allowing men the benefits of money, status, power, resources, and specialization in decision-making control and order—without directly competing with other male managers for their privileged positions. The development of business women's associations and women's caucuses in professional organizations and government bureaucracies (themselves not without contradictions) is an attempt to challenge such male control.

In short, the fact that women managers are forced into staff positions without power, equitable financial remuneration, or access to line positions is beneficial to both men and capital.

Predominant Recruitment of Women
into Secretarial Positions

A second and most crucial way (since it is most prevalent) in which patriarchal relations encourage male control over women in the capitalist bureaucracy today is through the relationship of secretaries to their bosses.

Feminization of clerical work in the age of monopoly capitalism has made it possible to elevate men to management, with women subordinate to them, guaranteeing higher wages, status, and control to men at the expense of women.

However, this was not always the case. Prior to the expansion of large corporations in the last decades of the nineteenth century, clerical workers were men (see Chapter 3). The clerkship of a male office worker acted as an apprenticeship for a young man learning the business before he moved on to a managerial position. It was only in the twentieth century that clerical work became "women's work." As it did, the nature and organization of clerical work itself changed. It became a dead-end job, with a high degree of replaceability and virtually no career ladder possibilities to managerial jobs.

Along with changes in the structure of clerical labor in the corporations came a change in ideology about the nature of clerical work. It took only a very short while for the ideology to shift so that people could accept the presence of women in offices and could even incorporate their changing beliefs about women's inherent "nature" into the ideology. Clerical work came to include "feminine tasks" and secretaries came to be judged as much on their feminine appearance as on their secretarial skills.

The rationalization of clerical tasks allows for a high degree of low-level skills, cheap labor, and the easy replaceability of workers —the keys to profits and control for male owners. This rationalization is exemplified in the work done by the vast majority of secretarial workers in work organized in such places as secretarial pools in the modern office. Tasks have been reorganized—around machines such as the typewriter, adding machine, dictaphone, billing machine, copier, and, more recently, the computer and microcomputer.

While it is clearly the case that these jobs are more routinized, boring, and, most especially, inexpensive for capital, the rationalization of jobs leads to an increased clarity of job description. The contradiction inherent in this situation is that it makes it possible for fe-

male office workers to challenge male bosses for asking them not only to do tasks outside the job description but also to perform personal services. Thus, for example, many women have begun to refuse to make coffee for the office in general or their bosses in particular, since it is not part of their formally defined clerical or secretarial job description. Women have also organized to regain the jobs of women who have been fired for refusing to perform such non-job-related and personal activities (Women's Work Project 1978).

In addition to keeping women out of the better jobs in the organization, unequal relations between secretaries and others in the organization serve, through sexual advances and harassment, to boost men's egos in the organization (all men's egos, whether or not they are part of management). However, while sexual harassment is used as a mechanism of social control by capitalist men—in collaboration with male supervisors and working-class men—to maintain a sex-segmented labor force and thereby justify male advantage in the market, it is a double-edged sword. In preserving the dominance of patriarchy and allowing men to feel more powerful than women (in part, as compensation for the lack of feelings of power in working-class men's own jobs), sexual harassment may very well contradict the needs of a rationalized profit-oriented system of production. If too many women are too harassed by men, they may be sufficiently afraid to enter or to remain in the labor force, thereby threatening capital's access to women's cheap labor (see Bularzick 1978).

In addition to the secretary in the typing pool, there is the more celebrated "personal secretary" to the individual male boss. Some features of the secretary-boss relationship are clearly antithetical to the bureaucratic nature of the modern rational corporation. It is by far the preferred arrangement to work for a particular boss (or a few bosses), because secretaries, like wives, learn to rely on a personal relationship with a boss for many rewards. Since male bosses and executives prefer this more personalized arrangement with their secretaries, a struggle between patriarchy and capital ensues as male executives fight to prevent more specialized, routinized, and efficient secretaries from replacing their own irreplaceable personal secretaries.

The work that women do as personal secretaries reinforces the sex-stereotyped image of the secretary and the patriarchal nature of the secretary-boss relationship. Thus, secretaries function as status symbols for executives; they are often doled out as rewards to bosses rather than assigned in response to real job needs. They participate in behind-the-scenes transformations of chaos into order, of rough ideas into polished letters and documents. They set the stage to awe or impress visitors. They act as buffers between the boss and the rest of the world, controlling access to him and protecting him from

callers. Sometimes they are asked to collude in lies on behalf of their boss. (For example, Rosemary Wood's alleged erasure of portions of the Nixon tapes.) They are often forced to provide personal, emotional, sexual, and housekeeping services (see Kanter [1977a] for these and further descriptions).

Placing these mainstream descriptions into a framework suggested by Later Marxist Feminism makes it possible to see that the large-scale bureaucratic organization in the contemporary United States is organized not only on the basis of an ethic of male domination but also as a system in which women do a lot of special work for men. Women shore up the male ego; women provide an arena for domination, control, status, letting off steam, managing fronts, gaining emotional support, and nurturance. Women provide, as well, housekeeping functions and sexual comfort and are the objects of physical/sexual exploitation—all for low wages. [17]

In sum, the concept of the dialectical relations of women's work helps to lay bare the independent importance of patriarchy in the labor market as it disadvantages women there.

To conclude, while it is certainly the case that some patriarchal controls in the family are diminishing, it is not the case that all or even the most important ones necessarily are. This point needs emphasis and special attention in the future in terms of the whole analysis of women in the labor market. Contradictory relations between men and women in the family emerge as unemployment escalates and opportunities for advancement and well-paying jobs become more and more constricted for both men and women in the labor market (see Chapter 3). In addition, the changing conflicts and alliances between men of different classes in the labor market (and the welfare state) must begin to be analyzed seriously by Marxist Feminists and feminist sociologists alike.

As both men and women work longer and harder to support themselves and their families, capital gets a larger and cheaper labor force, in part because of decreased pressure to raise men's wages absolutely, only to keep them above women's wages. Working-class men are then benefited relative to women of their own class and stratum and exploited by capital at the same time. Women's increased participation in the labor force intensifies and extends their labor but also provides collective experience with other women and wage earners, an understanding of the relationship between their home and market exploitation, and a paycheck. Further, their participation clarifies for us that all women are exploited in our society, but women of different classes and races are differentially exploited. It is out of these and other contradictions that change will come for women and wage earners, as they begin to challenge the patriarchal, capitalist, and racist organization of our society.

Researchers have barely begun to look at the nature of patriarchy in the capitalist labor market itself. More than an ideology or set of attitudes standing alone, it is grounded in the work women do that benefits both men and capital in our society. Hence, the author will close with the following key point.

Patriarchy is not decreasing its force and control in the labor market. On the contrary, at least one aspect of patriarchal control over women is actually intensifying in certain sectors of the contemporary labor force: in many executive and supervisory positions of the female-segregated labor market, men have taken over positions traditionally held by women. Alternatively, placing these jobs under male managers and supervisors maintains male control while increasing the number of low-level female workers (see Chapters 2 and 3).

Thus, one must distinguish between (1) those jobs that are increasingly held by females in the low-level positions—such as clerking in banks until recently—but that have become increasingly held by males in the supervisory and administrative positions from (2) those jobs that have been traditionally held by females in the twentieth century with female supervisors and administrators—such as elementary school principalships, full professorships at women's colleges, and library science positions—that are now becoming increasingly male in their upper levels. In both instances, patriarchal control is intensifying in the labor market.

As a result, the work women do in the labor market fails to provide them with avenues of mobility and control at the top of the organization, occupation, profession, or semiprofession. These are increasingly the domain of men, even when women are the major workers in the field.

In sum, these mechanisms are the persistent and even expanding features of the patriarchal nature of the contemporary private and public employers in U.S. society. Together all these mechanisms perpetuate the exploitation of women's labor by providing benefits and control for both men and capital. For women in the U.S. labor market, patriarchy, as well as capitalism, is alive and well, but there is evidence that there are contradictions inherent in these interlocking social relations. In both the home and the market, each reinforces the other to keep employed women in a disadvantaged position. At the same time, however, conflicts and challenges emerge within and between the dialectical relations of women's work to threaten the patriarchal capitalist organization of society. Only as these relations continue to be explored can one hope to understand and bring about changes in them and in the nature of women's work.

NOTES

1. What does exist has only recently been emerging among Marxist Feminists who use a psychoanalytic model to understand the dynamics, strength, and perpetuation of sex/gender and political economic systems. See Chodorow (1978b, 1978c) and G. Rubin (1975). This issue is further addressed by several British authors—for example, Mitchell (1974), Coward, Lipshitz, and Cowie (1978), McDonough and Harrison (1978), and Kuhn (1978). For an approach closer to symbolic interaction, see Stockard et al. (1975), and for an earlier nonpsychoanalytic account, see Morton (1971).

2. Future heirs are obviously the concern of the ruling class more than the working class. Earlier on, when working-class children did economic work for their families, they legally belonged to their fathers. As children became an economic burden, however, it became women's "natural right" to be responsible for them. The author is grateful to C. Brown (1979) for pointing this out.

3. Much of mainstream sociology in particular understands motherhood in terms of the social roles that women play as mothers —both in biological and cultural terms. For a critique of this approach, see Plotnick (1973/74). There are obvious exceptions to this position in which sociologists have understood motherhood as an institutionally organized experience. One of the most important is Bernard's The Future of Motherhood (1974). Unlike Marxist Feminists, however, Bernard focuses on the changing nature of technology (industrialization), rather than on the changing nature of the political economy, in understanding the bifurcation of women's home and market work. For a critique of the inadequacy of "industrialization per se as an explanatory factor" in understanding women's work in sociology, see Beechey (1978).

4. Although the focus will not be on how capital influences relations in the home per se in this section, it is interesting to note that certain Marxist Feminists interested in housework have recently begun to show how the application of monopoly capital methods of technology and forms of rationalization has affected the organization of the household as well as the labor market. See, for example, Strasser (1978a), Ehrenreich and English (1975), Ascher (Lopate) (n.d.), Baxandall, Ewen, and Gordon (1976), and Hartmann (1974).

5. See Lopata and Thorne (1978) for a critique of sex and gender terminologies in sociology.

6. Several key issues developed in this section owe much to the work of D. E. Smith (1975/76, 1977b), a Marxist Feminist sociologist. See also the work of other Marxist Feminists—Glazer (Malbin) (1978), Rapp (Reiter) (1978), and Weinbaum and Bridges (1976), who are helpful in articulating the dynamics of this interrelationship.

7. Among more recent Marxist Feminist analyses, only three stand out in their concern for gender production and reproduction. These three women take, quite clearly, only the first tentative steps in a long-neglected area. They are G. Rubin (1975), Chodorow (1978b, 1978c), and Hartsock (1978).

8. The latest data show that while this trend is clearly fluctuating, by the first half of 1979 real wages were almost 7 percent below those of the relative high in 1973 ("Inflation without End?" 1979).

9. In a recently published article, Kolko (1978) has argued that the key to understanding which wives have been employed since World War II is to look at their husbands' incomes. Through a variety of measures, he shows that it is the husband's inadequate income, in working-class families in particular, that sends wives increasingly into the labor market. He argues that many of the structural dilemmas and contradictions of postwar U.S. capitalism—unemployment, inflation, static post-1965 trend in real income, and installment debts that threaten to cut back on consumer spending—"were temporarily resolved as working class wives entered the labor market. Postwar American prosperity was not the consequence of the traditionally male-dominated working class's rising fortunes so much as that class's capacity to find solutions to problems which it could not resolve with traditional means" (p. 274). Such solutions lead to further contradictions, which are being faced today.

10. In his discussion on "Inflation and the Female Labor Force," Stover (1975) reminds us that greater use in the household of "convenience" products of capitalism, "places the working-class household even more at the mercy of inflation. What was once seen as 'convenience' now appears as 'necessity,' and this transition plays havoc with the family budget" (p. 57). See also Bland et al. (1978).

11. Another way of showing that women's labor power has been cheapened more than men's over the past quarter century is expressed in a recent report by the U.S. Department of Labor, Employment Standards Administration (1976). It shows that the percentage of men's earnings that exceeded women's earnings went from 56 to 75 percent between 1955 and 1974. Thus, the earnings gap in constant 1967 dollars between men and women's full-time, year-round wages went from $1,911 in 1955 to $3,433 in 1974.

12. Several recent publications by British Marxist Feminists have argued that women's role in production (either as members of the work force or as part of the permanent reserve army of labor) and in reproduction (or childbearing and child care) constitutes a major contradiction for capital, which builds its own divisions onto already existing sexual divisions so that they are inseparable, and for the state. In England it was with the labor government's commitment to full employment for men after World War II that married women be-

came a permanent part of the industrial reserve army. A way to manage this contradiction—whereby the need to expand the labor force conflicted with the need to increase the birthrate—was the rise in female part-time work (see Bland et al. 1978 for a summary of this position). In the United States, however, women are increasingly involved in full-time as opposed to part-time employment. It is important to understand how and why this happens.

13. See, for example, Bowman, Worthy, and Greyser (1965) and Kanter (1977a). Further, much of the descriptive materials throughout this final section on women and men in bureaucratic corporations can be found in Kanter.

14. Evidence abounds on the homogeneity of business leaders from 1900 to today. Also, there is evidence on the clear overlap between managers and the ruling class. For example, see Domhoff (1967).

15. Classic studies, not mentioned in Chapter 1, were done by Hall (1948) and Hughes (1945) in medicine and Smigel (1963) in law.

16. It was not until the recent period of feminist concern that the exclusion of women in the professions became a topic of serious discussion in mainstream sociology. Primarily those feminist social scientists who recognized sex stratification in the labor market as disadvantageous to women investigated these problems. These authors are more akin to dual labor market theorists (in Chapter 2) than to status attainment theorists (in Chapter 1). Included most particularly are the insightful work of Epstein (1972), Theodore (1971), Lorber (1975), and Lipman-Blumen (1976). The work of Kanter (1977a) extends these ideas to management in large-scale bureaucracies.

17. For their work, women get "praises not raises." This keeps them working as they do—in the interest of men and capital. Kanter (1977a) discusses this further (p. 87). For her,

> Indsco [pseudonym used by Kanter for the corporation she studied] secretaries were locked into self-perpetuating, self-defeating cycles in which job and opportunity structure encouraged personal orientations [parochialism, timidity and self-effacement, praise-addiction, and emotionality and gossip] that reinforced low pay and low mobility and perpetuated the original job structure. The fact that such jobs were held almost entirely by women also reinforced limited and stereotypical views of the "nature" of women at work. [P. 103]

Thus, while Kanter sees the structure of the organization as causal in creating self-defeating personality types for women as secretaries,

she does not focus in on the work women do for men as being their downfall. Rather, she focuses on the personality structures that develop because of the organizational structures. Although this is very important, the time has come to look at the benefits received, in this case, by men who are managers through women's concrete work, not only to look at women's socially structured personalities per se.

BIBLIOGRAPHY

Abbott, Elizabeth. 1969. Women in Industry. 1910. Reprint. New York: Arno Press.

Acker, Joan. 1973. "Women and Stratification: A Case of Intellectual Sexism." American Journal of Sociology 78 (January): 936-45.

Alexander, Karl L., Bruce K. Eckland, and Larry J. Griffin. 1975. "The Wisconsin Model of Socioeconomic Achievement: A Replication." American Journal of Sociology 81 (September): 324-42.

Almquist, Elizabeth M. 1977a. "Social Science Research on Women and Wage Discrimination: The Missing 40 Percent and the Missing Perspective." Paper presented at the annual meetings of the American Sociological Association, San Francisco.

_____. 1977b. "Women in the Labor Force." Signs 2 (Summer): 843-55.

Almquist, Elizabeth M., and Shirley S. Angrist. 1975. Careers and Contingencies. Port Washington, N.Y.: Dunellen.

_____. 1971. "Role Model Influences on College Women's Career Aspirations." In The Professional Woman, edited by Athena Theodore. Cambridge, Mass.: Schenkman.

Altman, Sydney L., and Frances K. Kaplan-Grossman. 1977. "Women's Career Plans and Maternal Employment." Psychology of Women Quarterly 1 (Summer): 365-75.

Anderson, Charles. 1974. The Political Economy of Social Class. Englewood Cliffs, N.J.: Prentice-Hall.

Andrisani, Paul. 1978. "Job Satisfaction among Working Women." Signs 3 (Spring): 588-607.

Applebaum, Eileen, and Ross Koppel. 1976. "The Impact of Labor Market Sex Discrimination on the Wages of Young Women." Unpublished manuscript, Philadelphia.

Aries, Philippe. 1962. Centuries of Childhood. New York: Vintage Books.

Aronowitz, Stanley. 1974. "Food, Shelter, and the American Dream." Socialist Revolution 4 (October): 9–43.

_____. 1973. False Promises: The Shaping of American Working Class Consciousness. New York: McGraw-Hill.

Ascher (Lopate), Carol. N.d. "Women at Home." Unpublished manuscript, New York.

Astin, Helen S. 1971. The Women Doctorate in America: Origins, Career and Family. New York: Russell Sage Foundation.

Astin, Helen S., Nancy Suniewick, and Susan Dweck. 1974. Women: A Bibliography on Their Education and Careers. New York: Behavioral.

Baker, Elizabeth F. 1964. Technology and Woman's Work. New York: Columbia University Press.

Baran, Paul, and Paul Sweezey. 1966. Monopoly Capital. New York: Monthly Review Press.

Barber, Bernard. 1957. Social Stratification: A Comparative Analysis of Structure and Process. New York: Harcourt, Brace & World.

Barrett, Michele. 1978. "Marxist Feminist Theory and the Oppression of Women Today—Draft." Unpublished manuscript, London, England.

Barron, R. D., and G. M. Norris. 1976. "Sexual Divisions and the Dual Labor Market." In Dependence and Exploitation in Work and Marriage, edited by Diana Leonard Barker and Sheila Allen. London: Longman.

Barry, Herbert, Margaret K. Bacon, and Irvin L. Child. 1957. "A Cross-Cultural Survey of Some Sex Differences in Socialization." Journal of Abnormal and Social Psychology 55 (November): 327–32.

Bart, Pauline. 1971. "Sexism and Social Science: From the Gilded Cage to the Iron Cage, or, the Perils of Pauline." Journal of Marriage and the Family 33 (November): 734–45.

Baruch, Grace K. 1976. "Girls Who Perceive Themselves as Competent: Some Antecedents and Correlates." Psychology of Women Quarterly 1 (Fall): 38-49.

_____. 1972. "Maternal Influences upon College Women's Attitudes toward Women and Work." Developmental Psychology 6: 32-37.

Bass, Bernard M., Judith Krusell, and Ralph A. Alexander. 1971. "Male Managers' Attitudes toward Working Women." American Behavioral Scientist 15 (November-December): 221-36.

Baxandall, Roslyn, Elizabeth Ewen, and Linda Gordon. 1976. "The Working Class Has Two Sexes." Monthly Review 28 (July-August): 1-9.

Becker, Howard S. 1952. "The Career of the Chicago Public School Teacher." American Journal of Sociology 57 (March): 470-78.

Beechey, Veronica. 1979. "On Patriarchy." Feminist Review 3: 66-82.

_____. 1978. "Women and Production: A Critical Analysis of Some Sociological Theories of Women's Work." In Feminism and Materialism: Women and Modes of Production, edited by Annette Kuhn and AnnMarie Wolpe. London: Routledge & Kegan Paul.

_____. 1977. "Some Notes on Female Wage Labour in Capitalist Production." Capital and Class 3: 45-66.

Bell, Daniel. 1973. The Coming of Post-Industrial Society. New York: Basic Books.

Bender, Marilyn. 1976. "More Women Becoming Owners of Businesses." New York Times, April 25, 1976, pp. 1, 38.

_____. 1974. "More Women Advancing into Key Business Posts." New York Times, January 20, 1974, pp. 1, 43.

Beneria, Lourdes. 1978. "Reproduction, Production and the Sexual Division of Labor." Unpublished manuscript, Geneva.

Benjamin, Jessica, Daphne Joslin, and Gail Seneca. 1976. "Women, the Family and Capitalism: A Re-evaluation." Unpublished manuscript, New York.

Benson, Susan Porter. 1978. "'The Clerking Sisterhood': Rational-
ization and the Work Culture of Saleswomen in American Depart-
ment Stores, 1890-1960." Radical America 12 (March-April):
41-55.

Benston, Margaret. 1973. "The Political Economy of Women's Lib-
eration." Monthly Review 21 (September 1969): 13-27. Ex-
cerpted in Women in a Man-Made World: A Socioeconomic
Handbook, edited by Nona Glazer (Malbin) and Helen Youngelson
Waehrer. Chicago: Rand McNally.

"The Berkeley-Oakland Women's Union Statement: Principles of
Unity." 1978. In Capitalist Patriarchy and the Case for So-
cialist Feminism, edited by Zillah Eisenstein. New York:
Monthly Review Press.

Bernard, Jessie. 1974. The Future of Motherhood. New York:
Penguin Books.

_____. 1972. The Future of Marriage. New York: Bantam Books.

_____. 1971. Women and the Public Interest. Chicago: Aldine.

_____. 1964. Academic Women. New York: New American Library.

Bibb, Robert. N.d. "Blue Collar Women in Low-Wage Industries:
A Dual Labor Market Interpretation." Unpublished manuscript,
Urbana, Ill.

Bidwell, Charles E. 1965. "The School as a Formal Organization."
In Handbook of Organizations, edited by James G. March. Chi-
cago: Rand McNally.

Bielby, Denise Del Vento, and William T. Bielby. 1976. "Career
Continuity of Female College Graduates: Capitalizing upon Edu-
cational Investments." Paper presented at the annual meetings
of the American Sociological Association, New York.

Birnbaum, J. A. 1971. "Life Patterns, Personality Style and Self-
Esteem in Gifted Family Oriented and Career Committed Wom-
en." Ph.D. dissertation, University of Michigan.

Blakkan, René. 1972. "Women Workers in America." Guardian
(New York), March 12, 1972, p. 12.

Bland, Lucy, Charlotte Brunsdon, Dorothy Hobson, and Janice Winship. 1978. "Women 'Inside and Outside' the Relations of Production." In Women Take Issue: Aspects of Women's Subordination, edited by Women's Studies Group, Centre for Contemporary Cultural Studies. London: Hutchinson.

Blau, Francine D. 1975. "Sex Segregation of Workers by Enterprise in Clerical Occupations." In Labor Market Segmentation, edited by Richard C. Edwards, Michael Reich, and David M. Gordon. Lexington, Mass.: D. C. Heath.

Blau, Francine D., and Carol L. Jusenius. 1976. "Economists' Approaches to Sex Segregation in the Labor Market: An Appraisal." Signs 3 (Spring): 181-200.

Blau, Peter, and Otis Dudley Duncan. 1967. The American Occupational Structure. New York: John Wiley & Sons.

Blau, Zena Smith. 1972. "Maternal Aspirations, Socialization, and Achievement of Boys and Girls in the White Working Class." Journal of Youth and Adolescence 1 (January): 35-57.

Blaxall, Martha, and Barbara B. Reagan, eds. 1976. "Women and the Workplace: The Implications of Occupational Segregation." Signs, vol. 3 (Spring).

Blinder, Alan A. 1973. "Wage Discrimination: Reduced Form and Structural Estimates." Journal of Human Resources 8 (July): 436-55.

Blood, Robert, and Donald Wolfe. 1960. Husbands and Wives. New York: Free Press.

Bloom, Samuel W. 1971. "The Medical Center as a Social System." In Psychosocial Aspects of Medical Training, edited by Robert N. Coombs and Clark E. Vincent. New York: Charles C. Thomas.

Blumberg, Rae Lesser. 1978. Stratification: Socioeconomic and Sexual Inequality. Dubuque, Iowa: William C. Brown.

Bose, Christine. 1973. Jobs and Gender: Sex and Occupational Prestige. Baltimore: Johns Hopkins University Center for Metropolitan Planning and Research.

Bowles, Samuel, and Herbert Gintis. 1976. Schooling in Capitalist America. New York: Basic Books.

_____. 1972/73. "I.Q. in the U.S. Class Structure." Social Policy 3 (November-December 1972, January-February 1973): 1-27.

Bowman, G. W., N. B. Worthy, and S. A. Greyser. 1965. "Are Women Executives People?" Harvard Business Review 43 (July-August): 14-30.

Brannon, Robert. N.d. "Feminist Ideology and Hard-Nosed Methodology." Unpublished manuscript, New York.

Braverman, Harry. 1974. Labor and Monopoly Capital: The Degradation of Work in the Twentieth Century. New York: Monthly Review Press.

Bridenthal, Renate. 1977. "Domestic Labor and the Social Reproduction of Labor Power." Paper presented at the New York University Conference on Dialectics, New York, April.

_____. 1976. "The Dialectics of Production and Reproduction in History." Radical America 10 (March-April): 3-11.

Bridenthal, Renate, and Claudia Koonz, eds. 1977. Becoming Visible: Women in European History. Boston: Houghton Mifflin.

Broverman, Inge K., Susan Raymond Vogel, Donald M. Broverman, Frank E. Clarkson, and Paul S. Rosenkrantz. 1972. "Sex Role Stereotypes: A Current Appraisal." Journal of Social Issues 38: 59-78.

Brown, Carol A. 1979. "The Political Economy of Sexual Inequality —Draft." Paper presented at the annual meetings of the American Sociological Association, Boston, September.

_____. 1977. "Perspectives on Aging Women and Public Policy: Contributions to a Marxist Analysis." Unpublished manuscript, Boston.

_____. 1975a. "Patriarchal Capitalism and the Female-Headed Family." Unpublished manuscript, Boston.

_____. 1975b. "Toward Socialist Feminism." Paper presented at Sociologists for Women in Society, San Francisco.

_____. 1974. "Women Workers in the Health Service Industry."
Unpublished manuscript, New York.

Brown, Judith K. 1977. "A Note on the Division of Labor by Sex."
In Woman in a Man-Made World: A Socioeconomic Handbook,
edited by Nona Glazer (Malbin) and Helen Youngelson Waehrer.
2d ed. Chicago: Rand McNally College Publishing.

Browne, Malcolm W. 1978. "Paper Using Cold Type." New York
Times, July 3, 1978, pp. 21, 38.

Bularzick, Mary. 1978. "Sexual Harassment at the Workplace:
Historical Notes." Radical America 12 (July-August): 25-44.

Caplow, Theodore. 1954. The Sociology of Work. New York: Mc-
Graw-Hill.

Carlton, Wendy. N.d. "Women and Workers and Protective Discrimi-
nation: Focus on Reproductive Capacity." Unpublished manus-
cript, Notre Dame, Ind.

Centers, Richard. 1949. The Psychology of Social Classes. Prince-
ton, N.J.: Princeton University Press.

"Charged Sex Bias: Retail Clerks Win Victory." 1973. Guardian
(New York), November 21, 1973, p. 19.

Chase, Ivan. 1975. "A Comparison of Men's and Women's Intergen-
erational Mobility in the United States." American Sociological
Review 40 (August): 483-505.

Chodorow, Nancy. 1978a. "Mothering, Male Dominance, and Capi-
talism." In Capitalist Patriarchy and the Case for Socialist
Feminism, edited by Zillah Eisenstein. New York: Monthly
Review Press.

_____. 1978b. "Mothering, Object-Relations, and the Female Oedi-
pal Configuration." Feminist Studies 4 (February): 137-58.

_____. 1978c. The Reproduction of Mothering: Psychoanalysis and
the Sociology of Gender. Berkeley: University of California
Press.

Clark, Alice. 1920. The Working Life of Women in the Seventeenth
Century. New York: Harcourt, Brace & Howe.

Clavir, Judy Gumbo. 1978. "Choosing Either/Or: A Critique of Metaphysical Feminism." Unpublished manuscript, New Paltz, N.Y.

Cleveland Modern Times Group. 1976. "The Social Factory." Falling Wall Review 5: 2-7.

Cochran, Thomas C. 1957. The American Business System: A Historical Perspective, 1900-1955. Cambridge, Mass.: Harvard University Press.

Cohen, Elizabeth G. 1975. "Open Space Schools: The Opportunity to Become Ambitious." In The Sociology of Education: A Sourcebook, edited by Holger R. Stub. Homewood, Ill.: Dorsey Press.

_____. N.d. "Parental Factors in Educational Mobility." Unpublished manuscript, Boston.

"The Combahee River Collective: A Black Feminist Statement." 1978. In Capitalist Patriarchy and the Case for Socialist Feminism, edited by Zillah Eisenstein. New York: Monthly Review Press.

Cook, Barbara. 1967. "Role Aspirations as Evidenced in Senior Women." Ph.D. dissertation, Purdue University.

Coser, Rose, and Gerald Rokoff. 1971. "Women in the Occupational World: Social Disruption and Conflict." Social Problems 18 (Spring): 535-54.

Coulson, Margaret, Branka Magas, and Hilary Wainwright. 1975. "'The Housewife and Her Labour under Capitalism'—A Critique." New Left Review 89 (January-February): 59-72.

Coward, Ros, Sue Lipshitz, and Elizabeth Cowie. 1978. "Psychoanalysis and Patriarchal Structures." Papers on Patriarchy: Patriarchy Conference, London, 1976. London: Women's Publishing Collective and Publications Distribution Cooperative.

Dalla Costa, Mariarosa. 1972. "Women and the Subversion of the Community." In The Power of Women and the Subversion of the Community, edited by Mariarosa Dalla Costa and Selma James. Bristol, England: Falling Wall Press.

Daly, Mary. 1973. Beyond God the Father: Toward a Philosophy of Women's Liberation. Boston: Beacon Press.

Davies, Margery. 1974. "Woman's Place Is at the Typewriter: The Feminization of the Clerical Labor Force." Radical America 8 (July-August): 1-28.

Deaux, Kay, and Tim Emswiller. 1974. "Explanations of Successful Performance on Sex-Linked Tasks: What Is Skill for the Male Is Luck for the Female." Journal of Personality and Social Psychology 29 (January): 80-85.

Deckard, Barbara Sinclair. 1975. The Women's Movement: Political, Socioeconomic and Psychological Issues. New York: Harper & Row.

DeJong, Peter Y., Milton J. Brawer, and Stanley S. Robin. 1971. "Patterns of Female Intergenerational Occupational Mobility: A Comparison with Male Patterns of Intergenerational Occupational Mobility." American Sociological Review 36 (December): 1033-42.

Delmar, Rosalind. 1976. "Looking Again at Engels's Origin of the Family, Private Property and the State." In The Rights and Wrongs of Women, edited by Juliet Mitchell and Ann Oakley. New York: Penguin Books.

Dinnerstein, Dorothy. 1976. The Mermaid and the Minotaur: Sexual Arrangements and Human Malaise. New York: Harper & Row.

Dixon, Marlene. 1977. "Monopoly Capitalism and the Women's Movement: Against the Socialist Feminist Response to Harry Braverman's Labor and Monopoly Capital." Synthesis 1 (Spring): 44-54.

Doeringer, Peter B., and Michael J. Piore. 1971. Internal Labor Markets and Manpower Analysis. Lexington, Mass.: D. C. Heath.

_____. 1970. "Equal Employment Opportunity in Boston." Industrial Relations 9 (May): 324-39.

Domhoff, William. 1967. Who Rules America? Englewood Cliffs, N.J.: Prentice-Hall.

Douty, H. M. 1977. "The Slowdown in Real Wages: A Postwar Perspective." Monthly Labor Review 100 (August): 7-12.

Douvan, Elizabeth. 1976. "The Role of Models in Women's Professional Development." Psychology of Women Quarterly 1 (Fall): 5-20.

Draper, Hal. 1972. "Marx and Engels on Women's Liberation." In Female Liberation, edited by Roberta Salper. New York: Alfred A. Knopf.

Dreeban, Robert. 1970. The Nature of Teaching: Schools and the Work of Teachers. New York: Scott, Foresman.

Dubnoff, Steven. 1979. "Beyond Sex Typing: Capitalism, Patriarchy and the Growth of Female Employment, 1940-1970." Paper presented at the meetings of the Eastern Sociological Society, New York, March.

Duncan, Otis Dudley. 1966. "Methodological Issues in the Analysis of Social Mobility." In Social Structure and Mobility in Economic Development, edited by Neal J. Smelser and Seymour M. Lipset. Chicago: Aldine.

Duncan, Otis Dudley, David L. Featherman, and Beverly Duncan. 1972. Socioeconomic Background and Achievements. New York: Seminar Press.

Durkheim, Emile. 1964. The Division of Labor in Society. Translated by George Simpson. 1893. Reprint. New York: Free Press.

Easton, Barbara. 1976. "Industrialization and Femininity: A Case Study of Nineteenth Century New England." Social Problems 23 (April): 389-401.

Eckland, Bruce. 1965. "Academic Ability, Higher Education and Occupational Mobility." American Sociological Review 30 (October): 735-46.

Edwards, Richard C., Michael Reich, and David M. Gordon. 1975a. Introduction to Labor Market Segmentation, edited by Richard C. Edwards, Michael Reich, and David M. Gordon. Lexington, Mass.: D. C. Heath.

Edwards, Richard C., Michael Reich, and David M. Gordon, eds. 1975b. Labor Market Segmentation. Lexington, Mass.: D. C. Heath.

Ehrenreich, Barbara, and John Ehrenreich. 1977a. "The New Left: A Case Study in Professional-Managerial Class Radicalism." Radical America 11 (May-June): 7-24.

_____. 1977b. "The Professional-Managerial Class." Radical America 11 (March-April): 7-32.

_____. 1971. The American Health Empire: Power, Profits, and Politics. New York: Vintage Books.

Ehrenreich, Barbara, and Diedre English. 1975. "The Manufacture of House Work." Socialist Revolution 26 (October-December): 5-40.

_____. 1973. Complaints and Disorders. New York: Faculty Press.

Ehrlich, Howard J. N.d. Selected Differences in the Life Chances of Black and White in the United States. Report no. 17. Baltimore: Research Group One.

Ehrlich, Howard J., Natalie J. Sokoloff, Fred L. Pincus, and Carol Ehrlich. 1975. Women and Men: A Socioeconomic Factbook. Report no. 13. Baltimore: Research Group One.

Eisen, Arlene. 1977a. "More Women Work—The Double Shift." Guardian (New York), January 12, 1977, p. 3.

_____. 1977b. "Women Face Segregated Job Market." Guardian (New York), January 19, 1977, p. 9.

Eisenstein, Zillah. 1978a. "Developing a Theory of Capitalist Patriarchy and Socialist Feminism." In Capitalist Patriarchy and the Case for Socialist Feminism, edited by Zillah Eisenstein. New York: Monthly Review Press.

_____. 1978b. "Some Notes on the Relations of Capitalist Patriarchy." In Capitalist Patriarchy and the Case for Socialist Feminism, edited by Zillah Eisenstein. New York: Monthly Review Press.

Eisenstein, Zillah, ed. 1978c. Capitalist Patriarchy and the Case for Socialist Feminism. New York: Monthly Review Press.

Eisenstein, Zillah. 1977. "Capitalist Patriarchy and the Case for Socialist Feminism." Insurgent Sociologist 3 (Summer): 2-18.

_____. N.d. "Patriarchal Capitalism and the Case for Socialist Feminism." Unpublished manuscript, Ithaca, N.Y.

Elder, Glenn. 1969. "Appearance and Education in Marriage Mobility." American Sociological Review 43 (August): 510-33.

Engels, Frederick. 1975. Socialism: Utopian and Scientific. Translated by Edward Aveling. 1880. Reprint. New York: International.

_____. 1972. The Origin of the Family, Private Property and the State. Edited with an Introduction by Eleanor Burke Leacock. 1884. Reprint. New York: International.

_____. 1958. The Condition of the Working Class in England in 1844. Translated and edited by W. O. Henderson and W. H. Chaloner. 1845. Reprint. Oxford, England: B. Blackwell.

Epstein, Cynthia. 1972. "Encountering the Male Establishment: Sex-Status Limits on Women's Careers in the Professions." In Sociological Perspectives on Occupations, edited by Ronald Pavalko. Itasca, Ill.: F. E. Peacock.

_____. 1971. Woman's Place: Options and Limits in Professional Careers. Berkeley: University of California Press.

Ericksen, Julia. 1977. "An Analysis of the Journey to Work for Women." Social Problems 24 (April): 428-35.

Etzioni, Amitai, ed. 1969. The Semi-Professions and Their Organization. New York: Free Press.

Evanoff, Ruthann. 1979. "Reproductive Rights and Occupational Health." WIN Magazine, Fall, pp. 9-13.

Falk, William W., and Arthur G. Cosby. 1975. "Women and the Status Attainment Process." Social Science Quarterly 56 (September): 307-14.

Featherman, David L., and Robert M. Hauser. 1976. "Sexual Inequalities and Socioeconomic Achievement in the U.S., 1962-1973." American Sociological Review 41 (June): 462-83.

Federici, Sylvia. 1975. Wages against House Work. Bristol, England: Falling Wall Press.

Fee, Terry. 1976. "Domestic Labor: An Analysis of Housework and Its Relation to the Production Process." Review of Radical Political Economics 8 (Spring): 1-8.

Feldman-Summers, Shirley, and Sara B. Kiesler. 1974. "Those Who Are Number Two Try Harder: The Effect of Sex on Attributions of Causality." Journal of Personality and Social Psychology 30 (December): 846-55.

Firestone, Shulamith. 1970. The Dialectic of Sex: The Case for Feminist Revolution. New York: William Morrow.

Fishman, Pamela. 1975. "Interaction: The Work Women Do." Unpublished manuscript, Santa Barbara.

Flint, Jerry. 1977. "Growing Part-Time Work Force Has Major Impact on Economy." New York Times, April 12, 1977, pp. 1, 56.

Flitcraft, Anne, and Evan Stark. N.d. "Household Violence against Women: The Social Construction of a Private Event." Unpublished manuscript, New Haven.

Fogarty, Michael, Rhona Rapoport, and Robert Rapoport. 1971. Sex, Career and Family. Beverly Hills, Calif.: Sage.

Freedman, Francesca. 1975. "The Internal Structure of the American Proletariat: A Marxist Analysis." Socialist Revolution 26 (October-December): 41-84.

Freidson, Eliot. 1973. Profession of Medicine. New York: Dodd, Mead.

Friedan, Betty. 1963. The Feminine Mystique. New York: Dell.

Fuchs, Victor. 1971. "Differences in Hourly Earnings between Men and Women." Monthly Labor Review 94 (May): 9-15.

_____. 1968. The Service Economy. New York: Columbia University Press.

Gannon, Martin. 1974. "A Profile of the Temporary Help Industry and Its Workers." Monthly Labor Review 97 (May): 44-49.

Gardiner, Jean. 1975. "Women's Domestic Labor." New Left Review 89 (January-February): 47-58.

Gerstein, Ira. 1973. "Domestic Work and Capitalism." Radical America 7 (July-October): 101-28.

Gimenez, Martha. 1978. "Structuralist Marxism on 'The Woman Question.'" Science & Sociology 42 (Fall): 301-23.

_____. 1975. "Marxism and Feminism." Frontiers: A Journal of Women Studies 1 (Fall): 61-80.

Glass, David. 1954. Social Mobility in Britain. London: Routledge & Kegal Paul.

Glazer (Malbin), Nona. 1978. "Toward a Theory of Women's Domestic Labor—Family Organization and Social Relations outside the Family. Part I. Preliminary Statement." Unpublished manuscript in progress, Washington, D.C., November.

_____. 1976. "Housework." Signs 1 (Summer): 905-22.

_____. 1975. "The Division of Labor in the Husband-Wife Relationship: Some Rethinking." Paper prepared for the Conference on Family and Gender Roles, Merrill-Palmer Institute/Ford Foundation, Detroit, November.

Glazer (Malbin), Nona, and Helen Youngelson Waehrer, eds. 1973. Woman in a Man-Made World: A Socioeconomic Handbook. Chicago: Rand McNally.

Glenn, Evelyn Nakano, and Roslyn L. Feldberg. 1979. "Women as Mediators in the Labor Process: Explorations in Class and Consciousness." Paper presented at the Conference on New Directions in the Labor Force, Binghamton, N.Y., May 1978. Revised version presented at the annual meetings of the American Sociological Association, Boston, September.

_____. 1977. "Degraded and Deskilled: The Proletarianization of Clerical Work." Social Problems 25 (October): 52-64.

Glenn, Norval D., Adreain A. Ross, and Judy Corder Tully. 1974. "Patterns of Intergenerational Mobility of Females through Marriage." American Sociological Review 39 (October): 683-99.

Goldberg, Phillip. 1974. "Are Women Prejudiced against Women?" Transaction 5: 28-30.

Goldberg, Stephen. 1973. The Inevitability of Patriarchy. New York: William Morrow.

Goode, William J. 1963. World Revolution and Family Patterns. New York: Free Press.

Goodman, Neal. N.d. "The (Non) Treatment of Women in the Study of Social Mobility." Unpublished manuscript, n.p.

Gordon, David M. 1972. Theories of Poverty and Underemployment: Orthodox, Radical and Dual Labor Market Perspectives. Lexington, Mass.: Lexington Books.

Gough, Kathleen. 1973. "An Anthropologist Looks at Engels." In Woman in a Man-Made World: A Socioeconomic Handbook, edited by Nona Glazer (Malbin) and Helen Youngelson Waehrer. New York: Rand McNally.

Gouldner, Alvin. 1970. The Coming Crisis of Western Sociology. New York: Avon Books.

Gove, Walter R., and Jeanette F. Tudor. 1973. "Adult Sex Roles and Mental Illness." American Journal of Sociology 78 (January): 812-35.

Grabiner, Virginia, and L. B. Cooper. 1973. "Towards a Theoretical Orientation for Understanding Sexism." Insurgent Sociologist 4 (Fall): 3-14.

Greenbaum, Joan, and Laird Cummings. 1978. "The Struggle over Productivity, Workers, Management, and Technology." In U.S. Capitalism in Crisis, edited by the Crisis Reader Editorial Collective. New York: Union for Radical Political Economics.

Grimm, James W., and Robert N. Stern. 1974. "Sex Roles and In-
ternal Labor Market Structures: The 'Female' Semi-Profes-
sions." Social Problems 21 (June): 690-705.

Gross, Edward. 1971. "Plus Ça Change . . . ? The Sexual Structure
of Occupations over Time." In The Professional Woman, edited
by Athena Theodore. Cambridge, Mass.: Schenkman.

Gubbels, Robert. 1973. "Characteristics of Supply and Demand for
Women Workers on the Labour Market." In Employment of
Women. Paris: Organization for Economic Cooperation and
Development, November 1970. Excerpted in Woman in a Man-
Made World: A Socioeconomic Handbook, edited by Nona Glazer
(Malbin) and Helen Youngelson Waehrer. Chicago: Rand Mc-
Nally.

Guettel, Charnie. 1974. Marxism & Feminism. Toronto, Canada:
Canadian Women's Educational Press.

Guttmacher, Mary J. 1971. "Occupational Choice as a Response to
Environmental Press: A Case Study of Teaching Aspirants."
Special qualifying paper, Harvard University Graduate School
of Education.

_____. N.d. "Effects of Social Class Background on the Career
Commitment of Women Attending Non Elite Colleges." Unpub-
lished research proposal, n.p.

Hacker, Sally. 1978. "Sex Stratification, Technology, and Organi-
zational Change: A Longitudinal Analysis of AT&T." Paper
presented at the annual meetings of the American Sociological
Association, San Francisco, September.

Hall, Oswald. 1948. "The Stages of a Medical Career." American
Journal of Sociology 53 (March): 327-36.

Haller, Archibald O., and A. Portes. 1973. "Status Attainment Pro-
cesses." Sociology of Education 46 (Winter): 51-91.

Hartmann, Heidi. 1979. Personal communication.

_____. 1976. "Capitalism, Patriarchy, and Job Segregation by Sex."
Signs 1 (Spring, pt. 2): 137-69.

_____. 1974. "Capitalism and Women's Work in the Home." Ph.D.
dissertation, Yale University.

Hartmann, Heidi, and Amy Bridges. 1977. "The Unhappy Marriage of Marxism and Feminism: Towards a More Progressive Union." Unpublished manuscript. To be published in Capital and Class (1979) and in Women and Revolution, edited by Lydia Sargent. Boston: South End Press, forthcoming.

Hartnett, Oonagh. 1977. "Sex-Role Stereotyping at Work." In The Sex-Role System: Psychological and Sociological Perspectives, edited by Jane Chetwynd and Oonagh Hartnett. London: Routledge & Kegan Paul.

Hartsock, Nancy. 1978. "Response to 'What Causes Gender Privilege and Class Privilege?' by Sandra Harding." Paper presented at the American Philosophical Association, Washington, D.C.

Hauser, Robert, and David L. Featherman. 1974. Social Indicator Models. New York: Russell Sage Foundation.

Havens, Elizabeth M., and Judy Corder Tully. 1972. "Female Intergenerational Occupational Mobility: Comparisons of Patterns." American Sociological Review 37 (December): 774-77.

Hayghe, Howard. 1978. "Marital and Family Characteristics of Workers, March 1977." Monthly Labor Review 101 (February): 51-54, with supplementary tables.

_____. 1976. "Families and the Rise of Working Wives—An Overview." Special Labor Force Report 189. Reprinted from Monthly Labor Review 99 (May): 12-19, with corrections.

"Health Professions Doled Part of a Loaf; Nurses Now Casualty." 1977. Nation's Health 1 (April): 5.

Hesselbart, Susan. 1978. "Some Underemphasized Issues about Men, Women and Work." Paper presented at annual meetings of the American Sociological Association, San Francisco, September.

Hill, Christopher. 1967. Society and Pre-Revolutionary England. New York: Schocken Books.

Hill, Judah. 1975. Class Analysis: United States in the 1970s. San Francisco: Synthesis.

Hoffman, Lois Wladis. 1976. "Effects of Maternal Employment on the Child: A Review of the Research." In Beyond Sex-Role Stereotypes: Readings toward a Psychology of Androgyny, edited by Alexandra G. Kaplan and Joan P. Bean. Boston: Little, Brown.

_____. 1972. "Early Childhood Experiences and Women's Achievement Motives." Journal of Social Issues 28: 129-56.

Hoffman, Lois Wladis, and Ivan Nye, eds. 1974. Working Mothers. San Francisco: Jossey-Bass.

Holmstrom, Lynda Lytle. 1973. The Two-Career Family. Cambridge, Mass.: Schenkman.

Howard, Suzanne. 1975. "Women Public School Teachers: Second Class, Second Rank, Second Rate?" Washington D.C.: Resource Center on Sex Roles in Education.

Howe, Louise Kapp. 1977. Pink Collar Workers: Inside the World of Women's Work. New York: G. P. Putnam's Sons and Avon Books.

Hudis, Paula M., Amy L. Miller, and David Snyder. 1978. "Changes in the Structure of Work and the Sexual Composition of Occupations: 1870-1900." Paper presented at the annual meetings of the American Sociological Association, San Francisco, September.

Hughes, Everett. 1945. "Dilemmas and Contradictions of Status." American Journal of Sociology 50 (March): 353-59.

Humphries, Jane. 1977. "The Working Class Family, Women's Liberation, and Class Struggle: The Case of Nineteenth Century British History." Review of Radical Political Economics 3 (Fall): 25-41.

Hunt, A. 1975. Management Attitudes and Practices towards Women at Work. London: Office of Population Censuses and Survey, Social Survey Division.

Hunt, Janet, and Larry Hunt. 1977. "Dilemmas and Contradictions of Status: The Case of the Dual-Career Family." Social Problems 24 (April): 407-17.

"Inflation without End?" Monthly Review 31 (November): 1-10.

Inkeles, Alex, and Peter Rossi. 1956. "National Comparisons of Occupational Prestige." American Journal of Sociology 61 (January): 329-39.

Inman, Mary. 1964. The Two Forms of Production under Capitalism. 1939. Reprint. Long Beach, Calif.: Mary Inman, P.O. Box 507, Long Beach, Calif., 90801.

Jacobson, Barbara, and John M. Kendrick. 1978. "Industrialization and Gender Domination: The Fusion of Class, Status and Authority." Paper presented at the annual meetings of the American Sociological Association, San Francisco, September.

Jaffe, A. J., and Joseph Froomkin. 1978. "Occupational Opportunities for College-Educated Workers, 1950-1975." Monthly Labor Review 101 (June): 15-21.

James, Selma. 1972. Introduction to The Power of Women and the Subversion of the Community, edited by Mariarosa Dalla Costa and Selma James. Bristol, England: Falling Wall Press.

Jencks, Christopher, with Marshall Smith, Henry Acland, Mary Jo Bane, David Cohen, Herbert Gintis, Barbara Heyns, and Stephen Michelson. 1972. Inequality: A Reassessment of the Effect of Family and Schooling in America. New York: Harper & Row.

Jones, Carleton. 1977. "For Ph.D.'s, It's 'Buddy Can You Spare a Job?'" Sunday Sun (Baltimore), April 24, 1977, p. 1.

Kahl, Joseph, and James A. Davis. 1955. "A Comparison of Indexes of Socio-Economic Status." American Sociological Review 20 (June): 317-25.

Kanter, Rosabeth Moss. 1977a. Men and Women of the Corporation. New York: Basic Books.

_____. 1977b. Work and Family in the United States: A Critical Review and Agenda for Research and Policy. New York: Russell Sage Foundation.

_____. 1975a. "Women and Hierarchies." Paper presented at the annual meetings of the American Sociological Association, San Francisco, August.

_____. 1975b. "Women and the Structure of Organizations: Explorations in Theory and Behavior." In Another Voice: Feminist Perspectives on Social Life and Social Science, edited by Marcia Millman and Rosabeth Moss Kanter. Garden City, N.Y.: Doubleday.

Kelly (Gadol), Joan. 1979. "The Doubled Vision of Feminist Theory: A Postscript to the 'Women and Power' Conference." Feminist Studies 5 (Spring): 216-27.

_____. 1976a. "Marxist Feminist Theory." Paper presented at the MidAtlantic Radical Historian Organization, New York, April.

_____. 1976b. "The Social Relation of the Sexes: Methodological Implications of Women's History." Signs 1 (Summer): 809-923.

_____. 1975/76. "Review of Woman's Consciousness, Man's World, by Sheila Rowbotham." Science and Society 39 (Winter): 471-74.

Kempton, Maureen. 1975. "All We Want for Christmas Is Our Jobs Back." Ms. 4 (December): 69-72.

Keniston, Kenneth, and the Carnegie Council on Children. 1978. All Our Children. New York: Harcourt Brace Jovanovich.

Kessler-Harris, Alice. 1975. "Stratifying by Sex: Understanding the History of Working Women." In Labor Market Segmentation, edited by Richard C. Edwards, Michael Reich, and David M. Gordon. Lexington, Mass.: D. C. Heath.

Keyserling, Mary Dublin. 1972. "The Socioeconomic Waste: Underutilization of Women." In Women's Role in Contemporary Society: The Report of the New York City Commission on Human Rights. New York: Avon Books.

Kihss, Peter. 1977. "Women's Wages Fall Even Farther Behind." New York Times, April 3, 1977, p. 35.

Kilson, Marion. 1977. "Black Women in the Professions, 1890-1970." Monthly Labor Review 100 (May): 38-41.

Klecka, C. O., and D. V. Hiller. 1975. "Impact of Mother's Life Style for Adolescent Gender Role Socialization." Paper presented at the annual meetings of the American Sociological Association, San Francisco, August.

Kleiman, Carol. 1977. "Women Get 'Protected' Right out of Their Jobs." Chicago Tribune, September 4, 1977, p. 10.

Klemmack, David L., and John N. Edwards. 1973. "Women's Acquisition of Stereotyped Occupational Aspirations." Sociology and Social Research 57 (July): 510-25.

Knudsen, Dean. 1969. "The Declining Status of Women: Popular Myths and the Failure of Functionalist Thought." Social Forces 48 (December): 183-93.

Kolko, Gabriel. 1978. "Working Wives: Their Effects on the Structure of the Working Class." Science and Society 42 (Fall): 257-77.

Komarovsky, Mirra. 1967. Blue Collar Marriage. New York: Vintage Books.

Krauss, Irving. 1964. "Sources of Educational Aspirations among Working-Class Youth." American Sociological Review 29 (December): 876-79.

Kreps, Juanita. 1971. Sex in the Marketplace: American Women at Work. Baltimore: Johns Hopkins University Press.

Kuhn, Annette. 1978. "Structure of Patriarchy and Capital in the Family." In Feminism and Materialism: Women and Modes of Production, edited by Annette Kuhn and AnnMarie Wolpe. London: Routledge & Kegan Paul.

Lane, Angela. 1974. "The Effect of Family of Origin on Female College Graduates' Sex Role Attitudes and Behavior." Paper presented at the Seminar on Theoretical and Methodological Issues in Sex Stratification meeting at the Social Science Research Council, New York, November.

Lane, Anne. 1976. "Women in Society: A Critique of Frederick Engels." In Liberating Women's History, edited by Berenice A. Carroll. Chicago: University of Illinois Press.

Larguia, Isabel, and John Dumoulin. 1975. "Aspects of the Condition of Women's Labor." NACLA's Latin America & Empire Report 9 (September): 2-13.

_____. 1973. "Towards a Science of Women's Liberation." Somerville, Mass.: New England Free Press.

Lazonick, William. 1977. "The Appropriation and Reproduction of Labor." Socialist Revolution 33 (May–June): 109–27.

Leacock, Eleanor Burke. 1977a. "On Engels' Origin of the Family, Private Property and the State." In The Family: Functions, Conflicts and Symbols, edited by Peter Stein, Judith Richman, and Natalie Hannon. Reading, Mass.: Addison-Wesley.

_____. 1977b. "Women in Egalitarian Societies." In Becoming Visible: Women in European History, edited by Renate Bridenthal and Claudia Koonz. Boston: Houghton Mifflin.

Levine, Adele G. 1968. "Marital and Occupational Plans in Professional Schools: Law, Medicine, Nursing and Teaching." Ph.D. dissertation, Yale University.

Liebowitz, Lila. 1975. "Perspectives on the Evolution of Sex Differences." In Toward an Anthropology of Women, edited by Rayna Rapp (Reiter). New York: Monthly Review Press.

Lipman-Blumen, Jean. 1976. "Toward a Homosocial Theory of Sex Roles: An Explanation of the Sex Segregation of Social Institutions." Signs 1 (Spring, pt. 2): 15–32.

Lipman-Blumen, Jean, and Patricia Thompson. 1976. "Maternal Employment and Adult Role Orientations of Young Married Women." Paper presented at the annual meetings of the American Sociological Association, New York City, August.

Lipset, Seymour Martin, and Reinhard Bendix. 1959. Social Mobility in Industrial Society. Berkeley: University of California Press.

Lloyd, Cynthia B., ed. 1975. Sex, Discrimination and the Division of Labor. New York: Columbia University Press.

Lopata, Helena Z. 1971. Occupation: Housewife. London and New York: Oxford University Press.

Lopata, Helena, Z., and Barrie Thorne. 1978. "On the Term 'Sex Roles.'" Signs 3 (Spring): 718–21.

Lorber, Judith. 1975. "Trust, Loyalty and the Place of Women in the Informal Organization of Work." Paper presented at the annual meetings of the American Sociological Association, San Francisco, August.

Lovett, S. L. 1969. "Personality Characteristics and Antecedents of Vocational Choice of Graduate Women Students in Science Research." Dissertation Abstracts 29: 228.

McClelland, David. 1961. The Achieving Society. New York: Free Press.

McClendon, McKee. 1976. "The Occupational Status Attainment Process of Males and Females." American Sociological Review 41 (February): 52-64.

Maccoby, Eleanore Emmons, and Carol Nagy Jacklin. 1974. The Psychology of Sex Differences. Stanford, Calif.: Stanford University Press.

McDonough, Roisin, and Rachel Harrison. 1978. "Patriarchy and Relations of Production." In Feminism and Materialism: Women and Modes of Production, edited by Annette Kuhn and AnnMarie Wolpe. London: Routledge & Kegan Paul.

McIntosh, Mary. 1978. "The State and the Oppression of Women." In Feminism and Materialism: Women and Modes of Production, edited by Annette Kuhn and AnnMarie Wolpe. London: Routledge & Kegan Paul.

Maeroff, Gene. 1973. "Education: College Faculties: Over 40, White, and Male." New York Times, August 26, 1973, p. 11.

Malos, Ellen. 1978. "Housework and the Politics of Women's Liberation." Socialist Review 37 (January-February): 41-71.

Marglin, Stephen A. 1974. "What Do Bosses Do? The Origins and Functions of Hierarchy in Capitalist Production." Review of Radical Political Economics 6 (Summer): 60-112.

Marini, Margaret Mooney. 1979. "Sex Difference in the Process of Occupational Achievement." Paper presented at the annual meetings of the American Sociological Association, Boston, August.

Marsden, Lorna R. 1976. Personal communication.

Martin, Ann M. 1971. The Theory/Practice of Communicating Educational and Vocational Information. Boston: Houghton Mifflin.

Marx, Karl. 1973. The Grundrisse. Translated with a Foreword by Martin Nicolaus. 1858. Reprint. New York: Random House.

_____. 1967a. Capital: A Critique of Political Economy. Vol. 1. 1886. Reprint. New York: International.

_____. 1967b. Capital: A Critique of Political Economy. Vol. 2. 1907. Reprint. New York: International.

_____. 1967c. Capital: A Critique of Political Economy. Vol. 3. 1909. Reprint. New York: International.

_____. 1967d. "On a Proposed Divorce Law." In Writings of the Young Marx on Philosophy and Society, edited by Loyd D. Easton and Kurt H. Guddat. 1843. Reprint. Garden City, N.Y.: Doubleday.

_____. 1967e. "On the Jewish Question." In Writings of the Young Marx on Philosophy and Society, edited by Loyd D. Easton and Kurt H. Guddat. 1843. Reprint. Garden City, N.Y.: Doubleday.

_____. 1963. The Eighteenth Brumaire of Louis Bonaparte. 1852. Reprint. New York: International.

_____. 1904. A Contribution to the Critique of Political Economy. 1859. Reprint. Chicago: Charles H. Kerr.

Marx, Karl, and Frederick Engels. 1954. The Communist Manifesto. 1848. Reprint. Chicago: Gateway Press.

_____. 1947. The German Ideology. 1846. Reprint. New York: International.

Mayer, Kurt. 1963. "The Changing Shape of the American Class Structure." Social Research 30 (Winter): 458-68.

_____. 1956. "Recent Changes in the Class Structure of the United States." In Transactions of the Third World Congress of Sociology. Vol. 3. London: International Sociological Association.

Mead, Margaret. 1935. Sex and Temperament in Three Primitive Societies. New York: New American Library.

Meillassoux, Claude. 1973. "The Social Organization of the Peasantry: The Economic Basis of Kinship." Journal of Peasant Studies 1 (October): 81-90.

Milkman, Ruth. 1976. "Women's Work and the Economic Crisis: Some Lessons from the Great Depression." Review of Radical Political Economics 8 (Spring): 73-97.

Millett, Kate. 1970. Sexual Politics. New York: Doubleday.

Millman, Marcia, and Rosabeth Moss Kanter, eds. 1975. Another Voice: Feminist Perspectives on Social Life and Social Science. Garden City, N.Y.: Doubleday.

Mills, C. Wright. 1956. White Collar. New York: Oxford University Press.

Mitchell, Juliet. 1974. Psychoanalysis and Feminism. New York: Pantheon Books.

_____. 1973. "Marxism and Women's Liberation." Social Praxis 1: 23-34.

_____. 1971a. Woman's Estate. New York: Vintage Books.

_____. 1971b. "Women: The Longest Revolution." New Left Review 30 (November-December 1966): 11-37. Reprinted in From Feminism to Liberation, edited by Edith Hoshino Altbach. Cambridge, Mass.: Schenkman.

Molyneux, Maxine. 1979. "Beyond the Housework Debate." New Left Review 116 (July-August): 3-27.

Montagna, Paul. 1977. Occupations and Society: Toward a Sociology of the Labor Market. New York: John Wiley & Sons.

Morgan, Robin. 1977. Going Too Far: The Personal Chronicle of a Feminist. New York: Random House.

Morton, Peggy. 1971. "A Woman's Work Is Never Done." In From Feminism to Liberation, edited by Edith Hoshino Altbach. Cambridge, Mass.: Schenkman.

Muelenbelt, Anja. 1978. "On the Political Economy of Domestic Labour." Quest: A Feminist Quarterly 4 (Winter): 18-31.

Muller, Viana. 1977. "The Formation of the State and the Oppression of Women: Some Theoretical Considerations and a Case Study in England and Wales." Review of Radical Political Economics 3 (Fall): 7-21.

National Manpower Council. 1957. Womanpower. New York: Columbia University Press.

Navarro, Vicente. 1975. "Women in Health Care." New England Journal of Medicine 292 (February 20): 398-402.

New American Movement Political Perspective. 1972. "Sexism." In Working Papers on Socialist Feminism. Chicago: New American Movement.

Newfield, Jack. 1975. "How Con Ed Conned Everyone." Village Voice (New York), November 3, 1975, p. 30.

Newson, John, and Elizabeth Newson et al. 1977. "Perspectives in Sex-Role Stereotyping." In The Sex-Role System: Psychological and Sociological Perspectives, edited by Jane Chetwynd and Oonagh Hartnett. London: Routledge & Kegan Paul.

Nye, Ivan, and Lois Wladis Hoffman, eds. 1963. The Employed Mother in America. Chicago: Rand McNally.

Oakley, Ann. 1974. Woman's Work: The Housewife, Past and Present. New York: Pantheon Books.

_____. 1972. Sex, Gender and Society. New York: Harper & Row.

Oaxaca, Ronald. 1973. "Sex Discrimination in Wages." In Discrimination in Labor Markets, edited by Orley Ashenfelter and Albert Rees. Princeton, N.J.: Princeton University Press.

O'Connor, James. 1973. The Fiscal Crisis of the State. New York: St. Martin's Press.

O'Leary, Virginia E. 1974. "Some Attitudinal Barriers to Occupational Aspirations in Women." Psychological Bulletin 81 (November): 809-26.

Oppenheimer, Martin. N.d. "The Hidden Proletariat: Women Office Workers." Unpublished paper, n.p.

Oppenheimer, Valerie Kincaide. 1977. "The Sociology of Women's Economic Role in the Family." American Sociological Review 42 (June): 387-405.

_____. 1973a. "Demographic Influences on Female Employment and the Status of Women." American Journal of Sociology 78 (January): 946-61.

_____. 1973b. "A Sociologist's Skepticism." In Corporate Lib, edited by Eli Ginzberg and Alice M. Yohalem. Baltimore: Johns Hopkins University Press.

_____. 1970. The Female Labor Force in the United States. Berkeley: Institute of International Studies, University of California.

Oren, Laura. 1973. "The Welfare of Women in Laboring Families: England, 1860-1950." Feminist Studies 1 (Winter-Spring): 107-21.

Ornstein, Michael. 1976. Entry into the American Labor Force: Quantitative Studies in Social Relations. New York: Academic Press.

Ortner, Sherry. N.d. "The Virgin and the State, Working Paper." Unpublished manuscript, n.p.

Otero, J. F., and Michael D. Boggs. 1974. "A New Awareness for Latino Workers." New York Teacher, June 16, 1974, pp. 11-14.

Pagelow, Mildred Daley. 1978. "Social Learning Theory and Sex Roles: Violence Begins in the Home." Paper presented at the annual meetings of the Society for the Study of Social Problems, San Francisco, August.

Parsons, Talcott. 1949a. "The Kinship System of the Contemporary United States." Essays in Sociological Theory. New York: Free Press of Glencoe.

_____. 1949b. "Social Classes and Class Conflict in Light of Recent Sociological Theory." Essays in Sociological Theory. New York: Free Press of Glencoe.

Parsons, Talcott, with Robert F. Bales, Morris Zelditch, James Olds, and Philip Slater. 1955. Family, Socialization and Interaction Process. Glencoe, Ill.: Free Press.

Pavalko, Ronald M., ed. 1972. Sociological Perspectives on Occupations. Itasca, Ill.: F. E. Peacock.

Pearson, Jessica. 1976. "Mothers and Daughters: A New Look at Female Intergenerational Occupational Mobility." Unpublished manuscript, Denver.

Pease, John, William Form, and Joan Huber (Rytina). 1970. "Ideological Currents in American Stratification Literature." American Sociologist 5 (May): 127-37.

Petchesky, Roslyn. 1978. "Dissolving the Hyphen: A Report on Marxist-Feminist Groups 1-5." In Capitalist Patriarchy and the Case for Socialist Feminism, edited by Zillah Eisenstein. New York: Monthly Review Press.

Phillips, Anne, and Barbara Taylor. 1978. "Sex and Class in the Capitalist Labour Process. Draft." London: Unpublished manuscript in progress.

Pinchbeck, Ivy. 1969. Women Workers and the Industrial Revolution, 1750-1850. 1930. Reprint. London: Frank Cass.

Piore, Michael J. 1975. "Notes for a Theory of Labor Market Segmentation." In Labor Market Segmentation, edited by Richard C. Edwards, Michael Reich, and David M. Gordon. Lexington, Mass.: D. C. Heath.

_____. 1974. "Upward Mobility, Job Monotony and Labor Market Structure." In Work and the Quality of Life: Resource Papers for "Work in America," edited by James O'Toole. Cambridge: Massachusetts Institute of Technology Press.

Pleck, Joseph. 1977. "The Work-Family Role System." Social Problems 24 (April): 417-27.

_____. 1976. "Men's Power with Women, Other Men, and Society: A Men's Movement Analysis." In Women and Men: The Consequences of Power, edited by Dana V. Hiller and Robin Ann Sheets. Cincinnati, Ohio: Office of Women's Studies, University of Cincinnati.

Plotnick, Margaret. 1973/74. "Why Men Don't Bear Children: A Power Analysis." Berkeley Journal of Sociology 18: 45-86.

Poll, Carol. 1978. "No Room at the Top: A Study of the Social Processes That Contribute to the Underrepresentation of Women on the Administrative Levels of the New York City School System." Ph.D. dissertation, City University of New York, Graduate Center.

Popular Economics Press. 1977. Why Do We Spend So Much Money? 3d ed. Somerville, Mass.: Popular Economics Press.

Presser, Harriet. 1975. "Female Employment and the First Birth." Paper presented at the annual meetings of the American Sociological Association, San Francisco, August.

"Productivity Slowdown: A False Alarm." 1979. Monthly Review 31 (June): 1-12.

Project on the Status and Education of Women. 1974. Minority Women and Higher Education #1. Washington, D.C.: Association of American Colleges.

Quick, Paddy. 1977. "The Class Nature of Women's Oppression." Review of Radical Political Economics 9 (Fall): 42-53.

_____. 1972. "Women's Work." Review of Radical Political Economics 4 (July): 2-19.

Rapoport, Rhona. 1977. "Sex-Role Stereotyping in Studies of Marriage and the Family." In The Sex Role System: Psychological and Sociological Perspectives, edited by Jane Chetwynd and Oonagh Hartnett. London: Routledge & Kegan Paul.

Rapoport, Rhona, and Robert Rapoport. 1971. Dual-Career Families. New York: Penguin Books.

Rapp (Reiter), Rayna. 1978. "Family and Class in Contemporary America: Notes toward an Understanding of Ideology." Science & Society 42 (Fall): 278-300.

_____. 1977. "The Search for Origins." Critique of Anthropology 3: 5-24.

_____. 1976. "Unraveling the Problem of Origins: An Anthropological Search for Feminist Theory." Paper presented at The Scholar and the Feminist III: The Search for Origins, Barnard College, New York.

_____. 1975. Introduction to Toward an Anthropology of Women, edited by Rayna Rapp (Reiter). New York: Monthly Review Press.

Red Apple Collective. 1978. "Socialist-Feminist Women's Unions: Past and Present." Socialist Review 38 (March-April): 37-58.

Reich, Wilhelm. 1966. Sex Pol. New York: Vintage Books.

Reinhold, Robert. 1977. "Decrease in Farm Population Accelerates; Figures Show a 14% Decline from 1970-76." New York Times, April 15, 1977, p. 14.

Reiss, Albert J., Jr., with Otis Dudley Duncan, Paul K. Hatt, and Cecil C. North. 1961. Occupations and Social Status. New York: Free Press.

Rich, Adrienne. 1976. Of Woman Born: Motherhood as Experience and Institution. New York: W. W. Norton.

Roark, Anne C. 1977. "First-Time College Enrollment of Women Leaps Dramatically." Chronicle of Higher Education 13 (February 7): 1, 10.

Roberts, Steven. 1977. "White Males Challenge Affirmative Action Programs." New York Times, November 24, 1977, pp. 1, 17.

Roby, Pamela. 1973. "Institutional Barriers to Women Students in Higher Education." In Academic Women on the Move, edited by Alice S. Rossi and Ann Calderwood. New York: Russell Sage Foundation.

_____. 1972. "Women and American Higher Education." Annals of the American Academy of Political and Social Science 404: 118-39.

Rogoff (Ramsøy), Natalie. 1973. "Patterns of Female Intergenerational Occupational Mobility: A Comment." American Sociological Review 38 (December): 806-7.

_____. 1953. Recent Trends in Occupational Mobility. Glencoe, Ill.: Free Press.

Rosaldo, Michelle, and Louise Lamphere, eds. 1974. Women, Culture and Society. Stanford, Calif.: Stanford University Press.

Rosenfeld, Rachel. 1978. "Women's Intergenerational Occupational Mobility." American Sociological Review 43 (February): 36-46.

_____. 1976. "Women's Employment Patterns and Occupational Achievements." Unpublished manuscript, Montreal.

Rossi, Alice S. 1977. "A Biosocial Perspective on Parenting." Daedalus (Spring): 1-25.

_____. 1973. "Summary and Prospects." In Academic Women on the Move, edited by Alice S. Rossi and Ann Calderwood. New York: Russell Sage Foundation.

_____. 1965. "Barriers to Career Choice of Engineering, Medicine or Science among American Women." In Women and the Scientific Professions: The M.I.T. Symposium on American Women in Science and Engineering, edited by Jacquelyn A. Mattfeld and Carol Van Aken. Cambridge: Massachusetts Institute of Technology Press.

Rothschild, Joan A. 1979. "Technology, 'Women's Work,' and the Social Control of Women." Paper presented at Women and Society: A Symposium, St. Michael's College, Winooski, Vt., March.

Rowbotham, Sheila. 1973. Women's Consciousness, Man's World. London: Penguin Books.

Rubin, Gayle. 1975. "The Traffic in Women: Notes on the 'Political Economy' of Sex." In Toward an Anthropology of Women, edited by Rayna Rapp (Reiter). New York: Monthly Review Press.

Rubin, Zick. 1968. "Do American Women Marry Up?" American Sociological Review 33 (October): 750-60.

Rubinstein, David M. 1977. "The Social Nature of the Person: The Concepts of Marx and Mead." In Sociology for Our Times, edited by Gerald L. Siccard and Philip Weinberger. Glenview, Ill.: Scott, Foresman.

Sacks, Karen. 1975. "Engels Revisited: Women, the Organization of Production, and Private Property." In Toward an Anthropology of Women, edited by Rayna Rapp (Reiter). New York: Monthly Review Press.

Saffilios-Rothschild, Constantina. 1970. "The Influence of the Wife's Degree of Work Commitment upon Some Aspects of Family Organization and Dynamics." Journal of Marriage and the Family 32 (November): 681-91.

Samuelson, Barbara S. 1977. "Temps: The Help That's Here to Stay." New York Times, May 22, 1977, p. 13.

San Francisco Bay Area Kapitalistate Group. 1975. "The Fiscal Crises of the State: A Review." Kapitalistate 3 (Spring): 149-58.

Sandler, Mark. 1977. "Toward a Theory of Clerical Proletarianization in Capitalist Development." Paper presented at the annual meetings of the American Sociological Association, Chicago.

Secombe, Wally. 1975. "Domestic Labour: Reply to Critics." New Left Review 94 (November-December): 85-96.

_____. 1973. "The Housewife and Her Labour under Capitalism." New Left Review 83 (January-February): 3-24.

Sewell, William H. 1971. "Inequality of Opportunity for Higher Education." American Sociological Review 36 (October): 793-809.

Sewell, William H., and Archibald Haller. 1965. Rural Youth in Crisis: Facts, Myths and Social Change. Washington, D.C.: U.S. Government Printing Office.

Sewell, William H., Archibald Haller, and G. W. Ohlendorf. 1970. "The Educational and Early Occupational Status Attainment Process: Replication and Revision." American Sociological Review 35 (December): 1014-27.

Sewell, William H., Archibald Haller, and A. Portes. 1969. "The Early Educational and Early Occupational Status Attainment Process." American Sociological Review 34 (February): 82-92.

Sewell, William H., and Robert M. Hauser. 1975. Education, Occupation, and Earnings. New York: Academic Press.

_____. 1972. "Causes and Consequences of Higher Education: Models of the Status Attainment Process." American Journal of Agricultural Economics 54 (December): 851-61.

Sexton, Patricia Cayo. 1977. Women and Work. R&D Monograph 46. Washington, D.C.: U.S. Department of Labor, Employment and Training Administration.

Shanahan, Eileen. 1976a. "Gap Earnings between the Sexes Reported up Threefold since '55." New York Times, November 29, 1976, p. 18.

_____. 1976b. "Jobs in Big Banks Found Hard to Get for Minority Men." New York Times, December 13, 1976, pp. 57, 61.

Shea, John R., Ruth S. Spitz, and Frederick A. Zeller, and Associates. 1970. Dual Careers: A Longitudinal Study of Labor Market Experience of Women. Vol. 1. Columbus, Ohio: Center for Human Resource Research.

Siegal, Alberta Engvall, and Elizabeth Ann Curtis. 1963. "Familial Correlates of Orientation toward Future Employment among College Women." Journal of Educational Psychology 54 (February): 33-37.

Siegal, Alberta Engvall, and Miriam Bushkoff Hass. 1963. "The Working Mother: A Review of Research." Child Development 34: 513-42.

Siegal, Paul M., Robert W. Hodge, and Peter H. Rossi. N.d. Social Standing in the United States. Manuscript in progress.

Silveira, Jeanette. 1975. The Housewife and Marxist Class Analysis. Pittsburgh: KNOW.

Simeral, Margaret. 1978. "Women and the Reserve Army of Labor." Insurgent Sociologist 8 (Fall): 164-79.

Simpson, Richard L., and Ida Harper Simpson. 1969. "Women and Bureaucracy in the Semi-Professions." In The Semi-Professions and Their Organization, edited by Amitai Etzioni. New York: Free Press.

Sindler, Allan P. 1978. Bakke, DeFunis, and Minority Admissions: The Quest for Equal Opportunity. New York and London: Longman.

Smigel, Erwin O. 1963. Wall Street Lawyer. New York: Free Press of Glencoe.

Smith, David. 1974. Who Rules the Universities? New York: Monthly Review Press.

Smith, Dorothy E. 1977a. Feminism : Marxism: A Place to Begin, A Way to Go. Vancouver, Canada: New Star Books.

_____. 1977b. "Some Implications of a Sociology for Women." In Woman in a Man-Made World: A Socioeconomic Handbook, edited by Nona Glazer (Malbin) and Helen Youngelson Waehrer. 2d ed. Chicago: Rand McNally College Publishing.

_____. 1975/76. "Women, the Family and Corporate Capitalism." Berkeley Journal of Sociology 20: 55-90.

_____. 1975. "An Analysis of Ideological Structures and How Women Are Excluded: Considerations for Academic Women." Canadian Review of Sociology and Anthropology 12 (November, pt. 1): 353-69.

Smuts, Robert W. 1959. Women and Work in America. New York: Columbia University Press.

Snyder, David, Mark D. Hayward, and Paula M. Hudis. 1978. "The Location of Change in the Sexual Structure of Occupations, 1950-1970: Insights from Labor Market Segmentation Theory." American Journal of Sociology 84 (November): 706-17.

Sokoloff, Natalie J. 1977. "The Economic Position of Women in the Family." In The Family: Functions, Conflicts and Symbols, edited by Peter Stein, Judith Richman, and Natalie Hannon. Reading, Mass.: Addison-Wesley.

_____. N.d. "The Influence of Mothers on Early Careers of College Educated Daughters from Different Socioeconomic Origins." Manuscript in progress, New York.

Somers, Peggy. 1975. "Socialism and Feminism: The Hegelian Marxist/Structuralist Marxist Debate." Paper presented at the East Coast Conference of Socialist Sociologists, Boston.

Sørenson, Aage B. 1977. "The Structure of Inequality and the Process of Attainment." American Sociological Review 42 (December): 965-78.

Sorokin, Pitirim. 1927. Social Mobility. New York: Harper.

Spaeth, Joe L. 1975. "Differences in the Occupational Achievement Process between Male and Female College Graduates (Revised Version)." Paper presented at the annual meetings of the American Sociological Association, San Francisco, August.

_____. 1970. "Occupational Attainment among Male College Graduates." American Journal of Sociology 75 (January): 632-44.

_____. 1968. "Occupational Prestige Expectations among Male College Graduates." American Journal of Sociology 73 (March): 548-58.

Spaeth, Joe L., and Andrew Greeley. 1970. Recent Alumni and Higher Education: A Survey of College Graduates. New York: McGraw-Hill.

Spence, Janet T., and Robert Helmreich. 1972. "Who Likes Competent Women? Competence, Sex-Role Congruence of Interests and Subjects' Attitudes toward Women as Determinants of Interpersonal Attraction." Journal of Applied Social Psychology 2 (July-September): 197-213.

Steinberg, Bruce, and Lourdes Beneria. 1978. "Labor Market Segmentation and the Labor Process." Unpublished manuscript, New York.

Stellman, Jeanne Mager. 1977. Women's Work, Women's Health: Myth and Realities. New York: Pantheon Books.

Stevenson, Mary. 1975. "Women's Wages and Job Segregation." In Labor Market Segmentation, edited by Richard C. Edwards, Michael Reich, and David M. Gordon. Lexington, Mass.: D. C. Heath.

Stockard, Joan, Miriam Johnson, Marion Goldman, and Joan Acker. 1975. "Sex Role Development and Sex Discrimination: Theoretical Perspective." Unpublished manuscript, Eugene, Ore.

Stone, Katherine. 1974. "The Origins of Job Structures in the Steel Industry." Review of Radical Political Economics 6 (Summer): 113-73.

Stone, Morris. 1978. "A Backlash in the Workplace." New York Times, June 11, 1978, p. 3.

Stover, Ed. 1975. "Inflation and the Female Labor Force." Monthly Review 26 (January): 50-58.

Strasser, Susan M. 1978a. "The Business of Housekeeping: The Ideology of the Household at the Turn of the Twentieth Century." Insurgent Sociologist 8 (Fall): 147-63.

_____. 1978b. "Mistress & Maid, Employer & Employee: Domestic Service Reform in the United States, 1897-1920." Marxist Perspectives 1 (Winter): 52-67.

Strauss, Murray A. 1976. "Sexual Inequality, Cultural Norms, and Wife-Beating." In Victims and Society, edited by Emilio C. Viano. Washington, D.C.: Visage Press.

Stuart, Reginald. 1977. "Shift to Smaller Cars Helps Chrysler Cut Work Force." New York Times, November 27, 1977, p. 26.

Suter, Larry E., and Herman P. Miller. 1973. "Income Differences between Men and Career Women." American Journal of Sociology 78 (January): 962-74.

Szymanski, Albert. 1976. "The Socialization of Women's Oppression: A Marxist Theory of the Changing Position of Women in Advanced Capitalist Society." Insurgent Sociologist 6 (Winter): 31-60.

_____. 1974a. "Male Economic Loss from Sexual Discrimination." Paper presented at the Society for the Study of Social Problems Meeting, Montreal, August.

_____. 1974b. "Race, Sex and the U.S. Working Class." Social Problems 21 (June): 706-25.

Tangri, Sandra Schwartz. 1972. "Determinants of Occupational Role Innovation among College Women." Journal of Social Issues 28: 177-99.

Tannis, Wendy Bunt. 1972. "An Analysis of the Effects of Social Class, Mother's Working Status, Mother's Occupation and Mother's Education on the Educational and Occupational Aspirations of Female Grade Ten Students in an Ontario Community." Master's thesis, University of Windsor.

Taylor, Frederich W. 1911. Shop Management. New York: Harper.

Theodore, Athena. 1971. "The Professional Woman: Trends and Prospects." In The Professional Woman, edited by Athena Theodore. Cambridge, Mass.: Schenkman.

Thompson, Patricia, Jean Lipman-Blumen, and Denise Abrams. 1976. "Adult Role Orientations of Married Daughters of Working Mothers: The Relative Influence of Parental Stratification Variables." Paper presented at the Pacific Sociological Association Meeting, San Diego, March.

Tobias, Sheila. 1973. "What Really Happened to Rosie the Riveter? Demobilization and the Female Labor Force, 1944-47." MSS Modular Publication no. 9, New York.

Treiman, Donald J., and Kermit Terrell. 1975. "Sex and the Process of Status Attainment: A Comparison of Working Women and Men." American Sociological Review 40 (April): 174-200.

Trey, Joan Ellen. 1972. "Woman in the War Economy." Review of Radical Political Economics 4 (July): 40-57.

Trigg, Linda J., and Daniel Perlman. 1976. "Social Influences on Women's Pursuit of a Nontraditional Career." Psychology of Women Quarterly 1 (Winter): 138-50.

Tyree, Andrea, and Judith Treas. 1974. "The Occupational and Marital Mobility of Women." American Sociological Review 29 (June): 293-302.

U.S., Department of Labor, Bureau of Labor Statistics. 1977. U.S. Working Women: A Data Book (Bulletin 1977). Washington, D.C.: Government Printing Office.

_____. 1975. U.S. Working Women: A Chartbook, 1975 (Bulletin 1880). Washington, D.C.: Government Printing Office.

_____. 1972. Black Americans: A Decade of Occupational Change. Washington, D.C.: Government Printing Office.

U.S., Department of Labor, Employment Standards Administration. 1976. The Earnings Gap between Women and Men. Washington, D.C.: Women's Bureau.

U.S., Department of Labor, Wage and Labor Standards Administration. 1969. Facts about Women's Absenteeism and Labor Turnover. Washington, D.C.: Women's Bureau, August.

_____. 1968. Working Wives—Their Contribution to Family Income. Washington, D.C.: Women's Bureau, November.

U.S., Department of Labor, Women's Bureau. 1975. 1975 Handbook on Women Workers. Washington, D.C.: Government Printing Office.

_____. 1969. 1969 Handbook on Women Workers. Washington, D.C.: Government Printing Office.

Vanek, Joanne. 1977. "The New Family Equality: Myth or Reality?" Paper presented at the annual meetings of the American Sociological Association, Chicago, September.

_____. 1974. "Time Spent in Housework." Scientific American 231 (November): 116-20.

Veres, Helen. 1974. "Career Choice and Career Commitment of Two-Year College Women." Paper presented at the annual meeting of the American Educational Research Association, Chicago.

Vogel, Lise. 1978. "The Contested Domain: A Note on the Family in the Transition to Capitalism." Marxist Perspectives 1 (Spring): 50-73.

_____. 1977. "The Longer I Stay the Better I Like: Class Action and the Woman Workers." Paper presented at the International Conference in Women's History, University of Maryland, College Park, November.

_____. 1973. "The Earthly Family." Radical America 7 (July-October): 9-50.

Waldman, Elizabeth. 1970. "Changes in the Labor Review." Monthly Labor Review 93 (June): 10-18.

Warner, W. Lloyd, Marchia Meeker, and Kenneth Eels. 1949. Social Class in America. Chicago: Science Research Associates.

Wartenberg, Hannah. N.d. "Married Women in the Labor Force: Research Findings and Needs." Unpublished manuscript, New Paltz, N.Y.

Weber, Max. 1968. Economy and Society. Edited by Gunther Roth and Claus Wittich. Translated by Ephraim Fischoff et al. New York: Bedminster Press.

_____. 1947. The Theory of Social and Economic Organization. Translated by A. M. Henderson and Talcott Parsons. New York: Oxford University Press.

Weill, Mildred. 1971. "An Analysis of the Factors Influencing Married Women's Actual or Planned Work Participation." In The Professional Woman, edited by Athena Theodore. Cambridge, Mass.: Schenkman.

Weinbaum, Batya. 1978. The Curious Courtship of Women's Liberation and Socialism. Boston: South End Press.

Weinbaum, Batya, and Amy Bridges. 1976. "The Other Side of the Paycheck: Monopoly Capital and the Structure of Consumption." Monthly Review 28 (July-August): 88-103.

Weinreich, Helen. 1977. "Sex-Role Socialization." In The Sex-Role System: Psychological and Sociological Perspectives, edited by Jane Chetwynd and Oonagh Hartnett. London: Routledge & Kegan Paul.

Weir, Angela, and Elizabeth Wilson. 1973. "Women's Labor, Women's Discontent." Radical America 7 (July-October): 80-94.

White, James J. 1971. "Women in the Law." In The Professional Woman, edited by Athena Theodore. Cambridge, Mass.: Schenkman.

Wilensky, Harold. 1964. "The Professionalization of Everyone?" American Journal of Sociology 70 (September): 142-46.

Williams, Gregory. 1975. "A Research Note on Trends in Occupational Differences by Sex." Social Problems 22 (April): 543-47.

Wilson, Elizabeth. 1977. Women and the Welfare State. London: Tavistock.

Winch, Robert. 1963. The Modern Family, Revised Edition. New York: Holt, Rinehart and Winston.

Winfrey, Carey. 1978. "How It Was, How It Is." New York Times, July 3, 1978, pp. 21, 38.

Winkler, Ilene. N.d. Women Workers: The Forgotten Third of the Working Class. N.p.: International Socialist Publication.

Wolf, Wendy. 1976. "Occupational Attainments of Married Women: Do Career Contingencies Matter?" Paper presented at the annual meetings of the American Sociological Association, New York, August.

Women's Work Project. 1978. Women Organizing the Office. New York: Union for Radical Political Economics.

Women's Work Study Group. 1975. "Loom, Broom, and Womb: Producers, Maintainers and Reproducers." Frontiers: A Journal of Women Studies 1 (Fall): 1-41.

Yorburg, Betty. 1973. The Changing Family. New York: Columbia University Press.

Yorburg, Betty, and Ibtihaj Arafat. N.d. "Sex Role Conceptions and Conflict." Unpublished manuscript, New York.

Young, Iris. 1979. "Two Approaches to Socialist Feminism: The Dual Systems Theory and Division of Labor Analysis—Part II—Draft." Unpublished manuscript, Chicago.

_____. 1978. "Two Approaches to Socialist Feminism: The Dual Systems Theory and Division of Labor Analysis—Part I." Paper presented at the American Philosophical Association, Washington, D.C.

Young, Kate, and Olivia Harris. 1978. "The Subordination of Women in Cross Cultural Perspective." In Papers on Patriarchy: Patriarchy Conference, London, 1976. London: Women's Publishing Collective and Publications Distribution Cooperative.

Zaretsky, Eli. 1978. "The Effects of the Economic Crisis on the Family." In U.S. Capitalism in Crisis, edited by Crisis Reader Editorial Collective. New York: Union for Radical Political Economics.

_____. 1976. Capitalism, the Family, and Personal Life. New York: Harper & Row.

INDEX

ABOUT THE AUTHOR

NATALIE J. SOKOLOFF is an Assistant Professor of Sociology at the John Jay College of Criminal Justice, a unit of the City University of New York. She is a recipient of a grant from the American Sociological Association's Problems in the Discipline Program to develop an on-going interdisciplinary workshop among experts in the field of women and work.

She has published in numerous journals, including: Women: A Journal of Liberation, Resources for Feminist Research (formerly the Canadian Newsletter for Research on Women), Quest: A Feminist Quarterly, as well as in several anthologies. She is also coauthor of Women and Men: A Socioeconomic Factbook, a pamphlet designed specifically for classroom use.

Formerly associated with the Mount Sinai School of Medicine in its Department of Community Medicine (New York City), the author of this book holds a Bachelor's Degree from the University of Michigan, a Master's Degree from Brown University, and her doctorate from the City University of New York, Graduate Center.